MIMESIS
AND
ALTERITY

A Particular History
of the Senses

Michael Taussig

ROUTLEDGE
New York • London

Published in 1993 by

Routledge
An imprint of Routledge, Chapman and Hall, Inc.
29 West 35 Street
New York, NY 10001

Published in Great Britain in 1993 by

Routledge
11 New Fetter Lane
London EC4P 4EE

Library of Congress Cataloging in Publication Data

Taussig, Michael T.
 Mimesis and alterity : a particular history of the senses /
Michael Taussig.
 p. cm.
 Includes bibliographical references and index.
 ISBN 0-415-90686-5 (hb)—ISBN 0-415-90687-3 (pb)
 1. Ethnology—Philosophy. 2. Imitation—Cross-cultural studies.
3. Difference (Philosophy).—Cross-cultural studies. 4. Mimesis in
art. I. Title.
GN345.T37 1991
306—dc20 92-35584
 CIP

British Library Cataloguing in Publication Data also available.

Every day the urge grows stronger to get hold of an object at very close range by way of its likeness, its reproduction.

Walter Benjamin *"The Work of Art in the Age of Mechanical Reproduction,"* 1936

CONTENTS

ACKNOWLEDGEMENTS

I like to think of writing itself as a mimetic exchange with the world—a cast of mind that helps me understand how deeply this idiosyncratic book on the mimetic faculty in its relation to primitivism is indebted to the students and faculty of the Department of Performance Studies, the Tisch School of the Arts, New York University. Here I was encouraged, as never before, to consider the political art and social power of make-believe, the reality of the really made-up—the foundation, in other words, of modern sociology, anthropology, and critical self-awareness.

To Susan Buck-Morss, for her stunningly original work on Walter Benjamin, I am also indebted, not least for her treatment of mimesis in relation to modernity's primitivism. This pivotal relation was impressed upon me through Gertrude Koch's work on film, as well. Margaret Cohen made me appreciate the power of Surrealism in Benjamin's Marxism. Charles Merewether got me thinking about the healing power of mimicry as in wooden figurines used by Cuna healers off the coasts of Panama and Colombia, and Dorothea and Norman Whitten provided the opportunity to publicly air my initial response in a symposium on shamanism, a response that was sharpened by Anna Blume inviting me to address her colleagues in art history. Discussions with Lynda Hill concerning her forthcoming work on Zora Neale Hurston made me understand better the distancing effects of copying. Calm infrastructural support was provided by Mark Sussman. Lorna Price

once again served meticulously as copy-editor, no less sympathetic to the project than with its need to be communicable.

To the Cuna themselves, as much as their ethnographers, beginning with Rubén Pérez Kantule and Erland Nordenskiold, I owe much and I hope they will understand my many excesses of interpretation—as if interpretation could be anything else. I have never travelled to Panama or the San Blas islands, present home of the Cuna, and I have borrowed much from N.M. Chapin's very fine doctoral thesis on Cuna healing and from Joel Sherzer's illuminating studies on Cuna language. Carlo Severi responded warmly and cautioned me on the Nia chant. Stephanie Kane's work on Embera life in the Darién provided with me a bridge to the Pacific coast of Colombia, a coast I first visited in 1971, and she also provided a stimulating model of writing not constructed around what Jim Clifford has called "ethnographic authority". Drawing upon his great fund of knowledge of things Central American, Charlie Hale provided me with a cartoon illustrating early U.S. attitudes towards Panama. Pamela Sankar and Paul Rabinow encouraged me to think about finger prints and mimesis.

My training (although "training" sounds too formal) in the magic of mimesis was through the tutelage of Santiago Mutumbajoy, of Mocoa, Putumayo, Colombia, beginning in 1975. My understanding of African-Colombian history and the legacy of African slavery in northern South America, including Panama, came through several years of working on the history of slave haciendas and on the abolition of slavery in northern Cauca, where I lived in Puerto Tejada thanks to the generosity of many people, especially Marlene Jiménez, Guillermo Llanos, Eusebio Cambindo, Felipe Carbonera, Tomás Zapata, Olivia Mostacilla, and José Domingo Murillo. Julie Taylor and George Marcus provided the encouragement that a post-colonial, culturally sensitive, anthropology of signification is possible, necessary, and necessarily exciting—a project that for me has meant coming to grips with the dialectic of civilization-and-savagery installed in contemporary signifying practices themselves. And in this I have benefited from the transgressive confluence of anxiety and insight in the work, spoken and written, of Cornell West and Paul Gilroy.

To declare that writing itself is a mimetic exchange with the world

also means that it involves the relatively unexplored but everyday capacity to imagine, if not become, Other. Benjamin sought a model for this capacity in what he understood to be "ancient" magical practices, no less than in the games of children. Here I need to add another practice, the to and fro of discussion—especially with Rachel Moore from whom so many thoughts were thus drawn, it being often impossible to claim single authorship. "The perception of similarity," wrote Benjamin in relation to the mimetic faculty, "is in every case bound to an instantaneous flash. It slips past, can possibly be regained, but cannot be held fast, unlike other perceptions. It offers itself as fleetingly and transitorily as a constellation of stars." I would like to think this book is just such an offering.

Acknowledgements of Illustrations

Erland Nordenskiold and Rubén Pérez, ed. Henry Wassén, *An Ethnological and Historical Survey of the Cuna Indians* (1938); Gerardo Reichel-Dolmatoff, "Anthropomorphic Figurines from Colombia, Their Magic and Art," 1961; Alfonso Díaz Granados in Leonor Herrera and Marianne Cardale de Schrimpff, "Mitología Cuna: Los Kalu" (1974); R. O. Marsh, *White Indians of Darien* (1934); National Anthropological Archive, Smithsonian Institution, Washington; British Museum; Bibliotheque Nacional, Paris; Quinta de Bolívar, Bogotá; Ann Parker and Avon Neal, *Molas: Folk Art of the Cuna Indians* (1977); Frances Hubbard Flaherty, *Robert Flaherty, The Odyssey of a Film-Maker: Robert Flaherty's Story* (1984); Les Blank and James Bogan, *Burden of Dreams* (1984); Museum of Anthropology, University of Cambridge; Alexander Buchner, *Mechanical Musical Instruments* (1978); Francis Galton, *Finger Prints* (1965); Oliver Read and M. L. Welch, *From Tin Foil to Stereo: Evolution of the Phonograph*, 1976; Herbert Cole, 1967.

A REPORT TO THE ACADEMY

> To *put it plainly, much as I like expressing*
> *myself in images, to put it plainly: your life as*
> *apes, gentlemen, insofar as something of that*
> *kind lies behind you, cannot be farther re-*
> *moved from you than mine is from me. Yet*
> *everyone on earth feels a tickling at the heels;*
> *the small chimpanzee and the great Achilles*
> *alike.*
>
> —Franz Kafka, "A Report to An Academy"

So what is this tickling at the heels to which Kafka's all too human ape would refer us all too apish humans to? I call it the mimetic faculty, the nature that culture uses to create second nature, the faculty to copy, imitate, make models, explore difference, yield into and become Other. The wonder of mimesis lies in the copy drawing on the character and power of the original, to the point whereby the representation may even assume that character and that power. In an older language, this is "sympathetic magic," and I believe it is as necessary to the very process of knowing as it is to the construction and subsequent naturaliza-

tion of identities. But if it is a faculty, it is also a history, and just as histories enter into the functioning of the mimetic faculty, so the mimetic faculty enters into those histories. No understanding of mimesis is worthwhile if it lacks the mobility to traverse this two-way street, especially pertinent to which is Euro-American colonialism, the felt relation of the civilizing process to savagery, to aping.

●　　　　　●　　　　　●

My way of traversing this two-way street takes me into an eccentric history which begins with the curious and striking recharging of the mimetic faculty caused by the invention of mimetically capacious machines such as the camera, in the second half of the nineteenth century. This history then somersaults backward in time so as to explore a foundational moment in the equation of savagery with mimesis—namely, the experience of young Charles Darwin, in 1832 on the beach at Tierra del Fuego, full of wonder at the mimetic prowess of primitives, especially as it concerns their mimicking him. This history then fans forwards in the form of other sailors setting sail from northern climes, as they appear carved in the shape of wooden curing figurines in the early twentieth-century Swedish ethnography of certain Indians of the Darién Peninsula between the Panama Canal and Colombia. Wondering about the magical possibilities in this image-making of Europeans makes me in turn speculate first about what it might be to live Darién-like in mimetic worlds where spirits copy physical reality, and second, what it means for me as a white man to trace a history in which an image of the white man is used by Indian men to access magical power emergent from the womb of the Great Mother. This somersaults me forward into myself from First Contact time with Darwin on

the beach, through the invention of mimetic machines, to late twentieth-century Reverse Contact now-time, when the Western study of the Third and Fourth World Other gives way to the unsettling confrontation of the West with itself as portrayed in the eyes and handiwork of its Others. Such an encounter disorients the earlier occidental sympathies which kept the magical economy of mimesis and alterity in some sort of imperial balance. History wreaks its revenge on representational security as essentialism and constructionism oscillate wildly in a death-struggle over the claims of mimesis to be the nature that culture uses to create a now-beleaguered second nature. And this brings me to the end of (my) history, wondering if the surge of mimetic sensitivity accompanying this death-struggle might indicate other ways of being identical, other ways of being alter. And this brings me to the vexing subject of "constructionism," of making things up.

● ● ●

For in this history I am often caught musing as to whether the wonder of the magic in mimesis could reinvigorate the once-unsettling observation that most of what seems important in life is made up and is neither more (nor less) than, as a certain turn of phrase would have it, "a social construction." It seems to me that the question of the mimetic faculty tickles the heels of this upright posture and makes it interesting once again. With good reason postmodernism has relentlessly instructed us that reality is artifice yet, so it seems to me, not enough surprise has been expressed as to how we nevertheless get on with living, pretending—thanks to the mimetic faculty—that we live facts, not fictions. Custom, that obscure crossroads where the constructed and the habitual coalesce, is indeed mysterious. Some force im-

pels us to keep the show on the road. We cannot, so it would seem, easily slow the thing down, stop and inquire into this tremendously braced field of the artificial. When it was enthusiastically pointed out within memory of our present Academy that race or gender or nation . . . were so many social constructions, inventions, and representations, a window was opened, an invitation to begin the critical project of analysis and cultural reconstruction was offered. And one still feels its power even though what was nothing more than an invitation, a preamble to investigation has, by and large, been converted instead into a conclusion—eg. "sex is a social construction," "race is a social construction," "the nation is an invention," and so forth, the tradition of invention. The brilliance of the pronouncement was blinding. Nobody was asking what's the next step? What do we do with this old insight? If life is constructed, how come it appears so immutable? How come culture appears so natural? If things coarse and subtle are constructed, then surely they can be reconstrued as well? To adopt Hegel, the beginnings of knowledge were made to pass for actual knowing.

●　　　　●　　　　●

I think construction deserves more respect; it cannot be name-called out of (or into) existence, ridiculed and shamed into yielding up its powers. And if its very nature seems to prevent us— for are we not also socially constructed?—from peering deeply therein, that very same nature also cries out for something other than analysis as this is usually practiced in reports to our Academy. For in construction's place—what? No more invention, or more invention? And if the latter, as is assuredly the case, why don't we start inventing? Is it because at this point the critic fumbles the pass and the "literary turn" in the social sciences

and historical studies yields naught else but more meta-commentary in place of poesis, little by way of making anew?

•　　　　•　　　　•

But just as we might garner courage to reinvent a new world and live new fictions—what a sociology that would be!—so a devouring force comes at us from another direction, seducing us by playing on our yearning for the true real. Would that it would, would that it could, come clean, this true real. I so badly want that wink of recognition, that complicity with the nature of nature. But the more I want it, the more I realize it's not for me. Nor for you either . . . which leaves us is this silly and often desperate place wanting the impossible so badly that while we believe it's our rightful destiny and so act as accomplices of the real, we also know in our heart of hearts that the way we picture and talk is bound to a dense set of representational gimmicks which, to coin a phrase, have but an arbitrary relation to the slippery referent easing its way out of graspable sight.

•　　　　•　　　　•

Now the strange thing about this silly if not desperate place between the real and the really made-up is that it appears to be where most of us spend most of our time as epistemically correct, socially created, and occasionally creative beings. We dissimulate. We act and have to act as if mischief were not afoot in the kingdom of the real and that all around the ground lay firm. That is what the public secret, the facticity of the social fact, being a social being, is all about. No matter how sophisticated we may be as to the constructed and arbitrary character of our practices, including our practices of representation, our practice of practices is one of actively forgetting such mischief each time

we open our mouths to ask for something or to make a statement. Try to imagine what would happen if we didn't in daily practice thus conspire to actively forget what Saussure called "the arbitrariness of the sign"? Or try the opposite experiment. Try to imagine living in a world whose signs were indeed "natural."

● ● ●

Something nauseating looms here, and we are advised to beat a retreat to the unmentionable world of active forgetting where, pressed into mighty service by society, the mimetic faculty carries out its honest labor suturing nature to artifice and bringing sensuousness to sense by means of what was once called sympathetic magic, granting the copy the character and power of the original, the representation the power of the represented.

● ● ●

Yet this mimetic faculty itself is not without its own histories and own ways of being thought about. Surely Kafka's tickling at the heels, brought to our attention by the ape aping humanity's aping, is sensateness caught in the net of passionful images spun for several centuries by the colonial trade with wildness that ensures civilization its savagery? To witness mimesis, to marvel at its wonder or fume at its duplicity, is to sentiently invoke just that history and register its profound influence on everyday practices of representation. Thus the history of mimesis flows into the mimesis of history, Kafka's ape standing at the turbulence where these forces coalesce. And if I am correct in invoking a certain magic of the signifier and what Walter Benjamin took the mimetic faculty to be—namely, the compulsion to become the Other—and if, thanks to new social conditions and new techniques of reproduction (such as cinema and mass production

of imagery), modernity has ushered in a veritable rebirth, a recharging and retooling the mimetic faculty, then it seems to me that we are forthwith invited if not forced into the inner sanctum of mimetic mysteries where, in imitating, we will find distance from the imitated and hence gain some release from the suffocating hold of "constructionism" no less than the dreadfully passive view of nature it upholds.

1

IN SOME WAY OR ANOTHER ONE CAN PROTECT ONESELF FROM THE SPIRITS BY PORTRAYING THEM

> *He is driven not merely to awaken congealed life in petrified objects—as in allegory—but also to scrutinize living things so that they present themselves as being ancient, 'Ur-historical' and abruptly release their significance.*
>
> —T. W. Adorno, "Uber Walter Benjamin"

He is driven . . . to awaken congealed life in petrified objects. Thus, Benjamin, in addressing the fetish character of objecthood under capitalism, demystifying and reenchanting, out-fetishizing the fetish. And if this necessarily involves a movement in the other direction, not awakening but petrifying life, reifying instead of fetishizing, doing what Adorno describes as the scrutiny of living things so that they present themselves as being Ur-historical and hence abruptly release their significance, then a strange parallel is set up with my reading of the Cuna shaman of the San Blas Islands off Panama, faced with a woman in obstructed labor and singing for the restoration of her soul. By her hammock in his singing he is seeing, scrutinizing, bringing into being an allegory of the cosmos as woman through whom is plotted the journey along the birth canal of the world—an action he undertakes by first awakening congealed life in his petrified fetish-objects, carved wooden figurines now standing by the laboring woman. With them he will journey. To them he sings:

The medicine man gives you a living soul, the medicine man changes for you your soul, all like replicas, all like twin figures.[1]

Note the *replicas*. Note the magical, the soulful power that derives from replication. For this is where we must begin; with the magical power of replication, the image affecting what it is an image of, wherein the representation shares in or takes power from the represented—testimony to the power of the mimetic faculty through whose awakening we might not so much understand that shadow of science known as magic (a forlorn task if ever there was one), but see anew the spell of the natural where the reproduction of life merges with the recapture of the soul.

The Objectness of the Object

Like Adorno and Benjamin, if not also this San Blas Cuna shaman, my concern is to reinstate in and against the myth of Enlightenment, with its universal, context-free reason, not merely the resistance of the concrete particular to abstraction, but what I deem crucial to thought that moves and moves us—namely, its sensuousness, its mimeticity. What is moving about moving thought in Benjamin's hands is precisely this. Adorno pictures Benjamin's writing as that in which "thought presses close to its object, as if through touching, smelling, tasting, it wanted to transform itself," and Susan Buck-Morss indicates how this very sensuousness is indebted to and necessary for what is unforgettable in that writing, its unremitting attempt to create "exact fantasies," translating objects into words, maintaining the objectness of the object in language such that here translation is equivalent to more than translation, to more than explanation—to a sizzling revelation exercising the peculiar powers of the mimetic faculty.[2]

The Object

I want to begin with the problem to be found in Baron Erland Nordenskiold's compilation *An Historical and Ethnological Survey of the*

Cuna Indians, published in Sweden by the Gothenburg Ethnological Museum in 1938, six years after the baron's death.[3] It was edited by Henry Wassén and, as its title page states, was "written in collaboration with the Cuna Indian, Rubén Pérez Kantule," a twenty-four-year-old secretary to the Cuna *Nele* de Kantule. (*Nele* is a title meaning High Chief and Seer which Nordenskiold and Pérez sometimes employ as a proper name.) You can see intimations of anthropological sympathy between the Swedish baron and the high chief's secretary from the frontispiece portrait photograph of Nordenskiold and that of Rubén Pérez, set above the title of the book's first chapter. Both well-groomed, in suit and tie, they share the same posture, these relaxed yet alert investigators of things Cuna.

Having been forced by illness to leave the land of the Cunas after a mere month of study there in 1927, two years after their successful revolt against the Panamanian government, the baron had invited Rubén Pérez to spend six months in Sweden to become his secretary and assist him in the interpretation of Cuna picture-drawings. When Pérez arrived in Sweden, he brought what Nordenskiold judged to be very valuable manuscript material—"songs, incantations, descriptions of illnesses, and prescriptions, all written in the Cuna language and mainly in our system of writing"—as well as a great many notes in English and Spanish concerning Cuna traditions and history dictated to him by the *Nele,* the Great Seer himself.

The problem I want to take up concerns the wooden figurines used in curing. Cuna call them *nuchukana* (pl.; *nuchu,* sing.), and in Nordenskiold and Pérez' text I find the arresting claim that "all these wooden figures represent European types, and to judge by the kind of clothes, are from the eighteenth and possibly from the seventeenth century, or at least have been copied from old pictures from that time". (345)*

Pérez had never seen a wooden figure with a ring in the nose. Only the women wear such a ring. But Henry Wassén, asserting editorial prerogative, added a note saying that such figures do exist, however, and referred the reader to one, "certainly very old," which had been given him in 1935 in Balboa by Mrs. Dove L. Prather, to add to his collection. Not only the Indians collect *nuchus.*

Nordenskiold raised the question whether the figurines were a rela-

*Throughout this book, where the same source is refered to often and continuously, the page reference is inserted in parentheses at the end of the relevant sentence.

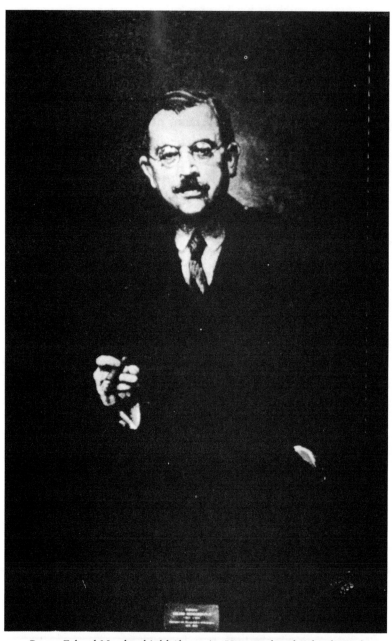

Baron Erland Nordenskiold (from *An Historical and Ethnological Survey of the Cuna Indians*, 1938)

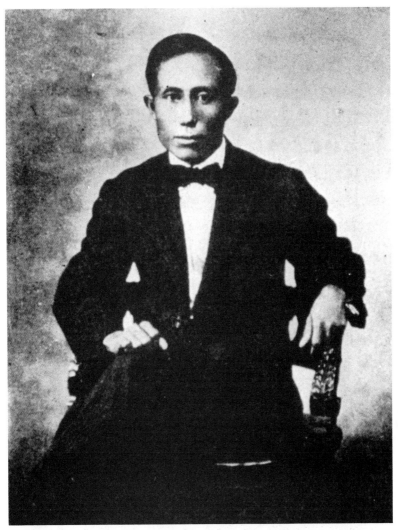

Rubén Pérez (from *An Historical and Ethnological Survey of the Cuna Indians*, 1938).

tively modern invention among the Cuna, based on their observations of the Catholic saints. (426) There is indeed reason to suggest that the figurines are a creation of relatively modern times, possibly no later than nineteenth century. "Until very recently," wrote the U.S. anthropologist David Stout in the 1940s, "none of the primary sources on

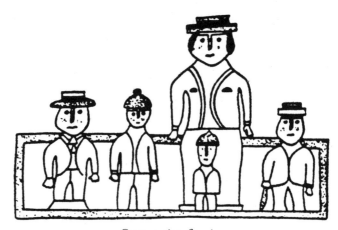

Cuna curing figurines
Drawn by Guillermo Hayans (cerca 1948)

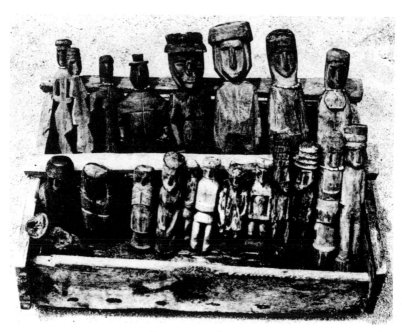

Cuna curing figurines

Cuna history mention *nuchus*."[4] In an article he published in 1940, Wassén speculated on the influence African slaves may have had on Cuna and Chocó Indian "magic sticks." He wrote, "that the carved sticks which are used by the Kuna medicine singers are equipped with figures of Europeans in cloth from an older period and have been influenced by figures of the saints etc., strengthens my opinion that the Kunas have adopted these sticks relatively late." As an afterthought he added: "The figures of, for example, the Spaniards on the sticks could be explained as an emblem of power."[5] Certainly there is no mention whatsoever of the figurines in the detailed account left by the pirate's surgeon Lionel Wafer concerning his four months' stay among the Indians of the Darién Peninsula in 1681, and Wafer was extremely interested in Indian medicine and curing ritual. Indeed, his prestige and safety among them depended on such knowledge. He reports vividly on lively healing ritual involving the mimicry of what he takes to be the voices of spirits conversing with the healer. But there is no indication of figurines.[6]

In any event, whatever the temporal relation to European colonialism might be (and whatever could be learned from it), Nordenskiold was sure of one thing: "It is certain at any rate that the wooden figures which the Cunas carve and use as abiding places for their helping spirits, no longer look like either Indians or demons, but like white people."(426) And half a century later, in 1983, with the authority of having spent four years among the Cuna, the anthropologist and former U.S. Peace Corpsman Norman Chapin made basically the same point—the figurines "almost invariably are carved to look like non-Indians; if they are made to represent Indians, they are somewhat more exotic, wearing suits and hats with serrated tops, and are occasionally riding horses."[7]

The Problem: Mimesis Unleashed

At this point the problem can be fairly stated (with some wonder, mind you) as to why these figures, so crucial to curing and thus to Cuna society, should be carved in the form of "European types." In short: why are they Other, and why are they the Colonial Other? This ques-

tion leads to still more of a very particular and particularizing sort, because in asking it I am, as a "European type," brought to confront my cultured self in the form of an Indian figurine! What magic lies in this, my wooden self, sung to power in a language I cannot understand? Who is this self, objectified without my knowledge, that I am hell-bent on analyzing as object-over-there fanned by sea breezes and the smoke of burning cocoa nibs enchanting the shaman's singing?

Something trembles in the whole enterprise of analysis and knowledge-making here: the whole anthropological trip starts to eviscerate. And about time, too. For if I take the figurines seriously, it seems that I am honor-bound to respond to the mimicry of my-self in ways other than the defensive maneuver of the powerful by subjecting it to scrutiny as yet another primitive artifact, grist to the analytic machinery of Euroamerican anthropology. The very mimicry corrodes the alterity by which my science is nourished. For now I too am part of the object of study. The Indians have made me alter to my self. Time for a little chant of my own:

And here where pirates arm in arm with Darién
Indians roamed,
Of their bones is coral made.
What Enlightening spirits can I sing into Being
For rethinking the thinking Self,
Its European histories, its other futures?

Embodiment

These questions are entwined in the puzzling fact that there is a fundamental split between the outer carved form of the curing figurines and their inner substance. For the ethnography emphatically states, as a Cuna article of faith, that the spirit of the wood, not its outer form, determines the efficacy of the figurine. Thus we are forced to ponder why it is then necessary to carve an outer European, non-Indian form. Why bother carving forms at all if the magical power is invested in the spirit of the wood itself? And indeed, as our puzzling leads to more puzzling, why is embodiment itself necessary?

This question in turn turns on an equally obscure problem, the most basic of all: how are such figurines supposed to function in healing? I find it exceedingly strange that in the research on Cuna curing I have consulted, not only is there almost nothing written directly on the figurines, let alone on their healing function, but that this problem of why they exist and are used is not posed.

Certainly the anthropologist can record and speculate upon the famous curing chants such as the Muu-Igala (The Way of Muu) and the Nia-Igala (The Way of the Demon). Central to both is the odyssey undertaken by these figurines, or rather—and this is the point—by the spirits they "represent" in their search for the abducted soul of the sick person. And the anthropologist can mention other functions of the figurines as well. Nordenskiold (427) presents the case of a girl of the Narganá community who used to dream a lot about people who had died. Rubén Pérez took a figurine that she had held in her hands for but a few minutes to the shaman, who was then able to diagnose her visions as those of evil spirits, not of deceased persons, and to declare that unless she bathed in certain medicines she would lose her reason. In another instance, a man who fell ill in a settlement along the Gulf of Urabá took in his hands one of these wooden figurines, held it in the smoke of burning cocoa nibs, and then had a friend take it to the seer, who kept it in his house for some time, until in his dreams its soul told him from what kind of disease the Indian in far off Urabá, was suffering. (348) Bathing one's head in the water in which a figurine has been placed is a way of acquiring strength to learn a new skill, especially a foreign language. (365) Furthermore, figurines can counsel the healer. Rubén Pérez used to believe that the seer or *nele* received instruction from the figurines about what medicines to use for different illnesses. But the nele later told him that he learned these things from the illness demons themselves, although sometimes the figurines would give him advice. (348) The figurines have the power to make evil spirits appear before the seer, whose powers are quite miraculous, as itemized in the baron's and Rubén Pérez' text:

There are a great many things that Nele of Ustúpu knows. He is able to see what illnesses are affecting any person who comes to consult him.

When he examines a sick person he seats himself facing the patient and looks at him. He sees right through him as if he were made of glass. Nele sees all the organs of the body. He is also able, with the assistance of the *nuchus* [i.e. figurines] to give his verdict as to what illness a patient whom he has not even seen is suffering from. Nele can foretell how long a person is going to live. It is of the greatest importance that he is able to say when and how a person's soul is carried away by spirits. (83)

And the text concludes at this point that the seers possess these occult powers, "thanks to the *nuchus* [the figurines], the tutelary spirits." (83)

Then again, there is the astonishing carving and subsequent use of as many as fifty or more figurines as large or larger than humans in the community-wide exorcism of serious spiritual disturbance of an entire island or region. These exorcisms last many days. The chief figurine in one such exorcism in the late 1940s was said by an American visitor to be a seven-foot-tall likeness of General Douglas MacArthur (and we will have occasion to think again of this representation of the general when we consider the meaning—to the Western eye—of Primitivist Parody and its mimetic relation to the West):

Because the Indians were not familiar with military regulations governing dress they made some grave errors. Instead of wearing khaki, the image is painted so as to be wearing a green cap with a pink band and one white star. His coat was painted a powder blue with two pink breast pockets. Below the left pocket was what appears to be a German Iron Cross. He also wore a black bow tie and black pants. Although the Indians have small flat noses, they admire long pointed ones. They therefore made the image with a nose that projected three inches from the face.[8]

The observer, of course, has the last word. Not content with describing the general, he has to tell us that because the Indians suffer from nose envy, they have therefore elongated and sharpened their image of MacArthur's nose—and here one senses the final victory of Enlightenment, its nosiness, its consuming will to stick its beak in other people's lives and "explain." But embodiment itself is never problematized. Why imagine a nose? Why imagine at all? Why this urge to tangibilize? But, then, is it possible to conceive of, let alone have, pure appearance?

Medicines Should Not Be Confused With Decoys

Nordenskiold and Pérez' book has many things that make your head swim concerning mimicry and how it implicates reality. Next to the curing figurines or nuchus, perhaps none is more intriguing than what they say about imitations of turtles. Under the heading "Various Cuna Medicines at the Göteborg Museum," they present a catalogued and numbered list, including figures of turtles carved in wood. Pérez writes that they are used as medicines by the Indians: "They bathe themselves with these figures which they make themselves. A man can own as many as a hundred small figures made of different kinds of wood which one finds along the coast, and the bathing is carried on in order to acquire skill in turtle hunting." (492) You can see them in the accompanying drawing the authors present, lifelike turtles doing their thing.

But then the editor, Henry Wassén, feels impelled to add a clarifying note. He wants us to be quite clear that these turtle-figures for "medicinal" use should not be confused with the balsawood turtles carved as decoys for hunting real live turtles. He quotes from a missionary describing the use of these decoys. They are *female* and the missionary refers to them as *tortuguillas,* cute-chicks of turtlishness, we might say, fixed to a net so as to attract male turtles, and even some females, so that they swim into the net and, in the vigor of pursuit, become entangled in the netted realness of this decoy's lure. (492–93)

Wassén provides a drawing of one of these decoys. It has a piece of rope around the stump where its head and neck "should" be. It strikes me as a "modernist" and unreal turtle with neither head nor neck nor flippers yet, to my way of seeing, which should never be confused with the turtle's, this is nevertheless quintessentially turtlish and irresistible. After all, it's a decoy. But then that's my point of view. My eye flicks back to the magically efficacious turtle, then back again to the decoy. In my mind's eye somewhere off screen, I see a "real" turtle happily splashing in the green-blue waters of the Caribbean. Is the decoy closer to the real turtle than the magically effective imitation? Or is the decoy closer to what the Indians think a real turtle thinks a real turtle looks

11

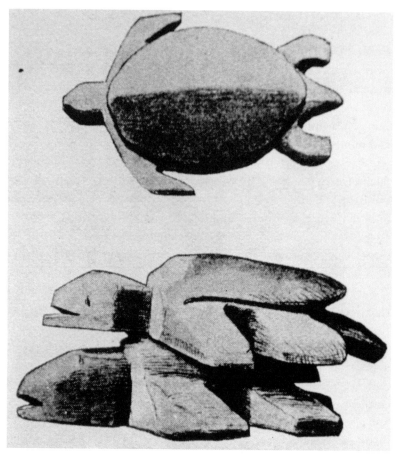

Turtle figurines used for hunting magic
(from Nordenskiold and Pérez, 1938)

like?—in which case why make the magical turtle-figures look so "real"?

"In Some Way Or Another One Can Protect Oneself From Evil Spirits By Portraying Them"

The baron and the Indian, more than other authors I have read, provide revealing descriptions of the use of the curing figurines carved as

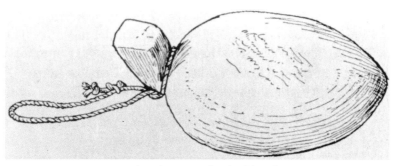

Decoy turtles (from Nordenskiold and Pérez)

"European types," but their text elides the problem of embodiment by taking it for granted. Making an object and thereby spiritualizing it, reification-and-fetishization, does not catch their eye. They simply say, for instance, that it was a certain mythical figure, Ibeorgun, who taught mankind how to use these wooden figures, and "from God originates the song that is chanted when one wishes the tutelary spirits to take up their abode in the wooden figures." (345)

But why does one so wish, and why does one need the object-figure to provide an abode for the tutelary spirits?

In a similar vein, in his 1961 essay "Anthropmorphic Figurines From Colombia, Their Magic and Art," the great Austrian-cum-Colombian anthropologist Gerardo Reichel-Dolmatoff states that "in certain curing ceremonies the sculptured or painted representation of these evil animal spirits is therefore of prime importance and therefore the shaman will make figurines of them and/or paint their forms on wooden slats." He refers the reader to an early essay by Nordenskiold, in which he wrote, "In some way or another one can protect oneself from evil spirits by portraying them."[9] The reference here is not to curing and curing figurines among the Cuna, but among their southern neighbors the Indians of the Chocó, with whom the Cuna have a fair amount of contact, including trade in magic and magical notions. Yet the important point about what I call the magic of mimesis is the same—namely that "in some way or another" the making and existence of the artifact that portrays something gives one power over that which is portrayed. But once again the issue is raised (in a footnote) only to be dropped,

and the author goes on to present in the all-too-typical unproblematizing gloss the notion that among the Cuna "the figurines, which are always imagined as embodiments of benevolent human spirits (though derived from ancestral plant spirits) help the shaman in retrieving the souls," the embodiment itself being taken for granted.[10]

Other Embodiments: Spirit Boats

Twenty-five years after this essay by Reichel-Dolmatoff, Stephanie Kane presented a vivid reminder (bearing in mind the Cuna story) of what we might tentatively call "the MacArthur effect" among these Chocó Indians. It is a tale of an Emberá shaman who was frightened speechless by the visitation of the spirits of white men, and who then decided, in a daring move, to capture them to add to his stable of spirit-helpers. She was being told this story by an Emberá man in a riverine settlement by the forest in the Darién peninsula of southern Panama in the 1980s. They were part of a crowd being lectured by a well-intentioned Catholic priest concerning the virtues of progress and community. "Back when I was a little boy," the Chocó Valentin is telling her, in the midst of this homily:

> Easter time, I went with my grandfather [the shaman] on a journey to the Congo river to seek a buried chest of money. We had to cross the great bay, by the island they call Enchantment. The moon was clear. My cousin Bernabé was there. We saw a boat of many colors, luminous with pure gringos aboard. It sounded its horn and we, in the canoe, hauling, hauling, trying to catch up to the boat. We wanted to sleep alongside it but the boat moved out to sea, escaping us. Then we smelled gasoline. Our vision could no longer stand the fumes and grandfather said: "Let's go back. This is not a boat. This is a thing of the devil."

At this point Stephanie Kane—who is telling the story of the story— informs us that the attractive boat of the gringos is an illusion created by spirits. On another occasion this boat is described as being pretty,

as if painted with red, with colored lights on every side.[11] Its smoke made your eyes burn. The shaman is talking with somebody or something in a strange tongue. Blurred with other foreign talk there were loud mechanical sounds like lifting a log with a winch. The anthropologist story-(re)teller describes this spirit boat "as the lure of an archetype; it represents spirit-motivated illusions of desire." It is more, she says, than an object of local mimicry.[12]

The Indians paddled like crazy yet got nowhere. The boat disappeared. They became violently sick, lost the power of speech, and were consumed by fever. When after great difficulty they managed to get home, the shaman oversaw their preparation of a healing ritual in which, through feasting and exchange of food and drink, he was able to get into the spirit world.

Valentin continues the story (and I want you to be alert at this point to the artwork he is now going to mention—to the three embodiments of body paint, balsa figurines, and dressing up the virginal young women in Indian gear). The shaman showed them:

> . . . how to paint the specific patterns necessary with the black dye called *jagua* [from the Genipa tree], how to work the balsa wood, and how to paint the young girls for the *chicha*. He put the girls in floor-length *parumas* [knee-length skirts worn by Emberá women].

The anthropologist breaks in to tell us that here the shaman has made an important choice. He could have decided to perform a defensive ritual, heal himself and his companions, and leave it at that. Instead he has boldly decided to take the initiative and acquire the gringo spirit-crew for himself, to capture them so as to add to his stable of spirit-powers. And how does he do this? He makes a copy of them:

> Grandfather could see all the crew members of the boat. And he made a [model of] the boat and put the crew in it. The captain with no head or neck, another crew member with no feet [and he] brought the boat from Yaviza. By means of his knowledge he made a tide, a current that came from below, like a motor, to get the boat up here. He tied it below the calabash tree, there next to Abibéba's house. The boat is still there.[13]

Other Embodiments: Ethnography as Embodied Retelling; On Being Concrete

I want to emphasize that unlike most ethnographic modes of representation, including some of the ethnography to which I have hitherto alluded (and will, perforce, continue to depend upon in my pursuit of the mimetic faculty), Stephanie Kane's mode relies not on abstract general locutions such as "among the Emberá it is believed that . . . ," but instead concentrates on image-ful particularity in such a way that (anticipating my major theme), she creates like magical reproduction itself, a sensuous sense of the real, mimetically at one with what it attempts to represent. In other words, can't we say that *to give an example, to instantiate, to be concrete,* are all examples of the magic of mimesis wherein the replication, the copy, acquires the power of the represented? And does not the magical power of this embodying inhere in the fact that in reading such examples we are thereby lifted out of ourselves into those images? Just as the shaman captures and creates power by making a model of the gringo spirit-ship and its crew, so here the enthnographer is making her model. If I am correct in making this analogy with what I take to be the magician's art of reproduction, then the model, if it works, gains through its sensuous fidelity something of the power and personality of that of which it is a model. Whether we want to call this "magic" or not does not much matter. My point is not to assimilate this writerly practice to magic. Rather I want to estrange writing itself, writing of any sort, and puzzle over the capacity of the imagination to be lifted through representational media, such as marks on a page, into other worlds.

This becomes wondrously complex when we take into account, first, that the original for the shaman's model is an apparition, an illusion and deception (so we are told) from the spirit world, an apparition itself a model of a prior (let us say the "original") boat and gringo crew, and second that the ethnographer, like me and many if not most of her readers, is identifiable as being from the land of the gringos and is modeling in words an ethnography of a shaman's magical modeling of ourselves!—which we are now in this instant being led into, to set

sail with our mirrored selves as we lift it from the page, coveting it forever so brief a moment in the crows' nest of our eyeball!

Neither Head Nor Neck

I am well aware that mimesis, or at least the way I am using it, is starting to spin faster and faster between opposed yet interconnected meanings, and yet I want to push this instability a little farther by asking you to observe the frequent interruptions and asides, changes of voice and reference, by which this text on the Emberá, so manifestly a text about us too, breaks up intimations of seamless flow that would immunize mimetic representation against critique and invention. Didn't Valentin say—indeed make quite a point of it, when you consider his short and concise description—that the captain of the model-boat had neither head nor neck, and that one of the crewmen had no feet? With this replica of the boat and its gringo spirit crew we have mimesis based on quite imperfect but nevertheless (so we must presume) very effective copying that acquires the power of the original—a copy that is not a copy, but a "poorly executed ideogram," as Henri Hubert and Marcel Mauss, in the early twentieth century, put it in their often critical discussion of Frazer's theory of imitation.[14]

Sliding between photographic fidelity and fantasy, between iconicity and arbitrariness, wholeness and fragmentation, we thus begin to sense how weird and complex the notion of the copy becomes (and please remember how high the stakes are here, insinuated with the struggle for life and), as we saw in the shaman's lusting for more—a will to power in the face of attack by (illusory and fragmented) copies of reality. The task to which the mimetic faculty is here set is to capture that very same spirit power, and for the ethnographer graphing the ethnos, the stakes are no less important.

There are still other ways in which this curious affair of embodiment and fragmentation ("neither head nor neck") is practiced by this mode of ethnographic representation. For Kane embodies us readers not only by retelling tales, but also by embodying those very tales into a variety

of distinct and conflicting contexts. She is being told the story of the gringo boat as she sits on the edge of a group being lectured to by a well-intentioned Catholic priest. That already fractured context is the embodiment of "modernity," in which paganism and paternalistic Catholic modernization jostle for discursive sovereignty. Another embodiment embodying this one is that this Emberá man's account of the history of these white men's spirits, and the destruction they eventually wreak after their release at the shaman's death, clearly conflicts with his cousin's story that blames gringo evangelical missionaries for the release of those spirits, because the missionaries, in a forthright ritual of the civilizing process, forced the shaman to burn his curing batons. "Bernabé [the cousin] was there," she writes, "when the gringos stood and poured gasoline on the batons. The other Emberá watching ran from the invisible spirits running wild out of the burning 'idol' that was their home and trap."[15]

Disembodiment

It is this disembodiment, this release and subsequent flight, that commands my attention. It is this moment that for me sums up Enlightenment, its reason, its signifying practice, as much as its relation to savagery, a relation that is not so much severed as preserved through colonial conquest and subsequent submersion in the bodily underground of mind. By their little bonfire on the edge of the forest, how ardently these gringos labor for the abstract universal! But what of the pestilent and uncontrollable spirit gringos thereby released, dancing wild through the flames? Where will their power, the power of magical mimesis reemerge?

2

PHYSIOGNOMIC ASPECTS OF VISUAL WORLDS

Nature creates similarities. One need only think of mimicry. The highest capacity for producing similarities, however, is man's. His gift of seeing resemblances is nothing other than a rudiment of the powerful compulsion in former times to become and behave like something else. Perhaps there is none of his higher functions in which his mimetic faculty does not play a decisive role.

—Walter Benjamin, "On the Mimetic Faculty" (1933)

Please note the pitch Benjamin makes, in his opening paragraph, for the importance of the "mimetic faculty" in all of our "higher functions." For this four-page essay is by no means an esoteric aside. All the fundamentals are herein composed—from his theories of language of persons *and* of things, to his startling ideas concerning history, art in the age of mechanical reproduction and, of course, that infinitely beguiling aspiration, the profane illumination achieved by the dialectical image dislocating chains of concordance with one hand, reconstellating in accord with a mimetic snap, with the other.

Benjamin's fascination with mimesis flows from the confluence of three considerations; alterity, primitivism, and the resurgence of mimesis with modernity. Without hesitation Benjamin affirms that the mimetic faculty is the rudiment of a former compulsion of persons to "become and behave like something else." The ability to mime, and mime well, in other words, is the capacity to Other.

This discovery of the importance of the mimetic is itself testimony

to Benjamin's enduring theme, the surfacing of "the primitive" within modernity as a direct result of modernity, especially of its everyday-life rhythms of montage and shock alongside the revelation of the optical unconscious that is made possible by mimetic machinery such as the camera and the movies. By definition, this notion of a resurfacing or refocussing of the mimetic rests on the assumption that "once upon a time" mankind was mimetically adept. In this regard Benjamin refers specifically to mimicry in dance, cosmologies of microcosm and macro-cosm, and divination by means of correspondences revealed by the entrails of animals and constellations of stars. Much more could be said of the extensive role of mimesis in the ritual life of ancient and "primitive" societies.

Benjamin's notion regarding the importance of the mimetic faculty in modernity is fully congruent with his orienting sensibility toward the (Euroamerican) culture of modernity as a sudden rejuxtaposition of the very old with the very new. This is not an appeal to historical continuity. Instead, modernity provides the cause, context, means, and needs, for the resurgence—not the continuity—of the mimetic faculty. Discerning the largely unacknowledged influence of children on Benja-min's theories of vision, Susan Buck-Morss makes this abundantly clear with her suggestion that mass culture in our times both stimulates and is predicated upon mimetic modes of perception in which sponta-neity, animation of objects, and a language of the body combining thought with action, sensuousness with intellection, is paramount. She seizes on Benjamin's observations of the corporeal knowledge of the optical unconscious opened up by the camera and the movies in which, on account of capacities such as enlargement and slow motion, film provides, she says, "a new schooling for our mimetic powers."[1]

The Eye as Organ of Tactility: The Optical Unconscious

Every day the urge grows stronger to get hold of an object at very close range by way of its likeness, its reproduction.

—Walter Benjamin, "The Work of Art in the Age of Mechanical Reproduction"

To get hold of something by means of its likeness. Here is what is crucial in the resurgence of the mimetic faculty, namely the two-layered notion of mimesis that is involved—a copying or imitation, and a palpable, sensuous, connection between the very body of the perceiver and the perceived. Later we will see how this ties in with the way Frazer develops what he takes to be the two great classes of sympathetic magic in *The Golden Bough:* the magic of *contact,* and that of *imitation.* Elementary physics and physiology might instruct that these two features of copy and contact and are steps in the same process, that a ray of light, for example, moves from the rising sun into the human eye where it makes *contact* with the retinal rods and cones to form, via the circuits of the central nervous system, a (culturally attuned) *copy* of the rising sun. On this line of reasoning, contact and copy merge to become virtually identical, different moments of the one process of sensing; seeing something or hearing something is to be in contact with that something.

Nevertheless the distinction between copy and contact is no less fundamental, and the nature of their interrelationship remains obscure and fertile ground for wild imagining—once one is jerked out of the complacencies of common sense-habits. Witness the bizarre theory of membranes briefly noted by Frazer in his discussion of the epistemology of sympathetic magic, a theory traced to Greek philosophy no less than to the famous realist, the novelist Honoré de Balzac; he explained the phenomenon of the photographic image as being the result of membranes lifting off the original and being transported through the air to be captured by the lens and photographic plate![2] And who can say we now understand any better? To ponder mimesis is to become sooner or later caught, like the police and the modern State with their fingerprinting devices, in sticky webs of copy *and* contact, image *and* bodily involvement of the perceiver in the image, a complexity we too easily elide as nonmysterious, with our facile use of terms such as identification, representation, expression, and so forth—terms which simultaneously depend upon and erase all that is powerful and obscure in the network of associations conjured by the notion of the mimetic.

Karl Marx deftly deployed the conundrum of copy and contact with his use of the analogy of light rays and the retina in his discussion of

"commodity fetishism."[3] For him such fetishization resulted from the curious effect of the market on human life and imagination, an effect which displaced contact between people onto that between commodities, thereby intensifying to the point of spectrality the commodity as an autonomous entity with a will of its own. "The relation of producers to the sum total of their own labor," wrote Marx, "is presented to them as a social relation, existing not between themselves, but between the products of their labor." This is the state of affairs that makes the commodity a mysterious thing "simply because in it the social character of men's labor appears to them as an objective character stamped upon the product of that labor." Decisive here is the displacement of the "social character of men's labor" into the commodity, where it is obliterated from awareness by appearing as an objective character of the commodity itself. The swallowing-up of contact we might say, by its copy, is what ensures the animation of the latter, its power to straddle us.

Marx's optical analogy went like this: When we see something, we see that thing as its own self-suspended self out there, and not as the passage of its diaphonous membranes or impulsions as light waves, or however you want to conceptualize "contact" through the air and into the eye where the copy now burns physiognomically, physioelectrically, onto the retina where, as physical impulse, it darts along neuroptical fibers to be further registered as copy. All this contact of perceiver with perceived is obliterated into the shimmering copy of the thing perceived, aloof unto itself. So with the commodity, mused Marx, a spectral entity out there, lording it over mere mortals who in fact, singly and collectively in intricate divisions of market-orchestrated interpersonal labor-contact and sensuous interaction with the object-world, bring aforesaid commodity into being.

We need to note also that as the commodity passes through and is held by the exchange-value arc of the market circuit where general equivalence rules the roost, where all particularity and sensuousity is meat-grindered into abstract identity and the homogenous substance of quantifiable money-value, the commodity yet conceals in its innermost being not only the mysteries of the socially constructed nature of value

22

and price, but also all its particulate sensuousity—and this subtle interaction of sensuous perceptibility and imperceptibility accounts for the fetish quality, the animism and spiritual glow of commodities, so adroitly channeled by advertising (not to mention the avant-garde) since the late nineteenth century.

As I interpret it (and I must emphasize the idiosyncratic nature of my reading), not the least arresting aspect of Benjamin's analysis of modern mimetic machines, particularly with regard to the mimetic powers striven for in the advertising image, is his view that it is precisely the property of such machinery to play with and even restore this erased sense of contact-sensuous particularity animating the fetish. This restorative play transforms what he called "aura" (which I here identify with the fetish of commodities) to create a quite different, secular sense of the marvelous.

This capacity of mimetic machines to pump out contact-sensuousity encased within the spectrality of a commoditized world is nothing less than the discovery of an optical unconscious, opening up new possibilities for exploring reality and providing means for changing culture and society along with those possibilities. Now the work of art blends with scientific work so as to refetishize, yet take advantage of marketed reality and thereby achieve "profane illumination," the single most important shock, the single most effective step, in opening up "the long-sought image sphere" to the bodily impact of "the dialectical image." An instance of such an illumination in which contact is crucial is in Benjamin's essay on Surrealism.[4] Here he finds revolutionary potential in the way that laughter can open up the body, both individual and collective, to the image sphere. He assumes as operant that images, as worked through the surreal, engage not so much with mind as with the embodied mind, where "political materialism and physical nature share the inner man, the psyche, the individual." Body and image have to interpenetrate so that revolutionary tension becomes bodily innervation. Surely this is sympathetic magic in a modernist, Marxist revolutionary key. Surely the theory of profane illumination is geared precisely to the flashing moment of mimetic connection, no less embodied than it is mindful, no less individual than it is social.

The Third Meaning

Benjamin's theses on mimesis are part of a larger argument about the history of representation and what he chose to call "the aura" of works of art and cult objects before the invention of mimetic machines such as the camera. These machines, to state the matter simplistically, would create a new sensorium involving a new subject-object relation and therefore a new person. In abolishing the aura of cult objects and artworks, these machines would replace mystique by some sort of object-implicated enterprise, like surgery, for instance, penetrating the body of reality no less than that of the viewer.

All this is summed up in Benjamin's notion of the camera as the machine opening up the *optical unconscious.* Yet before one concludes that this is ebullient Enlightenment faith in a secular world of techno-logical reason, that the clear-sighted eye of the camera will replace the optical illusions of ideology, we can see on further examination that his concept of the optical unconscious is anything but a straightforward displacement of "magic" in favor of "science." In my opinion, this is precisely because of the two-layered character of mimesis: copying, and the visceral quality of the percept uniting viewer with the viewed— the two-layered character so aptly captured in Benjamin's phrase, *physiognomic aspects of visual worlds.* Noting that the depiction of minute details of structure, as in cellular tissue, is more native to the camera than the auratic landscape of the soulful portrait of the painter, he goes on to observe, in a passage that deserves careful attention:

> At the same time photography reveals in this material the physiognomic aspects of visual worlds which dwell in the smallest things, meaningful yet covert enough to find a hiding place in waking dreams, but which, enlarged and capable of formulation, make the difference between tech-nology and magic visible as a thoroughly historical variable.[5]

But where do we really end up? With technology or magic—or with something else altogether, where science and art coalesce to create a defetishizing/reenchanting modernist magical technology of embodied knowing? For it is a fact that Benjamin emphasizes again and again

that this physiognomy, stirring in waking dreams brought to the light of day by the new mimetic techniques, bespeaks a newly revealed truth about objects as much as it does about persons into whom it floods as tactile knowing. "It hit the spectator like a bullet, it happened to him, thus acquiring a tactile quality," Benjamin pointed out with respect to the effect of Dada artworks, which he thus considered as promoting a demand for film, "the distracting element of which is also primarily tactile."[6]

The unremitting emphasis of the analysis here is not only on shock-like rhythms, but on the unstoppable merging of the object of perception with the body of the perceiver and not just with the mind's eye. "I can no longer think what I want to think. My thoughts have been replaced by moving images," complains one of Benjamin's sources.[7] By holding still the frame where previously the eye was disposed to skid, by focusing down into, by enlargement, by slowing down the motion of reality, scientific knowledge is obtained through mimetic reproduction in many ways. We see and comprehend hidden details of familiar objects. We become aware of patterns and necessities that had hitherto invisibly ruled our lives. But what is the nature of the seeing and comprehension involved?

Automatic Pilot

Habit offers a profound example of tactile knowing and is very much on Benjamin's mind, because only at the depth of habit is radical change effected, where unconscious strata of culture are built into social routines as bodily disposition. The revolutionary task—using the term with all the urgency of the time Benjamin was writing, and now, once again, as I write in the late twentieth century—the revolutionary task could thus be considered as one in which "habit" has to catch up with itself. The automatic pilot that functions while asleep has to be awakened to its own automaticity, and thus go traveling in a new way with a new physiognomy—bursting its "prison-world asunder by the dynamite of a tenth of a second."[8]

Benjamin asks us to consider architecture as an example of habitu-

ated physiognomic knowing. How do we get to know the rooms and hallways of a building? What sort of knowing is this? Is it primarily visual? What sort of vision? Surely not an abstract blueprint of the sort the architect drew? Maybe more like a mobile Cubist constellation of angles and planes running together in time, where touch and three-dimensioned space make the eyeball an extension of the moving, sensate body? Which is to say, an indefinable tactility of vision operates here too, and despite the fact that the eye is important to its chaneling, this tactility may well be a good deal more important to our knowing spatial configuration in both its physical and social aspects than is vision in some non-tactile meaning of the term.

Of course what happens is that the very concept of "knowing" something becomes displaced by a "relating to." And what is troublesome and exciting, not only are we stimulated into rethinking what "vision" means as this very term decomposes before our eyes, but we are also forced to ask ourselves why vision is so privileged, ideologically, while other sensory modalities are, in Euroamerican cultures at least, so linguistically impoverished yet actually so crucial to human being and social life. I am thinking not only of tactility and tactile knowing, and what I take to be the great underground of knowledges locked therein, as conveyed in the mysterious jargon of words like "proprioception," but also, in an age of world-historically unprecedented State and paramilitary torture, of the virtual wordlessness of pain too—a point recently made clear and important for us by Elaine Scarry.[9]

Benjamin wants to acknowledge a barely conscious mode of apperception and a type of "physiological knowledge" built from habit. The claim is grand. "For the tasks which face the human apparatus of perception at the turning point of history cannot be solved," he writes, "by optical means, that is, by contemplation, alone. They are mastered gradually by habit, under the guidance of tactile appropriation."[10]

So far, of course, history has not taken the turn Benjamin thought that mimetic machines might encourage it to take. The irony that this failure is due in good part to the very power of mimetic machinery to control the future by unleashing imageric power, on a scale previously only dreamed of, would not have been lost on him had he lived longer.

But, as he was ready to note, we live constantly in the shadow of history's incompleteness, in the aftertaste of the sound bite's rolling echo.

"I Fall and I Fly At One With The Bodies Falling"

"It almost makes you seasick," comments the Lieutenant Colonel in the United States Air Force as, with quiet pride two days into the Persian Gulf war in 1991, he queasily displays for U.S. television news a prolonged video shot taken by one of his precision bombs seeking its target, gliding in a soft wavy motion through the Iraqi sky. "Cinema isn't I see, it's I fly." Thus Paul Virilio in his *War and Cinema* paraphrases New York video artist, Nam June Paik, assuming this free-falling image of sensuous filmic participation into his argument about the role of the camera and the type of visualization it opens up for massive destruction as in war.[11] In the same work Virilio cites a Russian pioneer of cinema, Dziga Vertov:

> I am the camera's eye. I am the machine which shows you the world as I alone see it. Starting from today, I am forever free of human immobility. I am in perpetual movement. I approach and draw away from things— I crawl under them—I climb on them—I am on the head of a galloping horse—I burst at full speed into a crowd—I run before running soldiers— I throw myself down on my back—I rise up with aeroplanes—I fall and I fly at one with the bodies falling or rising through the air.[12]

Or, to take a recent commentary on a Hollywood film, Vincent Canby's *New York Times'* 1990 review of David Lynch's *Wild at Heart* "is all a matter of disorienting scale, of emphases that are out of kilter. The same object can as easily be the surface of the moon, seen in a long shot, or a shriveled, pock-marked basketball photographed in close-up." A shot of a traffic light held too long is no longer a traffic light. When a match is struck behind the credits, "the screen erupts with the roar of a blast furnace. The flames are of a heat and an intensity to melt a Cadillac Seville." And in an inspired act he draws

the parallel of a trip in a funhouse ghost-train: "Nightmares are made real. Without moving one seems to plummet through pitch darkness."

From pioneers of Soviet avant-garde to the capitalist ghost train so it goes, tactility all the way:

Tatlin, 1913: "The eye should be put under the control of touch."

Hollywood 1989: Burning Cadillacs erupting from screens, wild at heart.

Duchamp: "I want to abolish the supremacy of the retinal principle in art."

A lieutenant colonel of the U.S. Air Force At war (1991) having his tummy churned as his mechanical eye smartly dances death through the sky, linking so many tons of explosive with a programmed target on the ground.

And, of course, we must add that consumate theoretician and some-time (when he was allowed) maker of films, Sergei Eisenstein, contemporary of Vertov and Tatlin (and surely a profound influence on Benjamin), who time and again in word and image expressed those principles at the heart of Benjamin's fascination with the mimetic faculty—namely alterity, primitivism, and the resurgence of mimesis with mechanical reproduction. Especially pertinent was the way Eisenstein came to understand within and as a result of those principles the interdependence of montage with physiognomic aspects of visual worlds.

Taking his cue from the Kabuki theater of premodern Japan, Eisenstein complicated the theory of montage in film-making with his notion of the "visual overtone," first established with his making of *The Old and the New* in 1928. "The extraordinary physiological quality in the affect of *The Old and the New*," he explained, is due to such an overtone, a "filmic fourth dimension" amounting to a "physiological sensation." He concluded:

For the musical overtone (a throb) it is not strictly fitting to say: "I hear."
Nor for the visual overtone: "I see."
For both, a new uniform formula must enter our vocabulary: "I feel."[13]

And precisely these venerable techniques of Kabuki theater provided specific ideas no less than stimulus for the modernist theory and film practice of montage itself. Eisenstein understood Kabuki acting, for instance, as "organic to film," and in this regard emphasized its "cut acting" with sudden jumps from one depiction to another. There was also unprecedented slowing-down of movement "beyond any point we have ever seen," and "disintegrated" acting, as with the depiction of a dying woman, the role performed in pieces detached from one another, acting with the right arm only, acting with the leg only, acting with the head and neck only (compare with break-dancing). Each member of the death agony played a solo performance, "a breaking up of shots," as Eisenstein gleefully put it, working at a faster and faster rhythm.[14] Thus was the yoke of naturalism lifted for this early theoretician of mimetic machinery, so as to all the better exploit the nature of magic.

"The Genuine Advertisement Hurtles Things At Us With the Tempo of a Good Film"

I have concentrated on film in my exploration of the retooling of the mimetic faculty. But what about advertising, that other great explosion of the visual image since the late nineteenth century? Does it not also provide the everyday schooling for the mimetic faculty, even more so than film?

In his essay "Transparencies on Film," Adorno makes the muted criticism that Benjamin's theory of film did not elaborate on how deeply some of the categories he postulated "are imbricated with the commodity character which his theory opposes."[15] Yet is it not the case that precisely in the commodity, more specifically in the fetish of the commodity, Benjamin sees the surreal and revolutionary possibilities provided by the culture of capitalism for its own undoing, its own transcendence? Far from opposing the commodity, Benjamin seeks to embrace it so as to take advantage of its phantasmogorical potential. Take as an example his 1928 montage-piece, "This Space For Rent,"

concerning what he declared to be "today, the most real, the mercantile gaze into the heart of things, is the advertisement":

> It abolishes the space where contemplation moved and all but hits us between the eyes with things as a car, growing to gigantic proportions, careens at us out of a film screen (in "One Way Street," *Reflections*, p. 85).

Lusting to exploit the optical unconscious to the full, advertising here expands, unhinges, and fixes reality which, enlarged and racy, hitting us between the eyes, implodes to engulf the shimmer of the perceiving self. Corporeal understanding: you don't so much see as be hit. "The genuine advertisement hurtles things at us with the tempo of a good film" (86). Montage. Bits of image suffice, such as the shiny leather surface of the saddle pommel and lariat of Marlboro Man filling the billboard suspended above the traffic—in a strange rhythm, as Benjamin puts it, of "insistent, jerky, nearness"—the monteur's rhythm bartering desired desires internal to the phantom-object world of the commodity itself. And as with the fantasy-modeling of much shamanic ritual, as for instance with the Cuna shaman's figurines and the Emberá gringo boat, there is a cathartic, even curative, function in this copy-and-contact visual tactility of the advertisement, with this result:

> "Matter of-factness" is finally dispatched, and in the face of the huge images across the walls of houses, where toothpaste and cosmetics lie handy for giants, sentimentality is restored to health and liberated in American style, just as people whom nothing moves or touches any longer are taught to cry again by films. (86)

Frightening in the mimetic power of its own critical language, what could be a more convincing statement of the notion that films, and beyond films, advertisements, reschool the mimetic faculty than this observation: "People *whom nothing moves* or touches any longer are *taught to cry again* by films"? And how mobile, how complicated, the interconnected dimensions of copy and contact turn out to be with this dispatching of matter-of-factness! The copy that is as much a construction as a copy, and the sentient contact that is another mode of seeing, the gaze grasping where the touch falters. Not just a question

30

of changing the size and fragmenting the copy, but at the same time contact with it through an ether of jerky, insisting, nearness that, gathering force, hits us between (not in) the eyes. The question of being moved, *again.* The question of being *touched,* again. Rebirth of mimesis. Short-circuit. Copy fusing with contact. Fire in asphalt. For the person in the street, says Benjamin, it is money that arouses sentience. It is money that liberates these healthy American sentiments and brings the person into perceived contact with things. Hence, the gnomic parting shot to "This Space for Rent":

> What, in the end, makes advertisements so superior to criticism? Not what the moving red neon says—but the fiery pool reflecting it in the asphalt. (86)

The Surgeon's Hand: Epistemic Transgression

Here we do well to recall Benjamin likening the process of opening the optical unconscious to the surgeon's hand entering the body and cautiously feeling its way around the organs. For there is, as Georges Bataille would insist, great violence and humor here as a tumultuous materialism is ushered into modernity's epistemological fold. The taboo is transgressed, the body is entered, the organs palpated. Yet we are told, as result of Bataille's intellectual labors on taboo and transgression, that the function of the taboo is to hold back violence, and without this restraint provided by the unreason of the taboo, the reason of science would be impossible.[16] Thus, insofar as the new form of vision, of tactile knowing, is like the surgeon's hand cutting into and entering the body of reality to palpate the palpitating masses enclosed therein, insofar as it comes to share in those turbulent internal rhythms of surging intermittencies and peristaltic unwindings— rhythms inimical to harmonious dialectical flip-flops or allegories of knowing as graceful journeys along an untransgressed body of reality, moving from the nether regions below to the head above—then this tactile knowing of embodied knowledge is also the dangerous knowledge compounded of horror and desire dammed by the taboo. Thus if

31

science depends on taboos to still the ubiquitous violence of reality—this is the function of the whiteness of the white coats, the laboratory, the scientifically prepared and processed sociological questionnaire, and so forth—if science requires a sacred violence to hold back another violence, then the new science opened up by the optical unconscious is a science to end science, because it is itself based first and foremost on transgression—as the metaphor of the mimetically machined eye and the surgeon's hand so well illuminates. Confined within the purity of its theater of operation, science can proceed calmly despite the violence of its procedure. But . . . in the *theater of profane and everyday operations* where, thanks to the ubiquity of mimetic machinery, the optical unconscious now roves and scavenges, no such whiteness cloaks with calm the medley of desire and horror that the penetrating hand, levering the gap between taboo and transgression, espies—and feels. And "every day," as Benjamin reminds us, "the urge grows stronger to get hold of an object at very close range by way of its likeness, its reproduction."[17]

This is why the scientific quotient of the eyeful opened up by the revelations of the optical unconscious is also an hallucinatory eye, a roller-coastering of the senses dissolving science and art into a new mode of truth-seeking and reality-testing—as when Benjamin, in noting the achievement of film to extend our scientific comprehension of reality, also notes in the same breath that film "burst our prison world asunder by the dynamite of a tenth of a second, so that now, in the midst of its far-flung ruins and debris, we calmly and adventurously go travelling."[18] And it is here, in this transgressed yet strangely calm new space of debris, that a new violence of perception is born of mimetically capacious machinery.

3

SPACING OUT

He is similar, not similar to something, but just similar. And he invents spaces of which he is the convulsive possession.

—Roger Caillois, "Mimicry and Legendary Psychaesthenia" (1935)

Together with primitivism, alterity is a major component in Benjamin's assessment of the mimetic faculty. This is a lot more performative and physical, a lot more realist yet fanciful, than implied in the way "othering" is alluded to in discussions today. Indeed it is startling. "The gift of seeing resemblances," writes Benjamin, "is nothing other than a rudiment of the powerful compulsion in former times to become and behave like something else."[1] Seeing resemblances seems so cerebral, a cognitive affair with the worldly. How on earth, then, could it be the rudiment of "nothing other" than a "compulsion," let alone a compulsion to actually be the Other? What does this say about thought, let alone the ability to discern resemblance? Doesn't it imply that thinking is, like theater, a configuration of very object-prone exercises in differentiated space, in which the thought exists in imagined scenarios into which the thinking self is plummeted? And what does such a compulsion to become Other imply for the sense of Self? Is it conceivable that a person could break boundaries like this, slipping into Otherness, trying it on for size? What sort of world would this be?

At its most extreme this would be a world of "legendary psychaes-

thenia," as Roger Caillois put it in a memorable essay on mimesis in the noted Surrealist journal, *Minotaure,* in 1935 (two years after Benjamin wrote his piece on mimesis, in Paris too).[2] In a dizzying journey through insect biology, aesthetics of excess, theories of sympathetic magic, and the miming body as a self-sculpting camera, Caillois suggests that mimesis is a matter of "being tempted by space," a drama in which the self is but a self-diminishing point amid others, losing its boundedness. Caillois tries to describe this drama in its most extreme form where the mimicking self, tempted by space, spaces out:

> "I know where I am, but I do not feel as though I'm at the spot where I find myself." To these dispossessed souls, space seems to be a devouring force. Space pursues them, encircles them, digests them in a gigantic phagocytosis. It ends by replacing them. Then the body separates itself from thought, the individual breaks the boundary of his skin and occupies the other side of his senses. He tries to look at himself from any point whatever in space. He feels himself becoming space, *dark space where things cannot be put.* (30)

Scary enough. Then comes the punchline:

> He is similar, not similar to something, but just *similar.* And he invents spaces of which he is the convulsive possession. (30)

I take the extreme to instruct me as to what's most at stake with the mimetic faculty, this "degree zero" of similitude, an ineffable plasticity in the face of the world's forms and forms of life. I am struck with the way, therefore, mimesis is not only a matter of one being another being, but with this tense yet fluid theatrical relation of form and space with which Caillois would tempt us. I am especially struck by the notion of "presence" as an invented space of which the mime is the convulsive possession. And as such, presence is intimately tied to this curious phenomenon of "spacing out"—this plasticity and theatricality that I will later want to analyze as "mimetic excess" in late twentieth-century post-colonial time, and which I now want to consider in terms of the tasks facing human perception at the turning-points of history. For Benjamin asserted that these tasks that cannot be mastered by optics—

that is, by contemplation alone—are mastered gradually by habit under the guidance of tactility.

This is not only to run an eccentric psychology together with an eccentric Marxist accounting of history. It also invokes the child tracing the figures of this newness of a history-to-be across the body of its mother, an invocation which, in terms of the ethnography to be explored in later chapters, can also suggest an association, at once obvious and bizarre, of the womb as the mimetic organ par excellence, mysteriously underscoring in the submerged and constant body of the mother the dual meaning of reproduction as birthing and reproduction as replication.

Leaving the ethnographic analysis for later, here I want to draw out the presence of this mother in Benjamin's epistemology, first noting that to invoke the body of the mother is also to invoke the child, as when Gertrude Koch reminds us of Adorno's suggestion that the born-again mimetic faculty of modernity has affinity with "the earliest period of childhood prior to the ego having taken a definite shape." As with the child's communicative understanding with the clown and animals, at stake is a language that does not aspire to generate meaning.[3] There is fluidity, indeed porosity, of the ego here, and it is this, she tentatively suggests, that film stimulates and depends upon for its crushingly powerful reality effect achieved by "a smooth symbiotic sense of blending together, of dissolution into images and their movement," repeating "crucial motor experiences related to those first laborious efforts that every human being makes when learning to walk upright rather than crawl. In this process the gaze is directed towards objects which the hand tries to grasp but fails to reach."[4]

This provides a vivid notion of optical *tactility*, plunging us into the plane where the object world and the visual copy merge. "Every day the urge grows stronger to get hold of an object at very close range by way of its likeness, its reproduction," noted Benjamin in his essay on art in the age of mechanical reproduction, primarily an essay on film. This should be read against the free falling nostalgia of his essay on art in the age of the storyteller, an age long before the modern era of mighty mimetic machinery. There it is argued that the ability to communicate experience is grievously diminished by modernity, along

with the increasingly modest role of the hand in modern economic production wherein the constellation of eye, hand, and soul, is torn apart by the division of labor. For if the role of the gesturing hand as story is less today than in times gone by, and along with it a whole artisanry of experiential communication bound to the storyteller, there is nevertheless this new, this modern, "storyteller", the film. This preserves—indeed reinvigorates—the gesticulating hand in the form of the tactile eye, in that new constellation of hand, soul, and eye, provided by the opening of the optical unconscious—which turns out to be maybe not that far from certain aspects Freud's scheme of the unconscious. For in Koch's exploration of a childhood sense within the adult of the mimetic as sensuous connection with things, of that "smooth symbiotic sense of blending together, of dissolution into images and their movement," surely what is implicated is not just the sensorium of the child as bodily knowledge, but the child's relation to the body of the mother as well. Julia Kristeva's unsettling notion of the "semiotic chora," which strikingly overlaps with Adorno's and Koch's "mimetic," is a notion aimed precisely at this implication of the body in language wherein the subject blurs with the object, the child with its mother. The chora is a pulsational force of bodily drives invested in but developing before the acquisition of language per se, before syntax and the sign proper, but essential to their functioning.[5]

Hegel's phenomenology comes to mind where he insists on knowledge's inner necessity to steep itself in its object, "to sink into the material in hand, and following the course that such material takes, true knowledge returns back into itself." Benjamin's insight into mimesis as the art of becoming something else, of becoming Other, is quite crucial to this aspect of Hegel's epistemology of sinking into the material, of what Hegel describes as the movement of becoming another and thus developing explicitly into its own immanent content, the activity, as he puts it, of "pure self-identity in otherness."[6] Where Kristeva, Adorno, and Benjamin markedly differ from Hegel, of course, is over the function of negativity in shaping the final outcome of that immersion in the concreteness of otherness. In their hands, given their belief in the unsurpassability of the negative as a consequence of either patriarchy or the commodity, the mimetic immersion in the concrete-

ness of otherness can only teeter on the edge of stable knowledge and stable concept-formation. The rest is restlessness and the scarring of perpetual contradiction in which at any moment mimesis is likely to wildly spin off into sense-fragments or unstoppable metamorphoric reproduction.

Not In The Head But Where We See It

And in ruminating upon this sweeping assumption of the pulsational landscape of the mother as the mimetic basis of signification itself, I am drawn to two neglected passages in Benjamin. The first I borrow from Miriam Hansen's essay on Benjamin and film theory, where she writes that his theory of modern experience "hovers around the body of the mother." She feels compelled to underline the importance of this by adding that memory of the mother's body "has an intensity that becomes the measure of all cognition, or critical thought." She quotes from an early entry of Benjamin's in the notes to his "Arcades Project"—"What the child (and weakly remembering, the man) finds in the old folds of the mother's skirt that he held on to—that's what these pages should contain."[7]

"That's what these pages should contain": hardly an insignificant directive; something to guide an entire work, a life's work. And in following what she takes to be a fetishistic withdrawal by Benjamin from the body of the mother to the cloth of her skirt, Hansen locates another note Benjamin wrote to himself for the Arcades Project, under "fashion," in which fetishism is linked directly to death, the "sex appeal of the inorganic" which guides the senses through the "landscape of the [female] body."

Yet there are less obscure connections to this landscape in Benjamin's writings. It is invoked in his "One Way Street" as an offering to a young woman with whom he had become infatuated, a theater director credited with stimulating Benjamin's commitment to Marxism—Asja Lacis, "a Russian revolutionary from Riga," he wrote, "one of the most remarkable women I have ever met."[8] The strange dedication to this essay, in which Benjamin offers her passage through the (one way)

street she cut through him is, I think, testimony to what Hansen, citing other texts, finds to be a discourse of perception which is at once patriarchal and subversive of patriarchy. Directly under the title "One Way Street" we find this dedication:

> This street is named
> Asja Lacis Street
> after her who
> as an engineer
> cut it through the author

and midway through the essay where, in an exceptionally rare moment, Benjamin openly expresses a theory of perception—dazzlingly estranging and one that is of the utmost importance to his theory of mimesis— we again find dramatic invocation of woman's body. He writes: If the theory is correct that feeling is not located in the head,

> that we sentiently experience a window, a cloud, a tree not in our brains but, rather, in the place where we see it, then we are, in looking at our beloved, too, outside ourselves. But in a torment of tension and ravishment. Our feeling, dazzled, flutters like a flock of birds in the woman's radiance. And as birds seek refuge in the leafy recesses of a tree, feelings escape into the shaded wrinkles, the awkward movements and inconspicuous blemishes of the body we love, where they can lie low in safety. And no passer-by would guess that it is just here, in what is defective and censurable, that the fleeting darts of adoration nestle.[9]

Going Outside of Ourselves: Grasping the Actual and The Matter of Profane Illumination

"Sentience takes us outside of ourselves"—no proposition could be more fundamental to understanding the visceral bond connecting perceiver to perceived in the operation of mimesis. And here in this passage we have seen that it is a specific figure of woman that guides Benjamin's sensuous epistemology of detail, an epistemology whose aim it was, he said in commenting on "One Way Street," "to grasp the actual as the obverse of the eternal in history and to take an imprint of this hidden

side of the medal."[10] This figuration is all the more curious in that the "fetishism" to which Hansen alludes as the result of thought driven from its target of adoration (the mother) and into henceforth illuminated details (the fabric of her skirt), is in this passage staked out not only as a "torment of tension and ravishment," which is what we might expect from love, but also emphasizes—and this is what is so eye-catching—what is *defective*, reminding us of those chaste loves whose gifts and pleasures ostensibly lie as much, if not more, in their capacity to illuminate (as Benjamin would express it) than to arouse erotic pleasure—the *mystical* illumination of Dante's Beatrice and, from the equally chaste Nadja of Breton's Paris, the *profane* illumination of Surrealism, the "magic" of the secular, the tactile fruit of the optical unconscious. "The lady in esoteric love matters least," notes Benjamin in his essay on Surrealism. "So, too, for Breton. He is closer to the things that Nadja is close to than to her."[11] And of course where Nadja differs from Beatrice, where history makes the difference, is precisely in this matter of grasping the actual as the obverse of the eternal in history.

Flash of Recognition

The radical displacement of self in sentience—taking one outside of oneself—accounts for one of the most curious features of Benjamin's entire philosophy of history, *the flash* wherein "the past can be seized only as an image which flashes up at an instant when it can be recognized and is never seen again."[12] Repeatedly this mystical flash illuminates his anxiety for reappraisal of past in present, this understanding that "to articulate the past historically does not mean to recognize it 'the way it really was' (Ranke). It means to seize hold of a memory as it flashes up at a moment of danger." (255)

This flash marks that leap "in the open air of history" which establishes history as "Marx understood the revolution" as "the subject of a structure whose site is not homogenous, empty time, but time filled by the presence of the 'now'." (261) This flash is prelude to the numbing aftermath of shock that Benjamin recruits to destabilize familiar motifs of time and history as cumulative. Thinking, he asserts, "involves not

only the flow of thoughts, but their arrest as well." When this arrest occurs it creates a configuration in shock, and here the flash of recognition asserts itself again, as when Benjamin writes that in such a configuration one can "recognize the sign of a Messianic cessation of happening, or, put differently, a revolutionary chance in the fight for an oppressed past." (262–63) This recognition alters the very percept of recognition, entailing transformation of the recognizing self. One takes cognizance of this messianic cessation, he goes on, "in order to blast a specific era out of the homogenous course of history—blasting a specific life out of the era or a specific work out of the lifework." (263)

Everything in this somersaulting explosion of historical time blasting the homogeneity of abstract identity hinges on this singular act of *recognition*, the energy and consequences of its flashlike character. In trying to figure it out, my own flow of thought is brought to a halt by the following passage, where this complex movement of recognition of past in present is rendered as the unique property of recognizing similarity—which for Benjamin, as is clear from his essay "On the Doctrine of the Similar," is the exercise of the mimetic faculty. In that essay (which preceded "On the Mimetic Faculty" by a few months, and for which it served as a draft), Benjamin wrote that the perception of similarity is in every case bound to an instantaneous flash. "It slips past," he says (in language identical to that of the "Theses on the Philosophy of History," written some six years later), "[and] can possibly be regained, but cannot really be held fast, unlike other perceptions. It offers itself to the eye as fleetingly and transitorily as a constellation of stars."[13] In other words, the Messianic sign is the sign of the mimetic.

Going Outside of Ourselves: The Art of the Storyteller

The fundamental move of the mimetic faculty taking us bodily into alterity is very much the task of the storyteller too. For the storyteller embodied that situation of stasis and movement in which the far-away was brought to the here-and-now, archetypically that place where the returned traveler finally rejoined those who had stayed at home. It was from this encounter that the story gathered its existence and power,

just as it is in this encounter that we discern the splitting of the self, of being self and Other, as achieved by sentience taking one out of one-self—to become something else as well.

In Benjamin's discussion of the stories of the mid-nineteenth century Russian writer Nikolai Leskov, we are encouraged to picture the early modern economic landscape in human motion. We begin with the centrifugal movement of men from the village to the sea, from the village to war, from the village to the artisan's shop in the town to learn a craft. The tempting image of freedom in this movement is tempered when we realize how decidedly male it is, and that the probably far larger cause of early modern travel was the extrusion of poor women from their homes to work as servants. Benjamin mentions neither these women nor their stories, but they forcefully illustrate the indispensable mixture of coercion and freedom in migration, coercion to leave as much as to stay—and the pattern of catharses and forebodings attendant on these coercions as they are realized in the countermove, the return that brings the far-away to the here-and-now as metastructure of the tale. Coleridge provides a classic instance, the Ancient Mariner who has spread his wings in the tradewinds of the world, now returned and beginning his desperate tale, "He stoppeth one of three." And the man apprehended responds: "By thy long grey beard and glittering eye, Now wherefore stopp'st thou me?"

It is at this point that the freedom and foreboding bringing the traveler home insists on audience and attains voice, and it is here, in this moment of apprehension, that the listening self is plunged forward into and beyond itself. The storyteller finds and recreates this staggering of position with every tale.

The Maternal Touch

I find it immensely curious that this storyteller, in Benjamin's analysis of storytelling, is strategically femininized. Blessed with "a maternal touch" and a female-male body, the storyteller becomes "the symbol of god incarnate." In Leskov's view, writes Benjamin, the pinnacle of creation has been achieved with these "earthly powerful maternal male

figures," who form a bridge to the Other world where even inanimate matter acquires human, indeed spiritual, powers in the fight for justice. "Magically escaped," writes Benjamin:

> . . . are the beings that lead the procession of Leskov's creations: the righteous ones. Pavlin, Figura, the toupée artiste, the bear keeper, the helpful sentry—all of them embodiments of wisdom, kindness, comfort the world, crowd about the storyteller. They are unmistakably suffused with the *imago* of his mother.[14]

Later on we shall have reason to recall these connections when we consider the hermaphroditic and "maternal touch" of Cuna Indian healers, as related by ethnography, chanting their curing stories of voyages into the body and womb of the great mother, awakening with these stories the disturbing powers of image-worlds copying real-worlds, reaching out for lost souls with the aid of plant and animal spirits recruited from enchanted fortresses in the whirlpools of the sea, mountains, and clouds (see chapters 8 and 9). Not the least curious connection with the mimetic worlds of Cuna magic, as we shall see, is Benjamin's observation that, together with the nexus formed by the mother, the art of the storyteller, and the mimetic move of going outside of ourselves, there is the sexual continence of these "earthly powerful male maternal figures" who, notes Benjamin, while not exactly ascetic, "have been removed from obedience to the sexual drive in the bloom of their strength."[15] However we define eroticism, it is less important to Cuna ethnography, as we shall see, than the transgressions entailed by birth and reproduction—processes that become synonymous with the bewildering contradiction at the heart of mimesis wherein to mime means a chameleon-like capacity to copy any and everything in a riot of mergers and copies posing as originals.

Spirit Mischief: The World of Masks, Generalized Mimicry, Becoming Matter

Once the mimetic has sprung into being, a terrifically ambiguous power is established; there is born the power to represent the world, yet that

same power is a power to falsify, mask, and pose. The two powers are inseparable. What's more, both Caillois and Cuna ethnography testify to an almost drug-like addiction to mime, to merge, to become other—a process in which not only images chase images in a vast, perhaps infinitely extended chain of images, but one also becomes matter.

This is the world of spirit mischief, if not worse, death or epistemic panic. Those in league with the spirits, the great healers and seers, have the power to arrest this riot and transform forms including those that lead to death. This is crystallized by Caillois where he summons from Flaubert's *The Temptation of Saint Anthony* the general spectacle of mimicry to which the hermit (Benjamin's maternal male?) succumbs: "plants are no longer distinguished from animals . . . Insects identical with rose petals adorn a bush . . . And then plants are confused with stones. Rocks look like brains, stalactites like breasts, veins of iron like tapestries adorned with figures."[16] The hermit, notes Caillois, wants to split himself thoroughly, to be in everything, to immerse himself in matter, to be matter. "Oh Happiness! happiness! I have seen the birth of life, I have seen the beginning of movement," exclaims the hermit.

"The blood in my veins is beating so hard that it will burst them. I feel like flying, swimming, yelping, bellowing, howling. I'd like to have wings, a carapace, a rind, to breathe out smoke, wave my trunk, twist my body, divide myself up, to be inside everything, to drift away with odours, develop as plants do, flow like water, vibrate like sound, gleam like light, to curl myself up into every shape, to penetrate each atom, to get down to the depth of matter—to be matter!"[17]

This takes us not only to Surrealism but to the interplay of magic with film, of Flaubert's realism with Benjamin's optical unconscious, of the birth and rebirth of the mimetic faculty with modernity. Vibrating like sound, gleaming like light, copy blurs with contact at the heart of matter's sympathetic magic.

4

THE GOLDEN BOUGH: THE MAGIC OF MIMESIS

True scientific knowledge, on the contrary, demands abandonment to the very life of the object.
—Hegel, Preface to *The Pheneomenology of Mind*

My concern with mimesis, then, is with the prospects for a sensuous knowledge in our time, a knowledge that in adhering to the skin of things through realist copying disconcerts and entrances by spinning off into fantastic formations—in part because of the colonial trade in wildness that the history of the senses involves. Today it is common to lambast mimesis as a naive form or symptom of Realism. It is said to pertain to forced ideologies of representation crippled by illusions pumped into our nervous systems by social constructions of Naturalism and Essentialism. Indeed, mimesis has become that dreaded, absurd, or merely tiresome Other, that necessary straw-man against whose feeble pretensions poststructuralists prance and strut. I, however, am taken in by mimesis precisely because, as the sensate skin of the real, it is that moment of knowing which, in steeping itself in its object, to quote Hegel, "consists in actualizing the universal, and giving it spiritual vitality, by the process of breaking down and superseding fixed and determinate thoughts."[1] I am mightily intrigued by this mischief of reality's sensate skin to both actualize and break down, to say nothing of superseding universals, and I am disposed to locate such

mischief in the high-jinks of a backward somersault of European histor-
ical reckoning, the backward glance known as Primitivism. Hegel urged
the recuperation through the concrete because in modern times, as he
put it, an individual finds the *abstract form ready made,* and his world-
historical scheme informed him that therefore the present task was the
very opposite of what he took to have been the task of the earliest
epochs, namely "getting the individual clear of the stage of sensuous
immediacy." Historicized in precisely this way and redolent with ap-
peal to a precapitalist epistemology of the senses, Adorno's work
resonates with the power of this problem of sensuous immersion, it
being clearly understood that Hegel's "abstract form ready made"
is very much the form generated by commoditization of life under
capitalism. If in times past the shamans warded off danger by means of
images imitating that danger, and in this sense they used equivalence—
mimesis—as an instrument, then today we live a curious inversion of
this equivalence, a Hegelian *Aufhebung* of it. "Before, the fetishes were
subject to the law of equivalence," write Adorno and Horkheimer.
"Now equivalence itself has become a fetish."[2]

Yielding

For Adorno and, I think Hegel (with different consequences), the
sensuous moment of knowing includes a yielding and mirroring of the
knower in the unknown, of thought in its object. This is clearly what
Adorno often has in mind with his many references to mimesis, the
obscure operator, so it seems to me, of his entire system.[3] In *Dialectic
of Enlightenment,* he and Horkheimer present no less a historicist
position than Hegel, attempting the difficult argument that mimesis,
once a dominant practice and component of knowing becomes, in
Western historical development, a repressed presence not so much
erased by Enlightenment science and practice as distorted and used as
hidden force. This, of course, is not merely an argument about the
development of science as an idea, or even as applied technology.
Rather it is a blend of philosophical and historical argumentation
concerning the snowballing effect, in the West, of over two millennia

of what we might call the labor/domination complex, with its emphasis on the repression of the body by the social world of production that issues forth a world of things standing over the maker. The atrophy and subsequent refunctioning of the mimetic faculty, a faculty belonging as much to body as to mind, is to be clearly understood within this historical understanding. In respect to mimesis as yielding, in contrast to Enlightenment science's aggressive compulsion to dominate nature, Adorno and Horkheimer go so far as to write of that "trend which is deep-rooted in living beings, and whose elimination is a sign of all development: the trend to lose oneself in the environment instead of playing an active role in it; the tendency to let oneself go and sink back into nature. Freud called it the death instinct, Caillois *le mimétisme*."[4] Here the yielding component of mimesis is presented in a passive, even frightening, sort of way; the self losing itself, sinking, decomposing into the surrounding world, a yielding that is, be it noted, despite apparent passivity, an act both of imitation and of contact.

In his discussion of the comic (written in 1905, fourteen years before the work on the death instinct), Freud calmly presents the startling idea of "ideational mimetics," in which what I call "active yielding" as bodily copying of the other is paramount: one tries out the very shape of a perception in one's own body; the musculature of the body is physiologically connected to percepts; and even ideational activity, not only perception, involves such embodying—hence "ideational mimetics." Just as speech can be understood as thought activating the vocal cords and tongue, so thinking itself involves innervation of all of one's features and sense organs.[5]

In any event, this strange mixture of activity and passivity involved in yielding-knowing, this bodily mirroring of otherness and even ideas, is in the center of much of Horkheimer and Adorno's elusive discussion of mimesis, and precisely in the activist possibilities within such yielding lie serious issues of mimesis and science, mimesis as an alternative science. We can appreciate this when we realize that for Adorno and Horkheimer the imitative practices of the early shamans were crucial—and crucially ambiguous. For the early magician signifies, as they would have it, not merely "a yielding attitude to things," but the threshold of history where mimesis as a practice for living with nature blurs with

the transformation of mimesis into an instrument for dominating nature, the "organization of mimesis" necessary to that long march culminating in Enlightenment civilization.

Sympathetic Magic

It's my hunch that something insightful can be learned about mimesis, especially with regard to this question of (active) yielding, by taking up the issue of sympathetic magic. I therefore want to examine the notion of mimesis used at the end of the nineteenth century by James George Frazer, author of *The Golden Bough,* at Cambridge University. In the opening paragraph of his 150-page statement on sympathetic magic, in the third edition of that once-celebrated work, Frazer distinguished two great classes of magic (which he more or less identified with magical *charms*)—that involving similarity (or imitation), and that of contact:

> If we analyze the principles of thought on which magic is based, they will probably be found to resolve themselves into two; first, that like produces like, or that an effect resembles its cause; and second, that things which have once been in contact with each other continue to act on each other at a distance after the physical contact has been severed. The former principle may be called the Law of Similarity, the latter the Law of Contact or Contagion. From the first of these principles, namely the Law of Similarity, the magician infers that he can produce any effect he desires merely by imitating it.[6]

I am particularly taken by his proposition that the principle underlying the imitative component of sympathetic magic is that "the magician infers that he can produce any effect he desires merely by imitating it."(52) Leaving aside for the moment the thorny issue of how and with what success Frazer could put himself into the head of one of these magicians, and to what degree either the accuracy or usefulness of his proposition depends on such a move, I want to dwell on *this notion of the copy, in magical practice, affecting the original to such a degree that the representation shares in or acquires the properties of*

the represented. To me this is a disturbing notion, foreign and fascinating not because it so flagrantly contradicts the world around me but rather, that once posited, I suspect if not its presence, then intimations thereof in the strangely familiar commonplace and unconscious habits of representation in the world about me.

Of course Frazer's very notion that magic could be reduced to "principles of thought," as opposed, let us say, to the diegesis of ritual, and furthermore that such principles of thought could probably be reduced to no more than two, Similarity and Contact, are notions that have been attacked or simply been found uninteresting by later anthropology, beginning with the French school of the *Année sociologique* as exemplified in Marcel Mauss' and Henri Hubert's articles in that journal as early as 1902.[7] Yet no serious critic would challenge the singular importance of the work of Frazer's intellectual predecessor, E. B. Tylor, in working out, as Evans-Pritchard has put it, "the ideational logic of magic." Yet this is an exaggerated opinion. Tylor can hardly be said to have "worked this out," and it is the extension of this aspect of Tylor's work that makes Frazer's compendium useful for the analysis not so much of magic but of the magic of mimesis, beginning with the very first examples he supplied, those of effigies, as with the usage of the image of one's enemy "in the belief," as he put it, "that, just as the image suffers, so does the man, and that when it perishes he must die."[8] (55) Frazer went on to cite this same deadly imageric practice of sorcerers in ancient India, Babylon, and Egypt, Greece and Rome, as well as among the "cunning and malignant savages in Australia, Africa, and Scotland."[9] (55) His first example with any detail was drawn from a *History of the Ojebway Indians* of North America to the effect that when such an Indian desired to work evil, he made a little wooden image of his enemy and ran a needle into its head or heart or shot an arrow into it, thinking that wheresoever the arrow struck, so the person thus imaged would be seized with a sharp pain in the corresponding part of the body.[10] (55)

Employing the same psychological and evolutionist anthropology that Frazer would later use, Tylor had stated a quarter century earlier that "the principal key to understanding Occult Science is to consider

it as based on the Association of Ideas, a faculty which lies at the very foundation of human reason." But, said Tylor, instead of moving from fact to thought, from things to image, in magic the flow was reversed. An ideal connection, as he put it, was mistaken for a real connection. Analogy—such as we see with Frazer's examples of needle-stuck figurines—was taken too literally.[11] Yet a century later, in 1973, the anthropologist S. J. Tambiah could demonstrate with enviable skill the considerable scientific power of just such analogical reason in which the magic of similarity was involved.[12] By pointing up the complex explanatory mechanism holding positive and negative difference together in the structure of an analogy, Tambiah was at pains to distinguish his argument from the elegant simplicity of Frazer's brief commentary on the theory of the Law of Similarity, of like producing like. Yet the fact remains that the structural logic of analogy demands this mimetic assumption of similitude, just as does science itself—if we are to follow Tambiah's crucial usage of G. E. R. Lloyd's commentary of Evans-Pritchard's 1937 book on Zande magic in Central Africa. Tambiah quotes from Lloyd's book, *Polarity and Analogy: Two Types of Argumentation in Early Greek Thought:* Lloyd says that magic's "general aim is similar to that of applied science, to control events, and one of the means whereby it hopes to achieve this is *using the links which it believes may be formed between things by their similarities*" (Tambiah's emphasis).[13]

Frazer's multitude of examples of magical charms, fetishes, and practices offers dramatic testimony to the matching of the two bodies, the effigy and that which the effigy represents. Taking examples from reports of the late nineteenth-century Cambridge expedition to the Torres Straits, Frazer cited the sorcerers of Jervis Island who "kept an assortment of effigies in stock ready to be operated on at the requirement of a customer."(59) If the sorcerer pulled an arm or a leg off the image, the human victim felt pain in the corresponding limb, but if the sorcerer restored the severed arm or leg to the effigy, the human victim recovered. Another way of killing someone, as reported by this Cambridge-Torres Straits expedition, was to prick an effigy of that person with the spine of a sting-ray, "so that when the man whose name had

been given to the waxen image next went afishing, on the reef, a sting-ray would sting him *in the exact part* of his body where the waxen image had been pierced." (59) "In the exact part"—the emphasis is mine. At the time of Frazer's writing it was reported, closer to home, that in their practice of sorcery, country people in the Scottish High-lands sometimes made a rude clay image, a *corp chre,* of the person they wished to harm, and stuck it full of nails, pins, and bits of broken glass:

> As every pin is thrust into the figure, an incantation is uttered, and the person represented feels a *pain in the corresponding part* of his body. If the intention is to make him die a lingering death, the operator is careful to stick no pins in the region of the heart, whereas he thrusts them into that region deliberately if he desires to rid himself of his enemy at once." (68)

"In the corresponding part"—again, the emphasis is mine. Quoting from de Groot's famous work on Chinese religion, Frazer related how in Amoy, China, bamboo and paper effigies known as "substitutes of persons" could be bought cheaply at stores for the purpose of inflicting harm. Again the correspondences are impressive. If you run a needle into the eye of the puppet, noted Frazer, "Your man will go more or less blind; if you stick a pin in its stomach, he will be doubled up with colic; a stab in the heart of the effigy may kill him outright, and in general the more you prick it and the louder you speak the spell, the more certain is the effect." (61)

History in the form of colonialism intruded into such image-making too. From the Jesuit Arriaga's report, published in Lima, Peru, in 1621, one of several reports in the heroic campaign to extirpate idolatry, Frazer noted that the Peruvian Indians were said to burn images imitat-ing the persons they feared or hated. If the image was to represent an Indian, it was made of the fat from a llama mixed with corn (maize), native to the Americas. But if the image was of a Spaniard, pig fat and wheat, both associated with the colonizing power, were used instead (56). This coding of colonial relations makes us aware not just of the magic of the image, of the visual likeness, but of the magic of substances

as well, a staggering of the senses from sight to substance that impinges directly on the problematic nature of the copy itself.

A Poorly Executed Ideogram

How much of a copy does the copy have to be to have an effect on what it is a copy of? How "real" does the copy have to be? Without the text informing me of what they are meant to represent in Rubén Pérez' eyes, Nordenskiold's pictures of Cuna curing figurines would fail my realist test, and Reichel-Dolmatoff describes the wooden figurines used in Chocó curing as "all highly standardized and unrealistic."[14]

In *The Origins of Art* (a work quoted by Frazer) published in 1900, Yrjo Hirn points out that the magically effective copy is not, so to speak, much of a copy. "Strong desire always creates for itself," he declares, as if anticipating one of the arguments about mimesis central to Freud's *Totem and Taboo,* "an imaginary gratification which easily leads the uncritical mind to a belief in the power of will over the external world."[15] He thinks it is logical to expect that the form such an imaginary gratification would take is one of "the greatest possible resemblance to the original" so as to increase, in the case of magic, the efficacy of the charm, or in the case of art-images in the world of modern artistic production, what he calls "the pleasure to be derived from illusion." And he draws the conclusion that (what he holds to be) the belief in a magical connection between similar things would thus exercise an incalculable influence on the growth of realism in art.[16]

But no! This is not the case. Instead, "the primitive man who avails himself of dolls and drawings in order to bewitch is generally quite indifferent to the lifelike character of his magical instruments. The typical volt gives only a crude outline of the human body, and, which is most remarkable, it does not display any likeness to the man who is to be bewitched."[17]

A few years after Frazer's work on sympathetic magic was published, the French anthropologist-theoreticians Marcel Mauss and Henri Hubert drew attention, just as Hirn did, to the lack of realism of magically

effective mimetic images: "There is nothing resembling a portrait," and "The image, the doll or the drawing is a very schematic representation, a poorly executed ideogram. Any resemblance is purely theoretical or abstract."[18] They drew the conclusion that Frazer's Law of Similarity in its magical function presupposed *social conventions* of classification and representation as well as mechanisms of what they called "attention" and "abstraction." These mechanisms sound similar to the analysis of dream-work published by Freud one year before Mauss's work on magic, and with regard to the realism of the imitations involved in magic, it is noteworthy that in *Totem and Taboo* (published in 1912/13), Freud himself observes (mainly from his reading of the British anthropologists) that one of the most widespread magical procedures for damaging an enemy is to make an effigy of him, but notes, "Whether the effigy resembles him is of little account: any object can be 'made into' an effigy of him."[19]

The Copy that is Not a Copy

With this we are plunged, so I believe, into a paradox—namely that the copy, magically effective as it is, with the point-for-point correspondences of body part to body part, for instance, with all this implies for the transformation of the imagized, is *not a copy*—not a copy, that is, in the sense of being what we might generally mean when we say a "faithful" copy. Yet for it to be (magically) effective on the real world of things, persons, and events, it would very much seem that it has to be just that—a "faithful" copy such that the (Frazerian) Law of Similarity applies: that law by which "the magician infers that he can produce any effect he desires merely by imitating it."(52) It is here that Frazer's other principle, that of Contact, deserves consideration.

Contact

Frazer defined this second principle, of Contact or Contagion, as the principle of thought which holds "that things which have once been in

contact with each other continue to act on each other at a distance after the physical contact has been severed," and the most common examples of such magic were those practices requiring body parts or clothing of the person to be magically acted upon—hair, nails, semen, excrement, spittle, footprint, teeth, navel cord, placenta, and so forth (52).

I remember how in the southern Cauca Valley in 1972 my assistant Robier Uzuriaga, who worked as a ditch-digger for a labor contractor on one of the sugar plantations, told me how the gang of workers to which he belonged, who were like him descendants of African slaves brought in the colonial period to work the alluvial gold mines, once tried to persuade one of the plantation's foremen to record more work being done than was actually the case. Through this deceit, the laborers (and the foreman) would receive more money. Because the foreman was unwilling, the workers enlisted the services of an Ingano Indian *brujo* (magician/sorcerer) who lived at the headwaters of the valley and who told them to bring him hoofprints of the foreman's horse. This they did, but the brujo's magic turned out to be worse than useless. Instead of the foreman melting like butter in their hands, the labor contractor and all his workers were mysteriously fired. "You must have brought me the wrong horse's prints," the *brujo* mused, "the contractor's horse's prints in mistake for the foreman's"!

I cite this story of hoofprints as a complicating example of what Frazer would have classified as magic, or rather attempted magic, based on the Law of Contact, because we notice immediately that it is also an example of Similarity or Imitation. The hoofprint is virtually part of the horse and at the same time it is an image of (part of) the horse and, to complicate matters further, the horse is a substitute for the rider. In whatever way we decide to conceptualize this, we must recognize that the two distinct principles, Imitation and Contact, cannot easily be separated in this instance in which, like fingerprinting by the modern State, the horse's imprint in the soil amounts to a copy, indeed a potentially fairly accurate copy, of (part of) its unique self. The print is in fact a stunning instance of imitation blending so intimately with contact that it becomes impossible to separate image from substance in the power of the final effect.

It is also an illustration of the sort of magic that eluded Frazer's eye, as well as the eye of the anthropology that followed and spurned him from the beginning of the twentieth century until our time, namely the magic of the modern—not the primitive—world, in this case that of modern capitalist labor-relations, as on a Colombian sugar plantation in 1972.

And if this example of magic goes to the heart of what Marx called the struggle over the working day, it is nevertheless aimed, like the most ancient Graeco-Roman love-magic, at swaying a heart, at winning over the goodwill of the foreman. In this it is on a par with stories I have heard from women, such as my friend of some twenty years standing, Rejina Carabali, who used to sell refreshments at the gates of the sugar mills on payday, concerning magic used by a woman to keep a lover faithful or at least responsible for his share of the upkeep of the children he fathered, it being common for men to "sting, then fly away."

I have heard a formula for such love magic that clearly endorses the Law of Contact or Contagion, which includes hair from the man's head and pubes mixed with his sperm taken from one's vagina after intercourse, it being important for the woman not have an orgasm so that the sperm is kept as pure as possible. This mixture is placed in a bottle with alcohol and buried in the ground inside the house. Alternately a woman might put a toasted mixture of one's own armpit and pubic hair into his coffee.

Another type of *liga* described to me by Rejina Carabali is more complex. The woman obtains a cigar, a candle, matches and a candle stub. It's best to buy the candle and the cigar with money from the faithless consort, and to borrow the other items from someone notoriously mean. Once the cigar is lit and she is smoking, she cuts the candle in two, and when the cigar is half smoked, she lights the candle stub and one of the halves of the cut candle. Smoking at a furious rate, emitting clouds of smoke over the candles, she concentrates deeply on the man in question. As the ash drops she stamps on it, cursing the man by name—"Catalino *hijeputa!* Catalino *hijeputa!*"—Catalino you fucker!

I present this at some length to further complicate the effect of

Frazer's many examples in his discussion of sympathetic magic. But I also want to make the point that he himself makes clearly: in many, if not in the overwhelming majority of cases of magical practices in which the Law of Similarity is important, *it is in fact combined with the Law of Contact.* We see this in the very first examples he offers of magic based on the Law of Similarity or Imitation, those involving the use of figurines and images of one's enemy. For instance the Malay charm: "Take parings of nails, hair, eyebrows, spittle, and so forth of your intended victim, enough to represent every part of his person, and then make them up into his likeness with wax from a deserted bee's comb. Scorch the figure slowly by holding it over a lamp every night for seven nights, and say 'It's not the wax that I am scorching; it is the liver, heart, and spleen of So-and-so that I scorch.' After the seventh time the figure, and your victim will die." (57) Or take his description of the magical Chinese usage of the bamboo and paper image of a person that I cited above (p.50). "To make assurance doubly sure," he adds, "it is desirable to impregnate the effigy, so to say, with the personal influence of the man by passing it clandestinely beforehand over him or hiding it, unbeknown to him, in his clothes or under his bed." (61)

This "impregnation" of the image with the personal influence of the man whose image it is, is crucial here; it would seem that likeness is not sufficient in itself. Nor, for that matter, is the "impregnation" with the personal influence sufficient in itself. Both are utilized, indeed fused, as Mauss and Hubert strenuously insist.[20]

In the case of the love charms or *ligas* I have described, which are a response to a man reneging on paternal responsibility, we see the same combination of Likeness and Contact. The semen and pubic hair are quintessentially to do with Contact. But they are also profound indices of sexual attachment, impregnation, and the making of children: it becomes virtually impossible to separate their being *signs* from their being ontologically *part of* the sexually partnered Other. Nevertheless, such signs of contact are apparently not enough. Some additional manner of ensuring the connection is required, although in this case with candles and cigars the symbolism does not form an image of likeness in the same way as do one of Frazer's Malay figurines, and Chinese effigies, or Cuna sailor-figurines, or Emeberá gringo boats. In

Rejina Carabali's depiction of the mother making magic to restore the faithless consort, or at least his money, we can speculate whether the semantic equivalences of the cigar and the candle, both lit, signify the man's potency, and the cutting and reversals signify the rupture in the relationship and the wish to have it restored. But here again, could we say that such symbolic identities form an image of likeness in the same way as do Frazer's effigies? Surely the symbols belong to an order of abstraction removed from what we might like to call "real" likeness, and Mauss and Hubert are totally justified in reacting against naive notions of likeness.

But what happens if we move the frame outward from the realm of the ritual objects, the candles and the cigars, the flames and the curses, to include the gestus of the ritualist herself? Isn't this the image that captures the similitude that a Frazerian reading would seem to require? It lies not so much in the association of ideas as concepts, but in the association of images of sadness and anger, the sense of loss as well as the sense of initiative, in this scene of the woman smoking up a storm crouched over the flames of what now becomes the simulacrum of her crippled conjugal relationship—the cut half-candle side by side with her flickering stub, followed by stamping on the fallen ash and the vicious curses—deadly words, potent through ritual. Thus we move from image to scene, and from scene to performative action. But surely it is the fact that she is casting her smoking breath onto and into this simulacrum, and the fact that it is advisable to purchase the ritual items with the faithless man's money, that ties the otherwise general, and what I will for the sake of convenience here call "abstract," symbolism into the impassioned particularities of the tragedy of poverty she faces, just as she hopes this action will tie him and his money to the economy of the household his seed has in (vital) part created. In this light it might be important to consider the use of the person's name—Catalino *hijeputa!* Catalino!—for the name not only specifies but does so by superimposing the symbolic with the ontic essence of the person, the referential, we might say, with the actual—in the sense that (even in this world where God's naming has long been sundered) the person *is* the name. In short, her breath, his money, and his name all stand at the crossroads of sign and thing.

It is to this very crossroading of copy with substance that Yrjo Hirn refers us as a way out of the paradox posed by the fact that in so many instances of sympathetic magic the copy, far from being a faithful copy, is an imperfect ideogram. What makes up for this lack of similitude, what makes it a "faithful" copy, indeed a magically powerful copy, he declares, are precisely the material connections—those established by attaching hair, nail cuttings, pieces of clothing, and so forth, to the likeness. Thus does the magic of Similarity become but an instance of the magic of Contact—and what I take to be fundamentally important is not just that a little bit of Contact makes up for lack of Similarity, or that some smattering of real substance makes up for a deficiency in the likeness of the visual image, but rather that all these examples of (magical) realism in which image and contact interpenetrate must have the effect of making us reconsider our very notion of what it is to be an image of some thing, most especially if we wish not only to express but to manipulate reality by means of its image.

Where Action Puts Forth Its Own Image

A first step here is to insist on breaking away from the tyranny of the visual notion of image. The Navaho sand-painting is said to cure not by patients' looking at the picture inscribed therein, but by their placing their body in the design itself. Likewise, medicinally triggered visions ministered by healers in the Upper Amazon, about which I have written elsewhere in my work on the Putumayo, are surely effective not only because of visual imagery, but also on account of nonvisual imagery conveyed by nausea, sound, smell, and the changing cadence of chanting, not to mention less tangible qualities of presence, atmosphere, and movement.[21] Furthermore, the senses cross over and translate into each other. You feel redness. You see music. Thus nonvisual imagery may evoke visual means. The medicine creates nausea—one of the great untheorized territories of experience—and one which has an enormous effect on cognitive process and hermeneutic endeavor, no less than on the medley of the senses bleeding into each other's zone of operations. You may also see your body as you feel yourself leaving it, and one

can even see oneself seeing oneself—but above all this seeing is felt in a nonvisual way. You move into the interior of images, just as images move into you.[22]

Doubtless my example of Putumayo healing can be questioned as an extreme case because of the heightening effect of the medicines used and, in addition, I must be cautious not to burden my argument with unwarranted assumptions regarding the subjective experience of other participants. Nevertheless it is incontrovertible that the staging, the magician, the drug, combine to convert the eye into an optical means of *contact* in a stunning example of distracted tactility, all with the aim of changing the realities espied and hence contacted—so as to undo the illness and the misfortune caused by sorcery. To emphasize the "nonvisual" here is to emphasize the bodily impact of imaging, to the point where Contact is displaced from its Frazerian context to become the term required for conveying the physiognomic effect of imagery.

Now isn't this very similar to Benjamin's "optical unconscious" opened up by the camera, with all its implications of tactile consequence? Here Frazer's primitive magic of Similarity-and-Contact can be read as replicating Benjamin's argument regarding modernity's imaging technology, creating in place of magic what Benjamin referred to as the *profane illumination* resulting from the revelation of "physiognomic aspects of visual worlds which dwell in the smallest things, meaningful yet covert enough to find a hiding place in waking dreams."[23]

Only when in technology body and image so interpenetrate that all revolutionary tension becomes bodily collective innervation, and all the bodily innervations of the collective become revolutionary discharge, has reality transcended itself to the extent demanded by the *Communist Manifesto*.[24]

5

THE GOLDEN ARMY:
THE ORGANIZATION OF MIMESIS

They cannot stand the Jews, but imitate them.
　　　　—Horkheimer & Adorno, *Dialectic of Enlightenment*

I am fascinated by the notion emerging from Frazer's discussion of imitative magic as power that the copy extracts from the original. But I need to emphasize my ambivalence too, how I see in it a strange, indeed frightening explanation of the fetishlike power of the copy in my own daily life, yet I want to tread carefully when it comes to proposing it as a theory of primitive magic—as opposed to a primitivist theory of magic, which is where I feel it more fittingly belongs. Thus I feel the need to move from the mysterious isolation of the "world we have lost," *The Golden Bough*, to encompass equally fantastic possibilities for magical mimesis on the colonial frontier. Indeed, as will become obvious, it is here, with multinational capital and the modern State pressing on the wilderness, where we can see how appropriate the argument about magical mimesis—that the copy takes power from the original—is likely to be. Let me turn, then, from the lyrical splendor of the golden bough to consider that of a golden army at the headwaters of the Putumayo River in southwest Colombia, upriver from the publicized atrocities inflicted on Indian rubber-tappers by the Anglo-Peruvian Rubber Company of the Arana brothers at the

beginning of the twentieth century. At loggerheads over this rubber land, the governments of Peru and Colombia sent their troops to war in 1931. This war had few battles but brought plenty of soldiers marching, on the Colombian side, down the slopes of the Andes and along the foothills where, between 1975 and 1985, near the town of Mocoa, I occasionally met an elderly Ingano-and Spanish-speaking Indian man, Florencio, at the home of a mutual friend, a healer, Santiago Mutumbajoy.

The healing of serious misfortune there usually requires the healer and the patients taking together, at night, a "hallucinogenic" medicine known as *yagé*. When strong, this medicine brings forth mental pictures referred to as paintings or *pintas*, mainly but not exclusively visual, and these images can have curative functions. Sometimes in my experience this function is, for the healer at least, pragmatic and straightforward. The picture may tell the healer what type of illness someone has, whether it is of "natural" origin (as Western medicine would have it) or else is due to sorcery or to spirit attack. The picture may also tell the healer what the remedy should be. Or the pictures may be symbolic and need decoding, as with the meaning of a knife in Santiago Mutumbajoy's visions in the early 1980s, when he was approached by poor colonists wanting magic to kill the *commandante* of the *guerrilla* encamped in their midst. Having ascertained before taking medicine how the colonists planned to pay him, the healer interpreted this knife as sign that he himself would be killed if he got further involved. But beyond such forms of reading, there is that which is demanded by the intensity and mystical power of the image itself. Witness the following description of the vision not of the healer, but of one of his old friends, Florencio, who related it to me when we were chatting at nightfall about such experiences.

Years ago Florencio had gone to accompany a healer to cure a woman of splitting headache. At first nothing came from the yagé medicine but later, around midnight, he saw angels come from the clouds with quartz crystals that healers sometimes use for divining. The angels blessed him. That "painting" disappeared. Then jungle birds filed into the room, filling it up. Soon there was nothing but birds. Pure birds. Everywhere! Then that "painting" went away. Then he

found himself up in the Andean mountains where many Ingano Indians live. There he saw people lining up, dressed like healers in feathers and mirrors, singing and dancing with necklaces of tigers' teeth and curing fans—the spirits of yagé, no doubt. And they kept coming and coming, singing all the while. Then—in Florencio's own words:

> Finally, emerges a batallion of the army. How wonderful! How it enchants me to see that. I'm not sure how the rich dress, no? But the soldiers of the batallion are much superior in their dress to anybody! They wear pants, and boots to the knee of pure gold, all in gold, everything. They are armed, and they form up. And I try to raise myself [and he pauses] . . . so that I too can sing with them, and dance with them, me too. Then the healer, [again he pauses] . . . with the "painting," he already knows that I am trying to get up to go there, to sing and to dance with them just as we are seeing. And then, he who gives the yagé [i.e. the healer], he already knows, and he is quiet, knowing, no? Thus, those who know how to heal are given account. Seeing this, they are able to cure, no? And they pass this painting to the sick person. And that person gets better! And I said to the healer who was curing me, I said to him, "Seeing this, you know how to heal?" "Yes," he told me, "thus seeing, one can cure, no?"

Here there is no embodiment of image, carved figurines or body paint, but the ephemera of a memory of a purely mental image reminding us that even so, such an image counts as an entity, "a painting" that can be passed on—just as Florencio passed it on to me, and I am passing it on to you.

And in thinking about this, making a space for it to generate its meaning, like the healer, being quiet in our knowing, I want to draw attention to the active yielding of the perceiver in the perceived—the perceiver trying to enter into the picture and become one with it, so that the self is moved by the representation into the represented: "They are armed, and they form up. And I try to raise myself . . . so that I too can sing with them, and dance with them, me too. Then the healer . . . with the 'painting,' he already knows that I am trying to go there, to sing and dance with them just as we are seeing."

But what of the content of this "painting" into which he is trying to place himself? What of the golden battalion, similar to and following directly after the "painting" of the dancing healers, feathered and

mirrored like the yagé spirit-people on whom, in fact, yagé healers are modeled with the same clothes and face-paint, the same curing fans, and the same chants? Surely this battalion is an intercultural, spliced, image, using the magic of *yagé* for the State, and the magic of the State for *yagé*, referring in part to the yagé spirits and healers, but primarily to the Colombian army itself, hastily recruited and sent to fight the frontier war with Peru—an army that many Indians, like Florencio, assisted as canoeists and porters. It is a complex image, sobering in the simplicity of the mystical grace with which it adorns what I take to be the authority of the State as embodied in the presence of the army of blacks from the interior and mestizo highlanders from Nariño, moving down the mud of the jagged slopes of the Andes and through the Putumayo cloud forest onto war for reasons that nobody could explain to me other than for *la patria*, as if that were self-evident.

And self-evident it surely is when we turn to Florencio's "painting," a painting that captures just this mystique of the Nation-State, its sacred violence—and I use the word "capture" advisedly, it being a taken-for-granted way of vividly expressing not only the apparent physicality involved in imageric production, but also the capturing of something important, something otherwise elusive. But capturing what, and for what end? Surely, the power of that which the representation reflects—only in this case it is not so much a "faithful" likeness that is captured, nor is it a "faithful" likeness that is doing the capturing. What is faithfully captured is a *power*—I can think of no more specific term—invested in a montage of abutted likenesses, of yagé spirits, angels, and dancing soldiers—sacred power on the march spreading a mantle of gold and music over the diminshing waves of mountain crests that form the *cordillera*, sinking into the rain forest. It seems to me vital to understand that this power on can be captured only by means of an image, and better still by entering into the image. The image is more powerful than what it is an image of.

And if I have emphasized something of the various tones which in multifarious and gorgeously aesthetic ways constitute this representation, yagé spirits and the Colombian army, for instance, I also want to insist, nevertheless, that we take stock here of the magical usage by the colonized of the mystique of the colonizing State apparatus—just as

we, upon reflection, have to acknowledge the importance to such usage of the magic that in fact exists within the art of modern, secular, statecraft itself.

Terror and The Colonial Mirror: The Mimesis of Mimesis

The purpose of the Fascist formula, the ritual discipline, the uniforms, and the whole apparatus, which is at first sight irrational, is to allow mimetic behavior. The carefully thought out symbols (which are proper to every counterrevolutionary movement), the skulls and disguises, the barbaric drum beats, the monotonous repetition of words and gestures, are simply the organized imitation of magic practices, the mimesis of mimesis.

—Horkheimer & Adorno, *Dialectic of Enlightenment*

If the old Indian of the frontier forests gains access to healing power from his receiving an image of the State militant, the golden army ("the ritual discipline, the uniforms, and the whole apparatus . . ."), it is worth inquiring as to whether a colonial mirroring is not also practiced by those thus imagized—whether, in short, those within the "civilized" confines of that State find (magical) power in an image of the Indian forester. Certainly the army recruits from the interior valley of the Cauca River who marched down into the Putumayo in 1931 had strong beliefs in the magical power of the Indian healers to protect them, if the accounts of two old soldiers I talked to in the sugarcane town of Puerto Tejada decades later are any indication.[1] Certainly most of the poor peasant colonists who daily make their way down into the Putumayo today express similar notions as to the power of the Indian, a power that derives from the mysteries that they, the colonists, attribute to the primevality accorded Indian rite and lore, which places the Indian healer of the forest as much in a supernatural capacity as in an infrahuman one. Thus it is to these Indians that both black and white colonists will go for cure when they fear they have been ensorcelled by another colonist out of envy. A dramatically clear instance of this power attributed to the primitive is the yagé vision related to me one

evening in 1976 by a peasant colonist with whom I used to stay when awaiting a canoe to descend the Guamuez River, a tributary of the Putumayo.

At the age of fifteen this man had been taken by his uncle to drink yagé with an Indian (Cofan- and Spanish-speaking) healer upstream at Santa Rosa. As the medicine started to take effect, shadows gathering in storms of sound and images of forest animals, wild pigs and snakes, the Indian healer changed in front of his eyes into a jaguar and then into the devil himself. In the colonist's words:

> I heard someone talking to me, singing rather, and I saw something there, it was frightening, it was the devil himself. But how could that be? Sitting there; right behind me. But it wasn't the devil; it was the shaman. It was he who had been the devil.
>
> Then I opened my eyes and saw all the Indians sitting there with the shaman. He's put on his feathers, his crown too, sitting by the fire chewing tobacco. *Taita* [father] Martín, the tiger, the devil, it was *taita* Martín. The devil, he had horns and [he paused] . . . heated and red—you should have seen him—with a long tail down to his knees . . . just like they paint him—with spurs and everything. Ugly!

"Just like they paint him." At which point, thanks to this "painting" of this Indian as devil, the colonist, as he put it, "died," ascending in his lonely curiosity to the Godhead to be unexpectedly blessed by God himself. Thus fortified he could return through the mists of dawn clinging to the forest, down to this earth, feeling somewhat superhuman himself, everything easy, glad to be home on his own feet, and able to withstand for who knows how long the envy permeating the social landscape of poor peasant farmers struggling for survival, with and against each other.

God's singular power is obtained here by the colonist passing, as deadman, as spirit, into a narrative journey of images. By means of them he has entered into a domain of extraordinary power. He passes by and into them and hands them on to you through me. It is in the metamorphosing master-image, the pivoting trinitarian image of the Indian as jaguar, shaman, and Christian devil that secures the journey into the image-world.

How much more complex than Frazer's "like effecting like" this magical power of the image now becomes! Yet the mimetic basis remains, dependent, above all, on an alterity that follows the ideological gradient decisive for world history of savagery vis à vis civilization. If Florencio, the Indian, gains healing power by virtue of the "painting" of the Nation-State's golden army, and the poor colonist, emergent from that State, gains healing power through the "painting" of the Indian as devil, then we must needs be sensitive to the crucial circulation of imageric power between these sorts of selves and these sorts of anti-selves, their ominous need for and their feeding off each other's correspondence—interlocking dream-images guiding the reproduction of social life no less than the production of sacred powers.

But this power intrinsic to mimesis and alterity on the frontier is as much a destructive as a healing force. While today whites and blacks approach Indian in the Putumayo for magical succour, at the turn of the century along the lower Putumayo, Indians were tortured on a massive scale with what appears a good deal of ritual as well as blind fury and cold calculation, pleasure as well as fear, by the agents of the Arana Brothers' Anglo-Peruvian rubber company.[2] Reading the reports of this barbaric situation, as with so much of the State and paramilitary terror in Latin America today, one senses that it is next to impossible to write or talk about this, so monstrous it was, and is. But perhaps in pointing to my usage of the term "barbaric" you will get the point—you will see that my convenient term of reference, barbarism, does double service, registering horror and disgust at this application of power, while at the same time ratifying one of that power's most essential images, that of the barbaric—the savage, the brute, and so forth. In condemning violence as savage, I endorse the very notion of the savage. In other words, the imaginative range essential to the execution of colonial violence in the Putumayo at the turn of the century was an imagining drawn from that which the civilized imputed to the Indians, to their cannibalism especially, and then mimicked. It should also be pointed out that while this violence was doubtlessly motivated by economic pressures and the need to create labor disci-

pline, it was also, as I read the evidence, very much a passionate, and gratuitous, end in itself.

This mimicry by the colonizer of the savagery imputed to the savage is what I call the colonial mirror of production and it is, I now see, identical to the mimetic structure of attribution and counter-attribution that Horkheimer and Adorno single out when they discuss not the violence of the twentieth-century colonial frontier but the blow-up within modern European civilization itself, as orchestrated by anti-Semitism. This is what they mean where they write:

"They Cannot Stand the Jews, But Imitate Them"

And they continue:

> There is no anti-Semite who does not basically want to imitate his mental image of a Jew, which is composed of mimetic cyphers: the argumentative movement of a hand, the musical voice painting a vivid picture of things and feelings irrespective of real content of what is said, and the nose— the physiognomic *principium individuationis*, symbol of the specific character of an individual, described between the lines of his countenance.[3]

They, too, understand the power of mimesis in modern history as both imitation-and-sentience, Frazer's Similarity-and-Contact, hence the wanting *to be like* the Jew, and also *the sensuousity of that act of being similar*; detail upon detail, the hand gesture, the tone of voice, the nose, its shape, its size, its being the organ of smell, the "most animal" of the senses. "Of all the senses," they write, "that of smell— which is attracted without objectifying—bears clearest witness to the urge to lose oneself in and become the 'other'." Thus we are led back to Benjamin's sentience taking one out of oneself, led by the nose to think anew of what it means to objectify and sense an-Other, of losing oneself in that Other, as when Benjamin writes of mimesis as a rudiment of a former compulsion to be another, and Caillois toys with the scary idea of becoming similar, not similar to something, just similar. Small wonder, then, given this underworld of olfactory ontogenics resplicing

mimesis and alterity into dizzying epistemological conundrums that the sense of smell, in at least one well-recorded instance, plays a role in the magician's art. Indeed it "is the most important factor in the laying of spells on people," wrote Malinowski with regard to the Trobriand Islands in *The Sexual Life of Savages* (first published in 1929), and he went on to describe how, in order to achieve its greatest potency, magic there must enter through the nose. Just as love charms there were borne into the victim on the scent of some spellbound aromatic substance, so in sorcery the object over which the maleficent magic has been done is burned, the smoke entering the nostrils of the victim and thereby causing disease. "For this reason," says Malinowski, "houses are never built on piles in the Trobriand, as it would greatly facilitate this stage of the sorcerer's work."[4]

In Adorno and Horkheimer's account, civilization does more than repress mimesis, understood either as imitation or as sensuousness. On the contrary, civilization sniffs out the enemy, uses smell against itself in an orgy of imitation. Racism is the parade ground where the civilized rehearse this love-hate relation with their repressed sensuousity, with the nose of the Jew, their "instinct" for avarice, the blackness of the negro, their alleged sexuality, and so forth. There is furthermore a strange mapping of what is defined as sensuous excess whereby the "minorities" spill out, escape the grid of the normative, and therefore conceptuality itself. As sheer substance, matter out of place becomes matter with a vengeance, sensuousity shredding the very notion of conceptuality. Thus the idiosyncracy of the "minority" awakens "moments of biological prehistory"—according to Horkheimer and Adorno—"danger signs which make the hair stand on end and the heart stop beating."[5] Confronting what is taken as idiosyncracy, individual organs may escape the control of the subject, and it is this very animality projected onto the racial Other, so the argument runs, that is desired and mimicked as sadistic ritual, degradation, and ultimately in genocide against that Other. Accused of participating in forbidden magic and bloody ritual, the Jews:

are declared guilty of something which they, as the first burghers, were the first to overcome: the lure of base instincts, reversion to animality and

to the ground, the service of images. Because they invented the concept of kosher meat, they are persecuted as swine.[6]

Fascism, in this analysis, is an accentuated form of modern civilization which is itself to be read as the history of repression of mimesis—the ban on graven images, gypsies, actors; the love-hate relationship with the body; the cessation of Carnival; and finally the kind of teaching which does not allow children to be children. But above all, fascism is more than outright repression of the mimetic; it is a return of the repressed, based on the "organized control of mimesis." Thus fascism, through the mimesis of mimesis, "seeks to make the rebellion of suppressed nature against domination directly useful to domination.

Disorganizing the Mimesis of Mimesis: Josephine Baker, Count Harry Kessler, and the Question of Parody

The Negro, the world over, is famous as a mimic. But this in no way damages his standing as an original. Mimicry is an art in itself [and] he does it as the mocking-bird does it, for the love of it, and not because he wishes to be like the one imitated.

—Zora Neale Hurston *The Sanctified Church*

In Horkheimer and Adorno's analysis, fascism did not invent racism. Nor is racism much clarified by thinking of it as a mere side-effect of some more basic economic factor such as poverty. What makes Horkheimer and Adorno's thesis distinctive is that far from being side-effectual, racism is seen as a manifestation of what is essential to modern civilization's cultural apparatus, namely continuous mimetic repression—understanding mimesis as both the faculty of imitation and the deployment of that faculty in sensuous knowing, sensuous Othering.

A question then arises in this version of the history of the senses—from mimesis to the organized control of mimesis—as to whether the mimetic faculty can escape this fate of being used against itself, whether it could be used against being used against itself? Can parody supply an answer? After all, parody is where mimicry exposes construction,

suggestive of a new sort of anthropology, post-post-Frazerian, that defines its object of study not as Other but as the reflection of the West in the mimetic magic of its Others—as foreshadowed in the following tale Count Harry Kessler tells concerning that night in Berlin, February 24, 1926, when he brought Josephine Baker, the famous African-American cabaret dancer, then living in Paris, to dance for his dinner guests in a space cleared in the library.

Shy at dancing naked in the presence of his women guests "because they are ladies," she eventually overcame her hesitation as the count described the ballet he was planning to write for her. Then, in his own words, which I take to be a summary of all I have said on the mimetic faculty, most especially the inevitability with which it is embedded in modern thought with primitiveness and colonization:

> Josephine Baker was as though transformed. *When,* she implored, will the part be ready for her to dance? She began to go into some movements, vigorous and vividly grotesque, in front of my Maillol figure, became preoccupied with it, stared at it, copied the pose, rested against it in bizarre postures, and talked to it, clearly excited by its massive rigour and elemental force. Then she danced around it with extravagantly grandiose gestures, the picture of a priestess frolicking like a child and making fun of herself and her goddess. Maillol's creation was obviously much more interesting and real to her than the humans standing about her. Genius (for she is a genius in the matter of grotesque movement) was addressing genius. Suddenly she stopped and switched to her negro dances, spicing them with every sort of extravagance. The climax was reached when Fried tried to join in the clowning and she caricatured, ever more preposterously, ever more dizzily, any and every movement he made. Where Fried was just ungainly, with her it became a wonderfully stylish grotesquerie which struck a balance between what is depicted in an ancient Egyptian relief frieze and the antics of one of George Grosz's mechanical dolls. Now and again Luli Meiern also improvised a few movements, very delightful and harmonious; but one twist of the arm by Josephine Baker and their grace was extinguished, dissolved into thin air like mountain mist.[7]

6

WITH THE WIND OF WORLD HISTORY IN OUR SAILS

What matters for the dialectician is having the winds of world history in his sails. Thinking for him means: to set sail. It is the way they are set that matters. Words are his sails. The way they are set turns them into concepts.

—Walter Benjamin, "Konvolut N."

I have emphasized how mimesis, as either an unadorned human faculty or one revived in modernity by mimetic machines, is a capacity that alerts one to the contactual element of the visual contract with reality. I have also intimated that just as mimesis as a necessary part of thinking the concrete involves world history, especially that confluence of colonial factors resulting in primitivism, so by definition world history cannot be thought of outside the mimetic faculty itself. I want to push this notion pretty hard. I want to assert that in a terribly real sense, the practice of mimesis in our day, inseparable from imaging and thinking itself, involves the rehearsal of the practices of the body associated with primitivism. As the nature that culture uses to make second nature, mimesis cannot be outside of history, just as history cannot lie outside of the mimetic faculty. Here we take odds with the fashionable theses of construction, that nature itself is a social construction, just as we take odds with the converse, that history itself can be reduced to an essential nature. As the nature that culture uses to create second nature, mimesis chaotically jostles for elbow room in this force field of necessary contradiction and illusion, providing the

glimpse of the opportunity to dismantle that second nature and recon-struct other worlds—so long as we reach a critical level of understand-ing of the play of primitivism within the mimetic faculty itself. This is why I cite Benjamin's likening of thinking to the setting of sails in the winds of world history—let us emphasise the worldliness of this history—in which the sails as images (read mimesis) develop into concepts *according to how they are set*. Here is the space for human agency and shrewdness, the setting of the sail within the bufetting of history. This is the decisive factor, setting the sail's edge tensed so the image billows into the driving concept, and it is not without pathos that I recall it, because Benjamin's philosophy of the image is a profoundly historical, time-sensitive, theory bound to a perceived moment of great specificity within the development of European capitalism: it is bound to a specific philosophy of history arching toward the flash of recogni-tion of the past in an image that surfaces unexpectedly—that is to say, at a moment of danger, which is what he often had in mind—to achieve a type of mimetic remembrance in the face of the erosion of experience in modern times.

Here Benjamin's philosophy of history as a philosophy of picturing, adjusting the image to the salience of wind and map, force and goal, a philosophy that through imageric free-fall if not pictorial necessity invokes the history of sailors, the winds of world history to be sure—European colonial history binding colored people to the metropoli by means of those sails. This is why the gringo spirit sailors of the Emberá shaman and the wooden figurines of sailors, spirit-helpers of the Cuna shaman, seem to me to be so important—not just for the Emberá and the Cuna (that is after all very much their business) but for what I will generically refer to as the West thus depicted, embodied, and made (magical) use of.

So let us attend to these sailors whose image is put to such good use, those sailors calling at Central and South American ports, remote anchorages and estuaries, carrying the trade and mapping the shores—but first we have to contemplate, as they did before us, the vast empti-ness of oceanic space binding Europe to its others, the space between flooding with primitivism. For this space provides the location for the study of the mimetic faculty and its place in the history of the senses.

That study now becomes the study of the position of the primitive Other in modern Western notions of the mimetic faculty and of the place of wildness in sentience. Far from resting mimesis on a psychological or biological base-line such as a "faculty" and buttressing it with notions of "the primitive," as Benjamin does in his essay on the mimetic faculty with his suggestive assumptions about the ubiquity of mimesis in the dance and magic of the primitive world, can we not create a field of study of the mimetic which sees it as curiously baseless, so dependent on alterity that it lies neither with the primitive nor with the civilized, but in the windswept and all too close, all too distant, mysterious-sounding space of First Contact?

First Contact

In describing Frazer's Law of Contact, Mauss and Hubert evoke the world that such a notion of the magical power of the image entails. Tactility displaces the visual image into continuous impulses. "We find," they write with respect to the magicians' Law of Contact, "that both individuals and objects are theoretically linked to a seemingly limitless number of sympathetic associations. The chain is so perfectly linked and the continuity such that, in order to produce a desired effect, it is really unimportant whether magical rites are performed on any one rather than another of the connections." The magician's task is to know how to intervene in this chain of sympathy. It is anything but static. "It is the image of the thing to be displaced," they note, "that runs along the sympathetic chain."[1]

I want to ask where this wondrous chain of sympathy begins and ends, and whose image of what is continuously displaced by sympathetically attuned substances? For surely this chain cannot be considered as strictly limited to the magician's circle. Surely its wonders have also been displaced by the expansion of European colonialism from the sixteenth century on. And as primitive magic and modern mechanical reproduction were adjusted one to the other in a myriad of complex efforts at different times in different places through a common focus on the mysteries of representation and the powers of the mimetic

faculty in signifying practice, it was above all that auratic moment of "first contact" with the primitive that gave Europeans their first image of the mimetic treasure which lay, if not within, then between the collective bodies in contact with one another. Let us therefore turn to one such history of contact, in Tierra del Fuego, Land of Fire, where a particularly modern history of mimesis may be said to have begun.

A Windswept Space: Tierra del Fuego—Land of Fire, Land of Mimicry

On December 18, 1832, in his diary of the voyage of the *Beagle*, the twenty-three-year-old naturalist Charles Darwin recorded the mythical scene of almost first contact with the people of Tierra del Fuego.[2] The *Beagle* had sighted Fuegians lighting fires upon seeing the vessel two days earlier. "Whether for the purpose of communicating the news or attracting our attention, we do not know." Anchoring in the Bay of Good Success (naming is an essential part of discovery), he observed more Fuegians—the term is European, literally "fiery ones"—"perched on a wild peak overhanging the sea and surrounded by woods. As we passed by they all sprang up and waving their cloaks of skins sent forth a loud sonorous shout; this they continued for a long time. These people followed the ship up the harbour, and just before dark we again heard their cry and soon saw their fire at the entrance of the Wigwam which they built for the night."[3] Next day Captain Fitz Roy sent a boat with a large party of officers to communicate with the Fuegians. "It was," wrote the young Darwin, "without a doubt the most curious & interesting spectacle I ever beheld":

> I would not have believed how entire the difference between savage & civilized man is. It is greater than between a wild & domesticated animal, in as much as in man there is greater power of improvement. The chief spokesman was old & appeared to be head of the family; the three others were young and powerful men & about 6 feet high. From their dress etc etc they resembled the representations of Devils on the Stage, for instance, Der Freischutz. The old man had a white feather cap, from under which, black, long hair hung round his face. The skin is dirty copper colour.

Reaching from ear to ear & including the upper lip, there was a broad red coloured band of paint; & parallel & above this, there was a white one; so that the eyebrows & eyelids were even thus coloured. The only garment was a guanaco skin with the hair outside. This was merely thrown over their shoulders, one arm & leg being bare; for any exercise they must be absolutely naked. (118-19)

So much for the spectacle. Then the contact:

Their very attitudes were abject, & the expression distrustfull, surprised & startled. Having given them some red cloth, which they immediately placed around their necks, we became good friends. This was shown by the old man patting our breasts & making something like the same noise which people do when feeding chickens. I walked with the old man & this demonstration was repeated between us several times. At last he gave me three hard slaps on the breast and back at the same time, & making most curious noises. He then bared his bosom for me to return the compliment, which being done, he seemed highly pleased. Their language does not deserve to be called articulate. Capt. Cook says it is like a man trying to clear his throat; to which may be added another very hoarse man trying to shout & a third encouraging a horse with that peculiar noise which is made out of the side of the mouth. (119)

The mouth serves as an organ of language in other ways as well:

Their chief anxiety was to obtain knives; this they showed by pretending to have blubber in their mouths and cutting instead of tearing it from the body: they called them in a continued plaintive tone cuchilla [Spanish for knife]. (119)

But it is the body in its entirety—and not only the body of the fiery ones—that serves to articulate this inarticulate language. In his *Journal of Researches*, the young naturalist proceeds, preceding Walter Benjamin's assumptions about the intimate connection between primitiveness and mimesis by ninety-nine years:

They are excellent mimics: as often as we coughed or yawned or made any odd motion, they immediately imitated us. Some of the officers began to squint and make monkey like faces; but one of the young Fuegians

(whose face was painted black with white band over his eyes) succeeded in making far more hideous grimaces. They could repeat with perfect correctness each word in any sentence we addressed them, and they remembered such words for some time. Yet we Europeans all know how difficult it is to distinguish apart the sounds in a foreign language. Which of us, for instance, could follow an American Indian through a sentence of more than three words? All savages appear to possess, to an uncommon degree, this power of mimicry. I was told, almost in the same words, of the same ludicrous habit among the Caffres: the Australians, likewise, have long been notorious for being able to imitate and describe the gait of any man, so that he may be recognized.

And he concludes by asking: "How can this [mimetic] faculty be explained? Is it a consequence of the more practised habits of perception and keener senses, common to all men in a savage state, as compared with those long civilized?[4]

Perhaps Captain Fitz Roy supplies an answer. He was not only engaged in mapping the South American coast and accurately fixing the world's longitudinal reckoning, but was also the activator of a most audacious exercise in mimesis and alterity. He was returning three Fuegians—Jemmy Button, York Minster, and the woman, Fuegia Basket—back to their home from England, where he had presented them to Queen Victoria three years earlier, to serve now as civilized Christian missionaries instructing their own people. (Before the Admiralty agreed to outfit a vessel, Fitz Roy had been ready to complete this mission at his own expense.)

In his rendering of the same scene that Darwin describes, Fitz Roy provides the reader with a brief introduction, almost an apology. "Disagreeable, indeed painful, as is even the mental contemplation of a savage," he admits, there is nevertheless great interest in it as well. And he goes on to suggest reasons why this should be so.[5]

It seems to me that this audacious ship's captain, writing in the early nineteenth century, has deftly articulated the key issue of the mimetic faculty in the modern world, namely what makes the mental contemplation of a savage interesting (despite the pain). Moreover, Fitz Roy's explanation of *why* looking at the savage is interesting is that such looking is in itself a form of theorizing society and historical process.

The first reason he gives is that one should appreciate that we British were once like the Fuegians, and that is how Caesar found us—painted and in skins. The second reason is that there is something absorbing in observing people displaying childish ignorance of matters familiar to civilized man. And the third reason is the interest occasioned by the Fuegians' healthy, independent state of existence.

Of particular interest to what has been called "the civilizing process" is the second reason—this "something absorbing in observing people displaying childish ignorance of things familiar to civilized man." Wherein lies the mysterious power of this "something absorbing"? Could it be that this is the consequence of an unstoppable circulation of mimetic and alteric impulses along a sympathetic chain in which each moment of arrest stimulates further impulsion? Things familiar to the civilized are estranged by Fitz Roy's savage, yet by the same token they are re-familiarized . . .

Although his description in *the Beagle Record* of the landing on the beach was not as meticulous as Darwin's, Fitz Roy chose to draw out one detail that Darwin omitted. First, as with Darwin, there is the contemplation of the spectacle:

> One of these men was just six feet high and stout in proportion: the others were rather shorter: their legs were straight and well formed, not cramped and misshapen like those of the natives who go about in canoes; and their bodies were rounded and smooth.

Then the contact:

> They expressed satisfaction or good will by rubbing or patting their own, and then our bodies; and were highly pleased by the antics of a man belonging to the boat's crew, who danced well and was a good mimic.[6]

Note here first his optical focus on the Fuegian body, second the actual bodily, sensuous connection between the Fuegians and the sailors, and third the mimicry—but not on the part of the Fuegians, as Darwin so vividly depicted it, but on the part of the sailor. We are thus plunged into a chicken-and-egg problem. Who is mimicking whom,

the sailor or the savage? We find the same problem and the same "trick" of not seeing one's own indulgence in, and stimulation of, mimicry vis à vis the "savage" when it comes to the way that adults in Western societies teach and relate to infants and children. Adults imitate what they take to be baby talk or childish tones of voice and expression and insert themselves in what they take to be the "child's world," playing with the child, sometimes with the aim of controlling it, or teaching the child by getting it to imitate the adult's imitation—patting the dog this way, not that way, eating this way, not that way, and so forth. In fact the adult is imitating to differing degrees two different things here, one being the child, the other being the dog, the food, language, and so forth. Control and education comes about by judicious blending of these two realities, moving one into the other and thereby creating new behaviors and understandings. And the child? Does it respond to this with mimicry of mimicry? And what, then, was the adult imitating in the first place—a real reality, as we might like to simplistically describe the issue, such as the child's tone of voice or behavior? Or instead was the adult imitating the child's mimicry of the adult's mimicry? In which case we seem to be doing something quite strange, going round and round and unable to see that we are doing so, simulating and dissimulating at one and the same time for the sake of our epistemic health and the robust good cheer of realness.

Fitz Roy's observation about the mimicking prowess of his sailor dancing to the mimicking Fuegians across the colonial divide of First Contact is further sharpened by contrast with the account of Mick Leahy, a white Australian gold prospector in the New Guinea highlands a century later, in the early 1930s. First the Contact:

> When I took my hat off, those nearest me backed away in terror. One old chap came forward gingerly, with open mouth, and touched me to see if I were real. Then he knelt down and rubbed his hands over my bare legs, possibly to find if they were painted, and grabbed me around the knees and hugged them, rubbing his bushy head against me. His hair was done up in dozens of little plaits and stank terribly of rancid pig grease.[7]

The white men were hungry and wanted to exchange "gifts" for food with these people who had never before had contact with whites

and spoke an unknown language. They "bought" sugar cane with glass beads and a pig with a steel axe and decided to camp there the night as their coastal native porters were tired. (In New Guinea no white man could carry a pack.) Then the mimicry:

> We told the [highland] natives of our intention by signs and asked them to come down the next morning and show us the way. This was accomplished by leaning the head on one hand and closing the eyes—gestures of sleeping; pointing to the ground, to indicate this place; then pointing to the east, with a rising gesture—"sun he come up," and then pointing off down the creek, looking down for a trail and shaking our heads. The natives got it at once, and gave us to understand that they would be on hand. Pantomime serves surprisingly well for conversation when you have to depend on it.[8]

. . . whereas Darwin had seen the *natives* as mighty mimics!

The Space Between

Let us go back to Fitz Roy's sailor for this in a nutshell—in an image of a sailor of Her Majesty's Navy dancing, perhaps a little smile on his mimicking face wet with salt spray and probably hell-bent on drawing out the mimicry of his Fuegian audience—is what I mean by mimesis as a "space between," a space permeated by the colonial tension of mimesis and alterity, in which it is far from easy to say who is the imitator and who is the imitated, which is copy and which is original. Fitz Roy's sailor doing his little dance vis à vis savagery makes many of us think again about the exquisite ambivalence we feel at the shock of recognition we receive on reading Darwin—"All savages appear to possess, to an uncommon degree, this power of mimicry." Fitz Roy's sailor reminds us of the pleasure, if not the need, the civilized have of such a savage mirror on the edge of the known world, where mimesis as a faculty now burns with the intensity of a meta-category—not only an awe-inspiring concrete imitation of this or that concrete entity but the sheer fact of mimicry itself, mimicry as bound to the savage body as its rightful property. Yet it is the civilized eye that provides this

staging, this drawing-out and appreciation of the faculty, a drawing-out that impacts upon and blends into the body of that eye itself, as we in turn see it with Fitz Roy's image of the dancing British tar.

In this way mimesis as fact and as epistemic moment can be understood as redolent with the trace of that *space between*, a colonial space par excellence, a windswept Fuegian space where mankind bottoms out into fairy-tale metamorphoses with children and animals, so mimesis becomes an enactment not merely *of* and original but *by* an "original." Nowhere is this more dramatically played out than on the colonial stage of historic surreality of copy/original reversals as conveyed to us through crucially important snapshots such as Darwin's on the beach at Tierra del Fuego, an image in which civilization takes measure of its difference through its reflection in primitives. So deeply invested is this scene in Western cultural patrimony, and hence selfhood, that it cannot be shrugged aside or calmly studied from a distance because it enters in all manner of subtle ways into that very Self, into the apparatus that might attempt the shrugging and, most pertinent of all, into its very philosophy of the senses and of copying the real—all the more baffling on account of the way by which mimesis entertains bewildering reciprocities, mixes them with sentience, with pleasures, with pain, and with the "ludicrous" and "odd mixture of surprise and imitation."

Drawing Out the Mimetic Faculty: The Mimesis of Mimesis

But we must also admit of a peculiar feature in this when we are assailed time and again by the mighty bodiliness and reciprocal bodiedness of the slap of ("first") contact between sailors and primitives—all that chest-thwacking, bosom-baring, rubbing, patting, walking arm-in-arm, face-pulling, squinting, languaging, dancing, and so forth. And this is more than a substitute for lack of a common verbal language; one can hardly imagine Fitz Roy or his sailors acting like this with a group of German peasants or Norwegian fishermen with whom they shared no language.[9]

The very language of representation of this colonial mimesis acquires a crackling, sensuous character, beginning with the minute depiction of skin color and body paint, the patting and baring of breasts—as if the sailors were stripping off, becoming naked like the Fuegians—and then the noises! The noises that in this depiction stand in for language! The clucking noise one makes when feeding chickens. The throat-clearing noise. The hoarse-man-trying-to-shout noise. The horse-en-couraging noise made out of the side of the mouth. (All these animal references!).

So much for sentience, for physicality, for the objectness of the object, for trying to articulate the inarticulatable in which the very language of (Darwin's) articulation strains its utmost to become, like Artaud or Futurist and Dada Bruitism, noise itself, to mime the (Fuegian) mimers, thereby recruiting the animal kingdom—or at least its domesticated subkingdom: chickens being clucked into order by what their masters regard as somehow seductive chicken-sounds at mealtime; horses being cajoled by their masters with what their masters take to be horsey and horse-encouraging sounds. In short, these are the sounds that Englishmen use not merely to imitate animals but to control them, and Darwin, in describing the speech of the Fuegians—whom he catalogues as the lowest grade of man in the world—not only *compares* their speech to this imitating-controlling habit and vocabulary of "ours" vis à vis animals, but he himself as the major move in this comparison *imitates* these sounds—he imitates the imitation in order to better imitate the imitators. And in his imitating we become aware of the sound of sound—of its physical presence in action—and are reminded once again of the two-layered nature of mimesis as sentience and copying.

This double layer is brought out in another striking way when Darwin observes with awe that the Fuegians can imitate the sailor's language "with perfect correctness" while "we Europeans all know how difficult it is to distinguish apart the sounds in a foreign language." So while Darwin (for our sakes, never forget, for the sake of a communicating text, even if it is a diary that only later became a marketable book), mimes the Fuegians' language by its sentience, the Fuegians mime the sailors' language by deadly accurate copying.

But most endearing of all is the competition set up, a competition in miming. The instant they see a sailor, they yield into his shape, his speech, his gait, and of course, his face. "As soon as we coughed or yawned, or made any odd motion, they immediately imitated us," noted Darwin, such that the sailors, in his description, then begin to squint and pull faces and look awry. In other words, they get into the game too, not only as mimicry of mimicry but, so it seems to me, with a hint of parody as well—parody of sensuous capacity of face-pulling, and parody of mimesis itself. But, says Darwin, our referee in this matter, still they are outdone by the Fuegians mimicking the sailors mimicking the Fuegians.

It's as if the Fuegians can't help themselves, that their mimetic flair is more like an instinctual reflex than a faculty, an instinct for facing the unknown—and I mean *facing*. I mean sentience and copying in the face of strange faces. Note the way they are painted, especially the face, especially the eyes. Note the grimacing of the face that sets off a chain reaction between sailors and Fuegians. And most of all note that there seems to be a tight fit between surprise and mimicry—as Darwin himself noted in his *Journal*: "After our first feeling of grave astonishment was over, nothing could be more ludicrous than the odd mixture of surprise and imitation which these savages at every moment exhibited." (209) What we find here seems close to shock and subsequent mimetic reaction to it: that odd mixture . . . *at every moment exhibited*.

Keener Senses, Mighty Mimicry?

Darwin suggested that the extraordinary degree of development of the mimetic faculty amongst "savages" might be due to their "more practised habits of perception and keener senses, common to all men in a savage state, as compared with those long civilized." (206) In his *Journal* he noted on the *Beagle* before reaching Tierra del Fuego that the three Fuegians returning from London had remarkable eyesight, even superior to that of British sailors despite the many years the sailors had spent at sea. Only a telescope could pick out what the Fuegians, but nobody else on board, could discern unaided. Yet we are also told

that the senses are dulled by living close to nature, as when Darwin remarks that the skill of the Fuegians may be compared to the instinct of animals because it is not improved by experience. He gives the example of their canoes, "their most ingenious work, poor as it is, has remained the same, as we know from Drake, for the last 250 years," and we detect similar modes of interpretation where he describes how much insensitivity—not acuity—it takes to survive without clothes or shelter in such a bleak environment (216)—and I take the bleakness that he refers to here is not merely physical, but inevitably moral and aesthetic as well. Having been absent from the depiction of mimicry, now, as the topic of dullness and fortitude is broached, women suddenly enter and assume the burden of representation, as when Darwin declares in the *Journal* that the Fuegians kill and devour their old women before they kill their dogs, that the lot of women is one of laborious slavery to brutal masters who dash out their children's brains for misdemeanors, or, as in the following touching scene of motherhood amid the cruel elements:

> In another harbour not far distant, a woman, who was suckling a recently-born child, came one day alongside the vessel, and remained there out of mere curiousity, whilst the sleet fell and thawed on her naked bosom, and on the skin of her naked baby! These poor wretches were stunted in their growth, their hideous faces bedaubed with white paint, their skins filthy and greasy, their hair entangled, their voices discordant, and their gestures violent. Viewing such men, one can hardly make oneself believe that they are fellow-creatures, and inhabitants of the same world. (213)

Thus the animality of "these poor wretches," wrought to extreme by the picture of the women, seems eons distant from the hypersensitivity that primitiveness can also imply. It would therefore seem of dubious, or at least complex, logic to make the common sensical if somewhat racist assumption, as Darwin does, that the extraordinary miming ability attributed to the Fuegians is a result of their *keener* (note the comparative) senses. And even if the notion of sensory acuity was not complicated in this way, because of dullness existing side by side with keenness, we would have to consider another link in the chain of reasoning here involved, namely that there would seem to be no

necessary link between such (alleged) acuity, on the one hand, and wanting or being able to mime and mime well, on the other; having good eyes and ears neither makes one a good mimic nor want to be one.

The "Origins" of Mimesis Lie in Art and Politics And Not Survival

So, in trying to "explain" the alleged coupling of primitiveness with mighty miming (and the desire to mime), how do we understand this to bear upon an aspect of life that refers not to the individual organism as a biological entity adapted to tough material conditions, but instead refers to social life, particularly the life of the imagination as expressed by the art, ritual and mythology of "primitive" societies? After all, could the face-painting that so caught Darwin's curiosity be explained as necessary to and part of the materiality of surviving in a cold climate? And wouldn't one be likely to find the analogy of miming precisely in such painting?

If we take a cue from Darwin's pairing of the Fuegians with the Australian aborigines, we see that much later, as the *Beagle* heads for home, he briefly describes in his *Journal* what he calls a "corrobery or native dance" at Bald Head, Western Australia, in which mimesis is an important feature:

> There was one called the Emu dance, in which each man extended his arm in a bent manner, like the neck of that bird. In another dance, one man imitated the movements of a kanagaroo grazing in the woods, whilst a second crawled up, and pretended to spear him. When both tribes mingled in the dance, the ground trembled with the heaviness of their steps, and the air resounded with their wild cries. (451)

Some seventy years later the emu dance also caught the eye of Emile Durkheim. In his book *The Elementary Forms of Religious Life*, he observed that the pioneer ethnographers of the Arunta people of the central desert, Spencer and Gillen, pointed out that in that dance to augment well-being, the Intichiuma of the Emu "at a certain moment

the actors try to reproduce by their attitude the air and aspect of the bird," and he goes on to underscore what he sees as "the essentially imitative nature of Arunta rites."[10] Indeed there are (according to Durkheim's reading of Strehlow):

> ... scarcely any ceremonies in which some imitating gesture is not pointed out. According to the nature of the animals whose feast is celebrated, they jump after the manner of kanagaroos, or imitate the movements they make in eating, the flight of winged ants, the characteristic noise of the bat, the cry of the wild turkey, the hissing of the snake, the croaking of a frog, etc.[11]

And to that marvelous fidelity, we should add that for the initiated men, according to Spencer and Gillen, many months of the year were dedicated to just such mimicry. At the same time, at the close of the nineteenth century when Spencer and Gillen were writing their account of Central Australia, a young man born and bred in Tierra del Fuego, E. Lucas Bridges, saw the spirit Hachai come out of the lichen-covered rocks. He was painted all over with red and white patterns. Grey bird's-down was stuck over him, and he wore a horned mask with red eye-holes. No horned animal is indigenous to Tierra del Fuego, noted Bridges, yet a hunter of wild cattle would have admired the actor's performance. "His uncertain advances, his threatening tosses of the head, his snorting and sudden forward thrusts of one horn or the other—all were most realistic. The part he was playing came from legendary myth and had doubtless been enacted by the Ona [Selk'nam] for countless generations."[12]

Would not studious application to the ritual practice of myth and magic provide far more of a basis for the mimetic faculty than what the young Darwin called "the more practiced habits of perception and keener senses common to all men in a savage state"?

To gauge the intensity of such ritual practice in Tierra del Fuego one has only to consult Bridge's detailed memoir as well as the extensive works of the talented Austrian ethnographer, Martin Gusinde, who worked in the region between 1918 and 1924.[13] Both provide vivid descriptions of the ritual core of Selk'nam society, the lengthy men's initiation known as the Hain occurring in the men's ceremonial house.

(There was no such house for women). Not only is this stupendously "theatrical" and "staged", with the women and children providing the "audience", but it is obvious that in miming the (women-hating) spirits, the men invigorate powers essential for the reproduction of society, especially the power to control what they fear as the sorcery potentially possessed by women—the original fear that, according to myth, led them long ago to most brutally kill all the women and build the men's house in the first place. So important is the ritual power of the theater of the men's house that Gusinde refers to it as the sovereign power of an invisible state. He thus provides us with the elementary form not only of religion (to invoke the title of Durkheim's classic work) but of the state as well—a performative theory of the state as a mighty theater of male fantasies, illusions generated by potent male fear of women.

And thus it is apposite to invoke the theme of sacred violence in mimesis. If Frazer directed us to think of the copy as drawing on the power of the copied, and did so from a utilitarian perspective, it is to Georges Bataille's everlasting credit that, in his discussion of the Lascaux cave paintings, he dismisses such a view that sees these paintings as aimed at securing game and argues instead that they are *testimony* to the release of the sacred through the violence of killing and that they follow transgression (in this case, of the taboo against killing).[14] Both Gusinde and Bridges leave us in no doubt as to the mighty force of sacred violence in the mimetics of the Hain, a force that, following both Frazer and Bataille, we could see as securing its power from enacting the gods as well as from the violence entailed by that enactment. And here we see the most fundamantal cleavage in mimesis. For this sacred violence exists in two quite contrary ways.

On the one hand the women and children, forming the "audience," have to pretend—to mime—on pain of death that what they are witness to are real gods and not their kinsmen acting as gods. In this way the public secret essential to mystical authority is preserved.

On the other hand is the violence associated with the demasking of the gods that the male initiates are forced to witness in the privacy of the men's house. Through the violence of demasking fused with laughter, the power of the mimetic faculty as a socially constitutive force is thereby transfered from the older to the younger men, the duped

becomes one with the dupers, and what Bridges refers to as "the great secret" fortifies Gusinde's "invisible state."

In both instances, male and female, imagined worlds become not only theatricalized but factualized as religious axiom and social custom. Illusions thus serve the cause of belief, if not truth, thanks to the magical series of transfers between theater and reality held in place by mimetic art and the public secret. Mimesis sutures the real to the really made up—and no society exists otherwise.

Men become not only skilled in mimesis in the sense of simulating Others, which is what impressed Darwin, but become impressed by the power of mimesis to access the sacred and therewith control women's potentially greater power to mime. As simulators, with the forced connivance of women, they reproduce the invisible state in a process wherein acting recreates the authentic. In this vast scheme, women, however, become skilled in the use of the mimetic faculty in a totally different way—with the power not to simulate an Other but instead to dissimulate, to pretend to believe in the Other's simulation . . .

Colonial Violence: The Organization of Mimesis, the Final Solution

It is thought that the country of Tierra del Fuego would prove suitable for cattle breeding, but the only drawback to this plan is that to all appearance it would be necessary to exterminate the Fuegians.

—*The Daily News*, London 1882

Those who today attack private property in that territory are not the Onas [Selk'nam] but the white Indians, the savages from the big cities.

—Julio Popper, 1892, said to be one of the most formidable killers of Indians in Tierra del Fuego in the late nineteenth century.

To read Gusinde on the late nineteenth-century extermination of the indigenous peoples of Tierra del Fuego (from which these passages are quoted),[15] is to be flung into horror. As in so many other places in the Americas, north and south, at the same time, it is too familiar, yet beyond belief. You feel you are reading some primer on colonial brutal-

ity, the Ur-event of civilization and modern State consolidation, face
to face with "savagery"—the savagery imputed to the Other, then
mimicked on the body of that Other. The Selk'nam were presented
from the beginning, notes Gusinde, as "phantoms that threatened
European intrusion," and then declared to be "dangerous obstacles to
settlement." (143) The serious exterminating began with the discovery
of gold in 1878, and acquired a thoroughgoing character with the
setting-up of sheep ranches by whites shortly thereafter. The ranches
spread over the lands used by the Indians, who retaliated by killing
sheep for food, and a spiral of violence between these unequal forces
rapidly developed. Paid hunters were encouraged to wipe out the Indi-
ans. Gusinde says they were offered the same price for a pair of Indian
ears as the going rate for a puma—one pound sterling. A pregnant
woman's ears together with those of the fetus extracted from her womb
paid more. Gusinde knew persons who made money shipping Indian
skulls to a European museum. Mastiffs were imported from Europe to
hunt down Indians; slain sheep were poisoned with strychnine in the
hope that the Indians would eat them; and Indian children were innocu-
lated with fatal diseases (141-47)

Gusinde lists seven names given the whites by the Selk'nam at the
time of his fieldwork between 1918 and 1924. Two of them refer to
the whites' deployment of mimicry in genocide. One meant literally
"clumps of earth with roots extracted from black swampy water."
This refered to the fact that from the Indians' perspective the whites
always moved in a compact, massed, group, usually dressed in dark
clothing so that they were camouflaged. (No scarlet cloth here, my
friend!). The second name for the whites meant something like helmet
of earth/hairy leather hide, clumped earth with grass. In order to
frighten and intimidate the Indians, the hunters made simulacra of
cavalry, mounting on horseback humanlike figures made from earth
and grass or from hides. Hence this term for whites: "figures of earth
covered with hairy hides." (154) Could Horkheimer and Adorno have
found a better example of the channeling of the mimetic faculty by "civili-
zation" so as to simulate an imagined savagery in order to dominate or
destroy it? Could they have found a more frightening appellation for
civilization, disguised—"figures of earth covered with hairy hides"?

7

SPIRIT OF THE MIME, SPIRIT OF THE GIFT

Together with fire and smoke, the Fuegians wildness was manifested time and again by their hideous cries abruptly announcing their presence, incessantly demanding white man's stuff. If it is the visual sense and the precise vocal articulation of language that is tracked by Darwin's scheme of representation when he discusses mimicry, it is very much sonorous sound, hollow, noisy, human sound, that is tracked when presenting trade and barter. In his first paragraph concerning Tierra del Fuego, the *Beagle* entering the bay of Good Success, Darwin in his *Journal* registers the sonic as a principal scenic element:

> While entering we were saluted in a manner becoming the inhabitants of this savage land. A group of Fuegians partly concealed by the entangled forest, were perched on a wild point overhanging the sea; and as we passed by, they sprang up and waving their tattered cloaks sent forth a loud and sonorous shout. The savages followed the ship and just before dark we saw their fire and heard their wild cry.[1]

A month later, at Ponsonby Sound from where Jemmy Button hailed, the *Beagle's* boats were again greeted with fire and cries. It was as if in the form of sound, wildness itself erupted from its autochthonous lair:

> Fires were lighted on every point (hence the name of Tierra del Fuego, or the land of fire), both to attract our attention and to spread far and wide the news. Some of the men ran for miles along the shore. I shall never

forget how wild and savage one group appeared: suddenly four or five men came to the edge of an overhanging cliff; they were absolutely naked, and their long hair streamed around their faces; they held rugged staffs in their hands, and, springing from the ground, they waved their arms around their heads, and sent forth the most hideous yells. (218)

Captain Fitz Roy, also described this event in terms of sound and fire. Remarkably so:

Scarcely had we stowed the boats and embarked, before canoes began to appear in every direction, in each of which was a stentor hailing us at the top of his voice. Faint sounds of deep voices were heard in the distance, and around us echoes to the shouts of our nearer friends began to reverberate, and warned me to hasten away before our movements should become impeded.[2]

It was an impressive scene, a veritable stage framing the sound. The captain continues:

As we steered out of the cove in which our boats had been sheltered, a striking scene opened: beyond a lake-like expanse of deep blue water, mountains rose abruptly to a great height, and on their icy summits the sun's early rays glittered as if on a mirror. Immediately round us were mountain eminences, and dark cliffy precipices which cast a very deep shadow over the still water beneath them. (106)

When they saw the boats, the Fuegians came in canoes from all directions. "Hoarse shouts arose, and echoed about by the cliffs, seemed to be a continual cheer." Soon there were close to forty canoes, each with a column of blue smoke rising from the fire they contained, "and almost all the men in them shouting at the full power of their deep sonorous voices." (106-107) It appeared like a dream, noted the captain, pleased with the wind, which, filling every sail, allowed him to outpace those fiery, noisy, canoes.

When the scarlet cloth was unfurled, the sound nevertheless continued, its wildness taking on a different tone. "While in the boats I got to hate the very sound of their voices, so much trouble did they give us," Darwin writes in his *Journal*:

The first and last word was "yammerschooner." When entering some quiet little cove, we have looked around and thought to pass a quiet night, the odious word "yammerschooner" has shrilly sounded from some gloomy nook, and then the little signal-smoke has curled up to spread the news far and wide. On leaving some place we have said to each other, 'Thank Heaven, we have at last fairly left these wretches!' when one more faint halloo from an all-powerful voice, heard at a prodigious distance, would reach our ears, and clearly could we distinguish—"yammerschooner." (227)

Yammerschoonering, he said, meant "Give me!"—but it is obvious from the record that "give me" was a complex composite that did not fall neatly into British political economy, formal or informal. A composite of trade and gift, sometimes to be reciprocated, at other times not, it was all interwoven with a terrible insistence that the sailors came to define as outright theft—as notably suffered by poor Mathews the missionary no less than by the plump and London-tailored Fuegian Jemmy Button as soon as he was returned to his people, who stripped him clean as a whistle, and after a short while leaving him as thin as one. Captain Fitz Roy relates in his *Journal* that he saw one Fuegian talking to Jemmy Button while another picked his pocket of a knife. Yet from the woman, Fuegia Basket, nothing was taken. (111)

Again and again this refrain of Fuegian noise, Fuegian demanding, Fuegian stealing—and perfect Fuegian equality. The beleaguered missionary lost almost everything that he hadn't hidden underground, noted Darwin in the *Journal*, and every article taken by the Fuegians, he continued:

> ... seemed to have been torn up and divided by the natives. Mathews described the watch he was obliged always to keep as most harrasing; night and day he was surrounded by the natives, who tried to tire him out by making an incessant noise close to his head. (225)

"They would point to almost every object of the sailors, one after the other, even the buttons on the coats," Darwin remarks, "saying their favorite word in as many intonations as possible." It seemed as if it was the sound of the air itself, a savage melody "vacantly repeated."

Yammerschooner. The word hangs strangely on the English ear as we hear it through Darwin's sounding it out, the same way we might try to translate a sound of nature, the sea rolling, the waves crashing, the wind shrieking alongside the glaciers and the still water beneath them. Yammerschooner!

But not everything European caught their savage eye, and Darwin found wonder in this. The whiteness of the sailor's skins surprised the Fuegians, and even more so the blackness of the negro cook of a sealing ship. "Simple circumstances," Darwin said, and the term is revealing, "such as the beauty of scarlet cloth or blue beads, the absence of women, our care in washing ourselves,—excited their admiration far more than any grand or complicated object, such as our ship."[3] (228)

Mutual Aid, Theft, and Booty

Based on his fieldwork between 1918-1924, Martin Gusinde spends many pages wrestling with the difficulties that Fuegian exchange presents European political economy. Meticulous in their observation of mine and thine, and in the severe condemnation of theft, the Fuegians were scrupulous in sharing and in the practice of mutual aid no less than of a constant give-and-take of gift-giving among themselves. In addition to the exchange that occurred locally, Gusinde made the point that a visitor from near or far always brought something to give away, usually fresh meat or a beautiful skin. Then the recipient had to supply a return gift as soon as possible, the gift being given and received without a word—he noted—and without meaningful gestures expressing one's feelings. "It is one of the inescapable obligations," he reiterated, "of every Yamana to come now and then with a gift for someone." Attaching considerable importance to the fact that the Yamana language has scarcely any terms for asking for gifts, but many for expecting them (Darwin's 'yammerschooner'?), Gusinde observes that "great generosity and unselfishness are conspicuous basic features of the character of the Yamana." Echoing themes that later acquired mighty resonance through Malinowski's description of "primitive economics" in the Trobriands, no less than in Mauss's classic work *The Gift* and

Bataille's *The Accursed Share*, Gusinde says that some Fuegians took particular pleasure in lavishly remembering neighbors with the yields from hunting and gathering—that the "natives especially enjoy ownership in order to have the right to distribute what they have for the pleasure of being generous."[4] Much more could be said on these important topics, but perhaps enough of an idea has been expressed so that the depth of the incongruities brought into play by the arrival of the *Beagle* into this "system" of exchange can be appreciated. Of course the phraseology here is a little pedestrian. "System of exchange" sounds like something out of a car gear-box manual. At stake, however, are the greatest human passions, the very nature of being a person, and the strange intimacies that giving establishes between things and personhood.

Not wanting to identify HMS *Beagle* and its crew with an animal of prey, let alone a beached whale, my imagination is nevertheless stimulated by the following picture provided by Gusinde with regard to booty when customary territorial boundaries of hunting are opened to all to share:

> Anyone within the widest radius who learns of the stranding of a whale may head towards the spot unmolested and remains until all the suitable parts are consumed or distributed . . . Alerted by dense flocks of sea birds, the Indians come pouring in to the stranded whale, even from some distance, and they all enjoy the excellent taste of the blubber. No one would dare rebuff a visiting stranger nor hinder him; if one were to do so, he would be loudly decried as a selfish human being.[5]

The Spirit of the Gift, the Spirit of the Mime

They are excellent mimics: as often as we coughed or yawned, or made any odd motion, they immediately imitated us.
—Charles Darwin, *Journal of Researches*

In short these Fuegians, mighty mimics of British sailors and their sea-chanties, of their dances, face-pullings, and of their very language, "asked for everything they saw, and stole what they could," meticu-

lously dividing the item so that "no one individual becomes richer than another." They were insatiable. "It was as easy to please as it was difficult to satisfy these savages," wrote Darwin in the *Journal*, taken by that "odd mixture of surprise and imitation which these savages every moment exhibited" face to face with the *Beagle's* crew. (218-19) With every surprise, an imitation—with every sailor's good that catches the eye, a yammerschoonering! Mimicry and yammerschoonering seem intimately connected. You can trade fish for a knife, or steal a button, but you can't so easily trade a language or steal a squint or a strange motion. But what you can do is imitate them if you want to or have to—if they're surprising, that is. Put another way, you can imitate a sailor pulling faces, but you can't so easily or convincingly imitate his buttons or knife of steel. In either event there is a way in which imitating and trading, as much as imitating and stealing, amount to the same system of gift exchange (so neatly depicted by Darwin and Fitz Roy with regard to the veritable competitions of mimicry between British sailors and Fuegian men). In contemplating the analogy and the historical fact that here establishes a connection between consumately skillfull miming, on the one hand, and the practice of that peculiar noncapitalist economics of exchange which Marcel Mauss called "the spirit of the gift," on the other, are we not justified in assuming that there is more to this than analogy—that there is indeed an intimate bond between the spirit of the gift and the spirit of the mime, whose fullest flowering requires exactly the sort of "perfect equality among individuals" that Darwin bemoaned as the Fuegian obstacle to "improvement?"

Scarlet Cloth

Having given them some red cloth, which they immediately placed around their necks, we became good friends. This was shown by an old man patting our breasts & making something like the same noise people do when feeding chickens.
—Charles Darwin, *Diary of the Voyage of HMS "Beagle"*

Before saying farewell to the Land of Fire, to Jemmy Button left desolate on the cruel shore lighting a signal fire, the smoke curling

skyward as the *Beagle* stood out to sea, there is one more curious association to bear in mind concerning the mimetic faculty, a colorful association suggestive of profound links between mimetic facility on the one hand, and nonmarket forms of exchange and the absence of chiefs, on the other. This can be illustrated by returning to the fiery scarlet cloth and the tricky business of Europeans exchanging gifts and entering into trade with Fuegians, having to figure anew what used to seem pretty straightforward distinctions between gift, trade, and stealing.

For this scarlet cloth is no less puzzling than valuable. First we note its success as a gift, as in the diary-entry I have just requoted, reporting its spectacular success, sufficient to cause the old Fuegian man to pat the sailors' breasts and chuckle like a chicken. A month later the sailors landed among Jemmy Button's people, few of whom, wrote Darwin, could ever have seen a white man. The Fuegians were at first not inclined to be friendly. They kept their slings at the ready, but "we soon, however, delighted them by trifling presents, such as tying red tape around their heads." (218) Yet, as we shall see, things are not so simple. Violence or the threat of violence seems displaced into rather than overcome by the gift and, as I read the record of these encounters of sailors and Fuegians, I feel a deepening confusion (just as I did when studying the violent incursions of the late nineteenth-century rubber traders into the Putumayo region of the Upper Amazon) as to where gifts stop and trade begins, it being obvious that objects here take on the burden of negotiating between might and right. Of course this is Mauss' great point in his essay on the gift—that the "gift" composes an impossible marriage between self-interest and altruism, between calculated giving and spontaneous generosity. Take Darwin's account of the following joyous exchanges, with each party delighted at the other's delight, the other's silliness:

> Both parties laughing, wondering, gaping at each other; we pitying them, for giving us good fish and crabs for rags, etc.,; they grasping at the chance of finding people so foolish as to exchange such splendid ornaments for a good supper. It was most amusing to see the undisguised smile of satisfaction with which one young woman with her face painted black, tied several bits of scarlet cloth round her head with rushes. (227)

That was 1832, by which time the European bourgeoisie, male versions, unlike the aristocracy and Middle Ages of times past, were deeply invested in grey to a degree that brilliant colors such as red took on a wild, primitive, not to mention even a revolutionary hue— obviously the perfect gift for Fuegians (whom, we are later told, had the practice of daubing their naked bodies with black, white, and red). But from the beginning of European discovery and conquest, redness itself, first from a species of tree in India, called *Brasilium* on account of its fieriness, and later from Bahia (in what came to be called Brasil), and from Central and South America, fetched enormous prices in Europe into the eighteenth century. Indeed, after gold and silver and perhaps slaves, the commodity that seems to have most interested the bucaneers of the Spanish Main, those same sailor-buccaneers with whom the Cuna Indians allied themselves in the famous Darién peninsula in the seventeenth century, was red dyewood.[6]

But then how curious, how absurdly convenient, that the Fuegians valued scarlet so strongly! (And the list of peoples similarly implicated seems endless, across the great Pacific, island by island, into Australia . . .) Martin Gusinde assures us from his work in the Land of Fire in the early twentieth century that red face- and body-paint was the most highly esteemed color there. He notes an "emotional preference for bright scarlet," and that the "Indians are almost superstitiously exact in their preparation of this red pigment, for they are extraordinarily appreciative of its glowing brightness which neither dirt nor ashes impairs," and he cites late nineteenth-century ethnography affirming that "red is the emblem of friendship and joy."[7] In her study of the Selk'nam, Anne Chapman tells us that red, associated with the setting sun, "is considered to be particularly beautiful and pleasing to the spirits."[8]

Triggering endless sentient reciprocations, the sailors' welcome gift of scarlet cloth to the Fuegians thus represents not merely a profound irony—making a gift of what was in a sense a return, reissuing the exotic to the exotic from third to first, then First to Third world—but is in itself symbolic of the elusive pattern of mimesis and alterity undescoring colonialism that we have had ample opportunity to witness above. And as gift, initiating problematic distinctions and bewil-

dering cross connections between gift, theft, and trade—preeminently problems of establishing a frontier, let alone a capitalist frontier—the scarlet cloth can reveal to us subtle economic and exchange relations embedded in the mimetic faculty, beginning with certain features of property and authority.

For if, in the adamantly colonial drama of First Contact, it is their very primitiveness which makes the Fuegians such great mimics, then Darwin is also at pains to elaborate that this barely human condition is consequent to their having no chiefs and no sense of property in anything remotely approaching bourgeois understandings of this term. Thus deprived of chiefs and property the Fuegians are constitutionally incapable of what Darwin called "improvement." It is the "perfect equality among individuals composing the Fuegian tribes" that retards their society, and "until some chief shall arise," he writes as conclusion to the Fuegian section of his *Journal*:

> ... with power sufficient to secure any acquired advantage, such as domesticated animals, it seems scarely possible that the political state of the country can be improved. At present, even a piece of cloth given to one is torn into shreds and distributed; and no one individual becomes richer than another. On the other hand, it is difficult to understand how a chief can arise till there is property of some sort by which he might make manifest his superiority and increase his power. (229-30)

And not only did the Fuegians steal from the miserable missionary Mathews whom Captain Fitz Roy left behind to fend for himself, but every article thus stolen was torn up and divided by the natives. "The perfect equality of all the inhabitants," Darwin wrote in his *Diary*, "will for many years prevent their civilization, even a shirt or other article of clothing is immediately torn to pieces."(136)

Foolhardy as it is to speculate what it might be about the absence of chiefs and property, capital and the State, that would enhance the mimetic faculty—the terms are overly generous—I cannot resist specu-

lating that what enhances the mimetic faculty is a protean self with multiple images (read "souls") of itself set in a natural environment whose animals, plants, and elements are spiritualized to the point that nature "speaks back" to humans, every material entity paired with an occasionally visible spirit-double—a mimetic double!—of itself. Now as against that profoundly mimeticized world (about which much more later), think of another, different, picture drawn by the Romantic reaction to Western capitalism, illustrating what happens with the "disenchantment of the world," with the scuttling of the spirits, as I described earlier, into the Emberá forests of the Darién as the flames leap around the idols drenched in gasoline. Unlike the mimeticized world, this disenchanted one is home to a self-enclosed and somewhat paranoid, possessive, individualized sense of self severed from and dominant over a dead and nonspiritualized nature, a self built antimimetically on the notion of work as an instrumental relation to the world within a system wherein that self ideally incorporates into itself wealth, property, citizenship, and of course "sense-data," all necessarily quantifiable so as to pass muster at the gates of new definitions of Truth as Accountability. This latter feature especially might spell trouble for the mimetic faculty—accumulating sensation as private property and hence, like all commodities, incomplete without its necessary dose of abstraction that allows of general equivalence.

One way of thinking of Walter Benjamin's notion of sentience taking us outside of ourselves is to see it as adamantly opposed to this incorporative notion of sensing as personal appropriation, investing sense-data in the bank of the Self. Eccentrically object-bound, Benjamin sees surreptitious forces at work within modern capitalism whereby the scarlet of the scarlet cloth is what the perceiver enters into, rather than incorporating it into the self through the keyhole of the safe-deposit box of the eye. Assuming a nature that talks, and talks back, Benjamin is one of those primitive "animists," (albeit radically malpositioned) of which, in its beginnings with E.B. Tylor, British anthropology made so much. His task as modern critic, as a Marxist critic in fact, is to give human voice to that talk.[9]

It is as if he ingenuously applies the young Marx who, with gusto in the chapter "Private Property and Communism" in his Paris manu-

scripts of 1844 (twelve years after Darwin presented the Fuegians with scarlet cloth), saw the senses themselves as historically dependent and asserted that human perception correlated in some significant manner with the society's dominant mode of economic production, contrasting perception under capitalism with what he wildly imagined would be the case under communism. Private property, he argued "has made us so stupid and one-sided that an object is only ours when we have it— when it exists for us as capital, or when it is directly possessed, eaten, drunk, worn inhabited, etc.," such that the senses are *estranged* by having.[10] But all this sense-banking epistemology will be changed with the transcendance of private property, which will achieve:

> . . . the complete *emancipation* of all human senses and qualities, but it is this emancipation precisely because these senses and attributes have become, subjectively and objectively, *human*. The eye has become a *human* eye, just as its *object* has become a social, *human* object—an object made by man for man. The *senses* have therefore become directly in their practise *theoreticians*.[11]

Might not the mimetic faculty and the sensuous knowledge it embodies be precisely this hard-to-imagine state wherein "*the senses therefore become directly in their practise theoreticians*"[12]—and I wish to suggest that there is something crucially Fuegian, crucially "primitive" and antithetical to "possessive individualism" necessary for this degree of sensuousity and mimetic deftness to exist.

Marx can be taken further still, where in the same passage he goes on to assert, "The senses relate themselves to the *thing* for the sake of the thing, but the thing itself [under his ideal of communism] is an objective human relation to itself and to man, and vice versa." By way of clarification he adds, "In practice I can relate myself to a thing humanly only if the thing relates itself humanly to the human being." On the face of it, this is no less animistic than Benjamin or late nineteenth-century British anthropology's primitives. In an imagined society of perfect communism, where private property (along with the State) ceases to exist, property relations ensure human agency to things as social, as human, objects!

This has a significant implication for 'fetishism' as Marx used that

term in *Capital* to refer to the cultural attribution of a spiritual, even godlike, quality to commodities, objects bought and sold on the market standing over their very producers. He could just as well have used the term 'animism.' Under capitalism the animate quality of objects is a result of the radical estrangement of the economy from the person; no longer is man the aim of production, but production is the aim of man, and wealth-getting the aim of production. (No sharing, let alone tearing up of shirts here, my friend! No falling for that cheap old scarlet cloth, either, by Jove!) *Post*-capitalist animism means that although the socioeconomic exploitative function of fetishism, as Marx used that term in *Capital*, will supposedly disappear with the overcoming of capitalism, fetishism as an active social force inherent in objects will remain. Indeed it must not disappear, for it is the animate quality of things in post-capitalist society without the "banking" mode of perception that ensures what the young Marx envisaged as the human-ization of the world.

We are left to ponder two fascinating problems. How is the notion of a "rebirth" of the mimetic faculty with the Modernity of advanced Capitalism to be understood in terms of these different forms of fetish-ism? Second, insofar as "the gift economy" entails and perhaps depends upon mimetic facility, should we not be investigating this facility as a privileged component of post-capitalist utopias organized around the playful exchange of difference, weak chiefs, sharing, and what we may dare designate as a "human," perhaps "yielding" relation to nature?

8

Mimetic Worlds, Invisible Counterparts

So, what's it like to live in the world we have lost, a mimetic world when things had spirit-copies, and nature could thus look back and speak to one through dreams and omens, nature not being something to be dominated but something yielded to or magically out-performed, and people—like Darwin's Fuegians—were "born mimics"? To ask this rhetorical, even mischievous, question, redolent in its self-assuredness with utopian longing for a theory of iconic meaning soaked in correspondences bound to impulses surging through chains of sympathy, is to enter another body of knowledge, another bodily knowing. Let us begin with the soul.

The Soul As Theater of the World

It's the soul that plunges us into the heart of the mimetic world. In notes made in the early 1930s on Cuna notions of *purba*, which he hesitantly translated as "soul," Baron Nordenskiold tried to sum it up as being a mimetic double—an "invisible replica" he called it, of one's body. With his customary diffidence he emphasised his trepidation at translating metaphysically loaded notions such as the soul, and his posthumously published, fragmented, and in many ways jointly authored text always particularized context and always embodied cultural facticity—not so much what "the Cuna" believe, but what Rubén Pérez said to him about the matter in hand. Thus:

In this way one evidently can say, if one sums all ideas I have gotten from Pérez and from the songs and incantations collected by him, that everything, people, animals, plants, stone, things made by man etc., have invisible counterparts which we sometimes can see in dreams and which leave the body or at least for the most part leave it when it dies.[1]

So strange, this use of "we." It's as if through words "we" are being picked up, carried, and put down into the Cuna world, somewhat like their souls. And he goes on to say that even when awake we can sometimes feel the manifestations of "this invisible world, as in the warmth of the sun, in the noises of the thunder, in music etc. . . ." (How Vico would have loved this confirmation of the poetry of the ancients!)

Less diffident than the baron, whom he follows by some fifty years into the mimetic worlds of the Cunas, former U.S. Peacecorpsman Norman Chapin writes:

The world as it exists today has a dual nature: it is composed of what is termed 'the world of spirit' (*nek purpalet*) and 'the world of substance' (*nek sanalet*). The world of spirit is invisible to a person's waking senses, yet surrounds that person on all sides and resides inside every material object. Human beings, plants, animals, rocks, rivers, villages, and so forth all have invisible *purpakana* ('souls') which are spiritual copies of the physical body.[2]

The *purpa* or "soul" of a human being, he points out, is "in its general form and appearance, a representation of the body in which it lives. The purpa of a man with one leg, for example, also has only one leg." (75-76) With regard to the word purpa, in its meaning of 'soul' or spiritual counterpart of everything that exists, he writes, "The Cuna believe that all plants, rocks, animals, rivers, humans, houses, villages, etc., etc., have *purpakana* [pl.], which are spiritual 'doubles' of their material forms."[4] (565-66)

In considering the implications of this world of copies, it is startling and wonderful to come across other meanings of this word 'purpa,' soul or spirit; it also means menstrual blood (red purpa), semen (white purpa), shadow, photograph (face purpa), and speech (mouth purpa).

It is also the term used for the Cuna Origin Histories of important spirits—short orations in which the spirit is told how it was born and acts, thereby allowing the orator to control it. (566) To further fascinate matters, note that purpa also means what Chapin refers to as "the deep meaning" of the symbolism of curing chants, the understanding of disease causation, and the workings of the spirit world. The chants in themselves are not purpa, says Chapin. Knowledge of what they mean is purpa. (566) Hence, purpa "means":

> soul
> spirit
> menstrual blood
> semen
> shadow
> photograph
> speech
> Origin Histories
> deep meaning of curing chants

An intriguing insight into this synonymity comes from comparing a Cuna text on healing with its "clarified" rendering. The original Cuna text was provided by the Cuna Indian Mr. Charles Slater (on whom more below) in English. The "clarified" version was prepared by Baron Nordenskiold and the Cuna Indian Rubén Pérez.[3] It is intriguing that every time Mr. Slater used the term "image," the so-called clarified version replaces it with "soul" or "spirit." When Slater refers to the curing figurines, the *nuchus*, as "images," then the clarified replacement is simply "figures," as in figurines. He writes:

> Anywhere we want to go for *image* we can go. If I want to go far up in the blue sea I can go there for *image* and I can go under there too (emphasis added).[4]

Whereas in the "clarified" text:

> Wherever we want to go with the *spirits'* help we can go. If I want to go far out on the blue ocean I can do it with the help of *spirits* and I can also go down in the sea (emphasis added).[5]

Thus "clarification" parallels magical mimesis: from the (mere) image of a thing comes its soul and spirit. And what a comment on the implicitly sacred nature of image-making!

The Whole World

Reading these depictions of mimetic worlds, I cannot but wonder at the lack of wonder expressed by the anthropologists' depicting. It was one thing for Frazer to point to the ritualist making a likeness of this or that person, of this or that event, by means of figurine, paint, or spell; it is something altogether too grand to contemplate that the entire known world could be copied in this way. Thus construed on the principle of self-mimicry, this world becomes power-packed, too. "The world of spirit underlies the world of substance, resides inside it, and provides it with its vital force," says Chapin, and as we shall see, this is the force that, in strings of images, has to be tapped by the readers of dreams and the curers of disease. This strange world of reality-copy "extends out in all directions," Chapin tells us, through a series of eight levels labeled 'level one,' 'level two,' and so on." (77) Yet it is also modeled after nature, following the topography of the land. (88) And just as physical bodies, people, animals, and the land itself are mimicked in this way—or is it the other way around; which comes first, spirit or substance, original or copy?—so it follows that basic Cuna social relations themselves are replicated—chiefship, marriage rule, matrilocality, house-forms, households, and major life-ceremonies. "In short," concludes Chapin, "the spirits, both good and evil, live more or less as the Cuna live, and the basic model for the spirit world comes from the conception Cunas have of their own society." (98) Jean Langdon describes a similar mimetic geography of spirit and matter in her study of the culture of the Siona of Buena Vista, living downstream from Puerto Asís on the Putumayo River, an affluent of the Upper Amazon in the southwest of Colombia. She lived with them as an anthropologist in the early 1970s, and describes her conception of the Siona cosmos as one in which the earthly realm is but one of many making up the Siona universe. "Each different realm is a replica

of the others. They are all populated by people, domestic animals, cultivated fields, and other objects found in this world." In a sense these other realms form, she says, "an alter reality of this [earthly] realm"; it is as if "behind all objects, animals, and places in the concrete world there is a supernatural force that is the creative life source of the object."[6] This indicates that spirit is superior to and causal of the concrete/manifestation. From her work and from Cuna ethnography, as well as from mine in the Putumayo foothills, there certainly seems to be anxiety, even paranoia, about the spirit realms, the realm from which sickness and disaster can arise; and in this sense too the spirits' realms could be said to weigh over the earthly realm.

Conversing with Animals

Rubén Pérez informs us that the Great Seer, or *nele*, received visits from the wild animals of the forest. He would go into a partitioned hut, sit down and, bending his thoughts to the origin of the animals, would sing. There were other conversations with animals as well:

> An old man has told Pérez that once he assisted *nele* Iguasali on Río Perro in making a fire for fumigation with tobacco. Then a jaguar, snarling, came along and went right through the house into the *surba* [partitioned area] where the *nele* was sitting. All those who were present saw the jaguar and understood that it was not a spirit but a real jaguar. After the jaguar came some peccaries. These approached only as far as the outside of the house. Some dogs barked, and the peccaries went away again. The old man had told Pérez that at first he did not believe that *neles* in this way were able to call up the larger animals, but this time he had seen it himself and knew it was true. In the same way there were *neles* who received visits from caymans.[7]

And just before he left to join the baron at the Anthropology Museum in Sweden, Rubén Pérez had heard that someone was going to sing about the origin of the peccaries so as to entice herds of them to the coast.

These animal-conjurings suggest to me that singing origins is not

done so much to gain control over the object of the Origin-History song, but first and foremost to create that object through its soulful *evocation*—the jaguar, for instance, or the peccaries—such that "calling them up" is to conjure with their image, hence their soul, and hence give birth to the real. I am suggesting, in other words, that the chanter is singing a copy of the spirit-form, and by virtue of what I call the magic of mimesis, is bringing the spirit into the physical world.

Miming the Real Into Being

This brings us to reconsider the *modus operandi* of Cuna medical chants, those sung over the sick as well as those sung over medicines, the first remarkable point being that through detailed description, power is gained over the thing described. In the detailed description of Joel Sherzer:

> A detailed and exact description of an object, including representations of its spirit language in conversational form and its daily round of activities, demonstrates to it (really to its spirit) that the performer of the *ikar* [chant] has intimate knowledge of it and can control it.

As if this is not enough to stop you in your tracks:

> The subsequent narration of actions and events, adressed to the spirit world, causes their simultaneous occurrence in the mirror image physical world.[8]

Was ever Frazer's mimetic magic better expressed—except that the simulacrum here is created with words, not objects! In fact two mimetic movements are involved. One is the duplication in song of the spirits, detail by slow-moving detail, in songs that can last up to several hours. The other mimetic movement depends upon this invocation of the spirits because, since they duplicate the physical world, then to bring them forth by means of song is to mimetically gain control over the mirror-image of physical reality that they represent.

The spirits find pleasure in being told about themselves in a detailed

and poetic way. As Chapin puts it, speaking (as a common style of anthropological representation dictates) for *all* Cuna:

> Two skills are given particularly high value among Kuna ritual specialists: a thorough knowledge of the features of the spirit world, and an ability to articulate this knowledge in a coherent, comprehensive, and pleasing manner. The Kuna believe that in order to control the course of events in the world of spirit—and, consequently, in the world of substance—one must be able to tell the spirits about themselves. A specialist must demonstrate to the spirits that he knows who they are, how they came into being, what their physical and behavioral characteristics are, where they live, and what their names are. (189-90)

Note here that the "specialist" must *demonstrate*. But stop for a moment and ask yourself what it means to "demonstrate" and how does one do it? We are forcefully reminded, on account of the hope if not the reality of magical efficacy, that far from being "mere" revelation or passive copying, demonstration here has to transform reality. "You are being changed, you are becoming medicines." The verses are redolent with this strange sense of continuous becoming as the "description"—i.e. the copy—engages with the thing being described so as to bring out its spirit.

What is more, the chanter chants himself into the scene. He exists not just as a subject but also as a mimeticised Other. In this way, as both chanter and person chanted about, as demonstrator and demonstrated, he creates the bridge between original and copy that brings a new force, the third force of magical power, to intervene in the human world. The spirits of plants are generally female and the medicine-man, Chapin tells us, will try to make himself attractive to them by first bathing in sweet-smelling plants, painting his face, and wearing a special necklace. When he gets to the place where the plant or tree is growing, he stands for a few moments and chants—and it is instructive to compare the summary Chapin gives us with the actual chant because such summarizing action *demonstrates* just how radical is the difference between these two modes of representation—the concise, abstracting, mode of academic and technical discourse, as compared with the forever branching, slow-paced chant darting hither and thither in

an almost random fashion from detail to detail—a spreading network of clots of detail instead of an axial logic of main trunk with branches and "filler." Compare these two forms. First, the ethnologist Chapin's description of what the medicine man is doing, chanting before the plants:

> . . . telling the spirits of the plants how the Great Father placed them on the earth, how they grow, what their properties are, how they will be gathered and taken back to the community, and how they are expected to function as medicines to aid the patient.

And here are some "verses" from the chant itself:

> Long ago, Great Father stood your trunks upright, they all had good appearance, he did not leave any of the valleys empty.
>
> The medicine man begins to counsel your silver bark, your silver bark's *purpa* is coming to life; medicines you are being changed, you are becoming medicines . . .
>
> Long ago Great Father counselled your *purpa* for you, long ago Great Father brought your *purpa* to life for you, he stood your trunks in the bottoms of the valleys . . .
>
> The medicine man, on the side (of the tree) where the day rises (east), is gathering your silver bark . . . on the far side of the day (west) . . . out to sea (north) . . . to the side opposite the sea (south) . . . he begins to cut your silver bark, he is cutting your silver bark, he is gathering your silver bark . . .
>
> In the small basket he is placing your silver bark, all in pairs, all in pairs . . .
>
> In this way it is hoped that your *purpa* will follow me; with you (the medicine man) turns around to go toward his home, with you toward the house, (his) legs are opening and closing, one leg goes before the other, toward the house. . . . (247-48)

These verses create magical power. The anthropologist's summary mode of presentation is silent on this crucial fact, merely noting that the plants are told "what their properties are," and "how they are

expected to behave as medicines." The strange sense of time, detail heaped on detail, the inclusion of the chanter in the chant—surely all this is of another order of meaning and realization than being told what properties one is to have. For the chant is not so much instructing the spirits as, through the mimetic faculty, bringing them into being:

> The medicine man begins to counsel your silver bark, your silver bark's *purpa* is coming to life; medicines you are being changed, you are becoming medicines.

Lavishness of Description; The Problem of Excess

Time and again the ethnography remarks on the abundance of detail in the chants. Chapin for instance refers to their "lavish description" and emphasises that such excess of description by far outweighs narrative action, even in the long narrative chants. (199) Yet like Sherzer he disposes of the abundance within a functionalist-utilitarian vision that puts emphasis not on the content but on the purported aim, the aim of control. "Only by depicting the spirits and their actions exhaustively," he writes, "do chanters bring the spirit world under control." (202) But surely control can be gained by less baroque, more direct, less abundant, modalities? What is curious is the excessiveness itself. Understanding the singer's task as first and foremost that of having to create a copy, might, to my mind, explain just this stylistic feature. The excess hammers home this copiedness, bringing out the real through the detailing. Then there is Bataille's point—Bataille, our philosopher of excess—that the image follows the release of the sacred and is thus consequence, not cause! And lest one be carried away by excessively grim notions of the sacred, let us recall Bataille's fascination with laughter and how an unnamed Cuna chanter responded to Chapin upon being asked, after chanting six chants about the Great Mother, Muu, "what purpose they served?"

"He replied with an amused chuckle: 'Just play. It makes Muu feel good to hear about these things.' " (198)

The Art of Quotation

Copiedness is redolent in these mimetic worlds. Sherzer draws our attention to the way that repetition, retellings, and quotation form an outstanding set of features, not only in these chants but in everyday Cuna speech as well. Cuna speakers, he affirms, "tend to present facts, opinion, arguments, not as their own but as retellings and reformulations of what others or even they themselves have previously said. Discourse of all kind is heavily embedded with speech that has previously occurred, typically in the form of first person direct quotation" (which is what I myself am doing myself right now). (202) In other words, there is a decisive mimetic componenet built into Cuna speech. Sherzer goes on to state that Cuna "grammar does not readily make a distinction between direct and indirect quotations. The great majority of all quotation is direct—speakers are constantly uttering words that are not their own [and] it becomes very difficult," he notes in connection with Cuna chanting, "at each moment of the narration to decode exactly who is speaking." (202-203) This difficulty holds for outside analysts (such as himself) as well as for native members of the community. He quotes a chant in which the chanter is quoting his teacher who is quoting a mythical hero who is quoting a Chocó Indian who is quoting a chief in the spirit world who is quoting God. (And I am quoting him quoting this chanter who . . .). We are constantly made aware of the constantly mimetic sensibility of Cuna speech, of Cuna Being; that Cuna speech is always one or more steps, to quote Sherzer, "removed from the actual speaker and that what one is listening to at a given moment is always a retelling, a rehearing, a reviewing, or a reinterpretation of something said before." (210) These words deserve retelling themselves. With what nonchalance they estrange, making the new old, the oft-said new, undermining mimesis itself, creating (as Benjamin would have it, in his addiction to quoting) new forms through

doubling mimetic doubling such that, as Sherzer points out, "retellings blend into interpretations." (205)

A Slow-Moving Film: Death of the Author

For all the claims as to lavishness and exhaustiveness of description, is it not also the case that there is a lot of selecting and jumping around, a lot of leaving out? Take the movement as described in the medicine-gathering chant of the medicine man returning home. He is addressing a particular plant (spirit), saying it is hoped that its soul will follow him home. All this is being sung. Then the medicine man:

> . . . turns around to go toward his home, with you toward the house, (his) legs are opening and closing, one leg goes before the other, toward the house.

So, in what sense is this *exhaustive* description? Its completeness lies rather in a signaled movement, a scissorslike figure chopping up as much as it intimates a whole; in short a montaged unit in action—which brings us to the cinematic analogy advanced by Claude Lévi-Strauss who, in trying to assimilate a Cuna chant to his Structuralism, noted in an aside that the chant is like a film in slow motion.[9] Chapin also devised a useful analogy; he compares the chants to scripts in which the events being depicted take place simultaneously in the spirit world. He compares the chanter to a director of a complex and danger-ous drama that unfolds at the level of spirit at the same time as the chanter intones his chant.

Yet for all the make-believe suggested by analogies with (slow-moving) film and theater (whose authors unfortunately leave it unspeci-fied as to what sort of film and what sort of theater they might have in mind), there is one notable difference: the chants' images are so real that they can, so it is said, kill those who mouth them into life. This puts make-believe in a new light. "Any failure on the part of the chanter as he directs his spirit helpers on their quest," writes Chapin, results in their destruction. (337-38) He cites the case of a man who tried to

learn the chant for obstructed birth, the Muu-Igala or "Way of Muu" when he was too young, it being said that only a grandfather can learn this major chant. He was overcome by Muu, the great mother, vomited blood, and died shortly thereafter. (123-24) On the other hand, if one is too old, one's spiritual power diminishes. An old chanter runs the risk of being attacked by demons he is trying to control. Then again, if the spirit helpers embodied by the wooden figurines are trapped by other spirits, the chanter can die because (at least in the major chants) his spirit accompanies the spirit-helpers his singing has brought out from the figurines. The very ascension to spiritual insight makes on vulnerable—a sign of what it takes to enter the interzone of mimetic space.

The chanter chanting creates and occupies a strange position, inside and outside, part of, yet also observer of the scenes being sung into being. This is not to be confused with liminality because it is both positions at one and the same time. Embodying the doubling necessary for magical mimesis, the chanter runs the risk of self-annihilation. But what pleasure he brings the spirits with his lavish description, bringing them into life! To make an image is to resurrect a soul—invisible counterpart of the (mimetic) world.

9

THE ORIGIN OF THE WORLD

In these mimetic worlds things connect with their invisible counterparts by virtue of the womb. Rendering copying synonymous with reproduction, this organ ensures that mimesis fuses as a male secret with origins and, as we shall later see, with history as well.

Mr. Charles Slater, a Cuna who had served as a sailor on English-speaking ships, wrote down the origin of the world in the late 1920s in English. "God came from under the earth for himself," begins Mr. Slater's text, which was published by Baron Nordenskiold.[1] "That time earth was without form and darkness." He needed a woman. The earth was without form or firmament. And God thought to himself to take a heart because heart "is memory to the woman and then he take heart of string that which is gone straight down to bladder, that which will make a woman way to come out of womb to form a child."[2] In thus creating woman, God became dual in ways that imply his androgyny, and the world was then created by the womanly body in three ways: from her womb, from her body parts, and from her seeing souls of different colors. As an example we can see how an important plant is thus created in the Origin History (as the Cuna call them) given by Chapin concerning the black dye-plant genipa, a dye used ritually for painting the body.[3] I paraphrase and occasionally quote it thus. God called his woman ("calling" being a euphemism for sexual intercourse) and she became pregnant. When she neared term he said to her that he would make a table. He took the flat forehead of her vulva—i.e. says Chapin, her stomach, in its spiritual form—and as it was legless

112

he pulled off his penis and make legs out of that. Then he declared he would make a golden cup, and he pulled out the cup sitting in her lap—i.e. her womb, says Chapin—and he made a cup of good yellow from that. She climbed onto the table to face the rising sun. Cold menstrual blood dripped from her open legs and she began to speak; "Something is coming from inside me, I feel. It all feels cold along my body road." Then a person came descending to the top of the table. "He looked like a person, it is said. It looked like a person with a bud on his rear end, it is said [the genipa fruit has a sort of bud at one end]. The father received him and made him a person." (64) After that the different types of genipa plant—as persons—were born, following which the father and the mother made the river on which they were to live. The mother's vagina was transformed into a golden tunnel through which the genipa people would travel when called by the medicine men, and her breath became a golden wind to speed them in their canoes made from the lips of her vagina. From her large intestine the golden house of the genipa people was created, and her small intestine became the flags that adorned that golden house. The fire fans that Cuna women use to fan the hearth were made from her clitoris, and the different colored flowers in the garden came from her menstrual blood. (65) So (with different embellishments) we have the history for most everything in this womb-sprung world of disembodied color-seeing woman—a world that comes into being through men chanting or whispering its origin.

The Magic of Origins

The genipa plant Origin History introduces us to an important variety of magic, one to put alongside Frazer's double-layered sympathetic magic of Similarity and Contact. For now we see that chanting or whispering or simply just thinking a thing's *origin* gives the ritualist power over it. But let us not forget that here too it is necessary to make a simulacrum, a verbal, toneful, simulacrum, by means of chanting over or under one's breath the birth-history of the thing in question. This puts the power of historicism in a new light. Indeed the theme

of knowing something's history, in the sense of its conception and reproduction, is basic and ubiquitous to Cuna magic. It is one of the meanings of *purpa* ("soul" and spirit) given earlier. As Chapin put it:

> The "origin history" of any one of a number of animals, material objects, medicines, and curing spirits is called its *purpa*. These origin histories are short orations in which the spirit in question is told how it lives, how it behaves, and what its ritual names are. It constitutes the underlying "secret" of the spirit, and enables specialists to dominate and manipulate it as they please. (566)

And he refers us to the aforementioned Origin History of the genipa plant as an example. In the first Western publication of the curing chant Nia-Igala (to "cure madness," as it was there translated), the Swedish pupils of Baron Nordenskiold, Nils Holmer and Henry Wassén, published alongside the text what they called, following their informant, the "secret" of balsa-wood—the wood of which the curing figurines were made and whose spirit is essential for the chant to be effective. This "secret" is the Origin History of balsa, born of woman in somewhat the same manner as described for the genipa, and Joel Sherzer, in his book on Cuna ways of speaking, informs us that with almost every chant is a "soul"—which he describes as a relatively short text in everyday though somewhat esoteric Cuna.[4] This "soul," he says, "describes the origin of the object to be controlled by the chant. Likewise in the very chant (*ikar*) itself, origin is crucial, and he gives the example, "The Way of the Basil Plant" chant. The detailing is minute, the text repetitious, as if words heaped on words are delicately covering with baroque growth the silhouette and pulsations of what the words refer to, thereby recovering the reality described with fluctuating tissues of sound. Each line could be a caption to a picture, one picture strung next to the other:

> Inapiseptili [spirit name of the plant] in the golden box is moving
> In the golden box is moving.
> Inapiseptili in the golden box is swinging from side to side.
> In the golden box is swinging from side to side.
> Inapiseptili in the golden box is trembling.

In the golden box is trembling.
Inapiseptili in the golden box is palpitating,
In the golden box is palpitating.
Inapiseptili in the golden box is making a noise.
Inapiseptili in the golden box is shooting out.
In the golden box is shooting out.[5]

Copies That Are Not Copies

But just when it looked so neat and tidy, the ground starts to shift. Here was a new world brought to our attention by ethnography, an amazing world consisting of material reality bound to spiritual copy extending in all directions as force.[6] But the mimetic faculty doesn't necessarily work that way. Remember in Hubert and Mauss' critique of Frazer's sympathetic magic how they brought up the way the copy that effects the original can be an imperfect copy, an "imperfect ideogram"? Listen to Michael Lambek wrestling with this copy that is not a copy in his book *Human Spirits*, describing the spirits as conceived by people living on a small island in the Indian Ocean between the African mainland and Madagascar. On one page he says that the spirits "lead lives parallel, but usually invisible, to humans." On the next page he writes that "spirit society, although it does not mirror human society, is a transformation of it."[7] Think back to the basis of all simulacra and hence mimetic realization in this Cuna world (as it comes to us through ethnography)—the basis of the female body; the womb, body parts, and the woman's seeing. For in bringing together in woman's body copying, reproduction, and origin, as so many moments of the mimetic, what we find is not only matching and duplication but also slippage which, once slipped into, skids wildly.

You see this immediately in the fact that while the ethnography with enviable self-assuredness describes the Cuna world as made up of spirit doubles, it later on proceeds to inform us without any sense of hesitation that the spirits of plants and animals and so forth exist in human form! This slippage is essential, and I presume its specification for any particular plant, animal, object, or person is its "secret," so

that we could abbreviate by saying that "secret" equals slippage. Origin History then becomes the attempt to trace the connection through history and from beginnings of how one thing becomes another thing while in some profound sense remaining the (mimetic) same—the sort of action of becoming different while remaining the same that we will later encounter as the primary paradox of Cuna ethnohistory—how the Cuna stay the same by adapting to the outside world. The equation of Origin History with birthing provides a complex sequence of magical transformations of one thing into another thing while, through the very act of transforming, conserving the notion of an underlying sameness held together as so many analogues by the woman's fragmented body-parts. Look at the details of this woman-body-parted world. The father creates a table out of that body, her vulva, more precisely—"the flat forehead of the Mother's vulva"—her stomach, in its spiritual form, says Chapin—that does the job but, being legless, he provides his penis which he nails on, presumable multiplied into four. This provides the scene for the birth, yet the genipa people need somewhere to live and be housed and so forth. All that comes from the woman's body too; her vagina not only gives birth to the genipa people (and many, many others as well) but serves as the golden tunnel for the wind to speed them on their way to aid Cuna medicine men (occasionally there are women) doing their job, her clitoris becomes fire fans, her large intestine, their golden house, and so forth, all in one massive process of "birthing" of body parts into something similar yet different, formed yet transformed.

Post Modern Geography

One way of demonstrating this deflective fault-line that is disrupting but necessary to the logic of mimesis and alterity is to trace the jumps in Chapin's description of Cuna cosmology. First there is the depiction of the womb-emergent origin of the world from the Great Mother with the ontological corollary of a world of matter replicated in layered spirit worlds. Chapin observes that the world of spirit, underlying that of matter, "extends out in all directions through a series of eight levels

labeled 'level one,' 'level two,' and so on." (77) Yet these levels are strangely unrepresentable. His (cosmologically informed) specialist informants *could not represent them.* At least they couldn't draw them. And Chapin expresses irritation with Nordenskiold's text for not only presenting just such a drawing, but for having sixteen instead of eight levels. There is something a little comical about this, a cosmic-level problem, a problem of the precise nature, anatomy, and geography and more specifically, the depiction—of the visual representation—of that geography. Chapin writes that "queries as to whether the spiritual levels extend up or down, or whether the topside levels are the same as those below, often elicit seemingly contradictory responses." (78)

So if there is a problem for mimesis and alterity at the level of levels, there is also a problem, but quite a different one, in the next stage of presentation of the cosmos. We are also told (78) that "as conceived by the Kuna" there are three general areas where the spirits live—

The Cunas' idea of the construction of the world, according to Pérez

mountain strongholds, whirlpools, and clouds. This seems to me quite a different sense of spiritual geography than the levels, yet in its way it is even stranger because the sites exist bewilderingly as both fantastic and actual. They are physical sites, close at hand, with none of the splendid symmetry of axial sculpture of the multiple-layered cosmos like so many flapjacks piled one on the other. While some one-to-one modeling is observed—the spirit-doubles of marine and riverine animals, for instance, reside in whirlpools—it is also the case that (spiritual) elephants—elephants!—inhabit these whirlpools, and that the mountain strongholds of the spirits, for instance, some little distance inland from the San Blas coast, can appear like the gigantic skyscrapers to be found in the large cities of Panama and the United States, magnificently created out of gold and silver, with flamboyant coloring, containing elephants, towers, clocks, and flags as well.[8] Here is a picture of one such magical fortress or *kalu* drawn for some Colombian anthropologists in the late 1960s in color by Alfonso Díaz Granados, *cacique segundo* of a Cuna settlement in the north of Columbia in the Gulf of Urabá.[9]

In other such spirit-fortresses, such as the Kalu Tigun, the rhomboid shapes in the upper part of the building are tables—the same sort of "tables" (vulvas) that appear in the creation of the world, reminding us that while Panama skyscrapers as much as female body parts may serve as the model, and in serving as such fulfill a deadly serious mandate of fidelity, nevertheless such fidelity has its tricks. Euclidean space is shattered, as is the logic of identity. Chapin represents a world in which up is down and down is up. He reports that his Cuna "specialists who separate the world above from the world below have also told me with equal conviction that these two regions are one and the same. As one informant put it, 'the two levels curve around the surface of the earth like pots.' " (83-84) And unlike the levels-version of mimesis and alterity, maps *can* be drawn and do in fact exist of these spirit-locations and their geography. In a footnote Chapin tells us that "Kuna curing specialists memorize the location of spirit strongholds and whirlpools in their immediate region so they will know precisely where the various disease-causing spirits live."(80) The illustration he presents is of interest. It's not the sort of map you buy at the

Kalu Pitgun (after 1967 drawing by Alfonso Díaz Granados,
original in color).

gas stations in New Jersey. It's a series of stick figures moving from
frame to frame as in a comic-book, zig-zagging left to right and right
to left up the page, each little frame depicting an encounter with salient
features of the world therein. It's similar if not identical in form to the
healers' chants, as well as to the picture-writing of those chants—a
philosophic orientation to representation which takes each particular

as it comes, portraying it step by step but by no means "to scale," sometimes tiptoeing, sometimes in seven-league boots, depicting the spirit-helpers as persons walking in the midst of the world as well as how that world looks to those persons.[10]

Jumping Levels, Jumping Bodies

A graphic illustration of this non-Euclidean landscape is provided by Chapin's caustic critique of Claude Lévi-Strauss and of Henry Wassén for their assumption about the literalness of the woman's body referred to in the birthing song Muu-Igala, sung for a woman in obstructed birth and made famous by dint of Lévi-Strauss's semiotic analysis of it in his essay, "The Effectiveness of Symbols." While Lévi-Strauss follows Wassén's commentary that the song depicts the healer and his figurine spirit-helpers struggling through the laboring woman's birth canal to reach the stronghold of the Great Mother Muu, in Chapin's understanding they have committed the crime of misplaced concreteness because it is not an actual woman or an actual birth canal through which the healer's spirit helpers fight their way in search of the real woman's abducted soul, but instead a spiritual copy of woman—of woman in general, of the Great Mother who gave birth to all things! Remember the Origin of the World, the origin of the genipa plant, for instance?

The point according to Chapin is that to understand this song you have to realize that there are two sets of (what I call) mimesis; the one between the laboring woman's body and the copy of that represented by her "soul," and the second, the mimetic conjunction between this soul and what he calls the spiritual cosmos. Of the first mimesis Chapin says that to those with supernatural vision, the soul of the woman is:

> . . . in every detail, identical in appearance and behavior to the body in which it is housed. In other words the 'soul' is a 'spiritual copy' of the physical body. Every organ of a person's body has its spiritual counterpart, and the 'soul' of a pregnant woman is also pregnant and will suffer from those symptoms she may experience at the level of consciousness. (429–30)

And he adds that the two levels of reality, spiritual and substantial, are seen by the Cuna as distinct yet complementary, and that the curing song, the Muu-Igala, refers to the spiritual "rather than the physical level of reality." (430) (Here we encounter once more, incidentally, my notion of "magical mimesis": how working on the copy, in this case the "spiritual copy," is meant to effect the "original," in this case the substantial body.)

The second mimesis between the woman's soul and the spiritual cosmos rests on the notion that the earth is in an important sense "the mother," and that a section of the cosmos is given over to mythic women, particularly the spirit Muu, to reproduce all living things— from the point of view of mimetic connection the crucial factor being that during pregnancy a woman's "soul" or purpa becomes, as Chapin puts it, "one with the cosmos itself. The two spiritual realms are fused together in the never-ending process of creating offspring and replenishing the Earth's stock of living beings." (433)

On this view, then, the singing of the Muu-Igala for a woman suffering from obstructed childbirth is an enactment of the spirit help-ers in the wooden figurines making their way at one and the same time into both the cosmic domain and the soul of the laboring woman— that is, the soul of the real pregnant woman attempting to give birth. As Chapin puts it, "When the chanter's spirit helpers journey along Muu's river and then Muu's path through the levels [of the cosmos], they are simultaneously travelling along the spiritual vagina of the woman." (433)

If this double-tracking along a spiritual river and along a spiritual birth canal is not too hard to hang onto—then take hold of this (to quote Chapin again): "When they [the spirit helpers] arrive at Muu's house [in the cosmos], they come to the [real woman's] spiritual womb. *At this point in their journey, however, the landscape alters (as often happens in the exotic world of spirit) and Muu's house becomes the woman's spiritual body* [emphasis added]. (433) The walls of Muu's house are now her ribs, the door is her vulva, the door frame is her thighs, and the door chain is her pubic hair—all this in a song designed to change reality (as I understand this process, by acting on a copy of it). Moreover, I might add, this means that in this particular type of

illness, the soul of the sick woman is abducted into her own (spiritual) womb (a sort of reverse hysteria), and it is into this womb that the character's spirit and his spirit-helpers have to enter so as to free her soul and place it back into her (real) body.

Thus the joker in the mimetic pack is smartly dealt. We are lost, yet perhaps not uncomfortably, between so-called levels of reality which are levels of reference, cross-reference, and "as often happens in the exotic world of spirit," of all-of-a-sudden altering landscapes in which the Great Mother's house *is* another woman's body, more specifically spirit-copies of her womb and genitalia. Yet at the same time mimetic fidelity, His Master's Voice, is somehow maintained. This is exceedingly strange, wonderful, and, of course, a little uncanny in the way it so imagerically, so iconically, copies Freud's analysis of the uncanny (as experienced by men) as that powerful medley of revelation and concealment exercised by the slippage through the gates of repression of the secretly familiar, that origin of the world, that home of all homes, the (great) mother's genitals. In what has by now become a homely quotation, Freud wrote:

> Thus *unheimlich* [uncanny] place, however, is the entrance to the fomer *Heim* [home] of all human beings, to the place where each one of us lived once upon a time and in the beginning. There is a joking saying that 'Love is home-sickness'; and whenever a man dreams of a place or a country and says to himself, while he is still dreaming: "this place is familiar to me, I've been here before," we may interpret the place as being his mother's genitals or her body.[11]

The Unstable Womb

I want to emphasize that while access and recourse to alterity—the Other world of spiritual reality—is both necessary and magically empowering, and that while that alter-world is deemed to be mimetic with the world of substance and modeled on it, there is also, as the reference to suddenly altering landscapes and jumping from signifiers to signifieds indicates, a curiously unstable aspect intrinsic to this mimetic doubling. What intrigues me about this instability, this copy

which not a copy, is that this particular feature of sudden alteration in the plane of reality of the referent occurs precisely at the moment of evocation of the womb. At that moment the genipa plant spirit is born, not as a plant but as a person (with a bud at its end). At that moment of entry into the Great Mother's womb during the song for obstructed birth, landscape suddenly alters; the walls of the Great Mother's house become the laboring woman's spiritual ribs, the door becomes the spiritual vulva, and so forth. Surely this suggests that the womb is of importance not merely for reproduction but also for the transformation of the level of reality that the chant both evokes and transforms and hence for the transformations required for healing. It is as if Muu's abode, meaning the flesh-and-blood earthly woman's spiritual womb as well, is the switchboard of the male magician's reality-control apparatus and that mimetic power and the mimetic faculty begin with this consideration. But what provides the switching so that copies heap on copies that are not copies in order to conceive and deceive the doubleness of reality?

Taboo and Transgression

Freud ends the passage just quoted on the uncanny and homesickness with a play on the German uncanny, *unheimlich*, and familiar, *heimisch*, noting that "the prefix *un* is the token of repression." This token of repression springs to my mind when I come across a peculiar and frequently mentioned but never developed feature in Cuna ethnography, namely the powerful taboos existing with respect to the representation of "sex" and birth, especially birth.[12]

For reasons he finds inexplicable, Chapin, for instance, notes that the Origin Histories which describe the birth of important spirits (such as balsa and genipa) from the womb of the Great Mother are not chanted in specialized wooden-figurine language but in colloquial Cuna and are therefore intelligible to nonspecialists.[13] He describes their content as "blatantly sexual" and says that on account of this sexual nature, these Origin History texts are closely guarded by the specialists who know them. Indeed they are not chanted our loud but spoken

softly or merely thought. As a dramatic illustration of the tension implicated by their sexual imagery, he tells of how when he was living among the Cuna, teenage boys discovered some Origin Histories written in a healer's notebook and were caught reading them with some girls. They were severely punished and the book was locked up. Sexual matters, he says, are never discussed publicly. (191–92) We are left with an emphatic set of images of repression repressing itself; the locked book made magically powerful by its "sexual" secrets, inscribed in ways accessible to common folk, even though what is inscribed is so flagrantly transgressive.

"The area of conception and childbirth is a particularly sensitive and taboo subject, intimately related to curing and magical control," states Sherzer. As a consequence he finds here plenty of euphemisms, indirect and what he finds to be curious figures of speech such that conception becomes "to buy a child," and pregnancy is referred to as "a worm entered," "the eye got burned," or "the wing is broken."[14] Forty years earlier, Baron Nordenskiold also presented examples of such taboos, which he saw as an unremitting effort to keep children ignorant of what he called "everything that concerns sex." When a woman has given birth, the siblings are told that the father out hunting came across a deer with a child in its horns. Hence the coming of the child is expressed not as birth but as "to catch a deer." This mystification carries over to the animal sphere too: children are kept away when a bitch whelps and are told that a worm in the sea in contact with the dog is changed into puppies. Pérez said he remembered once seeing a girl of marriageable age go down to the beach and throw a bitch into the sea so as to have puppies. Children are told that lizards carry eggs to the hen, and when chickens lay they are shut away so that children shall not know how eggs come into the world. A pregnant animal must not be butchered in the presence of children. The point is, concludes the baron, that "everything concerning sex is to be treated with the utmost secrecy," and this prohibition is very strictly upheld. He goes so far as to say what seems quite unbelievable, that it is "therefore usual that the girls and even the young men when they marry are entirely ignorant in these matters," and, more pertinently, suggests that the purpose of the taboos is not so much to protect the innocence of

children as it is to surround the core of the society's cosmology (a cosmology of wombing, we could say), with secrecy.[15]

For Freud the uncanny conveyed the sensation of magical, spiritual, and animistic powers, an eerie feeling that invisible powers were at work behind the facade of reality. And while there is nothing in Cuna ethnography which would help us definitively ascertain if this feeling of the uncanny exists among healers or their patients, and indeed so far as I can tell there is no ethnographic mention whatsoever of *any* sort of affect (unfortunately so typical of anthropological writing), we do at least know that reality is said to be a facade behind which spiritual doubles are active. This doubleness is so striking that it can hardly be exaggerated. Even more to the point. Freud was unremitting in his emphasis on the uncanny as that "secretly familiar" which has undergone repression and then returned, albeit in distorted form. What gives us, now, after reading Cuna ethnography, much food for thought, indeed our own uncanny feeling, is that Freud's "secretly familiar" turns out to be a Western psychoanalytic version, indeed a double, of what the Cuna call Origin Histories (equivalent to a thing's soul/psyche)—except for the Cuna, it is not merely one's self which came from the womb of the Great Mother but everything in the world, especially the great medicines and woods from which the curing figurines are carved. Given the zealous prohibition of "sexual" matters, more accurately of birth-matters, and the fact that the Origin Histories and other originary features of the chants so blatantly, so assiduously, detail by loving detail, overturn this prohibition, thus "returning" the repressed, then surely we are justified in calling attention to the connection between the womb and the magical powers of mimesis of which these chanters and herbalists, nearly always males, are masters—patriarchal masters in a matrilineal society of the return of the repressed, of the secret, the great secret, the Great Mother's secret which, bodies immobilized, looking straight ahead, they chant into their European and "non-Indian" wooden figurines, gateways to a mimeticizing world.[16]

This is where we must differ with the great classical tradition yearning for harmony, narrative closure, and structural integrity, that recurring Western tradition which would "explain" the magic of heal-

ing rite as bound to the restoration of balance and the resolution of contradiction. To the contrary, this voicing the secret and breaking of taboo responds to an aesthetics of transgression contained by ritual. The "magical force" at work here cannot be assimilated into narrative closure. Nor can such magical power be meaningfully assimilated into the formula of the "return of the repressed" unless we focus on the implications and character of the transgressive power of that "return"—its danger and fascination, its insinuation into normality, in short its explosive power. It is true that the transgression occurs and can only occur within the bounds and buffers set by ritual. It is true that just as taboo exists in order to be broken, so transgression fortifies the taboo. But these equilibriums do not diminish the fact that the act of transgression is in itself fraught with the perils of indeterminacy, an indeterminacy constitutive of Being no less than threatening it with dissolution. It is the precariously contained explosion of the transgressive moment that allows for and indeed creates the "mimetic slippage" whereby reproduction jumps to metamorphosis, whereby the duplicating power of spirit (image) is also a self-transforming power— and hence a power for healing and for evil, transforming Being itself.

Trans/forming

What is obvious, once stated, is that for all this fixation upon and fixing of spirit copying and doubling, spirits are great transformers. They are great mimes, the greatest the world will ever know.[17] They may be modeled on This world, but that does not mean that they therefore possess the apparent stability of forms in This world. Emerging from the transgression of the taboo, their very mastery of fidelity is the sign of their infidelity.

Take the young Cuna woman of the island of Ustúpu who, Chapin relates, dreamed she made love with a young man she had never seen before. Three months later she gave birth to turtle eggs. She and her mother kept this secret, but neighbors began to hear water gurgling beneath the ground, and the story got around that spirits bent on harm were about to innundate the island with a tidal wave. When someone

126

found out about her dream, a seer was consulted who discovered that the woman's lover had not been a man, but a turtle spirit in disguise! (113–14) The medicinal cure for dreams like this may well be fatal—as we shall discuss later on.

Such personifications usually spell deep trouble but can sometimes have a positive side, the spirit being a source of knowledge and information, as was the elephant, in human form, that taught the *nele*, the seer for whom Rubén Pérez worked. The most virulent type of evil spirit is the *nia*, usually translated into Spanish as *diablo*, *demonio*, or devil, often pictured as a black (ie. African-American) man. Such spirits can also disguise themselves in different ways, as attractive women or men, for instance, by means of which they try to seduce Cuna people, and they may also take the form of a friend or close relative. (344)

"Everything in this world, the visible reality, has a spirit counterpart in another reality which controls it," wrote Jean Langdon summarizing what she had learnt of cosmology amongst the Siona Indians of Buena Vista along the Putumayo river in southwest Colombia in the early 1970s.[18] Here again the ability of spirits to transform themselves is impressive. They may appear in any form, as person or animal, and sometimes only as a sound or feeling, such as the feeling one has entering a haunted cave, and there is generally, she observes, "a transformation of beings as they journey to different realms."[19] Thus a pig in This realm appears as a young girl in the spirit house of the animals reached through dreams or drug-induced visions. But "at other times, what may appear to be a pig in This realm is actually a spirit that has taken on a pig form in order to bring harm to the hunter."[20]

Thus there would seem to be in this world of seeming a deeply puzzling capacity for copying and hence deception in which the "original" and the "copy" fight it out for ontological preeminence—for a claim to power over the perceptual fidelity, epistemic certainty, and very life of humans.

And this is why there have to be "seers." This is why there have to be healers, persons capable of judging appearance, able to distinguish the different forms of doubling.

Even so, such discernment is insufficient. "Seeing" is only part of the story. For the healer's power depends, in its turn, on doubling also!

The healer's capacity to diagnose and cure, to restore souls (read double, read image) depends on out-doubling doubling. Through his wooden figurines activated by his chants bringing forth doubles by means of mimetic magic, he brings forth images that battle with images, hence spirit with spirit, copy with copy, out doubling the doubleness of the world. Until the next time.

10

ALTERITY

Pulling you this way and that, mimesis plays this trick of dancing between the very same and the very different. An impossible but necessary, indeed an everyday affair, mimesis registers both sameness and difference, of being like, and of being Other. Creating stability from this instability is no small task, yet all identity formation is engaged in this habitually bracing activity in which the issue is not so much staying the same, but maintaining sameness through alterity. The available histories of the Cuna shed strange light on the logic of this process, for by remaining resolutely "themselves," resolutely *alter* vis à vis old Europe as well as—note clearly—its black slaves, the Cuna have been able to "stay the same" in a world of forceful change.

Time and again this (appearance of) persistent Cuna sameness has been pointed out, in sharp contrast to the conventional liberal trope of nostalgic despair about the eclipse and extinction of Indian societies from Alaska to Tierra del Fuego, due to what is seen as the inevitable path of cultural destruction on account of Western religions and moralities, land-grabbing, Western diseases, Western language, Western clothes, Western junk food, Western alcohol, Western haircuts, and, more often than not, Western mirrored self-deprecation and tortured ambivalence regarding Indianness. But the Cuna refreshingly prove that this is not inevitable, and this is why they are such favorites in the Western treasure-chest of exotica, a jewel in the crown of New World ethnography—Indians who made it by being real Indians to the end of the twentieth century. Quite a feat, especially when you take into

account that alterity is every inch a relationship, not a thing in itself, and is in this case an actively mediated colonial relationship meeting contradictory and conflicting European expectations of what constitutes Indianness. What is more, much more, this particular colonial history is profoundly gendered; it is the Cuna women, not the men, who bear the mark of tradition—the nose-rings, the vivid and strikingly beautiful appliquéd *mola* blouses and head coverings. In the visual scheme of things it is not the men but the Indian women who are alter, and here everything pivots on releasing the spirit powers of appearance.[1]

Dream-Worlds of Foreign Ships

Here dreams provide the royal road not so much to the unconscious but to where the spirit-action exists in paranoid dreamscapes of attraction and repulsion. Take the place of dreams in spirit-attack, bearing in mind that this is virtually the sole cause of serious misfortune, and such an attack always comes from *outside* the Cuna community. The assertion bears the stamp of finality. All mysterious misfortune is alteric. And if it so happens that a Cuna appears to be the cause of another Cuna's magical illness, it is because that first Cuna, categorized as a *kiatakkalett*, has had his or her soul possessed by an *outside* spirit. Thus possessed, such a person appears as spirit in the dreams of fellow villagers, plural, and can even cause their deaths—not to mention the self-destruction of the seductive distinction between "inside" and "outside," a distinction which has more than its fair share, we might say, of erotic power, binding dreaming to that always-present, interiorized alterity shaped by longing for the Other, such as the Other who comes in ships.

This is attested by what Rubén Pérez told Baron Nordenskiold of his grandfather's dreams. In one dream he saw a large ship entering the bay and making fast alongside the quay. A handsome woman stepped ashore and came to him, intent on making love. He kept dreaming this same dream. In fact during the day he used to go down

to the beach and even far out into the water to see if the ship was coming. Medicine cured him.

Pérez' grandfather seems to have attached a lot of importance to this dream, and advised his grandson to let him know in good time if he was every troubled by a similar one, which suggests that such a dream is not only a notable and perhaps culturally standardized phenomenon, but the cause of anxiety as well. What might happen if this Cuna man made love with the beautiful lady, the alluring Other? Why is this dream so threatening?

"In the old days," writes the baron cryptically, "the Cuna Indians used to give poison to those who were subject to dreams of this description. Occasionaly they burnt them." And he went on to cite that long ago there was a woman who repeatedly had the same dream as Pérez' grandfather, only in her case it was men who visited her, and the village she lived in collapsed into the ground and was swallowed up. "Therefore," he concludes, "Cuna Indians made a practice of killing people who habitually dreamed in this fashion."[2]

If the ethnographic literature is accurate, Cuna women get far more drastic cures for such dreaming than Cuna men. Not only is this suggested in the two dreams related by the baron, but also in Norman Chapin's retelling of the Cuna woman who several years ago, in her dreaming, gave birth to turtle eggs after sexual intercourse with a strange man, causing village-wide fears of being engulfed by a tidal wave. He adds, in a footnote, that this woman was then taken to an uninhabited island and given medicines to drive the turtle spirit out of her. The medicine was too powerful. She fell into a coma and died.[3]

Cuna Heaven: Cuna Paradox

Baron Nordenskiold was impressed by what he saw as a certain Cuna paradox in absorbing the outside and changing world in order to stay the same. The Indians were deeply conservative, he said, but very susceptible to novelty.[4] The immediate stimulus to this observation was what he had been told about the journey of a Cuna soul after death, how decidedly Western, how decidedly modern and modernizing was

the landscape of the dead that the soul passed through, yet how all this conspired to keep the Cuna the same. According to the baron, who got it from the Cuna Rubén Pérez when he was relating things Cuna to the anthropologists in the Göteborg Museum in Sweden, the Cuna kingdom of the dead is not only stuffed with Western consumer goods but is wide open to the winds of fashion and progress as well. "It is painted as a wonderful dreamland," concluded the baron. "Much of it is taken from the white men and it is changed from time to time as the Indians have new experiences." Hence what appears as a horse drawn wagon in the 1920s will appear as an automobile in the 1930s. "In other words," he goes on in an even more thought-provoking passage, in this Cuna society of the dead:

> The Indian is rich and the white man poor. Everything which the white men now has, such as steamboats, automobiles, and trains, will belong in the other world to the Indians. Many of the souls of these objects already exist there. If a Cuna Indian can go aboard one of the ships which pass through the Panama Canal, then this ship will belong to him in the next world. Pérez used to say jokingly that in the kingdom of the dead the Gothenburg Museum would belong to him. (291)

We will have reason to return to this change in ownership of the Anthropological Museum in the future time of the dead Indian. For now, it is important to register this assemblage of Cuna life possessive of the souls of Western commodities as a striking picture of what it can mean to stay the same by adapting to the white man's world, or to a crucial aspect of it, all of which we now start to see as crucially dependent on this strange word "adapting"—as when the ethnolinguist Joel Sherzer, for example, in his thoughtful study of Cuna speech, points out that despite changes such as the men working in the Canal Zone (and prior to that on white men's ships), using new technology such as tape recorders, learning foreign languages, and so forth, such changes are integrated into Cuna life analogous to the "designs" created by Cuna women when integrating mousetraps, lunar modules, and baseball games into the traditional scheme of their appliqued shirt-fronts—the famous *molas*, international sign of Cuna identity. In his words, "The Cuna ability to adapt should not be confused with accul-

turation. It is a constant, traditional, feature of Cuna social and cultural life to transform the new into the old, incorporating rather than rejecting.[5]

But this not so much resolves as restates what the baron's paradox problematizes, namely the very concepts composing it—concepts such as tradition, transformation, and adaptation (without acculturation). Surely these concepts are themselves glosses on a still more basic issue of identity, which has to be seen not as a thing-in-itself but as a relationship woven from mimesis and alterity within colonial fields of representation. Everything hinges on appearance.

The Soul of the Commodity Is Its Image which, Released on Burning, Fascinates Dangerous Spirits and Keeps Them from Doing Harm to Cunas

A striking instance of the spiritual and hence imageric power of alterity is provided by what Nordenskiold relates about certain cures of snakebite that were told to him. It must be first appreciated that snakebite is both a physical and a metaphysical cataclysm. Chapin describes it as "a crisis situation" in which the patient and the entire village become vulnerable to further attack by snake and allied spirits such as the spirits of the toad, which cause swelling, the squirrel fish, the morning star, the fishhook (which cause great pain), and red animal spirits which cause hemorrhage.[6] Sherzer also informs us that snakebite is a "very sensitive area" because the mainland, where the men tend crops and the women go for fresh water, abounds in very dangerous snakes, and because it is believed, as with all serious problems, that snakebite attracts dangerous spirits to the village of the bitten person. For this reason, in the event of snakebite complete quiet must obtain throughout the village; indeed it is not unusual, apparently, for a whole island to be sonically shut down—no radios, no outboard motors, not even the flip-flop of thonged sandals, and no talking except when necessary, and then softly: this, in a culture outstanding for its amount of talk-noise.[7] Chapin says quiet is considered necessary because the souls of noises fly through the air and jolt the weakened soul of the patient.[8]

We should note as well that Sherzer includes the treatment of epidemics along with that of snakebite, and that for dealing with epidemics an island-wide rite lasting eight days and involving the entire population is undertaken; it also involves the use of many life-sized wooden figurines. The image of General Douglas MacArthur described previously, with powder-blue jacket, pink breast pocket, and what appeared to be a German Iron Cross was one of these *apsoket* figurines. When it's a matter of treating a snakebite victim, the smaller wooden curing figurines (*nuchus*) are placed around the patient—just as the life-sized figurines are placed around the island to protect the community as a whole.

Now the fascinating thing is that the baron was told of a medicine man who collected "all sorts" of pictures from trade catalogues and illustrated periodicals, so that when someone was bitten by a snake, or seriously ill, the medicine man would then burn these illustrations and strew the ashes around the patient's house. The rationale was that this burning released the soul of the pictures, thus forming, in the baron's words, "a vast shopping emporium and the evil spirits that were congregating upon the house got so busy looking at all the wonderful things contained in that store that they had no time to spare for the sick person." He added that the great seer and political chief he called *nele* collected pictures in large variety, although Rubén Pérez had no idea how he used them. (366, 398, 533)

It seems to me that the Western presence is here invoked as much as any particular picture. Indeed, if there is one expression more fit to invoke that presence than consumer commodities then surely it is the *image* of them. It should also be remembered that the image of a Western commodity bears a triply-determined spiritual connotation— as when Charles Slater, quoted above, writes "image," the Swedish text translates it as "spirit"; as when Chapin gives us "photograph" as a meaning of *purpa*, or spirit/soul; and as when the baron, describing the Cuna land of the dead as stuffed with white men's commodities, says that many of the spirits/souls of these objects are already there. But why does the illustration have to be burned?

Perhaps the use of parrots to acquire a foreign language may shed light on this question. The baron reported that parrots that can speak

words in a foreign language were bought at fabulous sums and eaten or (more often, so it appears) burned, in which case the ashes are daubed on the tongue of the person wanting to learn. It is the soul of the parrot, the baron emphasises, that then does the teaching, and this occurs in dreams, where the parrot's soul may appear as a foreign person. In the catalogue of the Göteborg Museum is an entry by Rubén Pérez for "medicine for a quick tongue," which was used by his brother in the 1920s. This medicine consists of various plants, two special birds, pages from the middle of the Bible, and pages from the middle of works of history. The birds and the pages are burned to ashes. (341, 349, 351, 365, 517)

Obviously, then, the burning is of some significance for releasing the soul of the entity burned, activating and bringing it into the world as an effective agent in a process parallel if not identical to the healer activating the spirit-power of his wooden figurines by chanting to and with them. We could think of the burning of the commodity-images as being like a sacrifice—the making of the sacred through willful destruction and subsequent exchange with the gods. We could also think of the fire as releasing the fetish power of commodities within the commodity-image. But both these efforts to understand are overly general and fail to engage with what seems most instructive and most magical, namely the creation of spiritual power as animated image through the death of the materiality of the image.

Put another way, appearance seems crucial, pure appearance, appearance as the impossible—an entity without materiality. It's as if some perversely nostalgic logic applies wherein the spirit-form can only exist as an active agent through the erasure of its material form. Creation requires destruction—hence the importance of the Cuna land of the dead where images float in such abundance; hence the phantas-magoric quality of photographs.[9]

But then there is the ash! No longer the immateriality of appearance, of spirit. Just matter itself! The uttermost matter of matter. The end of form. A pile of ash to be daubed on the tongue, in the case of talking birds, or around the house of the snakebitten in the silent village so as to entertain the malevolent spirits gathering in force.

Through burning to ash is thus enacted the strange Frazerian logic

of Sympathy, of Imitation *and* Contact, of copy *and* sentience—and I cannot but once again be mindful of the configuration of the wooden figurines, outer *form* European (imitation), inner *substance* Indian (contact)—that provides the curer with (images of) active spirit-helpers. The point of my emphasis here is the assertion from the ethnography that the magically important thing is the spirit of the wood, not its carved outer form. Might not the burning of the pages of the Bible, of history books, of parrots be equivalent to this carving of wooden figurines followed by the *conceptual* erasure of the material outer form, the material simulacrum, of the Europeans? This puts the practice of "reading under erasure" in a new light, and we see that just as the question of the content of the image gave way to questions: Why make images anyway? Why embody?—so now we see that making requires unmaking, embodiment its disembodiment.

A Premonition

Busily plying the trade with the Indians of the eastern coast of Central America in the early nineteenth century, Orlando Roberts has left us with a charming scene, forerunner of the storehouse of Western commodities in the Cuna land of the dead noted by the baron a century later. The ship anchored off the Diablo River in 1816, its arrival signaled by firing a gun. The chiefs and priest of the great and little Payone tribes arrived:

> By their advice we hired a few Indians, who very expeditiously erected a temporary house for us, on the kay, in which we had more room to display our commodities to advantage, than we could have had in the vessel. In two or three days, we landed and arranged the goods we had to offer, cleared a spot for the reception of fustic [yellow dye-wood], which the Indians had gone to collect at their different settlements, and every thing augured favorably for the success of our voyage. The Indians, shortly began to arrive from all parts of the coast, with fustic, in canoes and dories; some of them brought from five hundred weight, up to three, four, or five tons, but none of them exceeding the latter quantity. In exchange we gave them ravenduck, osnaburg, checks, blue baftas, and

other manufactured goods—mosschettes, (or G.R. cutlass-blades), and a variety of toys and small articles adapted to this trade, for which articles in barter, an enormous price was obtained.[10]

"They Continue the Time-Honored Principle of Playing One Outside Power Off Against Another"

Thus does James Howe along with other commentators of the Cuna scene sum up the continuing Cuna strategy of survival over four centuries of Western European and U.S. colonialism in the Caribbean—a strategy that in my opinion owes everything to the politics of mimesis and alterity.[11] Let us review this tale, bearing in mind that it necessarily misleads when I speak of "the Cuna." For not only are there men Cuna and women Cuna and all grades of powers between chiefs and commoners, but to create discourse around "the Cuna" is in fact to create and solidify what really needs analysis—namely the nature of that very identity.

The first wave of colonization between 1511 and 1520 appears to have devastated the indigenous societies of the Darién Isthmus and of the adjoining Gulf of Urabá and the Atrato Basin. But thereafter the Indians were able to take advantage of the geographical peculiarities that made the isthmus strategic to the Spanish Empire; transshipment across it to Spain was the principal route for the silver from the fabulous mines of Potosí in Peru, on the Pacific side of the continent. Such a narrow strip of land separating the Pacific from the Caribbean could not but attract buccaneers; the tale of Lionel Wafer, William Dampier's surgeon, shows just how Darién Indians succeeded in taking advantage of the rivalries between European nations and of the instabilities of the European frontier.[12] In Wafer's case this conflict was one of British and French pirates in alliance with Darién Indians against the Spanish Crown. As is obvious from Wafer's tale, as well as the account of piracy in the isthmian region provided by Elliot Joyce, the Indians were eager to support the pirates by suggesting targets and providing local knowledge and food—not to mention occasional divination and herbal medicine. One reason why the ill-fated Scots colony founded in 1698

in the Darién lasted as long as it did was because of support from the Indians, the Scots being potentially hostile to Spanish (as well as English) interests. When the more successful French Huguenots settled there at the beginning of the eighteenth century, they married Cuna women with whom they had children. The French settlers were important, according to Nordenskiold, in warfare against the Spanish. In 1712, for example, the village of Santa Cruz de Caña was sacked by 80 Frenchmen and 300 Cunas under the command of the Frenchman Charles Tibou. When the Spanish were unable to subdue the Indians by force, they signed a treaty which included these French and their descendants, but in 1757 the Cuna killed these Frenchmen—according to Nordenskiold (4), reportedly at the urging of British, who supplied the Cunas with arms. It is said that French was spoken extensively among the Indians at that time.[13]

After 1790 peace seems to have settled on the isthmus. Foreign powers had their hands full elsewhere. Yet contact with trading vessels, particularly from the United States was important throughout the nineteenth century, and many Cuna men took jobs as sailors, a circumstance that writers on the Cuna see as as having created their fondness for Americans. A revealing instance of the baron's Cuna paradox of conservatism mixed with love of novelty, no less than of Sherzer's "adaptation without acculturation," is the fact that Cuna men acquired European names as a result of their taking jobs as sailors on such ships—as with the English-speaking Cuna Indian Mr. Charles Slater. The anthropologist David Stout, on the basis of fieldwork among the Cuna in the early 1940s, thought that such name-changing owed something to what he called Cuna "circumspection in the use of Indian names, particularly in speaking one's own."[14] He also pointed out that on most of the islands, few Cuna *women* had yet had the opportunity or the need to adopt a foreign name.

Although technically part of the Colombian nation-state for most of the nineteenth century, the Cuna inhabited a political backwater at the farthest extreme imaginable from the capital of Colombia, Bogotá, lying deep to the south in the mountainous interior of the mainland. The Cuna were left to themselves, their foreign ships, and their traders. All changed, however, in 1903 with United States President Theodore

Roosvelt's orchestration of the secession from the Republic of Colombia by the province of Panama, followed by U.S. construction, some 50 miles from the Cuna, of the "greatest engineering feat in the history of the world," the Panama Canal, one year later.[15] Now the governing circles of the fledgling nation-state of Panama, in certain respects an "imagined community" of the U.S. and certainly its de facto colony, began to play out their love-hate relationship with the colossus of the north on a Cuna theater, enacting on the Indians what had been enacted on Panamanians—aping hideous little reconstructions of civilization-versus-savagery dramas on the frontier and vigorously attempting to demolish, in this case of the Cuna, their appearance—meaning the most visible signs of difference, notably the clothes and adornments of the women.

Lying close to the national border, the Cuna were initially able to set the Panamanian government off against the Colombian government. But with the consolidation of schools and police in Cuna territory by the Panamanian government, the Cuna found that the global pattern of international power politics and racist energies provided the perfect occasion for their trump card. Using their very Indianness vis à vis "civilization," they played the United States off against the Panamanian State, finding ready allies with Americans from the Canal Zone and from members of the scientific establishment of Washington D.C.— many of whom were eugenicists committed to racist theories of society and history, especially anti-negro theories.[16] It should be remembered that for most Americans the Panamanian State was not just a State but a black State, and whether such "blackness" was negro or mestizo (offspring of Indians and whites) was irrelevant.

Fueled by apparently exaggerated accounts of black Panamanian police abuse of Cuna women, this alliance between Cuna Indians and their protectors from the north was activated in the dramatic uprising of the Cuna in 1925, an uprising which succeeded thanks to the timely appearance of the cruiser USS *Cleveland* steaming off the San Blas coast. This truly amazing rebellion was "led" (shades of Charles Tibou, the eighteenth- century French leader of Cunas!) by R.O. Marsh, white U.S. citizen disguised in "Indian costume," who had been for a short time First Secretary of the U.S. Legation in Panama in 1910, and who

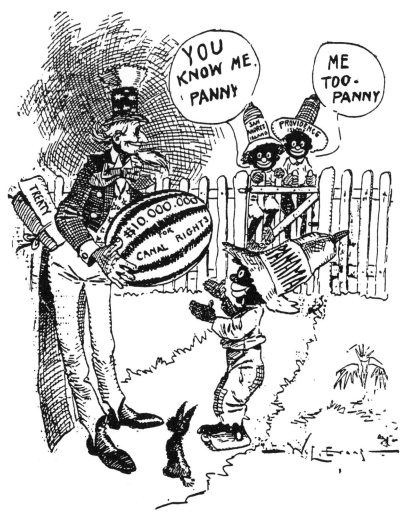

They Would Like To Get In ("The Islands of San Andres and Providence want to join the Panama republic."—News item) Cleveland Leader, ca. 1904

in 1923 became obsessed with the search for white Indians in the Darién while searching for rubber plantation lands at the bequest of those colossi of early twentieth-century U.S. industrial capitalism, Henry Ford and Harvey Firestone. Quite a tale—and curtain-raiser to a productive U.S.-Cuna partnership lasting till today, the Cuna using

the military anxieties and scientific concerns of the United States in this sensitive part of the globe to defend themselves against the pressure of the Panamanian State—beginning with the demand by that State just prior to 1925 that the Indians become "civilized" by dismantling the appearance of the women, the alteric sine qua non of Cuna Indianness.

Banana Republic

A nice example of the contradictory currents at work in this triangular relationship between Panama, the Cuna, and the U.S., was recently presented by *The New York Times* in its coverage of the drawn-out conflict between the U.S. government and the President of Panama, General Manuel Antonio Noriega. On April 1, 1988, the *Times* published a photograph captioned "Demonstrators burning an effigy of Uncle Sam in Panama City." The picture shows a burning, life-sized effigy of a human figure with a dour, Lincolnesque face, long black trousers, no feet, and an oversized hat painted with U.S. stripes (not all that different from the life-sized figure of General Douglas MacArthur used by the Cuna for curing an island community). Behind an iron fence stands a woman waving the Panamanian flag. The accompanying article makes it plain that this little ritual indicates considerable support for General Noriega on the part of people in Panama City.

Three weeks later the same newspaper published an article of equal prominence and length, in which it reported the San Blas Cuna to be in revolt against the Panamanian State. This was shown by their raising not their own but the U.S. flag, "angering soldiers at the local Panamanian military garrison," according to the journalist David E. Pitt, who went on to say in his April 21 dispatch from Panama City that the flag-raising was not a random event. "Although the Cuna say they did it partly because they knew it would infuriate the troops, many Cuna have a special fondness for Americans," he added. What happened later on, as they say, is history; yet another U.S. invasion of yet another disorderly banana republic.

Good Savage/Bad Savage

The strategy of mimesis and alterity involved in using a powerful First World State, notably the United States, against the exactions of the local Third World State, is an important and often tragic element of modern history. Think of the *montagnards* as well as other "hill tribes" in Southeast Asia used by the U.S. in the Vietnam war. Think of the Miskito in Nicaragua, used by President Reagan and the C.I.A. taking advantage of Miskito resentment at high-handed Sandinista policy toward Indians following decades if not centuries of such alliances with European powers on the part of these Indians. Think of the alliances between Indians in Brazil, with well-intentioned North Americans and West Europeans, the Indians looking for power to hold back miners and ranchers and thereby infuriating the Brazilian State by what is seen as a challenge to national sovereignty—just as the Panamanian State was infuriated by that proto-Fourth Worldist R.O. Marsh "leading" the Cunas to a (U.S. enforced) autonomy in 1925.

As I see it, sustaining the realpolitik of these situations is a powerful modern mythology of good savage/bad savage by which the whites of Europe and North American purify themselves through using the good savage to purge the bad one, whether communists in Vietnam, Sandinistas in Nicaragua, supposedly corrupt and ecologically-insensitive Third World government in Brazil and Panama or, most especially, the bad savage within the historic constitution of First World whiteness itself.

This Janus-faced sense of the savage corresponds to the great mythologies of modern progress. The good savage is representative of unsullied Origin, a sort of Eden before the Fall when harmony prevailed, while the bad savage is the sign of the permanent wound inflicted by history, the sign of waste, degeneracy, and thwarted narrative. In the New World, as we shall spell out in some detail in a later chapter, these signs fell on the Indian and the African-American respectively. But while the phantom figure of the pure Indian becomes the object of desire by the First World, that same Indian tends to be the cause of unease if not the object of erasure in the Third World—as in Guatemala, to cite a well-known instance—no matter how much a certain

style of Indianness may be appropriated and promoted by the State in the designs on the currency, a concern for archaeology, and in the promotion of weavings by Indian women for tourism. Indeed, these signs indicate not only the degree to which that national identity in a Latin American country is bound to First World criteria and First World recognition of palatable and rousing difference, but that the carriers of that national identity, which is to say the elites as much as the populace at large, are placed in a basically untenable ambivalence— neither truly Indian nor truly civilized, and forever at the beck and call of the White House or travel-guides such as the *South American Handbook*. This infernal American identity machine thus composes a mosaic of alterities around a mysterious core of hybridity seething with instability, threatening the First World quest for a decent fix of straightforward Othering—were it not for the degree zero provided by the black man, not to mention even more fabulous creations like the white Indian women of Darién. To them we now turn.

11

THE COLOR OF ALTERITY

In the summary of his research of what he quaintly called, following U.S. anthropological convention, "the contact continuum," among the Cuna in the early 1940s, the anthropologist David Stout has left us with the intimation of an arresting idea: that the cultural politics of alterity should be seen as composed not simply of one-on-one, for instance Americans and Cunas, but as a hierarchy of alterities within a colonial mosaic of attractions and repulsions, in which some alters exert positive, and others negative, charges. In his own words:

> In summary, the contacts of the San Blas Cuna with the Spaniards have been, until recent years, predominantly hostile; those with the English, Scotch, French and Americans predominantly friendly; while the Negroes and mulattoes have long been objects of contempt. Though Cuna ethnocentrism has been remarked upon by earlier observers, it has not been a deterrent to extensive cultural changes. Rather it serves as the starting point of the Cuna scale of rating of other groups, for they place themselves first, Americans and English second, Spaniards and Panamanians third and Negroes last.[1]

Elsewhere referred to as a "deep prejudice" by Stout, this notion of "ethnocentrism" might be more honestly termed racism plain and simple (although racism is anything but simple). Stout sees it as based in part "on the fact that the Negroes have long been economic competitors, have encroached on the Cuna's lands and turtle catching spots and frequently stolen coconuts and bananas from their farms."[2] Whatever

weight the "based in part" is meant to carry, this familiar invocation of the competition for scarce resources cannot even remotely explain the sociological and mythic terms of the racial groupings involved in the competition itself.[3] From the ethnographic record it would appear that the Cuna "contempt" (as Stout puts it) for Negroes and mulattoes goes far beyond economic rationality, and it is this "excess," drawing on the rich imaginative resources that colonial history offers border culture, that stands out like a beacon. Moreover, this contempt fits only too well with European racism as instituted by almost four centuries of the African slave trade and the massive infusion of antiblack sentiment created by the construction of the Panama Canal, beginning to some extent with the French attempt in 1881, and locked into place by the military-engineering apparatus of the U.S. government under Theodore Roosevelt starting in 1904. "A rigid caste society," is how one historian of the canal describes the society then put into place.[4]

Black Labor on a White Canal

A recent study of the attitudes toward blacks finds that the racism instituted by the canal authorities was greater than in the U.S. itself, north or south, and that this became more rigid as the twentieth century progressed, leaving the Canal Zone a sort of South African enclave of the United States until at least the 1970s.[5] Racism toward blacks was surely important in Panamanian society before Roosevelt captured the Isthmus for U.S. interests in 1903, but the mythology of color built into the cultural apparatus of work and bureaucracy organized to construct the canal surely took it to a higher level. The building of the canal needs to be seen not only as "the greatest engineering feat in history of the world," as it was presented to the public at large, but also as a feat of racial engineering. Not only was a canal built but also a cosmos—a culture stitched together by white-defined dictates of work discipline and efficiency in which blacks were the butt, the sign of all that was incompetent, the black nature through which the white canal had to bore in order to join the oceans for commercial might. Intrinsic to the refrain, and as natural as the endless complaints about

the ghastly climate with its heat, humidity, mold, malaria, yellow fever, and death, was that of how poorly the negroes worked. "It was a common saying in the Zone," writes Frederic J. Haskin in his book bearing the endorsement of officialdom, *The Panama Canal* (published as early in the canal history as 1913), "that if the negro were paid twice as much he would work only half as long."

This is the infamous "b[l]ackward sloping supply curve of labor," curse of colonial enterprise (not to mention the wage labor systems of early capitalism in Europe) and source of the rampant mythologizing if not envy regarding the sexual character and carefree attitudes of the "lesser breeds without the law." Indeed, Haskin's following remark endorses this intimate relationship, its anxiety, its dreamscapes. Most of the negroes, he writes, "worked about four days a week and enjoyed themselves the other three. It may be that the 'bush dweller' [meaning those blacks who refused to live in the Canal Zone's housing, designed for lower grade workers in accordance with sanitary principles] was not fed as scientifically as the man in the quarters, but he had his chickens, his yam and bean patch, his family and his fiddle, and he made up in enjoyment what he lost in scientific care."[6] Haskin failed to point out that despite the much-publicized efforts in public health and medical technology, the death rate of blacks employed on the canal construction was something like three times that of whites.

Gold and Silver

The color of money officially designated race in the Canal Zone into two castes, gold and silver. Gold meant the United States "gold standard"-based dollar, which is what U.S. whites were paid in. Silver meant the Panamanian balboa, which is what the Panamanians, West Indians, and (initially) a few whites from other nations, were paid in.[7] Gold and silver came to divide this new cosmos as effectively as Apartheid did in South Africa, decades later, and this division bred on itself, becoming more complex and resistant as time went by. This was more than a matter of offical convenience. "In truth, the color line, of which almost nothing was said in print," writes a recent historian of

the canal, "cut through every facet of daily life in the Zone, and it was as clearly drawn and a closely observed as anywhere in the Deep South or the most rigid colonial enclaves in Africa."[8] As early as 1913 Frederic Haskin could write, with the formal approval of the canal's chief executive, Colonel Goethals, that "the color line was kindly but firmly drawn throughout the work, the negroes being designated as silver employees and the Americans as gold employees."

> The post office had signs indicating which entrances were for silver employees and which for gold employees. The commissaries had the same provisions, and the railroad company made the general distinction as much as it could by first and second class passanger rates. Very few of the negroes made any protest against this. Once in a while an American negro would go to the post office and be told that he must call at the "silver" window. He would protest for a while, but finding it useless, would acquiesce.[9]

In fact the gold/silver distinction was hit upon by the paymaster as a "solution of the troubles growing out of the intermingling of the races"[10]—not that the distinction lacked poetry, gold and silver, a fantasy-land under the sway of ancient cosmologies of sun and moon. Little wonder that in the heavy irony he practiced in the writing of his memoir as a Zone policeman, it came naturally to Harry Franck to register this bureaucratic distinction as a religious, indeed cosmic, one. He expected from the media reports and perceptions of the canal in the United States to find happy white men digging the canal themselves with pick and shovel, "that I might someday solemnly raise my hand and boast, 'I helped dig IT.' But that was in the callow days before I ... learned the awful gulf that separates the sacred white American from the rest of the Canal Zone world."[11]

Silence—that "awful gulf"—is as important here as glittery designations of gold and silver, the virtual erasure, as far as the official representations are concerned, of the black work force swarming like ants down in the huge cuttings through the mountain ranges, working in the hotels serving food and drink, on the wharves unloading the boats, cooking and cleaning and looking after the white children, sorting the mail, painting the houses, carrying the ice, spraying oil on mosquito-infested water, and collecting in a glass vial for the Sanitary Department any stray mos-

quito that was found in a white household.[12] They exist, yet they don't exist. Invisible Man. Invisible presence—all the more available to score fantastic racial readings of modern history and the human condition.

It is difficult to believe that this minutely orchestrated color-line, traced remorselessly throughout everyday life as much as official work rolls and emanating from the overwhelmingly most important generator of employment, money and power, in Central America and the Caribbean, could not have had an effect on the reckoning of blacks and whites held by Cuna people, centuries-old adepts at "playing one side off against the other." Moreover, everything indicates that the Cuna Indians in the San Blas islands, 50 miles from the canal, occupied a totally different place for the North Americans, as they still do—an endearing, utopic, place, full of sweet longing.[13] This mosaic of alterities, with its hierarchy of attraction and repulsion, was not only colored by money into gold and silver; it was also sexualized.

Of Being and Borders: The Sexuality of the Color of Alterity

Nordenskiold points out that while French, and possibly other European "blood" has entered into the racial composition of the Cuna, "miscegenation with Negroes, on the other hand, has never taken place. The blacks have always been held in the most profound contempt by the Cunas."[14] And with regard to blood, Chapin tells us that because *purpa* or soul is thought to be carried in the blood, Cuna are extremely wary of blood transfusions. In a footnote he adds that "the thought of receiving transfusions from negroes fills the Cuna with horror."[15]

In the peace agreement the Spaniards were forced to sign with the Cunas as early as 1741 (when some 800 French Huguenots were living with Cunas and when marriages between Huguenot men and Cuna women occurred), it was expressly stipulated, according to Baron Nordenskiold, that no negroes, mulattoes or *zambos* (offspring of Indians and Blacks) were to live in or pass through their territory.[16] The baron thinks the Cuna motivation was fear of what he calls "miscegenation" but, as he points out, the Cuna men apparently entertained no objection

to the intercourse between their women and the Frenchmen in the eighteenth century.[17] Indeed, the *nele*, the great seer to whom he frequently refers and defers, is said to be of French-Cuna descent. We should also be aware that the English pirate Lionel Wafer in the late seventeenth century, and the ex-U.S. chargé d'affaires in Panama R.O. Marsh, in the early twentieth century, both say that they were offered the hand of young Indian women by their high-ranking Indian fathers. Contrast the alleged offers of marriage to these white men with the reports that after the 1925 rebellion, some children who were the offspring of unions of Cuna Indian women and Panamanian negro police were killed by the Cunas, "in order to preserve the racial purity," says Nordenskiold, who adds that "the women who were pregnant with negro children were forced to have abortions."[18]

Contrary to what Marsh and Nordenskiold say, the Panamanian police serving in Cuna territory were not mostly blacks but mestizos, according to James Howe, an anthropologist of the Cuna writing in 1986, long after the event.[19] This rectification of the record suggests how ready people were to apply the "negro" label, alerting us not only to the wrongness of Marsh's account but more important, to the stretch and tension of its excessiveness, its hallucinatory imagery of the black man besmirching Cuna racial purity, which means, above all, female sexual purity—and in this fearsome imagery there is an uncanny coincidence, a veritable mimesis, between what Cunas fantasized and what Marsh fantasized as the absolute degree zero of alterity, the black penis. Cuna ethnography informs us that the most dangerous spirit, the *nia* (or devil), which causes madness and suicide as well as illness, can assume any form but is

> . . . often described as short, squat, and black, with a huge penis [and] appears to people in dreams as a *waka*, that is, as a non-Indian foreigner, of whom the paradigmatic example is a Spanish-speaking black.[20]

It is crucial to grasp not merely the imaginative effort that has gone into this creation of inside and outside, Cuna and non-Cuna, in a racist pattern of global history, but the historical confluence of soulful power rippling through an alteric mosaic creating sexually charged boundary-

markers. Interesting and disturbing about the Cuna case are the strange complicities achieved between whites and Indians despite the enormity of cultural misunderstanding that existed, complicities in which the positive and negative poles of savagery, as defined by white culture, were meticulously stitched into Indian cosmologies of cultural identity-formation through mirroring and alterizing.

Yet it would be wrong to see this as unique to the Darién. On a more sweeping view of identity-formations in the American continent, the marked attraction and repulsion of savagery as a genuinely sacred power for whiteness has continuously been concretized in terms of noble Indians at home in nature, as against degenerate blacks lost no less in history than to history. That this history is every inch a history of labor discipline, a tropical version of Hegel's Master and Slave in so many banana republics, I hope to make clear. That this history is, in secular times, a Sacred History too, in which race-fantasy takes the place of heavenly fantasy, I hope also to make clear because "race," as defined, acquires the burden of carrying the emotive charge of men exchanging women across the colorless line of tropical proletarianization. It is here that the color of the penis acquires its full charge of demonic power, the powers of what Emile Durkheim, following Robertson Smith, called the "impure sacred":

> . . . evil and impure powers, productive of disorders, causes of death and sickness, instigators of sacrilege. The only sentiments which men have for them are a fear into which horror generally enters. Such are the forces upon which and by which the sorcerer acts, those which arise from corpses or the menstrual blood, those freed by every profanation of sacred things, etc. The spirits of the dead and malign genii of every sort are their personified forms.[21]

Of consequence here is the necessary reminder that the primacy of Being is secondary to the safeguard of the Border. The figure of the nia or black phallus, as exposed by Cuna ethnography, alerts one to the sexual fear and excitement of the boundary created out of mimesis and alterity under specific colonial histories. Rather than thinking of the border as the farthermost extension of an essential identity spreading out from a core, this makes us think instead of the border itself as that

core. In other words, identity acquires its satisfying solidity because of the effervescence of the continuously sexualized border, because of the turbulent forces, sexual and spiritual, that the border not so much contains as emits.

White Indians of Darién

It is here where we return to the adventure of R.O. Marsh who, by his own account (reminscent of *Lord Jim* and Rajah Brooke in the Malay archipelago at about the same time), led the successful Cuna rebellion of 1925 against the fledgling Panamanian State as the direct result of his wildly improbable search for a lost tribe of "white Indians" in interior Darién. A romantic explorer, tied to the purse-strings of great industrialists such as Henry Ford and Harvey Firestone of Detroit, Marsh zigzags across a tropical frontier that is as much within his being as within the modern mythology of sex, race, and capitalism that the Darién magnifies.

He comes down to us with a reputation for inordinate clumsiness as a diplomat, an innocent of sorts, stepping on toes, bullying, and openly espousing visceral dislike of African-Americans. As U.S. chargé d'affaires in Panama in 1910 (four years before the completion of the canal), he tried to manipulate Washington and the Panamanian Congress, threatening military occupation and annexation if the mulatto Carlos Mendoza was elected president instead of a white man. "Mendoza's election," he wrote to Washington, "will strengthen the hold of the Liberal party, which includes the Negro and ignorant elements and is most apt to be anti-American." But it was lack of discretion, not his racism, which forced the U.S. government to demand his return to Washington.[22]

His depiction of his role in the Cuna rebellion in 1925 offers further testimony to his lack of discretion. Indeed what makes his text (*White Indians of Darién*, published in 1934) valuable is precisely that it gives voice to unbridled fantasy couched as matter of factuality in the development of two amazing events—the Indian revolt against the Panamanian State, and the Smithsonian-backed search for white Indians. The very excess of the text is what allows us, some sixty years

later, to take measure of the play of colonial fantasy in real-life events, both then and now, both with Mr. Marsh and in ourselves too.

His text is also valuable for what it suggests about psychosexual racial connections in twentieth century natural science in the United States. It was through the Smithsonian expeditions of 1924 and 1925 that Marsh initiated the search for white Indians in the Darién. It is an evasion to shrug off his text as if it bore no intimate relation to the spirit of positivist science, either then or now. This search was rationalized, if not motivated, by a patently eugenecist and weird physical anthropological concern with the mysteries of whiteness at a time when there was considerable anxiety about immigration and "racial mixture" in the U.S.—a concern serendipitously shared by Cuna Indians (at least by their male spokespersons) regarding their own situation. As loin-girding mental impetus, this racial purity had everything to do with paranoid fantasies of certain men zealously guarding the Cuna womb, a larger-than-life figure for a cosmic model of mimetic reproduction of nature, society, tradition, and Indianness itself. But of course it was the border which defined that tradition and that Indianness, thus making the womb into an organ of alterity as much as mimesis, and this is where the "science" of the men from the United States blended so well with the "cosmology" of the men from the land of the Cunas. What is more, while certain tones and shades may have changed, this confluence of interests seems even stronger today than it ever was. *White Indians of Darien* is the story of an amazing episode in the life and dream histories of the New World. It is all the more valuable for being clichéd and sensationalistic—tropical, colonial, hysteria.

Mr. Marsh's Trunk

You feel something acutely at the level of the body, the male Indian body as celebrated in Marsh's *White Indians of Darién*. You feel him ogling this sturdy musculature, the eye grasping what the hand can't, lovingly scrutinised by Marsh's writerly eye, like a sculptor running his hands over the rippling flesh, like the magician deploying the magic of Contact, and there is something of the evaluative eye of the employer

of muscle-power in this paen of praise to the uncorrupted Primitive body too—the perfect reciprocal, perhaps, of Cuna dreams of foreigners stepping lustily from foreign ships.

At the first "base camp"—the terminology is decidedly militaristic, the entire "expedition" in search of white Indians being an amalgam of science and war—Marsh had to deal with the nemesis that had dogged him from the wharves of New York to the jungles of the Darién, the 370-pound weight of his "travelling salesman type of trunk, particularly strong and heavy, in which were many of the articles intended as gifts for the Indians—machetes, axes, hunting knives, beads, mirrors, etc."[23] It had required four men to carry it onto the boat in New York, but in the Darién just one Indian, all on his own, carried this trunk of mirrors and beads off the boat, grinning from ear to ear. "I have seen remarkable feats of physical strength and endurance," Marsh remarked, citing a list of Third World strongmen he had beheld in his rubber exploration and other trips in Mongolia, China, the Philippines, and Peru, "but for spring-steel muscles and inexhaustible endurance, pound for pound, I have never seen the equal of those Darién Chocoi Indians."

> And yet they are not big men—in fact, in stature they are rather small, seldom over five feet, four inches in height, with symmetrical well-shaped bodies, full deep chests, powerful shoulders and finely muscled legs. It is not the size of the muscles so much as the quality, which gives them their great physical powers. I later saw them pole their dugout canoes up swift mountain streams from daybreak to midnight with never a sign of weariness, while our most powerful negroes became so exhausted after one hour of the same work that they literally fell overboard from sheer exhaustion. (67–68)

Emptying The Trunkful of Gifts Displays not only How Exchange Makes Colonial Subjects but How Subjects Connive in their Subjecthood

The gift-giving from this massive trunk hauled through the Darién rain-forest was somewhat different from Darwin's scarlet cloth given

to the Fuegians, more discriminating by gender, more complicated mimetically. Indeed it is in the gift-giving from Marsh's wonderful 370-pound trunk that we get the full measure not so much of the white man making colonial subjects, women subjects and men subjects, but of the forces at work ensuring Cuna connivance in that subject-making. In reading it one should take note of the fact that since the 1960s or 1970s, the international signifier of Cuna identity is the woman's "traditional" attire, the famous *mola* appliquéd cloth, and that cloth, needle, thread, and scissors all come via traders from the outside—the mola itself, in the form of appliquéd cloth used by women as clothing, probably being no older than the mid-nineteenth century.

Chaperoned by the Cuna chief Mata, on whose good will deep in the Darién he was totally dependent if he were to ever locate the cherished objects of his endeavor, Marsh led Chief Mata's daughter Carmelita and her mother back to what he called his "office tent," where he presented them with samples of everything he had:

> . . . cloth of gold, red and blue cotton cloth, scissors, mirrors, combs, needles, thread, etc. Finally a jar of English candies capped the climax. Chief Mata, on seeing the gorgeous presents given his women folk, glanced rather ruefully at his own clean, but somewhat worn clothing. The chief was about my size, so I took him into my sleeping tent and presented him with a pair of white duck trousers, a pair of white tennis shoes, white cotton socks and garters, and a gray felt hat. He made a quick change under my supervision and emerged proudly in his new clothes to receive the admiration of his family and followers. (102)

It is not simply the fact that men get presents such as guns, knives, and pants and hat, while the women get, and are said to gratefully receive, cloth for clothing—nor that the women are thus made, by Cuna chiefs as much as white men, into the "real" Indians, the bearers of authenticity and alterity in their markedly Other clothing, nose-rings, and haircuts. Rather, there is such positive agreement on both sides that this is how it should be—a positive connivance in Cuna men being mimetic with white men, and Cuna woman being Alter.

In the late seventeenth century, according to the record of the Darién by Lionel Wafer, the Indian men he encountered wore naught but a

penis-cover of gold or silver or of a plantain-leaf—a conical vessel shaped like the extinguisher of a candle, he said.[24] The women wore what he called a clout or piece of cloth tied around their middle and hanging down to the knee. This they made out of cotton but sometimes, he said, "they meet with some old Cloaths got by trucking with their Neighbour Indians subject to the Spaniards; and these they are very proud of."[25] Here George Parker Winship adds a note to his edition of the pirate's manuscript, recording the encounter between Wafer's chief, the esteemed buccaneer Mr. William Dampier, and a recalcitrant Darién chief—in respect of whom Mr. Dampier wrote:

> At first he seemed very dubious in entertaining any discourse with us, and gave very impertinent answers to the questions that we demanded of him; he told us that he knew no way to the North side . . . We could get no other answer from him, and all his discourse was in such an angry tone as plainly declared he was not our friend. However, we were forced to make a virtue of necessity, and humour him, for it was neither time nor place to be angry with the Indians; all our lives lying in their hand.
>
> We were now at great loss, not knowing what course to take, for we tempted him with Beads, Money, Hatchets, Macheats, or Long Knives; but nothing would work on him, till one of our men took a Sky-coloured petticoat out of his bag and put it on his wife; who was so much pleased with the Present, that she immediately began to chatter to her Husband, and soon brought him into a better humour. He could then tell us that he knew the way to the North side [and] he would take care that we should not want for a guide.[26]

Color of Independence

And if the Chocoi Indians carrying his trunk were impressive, how much more so the Cunas themselves—"how infinitely superior," Marsh wrote, "were these independent Indians to the mongrel negroes who were pressing in on them from all sides." The more he saw of the Cuna:

> . . . the better I liked them. They were dignified, friendly, hospitable, and cheery. They were intelligent and quick-witted. They were valiant, or they

would not have kept their independence so long. They were skillfull seamen and artistic handworkers. Their social organization was highly developed and stable. I had not been long at [the long abandoned Scots colony of] Caledonia before I came to the conclusion that this little "Tule Nation" with its culture kept unchanged since time immemorial was too precious a thing to abandon to exploitation by commercial Americans and the negroes of Panama. (196)

Marsh seizes on the Indian as a foil, a utopic hope designed to silhouette the black man as Primitivism Corrupted, not the Noble African but the bestial product of a bestial modern civilization, first on account of its slave trade and slave mode of plantation production, and then because of more recent enterprises such as the United Fruit (Banana) Company spreading along the Panamanian coast. "I have never wholeheartedly applauded the onward march of civilization," he wrote:

In tropical America the net result is usually the replacement of the attractive free Indians by a degenerate population of negro semi-slaves. Indians are too independent and self-respecting to work under such conditions. They prefer to emigrate or die. Negroes hate work, but they can be driven to it. (36)

What is thereby discernible as the hidden historical force in Marsh's quest for white Indians is this dream of power and freedom promised yet continuously thwarted by capitalist development. As in a shadow play, the Indian and the black are the beings through which the ceaseless dilemma of labor-discipline and freedom in capitalist enterprise is to be figured. The frontier provides the setting within which this problem of discipline magnifies the savagery that has to be repressed and canalized by the civilizing process.

Anarchic Rubble of Racial Time

While the white Indians for whom Marsh is searching are at least fixed by their mysterious location at the headwaters of the river in an

unknown valley into which no black man will venture, the black people of the coastline and of the riverine villages on the way to that valley create irruptions and unexpected time-warps. The blacks of Panama (and of the coasts of Colombia) upset white histories and the attempts of their authors to come to terms with the overwhelming turbulence of modern times. But the Indians are there to fix history and restore its sublime order. They are Origin—and as such they are also White and Woman.

By no means does Marsh's gift-laden trunk travel, step by mythic step easing backwards through evolutionary time, to the home of the racially pure, the home of the Primitive. For as Marsh fights his way upstream in 1924 in search of white Indianness, blasting his way clear with sticks of dynamite, what he discovers, indeed what he himself is part of, is not the originary but the rubble of history. At first this rubble occurs as isolated outcrops of white ruins. He curses Captain Selfridge who, engaged in 1871 with his 370 marines in surveying the area for a future canal, produced a map for U.S. Intelligence which proves to be extremely inaccurate.[27] Then a United Fruit Company man claims to have got a fair way upriver a few years before, but Marsh decides he is bragging. The Sinclair Oil Company has its malaria-sickly explorers at work in the forest, and they assure him they have seen numerous white Indians, "white as any white man." Marsh suspects they are secretly looking for gold, not oil, and passes on. Marsh's "base-camp" is itself established with its 370-pound trunk where the oilmen were, in a pleasant coconut grove said to have been conceived by a runaway First World War German soldier who had been part of a team setting up a radio station near the mouth of the Gulf of Urabá for a secret submarine base. The team had been massacred by the British Navy, except for this soldier who hid out in the forest and got the blacks to plant coconuts. After the Germans, the U.S. Army established a secret radio station in much the same place. In fact, when an army plane was on its way back from dropping off mail there, it flew against rules across the interior of Darién and, forced to fly low on account of clouds, spied a village inhabited by white-skinned people. So you can see that this Darién, even in 1925, is a pretty busy place, isolated and trackless, yet at the crossroads of histories where white and black

create strange effects. You get a sense of this when Marsh settles into his account of the Cuna revolt against the Panamanian police. In the space of a few days we hear:

> The U.S. Navy mine sweeper *Vulcan*, which turned up too late to help Professor Baer of the Smithsonian, and whose commander was too scared of the vapors emanating from his corpse to take it on board.
>
> The Store-ship *El Norte* of the Colon Export and Import Company at anchor off Cardi, raided by Marsh and Cuna men for ammunition.
>
> A Greek trader, together with his negro assistant, with a store at Orange Key.
>
> Three "husky Americans" who claimed to be working for the Canal administration and had a small plantation by Gatun Lake where they employed four Cunas. (Remember, Marsh had said Indians would not work.)
>
> Five "heavily armed and rough-looking Americans and Canadians," employees of an American Banana company.
>
> Four U.S. submarines paying a visit.
>
> Numerous U.S. army reconaissance aircraft.
>
> And finally, the cruiser USS *Cleveland*, taking Marsh to safety and decisively swinging the balance of force in the Cuna's favor.

"Anachronism" abounds in this jumbled-up Darién time-race space. The Primitive races refuse to conform, to grant the Originary Fix. When Marsh finally makes contact with the wild mountain-Cuna Indians, he meets the chief, who is lying in a hammock and who greets him in perfect English! "How are you boys? Glad to see you." He had learned his English in New York City and had worked on sailing boats for twenty years, visiting New York, California, Hamburg, Paris, and Japan. His name was "Salisiman," which is an English name, Marsh says, a corruption of "Charlie Seaman."

Far from being children of nature, much of the population of the Darién, one of the most remote parts of the globe, turns out to be a *lumpen*-refugee mass fled from the city. It's as if the farther Marsh pushed into the wildness of nature in search of his white Indians, all he found was the wildness of history. Braced for his leap into the

unknown, it was obvious to him that there was no way his whites had the strength or skill to manage the canoes and, because labor was scarce, he had to search "furiously" for what he called "competent negroes" among the settlements in the rain forest. Promising high wages he recruited "the toughest bunch of negro renegades" he had ever seen, similar, he thought, to the blacks working for the labor-starved United Fruit Company on the Caribbean coast at Puerto Obaldía which had had to use its influence with the Panamanian government (according to Marsh, who as First Secretary of the U.S. Legation ought have known) to round up "negro criminals, vagabonds, dope-sellers, etc." and ship them to the plantations where, with the eye of the local government *corregidor* on them as well, they had (so it is explained) no choice but to work. From this we gain insight into the daily reality guiding the perception of the white employer casting his philosophical eye skyward in search of racial understandings of the human condition, as with Marsh's axiom: "Indians are too independent and self-respecting to work under such conditions. They prefer to emigrate or die. Negroes hate work, but they can be driven to it."(36) The black is cast as historical jetsam, matter out of place, the irrationality of history, while the Indian roots an order, an order of nature—as against history: matter in place. This exerts magnetic force over Marsh and the whiteness in the Indianness for which his text stands, for it is by learning how to employ the very irrationality of history that the secrets of its Origin shall be captured.

Every grouping in this tale inevitably has a chief, leader, or headman, and the "leader" of Marsh's recruits was an "old negro named Barbino" who had murdered a gold prospector several years before and was under sentence of death in Panama City. Marsh describes him as a "fugitive negro murderer." Only one other person is singled out for mention, "a powerful and scarred ruffian." Marsh "herds them back to camp" where he will "fatten them up for the slaughter."(133) Later on when they threaten rebellion out of fear of bad Indians and their magic, Marsh forces them into line, declaring they are all eligible for jail in Panama. (139) Not only the Banana Company uses the State when the labor market dries up, and obviously the State—in this case a State formed by the U.S.—has a different relationship to blackness

than it does to Indianness. Yet because of their anarchic temperament and criminal ways, this very degeneracy of the tropical lumpen can prove indispensable—as in the search for white Indians. Caught in the undertow of history has made the lumpen wise to the ways of the savage man and the savage land. Despite the negro fugitive's record and attempted mutiny early on in the expedition, Marsh begins to respect him. "He was the best bad-water canoemen I have ever known," he predictably writes, "and in emergencies his brain worked like lightning. He later developed into my most loyal follower and was one of the four negroes to get back to the Canal Zone with me." (145)

The Epiphany

The first settlement at which Marsh stopped on his way upriver into the Darién on his first expedition was Yavisa, where history had crumbled into an anarchic scrap-heap, a putrefying threshold. First he espied—and smelled—the negro settlement of "some fifty ramshackle bamboo huts beside the stream—black babies everywhere, flies, mangy dogs, garbage, rubbish, and mud." (25) The villagers struck him as superstitiously afraid of the Indians of the interior whom, they said, would kill any negro who ventured above the Membrillo tributary, proof enough to Marsh that they were all too typically strange throwbacks, "degenerate blacks, less civilized than when they came from Africa." (25) Then came the epiphanic moment. Standing in the midst of this degeneracy, looking into a clearing in the forest, Marsh blinked and rubbed his eyes:

> Across the narrow clearing were walking three young girls, perhaps fourteen to sixteen years old. They wore nothing but small loin-cloths. And their almost bare bodies were as white as any Scandanavian's. Their long hair, falling loosely over their shoulders, was bright gold! Quickly and gracefully they crossed the open space and disappeared into the jungle.
> I turned to the negro headman in amazement. *White Indians!* (26)

We note the swoon. It is Walter Benjamin's observation of the mimetic faculty, where he says that the perception of similarity—as

for Marsh's, in the Darién—is bound to an instantaneous flash. "It offers itself to the eye as fleetingly and transitorily as a constellation of stars." It is the mimesis of mimesis, wherein the primitive and/or the child and/or woman is recruited to endorse the magic of the mimetic faculty. The golden hair. Speed and grace. White-fleshed nakedness and pubescent women making a mockery of, yet heightening, all that seems emotionally at stake where racism, labor discipline, and sexual desire come together for a flashing moment in a clear, elusive image.

12

THE SEARCH FOR THE WHITE INDIAN

Marsh's search for the white Indians of Darién blends sublimely with his account of the spectacularly successful rebellion of the Cuna, as if the very search for that whiteness secreted in the jungle had predetermined such an extraordinary political event. Indeed, it is the revelation of choreographed spurts of whiteness that cascade into the rebellion against the "black" Panamanian State itself. What is at first a poetic and erotic mystery represented in hallucinatory and specifically female terms, swaying golden-haired nubility infinitely desirable yet impossibly difficult to locate and fix, becomes the crucial commodity for which the Cuna willingly open the doors to European and United States anthropologists to study first their whiteness, and then their culture and surrounding ecosystem as a way of gaining autonomy from the Panamanian government. What carries this off is a mimetic contract, a set of largely unconscious complicities between the whites from the north and the Indians they are studying and "saving."

Eroticization of the whiteness of Indians punctuates Marsh's revelation in several places. We have just witnessed the flash of recognition— Marsh granted his first glimpse of white Indians in the form of three golden-haired girls in 1923. And there is also the revelation a year later, reported by his Smithsonian ethnologist the rapidly sickening Professor Baer, who died a little later on the same beach where the legendary Balboa had been executed in the sixteenth century. Attempting to take "complete anthropolgical measurements" of the Paya Indians, Baer had seen "—or at least he thought he had seen," notes

Marsh—the first white Indians of that expedition. With the aid of a friendly chief, Baer had been taken to a small house in the jungle beyond the village:

> As he entered, a frightened young girl, the only occupant, rushed out of the house into the jungle. She wore only a loin cloth. Her entire body and long hair had been dyed a very dark blue, almost black, but her eyes were decidely blue, and the skin around her eyes and on other parts of the body where it had escaped the dyeing process was distinctly white.
> The arrival of a number of angry Paya Indians prevented Baer from making any further search for the girl, and he was not permitted to return to the isolated house. I had no doubt [writes Marsh] that the girl was a young white Indian.[1]

Baer's vision was a desperate one. On account of his illness he had had to plead with Marsh to continue with the expedition, stating that "this was the greatest scientific opportunity of his life. If he was the first accredited anthropologist to study the white Indians, it would be the making of his career," and Baer had already spent time weighing the bodies, brains, and other organs of monkeys they had found. (134) A new species of small white frog had been discovered by Breder, the naturalist from the American Museum of Natural History, and Baer's excitement had been further aroused by his own measurements of around 100 "Chocois" Indians for their "Cephalic Index," and his discovery that the hair of a great many of the children was decidedly light brown.

Doubting the endurance of this obese man, who was in poor physical condition, Marsh had only accepted him to begin with because he wanted the Smithsonian represented, together with its guarantee of scientific authority. But no doubt the Smithsonian needed Marsh, too, with his promise of authentic tropicana nicely packaged in mysterious overlays of sex and color, mimesis and alterity. The iconographic framing of Marsh's book evokes just this intimacy, a transcendent need to merge science with the unknown as woman. The long dedication in its opening pages laments the death of Professor Baer, "Anthropologist and Ethnologist of the Smithsonian Institution of Washington, D.C.," while opposite the title page is a full-page frontispiece of a young woman with a crown of feathers, captioned just as reproduced here.

It is as if this woman will resurrect Baer, if not white science itself, which died taking her measure.

There is every reason to conclude that this use of woman to figure the white Indians is part of a more encompassing urge by which the aura of Indianness per se can be most meaningfully figured by white Indian women. Where whiteness is unavailable, the text nevertheless provides hallucinatory encounters with "ordinary" Cuna women, albeit "light-skinned," as in the following episode when Marsh awoke in what had been an unoccupied house to find a woman looking down at him.

> She was a beautiful young woman, with a splendid figure and the very light olive skin typical of so many of the mountain Cunas. She had done me the honor of treating me as a familiar house guest, not as a stranger. That is, in accordance with Tule [Cuna] woman's custom within the confines of her own house, she had taken off her long skirt and appliquéd blouse and was dressed like the Chocoi women in merely a short loin cloth. I had decided to attempt no amorous adventures among the Indians as I knew the resentment such affairs can cause. But I could not help thinking . . . (110)

Such thoughts can lead to spectacular actions, little performances of civilized power ejaculating multicolored magic against the dark backdrop of the jungle. That night back in the village Marsh decided "to give a big splurge in the chief's honor" and use up all the fireworks he had brought. (There are basically two types of Indians in his account, light and white-skinned women on the one hand, male chiefs, on the other.) Posts were erected for pinwheels. Chutes were prepared for the big military signal rockets, and the colored flares were arranged in a semicircle. "At the end of the meal we whites showed off our fireworks against the dark jungle background to as an appreciative audience as at any country fair." (111)

White Indians At Last

"I explained that nothing would arouse more sympathy among the powerful Americans," said Marsh, relating his speech to the Cuna

Mimi: White Indian Girl (Marsh, *White Indians of Darien*, frontispiece)

gathering of chiefs at Sarsadi on the San Blas coast, "than the knowl-
edge that some Darién Indians had white skins like their own." (194)
This was one year before the armed uprising. And he went on to tell
them that the "Tule [Cuna] race was doomed to extinction, mongreliza-
tion with the negroes, or practical slavery if they did not train them-
selves to meet the white man's civilization on its own ground." (194–
95)

After a night's deliberation the chiefs were more than willing to send
delegates with Marsh to seek aid in Washington, D.C.

> "Do you still want to take with you some *Chepu Tules*—white Indi-
> ans?" Chief Ina Pagina asked him.
> "Yes," he said, unable to believe his ears.
> "The people along the coast all want to see you," said the chief. There
> will be many *Chepu Tules* amongst them. You can take all you want."
> (195–96)

Thus Marsh turned the corner. Whereas before, despite massive
exertion, he had not obtained more than a glimpse of white Indian
skin, now the Indians had caught on to the new requirements for the
time-honored game, playing "one side off against the other." Earlier
the white man had wanted gold and silver, then fustic, i.e. yellow dye
wood. Now what they wanted was whiteness, white Indianess, to be
exact. Making its triumphant way along the San Blas coast, first leg of
the voyage back to Washington, Marsh's boat stoped at Portogandi.
A great number of canoes brought him his first white Indian. This was
no scintillating eyeful of fast-moving girlhood, but a boy of fourteen,
stolidly there in his sheer whiteness:

> He certainly made a strange appearance among his dark-skinned coun-
> trymen. His hair was light golden yellow. His skin was as white as a
> Swede's. His eyes were brown, not blue or gray. His features were decid-
> edly different from the rest of the Indians—rather more like a Nordic
> white man. And his whole body was covered with fine downy white hair,
> three quarters of an inch long.
> I looked at him in amazement. Here was my white Indian at last. But
> I didn't know what to make of him. He wasn't the usual type of albino
> by any means, for albinoes have pink eyes and white hair. But whatever

he was, the scientists [back in the U.S.] would have a grand time explaining him. (199)

Then came that wondrous curtain-drawing moment when the Cuna turned themselves into ethnographic curios. In stark contrast to previous times, "We were given full permission to wander about the village, taking pictures and examining the houses, boats and other possessions of the people. It was rather exciting to realize that no white man had ever had such privileges at Portogandi before." (199)

Marsh impressed upon the chief that white Indians "might help prove closer relations between the Indian and the white man." The chief said it was good. "He would see that I got all the white Indians I wanted." (201) But before the Indian is given a chance to Other himself by producing this curious mimetic double of the white man, Marsh has first to Other the Indian—which inevitably means working over the women.

On hearing that the Panamanian government was preventing "the Indians" (meaning, of course, the women) "from wearing their gay native costumes" and was trying to get them to wear "the hideous 'mother hubbards' worn by the negroes near the Canal Zone," Marsh swung into action:

> My reaction to this was to buy from the captain all the bright cloth and trinkets he had on the yawl. The San Blas costume is extremely picturesque and very modest. The women wear a blouse gayly decorated in many colors, a long appliquéd skirt, and plenty of golden ear-rings, nose-rings, beads, etc. I took the gifts ashore and began distributing them to the women. (202)

Then the Indians brought him another white Indian—a little naked white boy about eight years old with golden hair and blue-green and brown eyes. The chief made a formal present of him. (202) Marsh was now on a roller-coaster of mimesis and alterity. He "casually" mentions he wants to "buy pottery, arrows, spears, wooden images, baskets etc.":

> In no time I was mobbed by hundreds of men, women, and children bringing me all sorts of things. I got barrels full—elaborate, artistic

pottery, gaily decorated grass baskets, weapons, carved canes, alligators in clay and wood.

The price didn't seem to matter. I paid a few cents each. In a few minutes I had all my canoe would carry, but still the people came. I think every family in the village brought something to sell me or give me. I retreated to the yawl, but the deluge continued, and I had to take them all, including song birds, fruit, and beautiful gay dresses with strange hieroglyphic embroideries. In two hours I collected more San Blas works of art than all the museums in the world possessed. By evening the hold of the yawl was full of ethnological specimens of every conceivable kind. (202–203)

More white Indians were coming into the village from the mountains, the rivers, and other islands. Some were pure white, others midway between white and brown. "We took pictures of them and asked them questions without reserve." (203–204) Thus was the pact consumed with ethnological science—white science, we might call it, engaged in the politically powerful transfers, subtle and crude, conscious and unconscious, of mimesis and alterity.[2]

Perfect Timing

Fifty years later a close student of the Cuna could observe that "the first truly scientific expedition" moved into San Blas in 1927 (a bare two years after the revolt) under the leadership of the Swede Baron Erland Nordenskiold. "The timing of the Swedes was perfect" this scholar observed, for the chief (*nele*) was "involved at that time with a project to record the traditions, and had been encouraging those Indians with writing skills to copy all the sacred knowledge of the tribe into notebooks."[3]

In fact it was one of the nele's secretaries, Rubén Pérez, who put Cuna culture into the world catalogue of ethnographic knowledge during his six-month stay in Sweden, working in the Göteborg Ethnographical Museum in 1931. Having been the secretary of the Great Seer on the San Blas coast, he now became the secretary of the great ethnologist in the Göteborg Museum. He not only brought what the

"White Indian" having her voice recorded by J.P. Harrington at the
Smithsonian Institution, Washington D.C.

baron considered to be valuable documentary materials in Cuna and
in Spanish—medicinal chants taken down from healers, others taken
in dictation from the nele, High Chief and Great Seer—but he also
spent a good deal of time cataloguing this material and adding to items
already in the catalogue. We have to see Pérez as part of an audacious

Two Cuna men with recording machine, Smithsonian.

movement led by the Great Seer. He was, moreover, an avid collector of Cuna history. Earlier he had been sent across the gulf to the fortified Colombian port of Cartagena in search of records relevant to the Cuna past, and it seems that he saw his task in Sweden this way too.

We have here, then, a sort of figure-eight whereby mimesis curves over into alterity, then comes back again, enlivened by a little joke. The ethnologist moves out from old Europe to the Indians, and the Indian moves into Europe—incidentally one of its "whitest" parts, and one that features quite remarkably in Marsh's account of the Darién. (He recorded his first glimpse of Indian whiteness as Norwegian, later as Swedish.) Moreover his Smithsonian linguists told him that the Cuna language was like no other Indian language. Instead it showed traces of Old Norse! It is easy to laugh, now, at what many of us would like to feel are dead sentiments, relics of prejudice long passed by. And then there is Rubén Pérez' little joke in Göteborg, fondly recorded by the baron in connection with the cataloguing of Cuna beliefs about the

land of the dead stuffed with the white man's commodities. Pérez used to say jokingly that in the kingdom of the dead the Göteborg Museum would belong to him.[4]

It seems clear that being objects of scientific curiousity has provided the Cuna with political currency as well as a little joke between friends concerning the future of the dead Indian: what first and foremost makes and marks the Cuna is the skill with which they have been able to market themselves in the great gamut of white Otherings, a task that could not be achieved without a considerable degree of assistance—a two-way street. A noted recent scholar of the Cuna is not just being polite when he declares in his preface that these otherwise restrictive people among whom he carried out his fieldwork in 1968 and 1970 "have been superbly hospitable hosts, sensitive to, interested in, and supportive of my research."[5]

The Lay of the Land

The Earth is the body of the 'Great Mother,' and in the beginning she was naked.

—Chapin, "Curing Among the San Blas Kuna."

The lay of the land is crucial to the emplotment of Indianness as elusive, white, and female, against a gathering storm of blackness. For both the Cuna and Marsh, albeit with different resonance, this land is preternaturally female. For Marsh, the land is the Great White Cunt, the "unknown valley" first espied and "shot" by scientific means with the sextant and later with aerial photography, using military equipment and military aircraft from the Canal Zone. For the Cuna, if the healer's chants and theories of power are any guide, much of the world is conceptualized, imagized, and activated as womb-sprung; the land, in a specific and also a cosmic sense, is the Great Mother. Moreover, in both figurations of the lay of the land, Marsh's and Cuna's repression is at work displacing the sexual through other signs. In Marsh's case this is obvious, the displacements no less than his constant reference to the hostility of Cuna men toward foreigners eyeing their women,

while the censorship and repression of sexual matters amongst the Cuna themselves if notorious throughout the ethnographic literature, whether in everyday Cuna life or in the double meanings and word play in the formalized healing and other chants.

Once again the point to marvel at is not simply the poetical and ultimately political labor involved in representing the land this way, but also the curious mimetic overlapping between Marsh and the Indians concerning what Freud, in his essay on the uncanny, designated as that homey place between the mother's thighs. The labor exercised on behalf of this place is a constant in Cuna Studies, as reference to the most famous anthropological commentary and analysis of the Cuna makes clear—namely, that of the curing chant for obstructed birthing, the Muu-Igala, first published by the Swedes Nils Holmer and Henry Wassén in 1948, and then analysed by Claude Lévi-Strauss in 1952. Their interpretations rest on the assumption that the Cuna believe the shaman's spirit-helpers journey into and along the laboring woman's birth canal in search of Muu, the Great Mother. Coming thirty years later into the debate with a good knowledge of the language, Chapin vigorously contests this assumption by arguing (on the ultimately treacherous ground that literality can be separated from the metaphorical) that the Cuna in fact believe the shaman's helpers travel not along the laboring woman's actual vagina but along a spirit river that suddenly "snaps" into becoming a mimetic spiritual copy of the birth canal, a copy crucial to the spiritual architecture of the Cuna world. You can see how curiously complex this all is, what strange paths this mimetic faculty leads one into—not least of all Mr. Marsh whose first chapter, "The Unknown Valley," begins thus:

> This story properly begins with a sextant "shot" of Mt. Porras on the Pacific coast of Darién. If I had not taken that "shot" I would probably have made a superficial survey of the region, reported to my employers, Henry Ford and Harvey Firestone, that there was no suitable rubber land in Panama, and passed on to Liberia or the Philippines. (3)

It is this lucky sextant "shot" that reveals to him, capable man of navigating science that he is, that the maps of the Isthmus are incorrect

and that an unmapped, unrepresented, and in that sense unknown valley runs along its interior, irresistibly drawing him into it.[6] But why does this valley fascinate him so? He does not know why. Gradually it swirls with images bearing strange powers of attraction. But why are they so attractive? What is behind the mysterious process whereby he chucks in commerce—Ford and Firestone—because of an unquenchable passion to explore the valley instead? As he gets closer he can't sleep for thinking of the "undiscovered valley just beyond; then of my little friends, the Indian girls with the Swedish complexions." (29) As what he calls the "defenses" to the valley loom ever larger, it becomes "fertile," yet "death to any black man"—a secret reserved for white men and to be opened exclusively by them—a little intimacy between strangers, bound by their lack of melanin. Finally, as a still to be discovered entity, it becomes "my" valley and the lure of big Capital is hurled aside:

> I had ceased to care if Akron got its rubber or not. I didn't want this lovely wild valley to be overrun by thousands of degenerate Jamaica negroes like those who worked on the Panama Canal. I didn't want its harmless and attractive Indians oppressed and exterminated. It was "my" valley. (35)

The Blind Spot: The Closer You Get, The Greater the Mystery

How strange a thing it is, Marsh ruminates, that unknown tribes exist in the Darién Isthmus within a few miles of one of the world's great shipping routes. To him it is "one of the numerous blind spots of Latin America," comparable to the slums under the Brooklyn Bridge that exist unbeknown to the strap-hangers who pass above in the trains. The curious thing, he states, is that the closer you get, the greater the mystery becomes. (11) How curious, we might want to add, that this *blind* spot is to be characterized, in the Darién, at least, adjacent to the great U.S. Canal, by *whiteness*, the color of light, and that this light shall be obsessively silhouetted by ominous darkness, a phallic blackness

spearheading the destructive commercial world. How cunningly this blind spot blends sex, race, commodity production, and land in an alternating current of revelation and concealment: "The closer you get, the greater the mystery becomes"—a colonial version of Freud's uncanny. What better way for a white world to capture the alternating rhythm of mimesis and alterity than with the uncanny image of the white Indian? On the one hand is the mimetic revelation of whiteness, on the other, the alterity of the Indian hidden in Darién jungles, the two "moments" of mimesis and alterity here energizing each other, so that the more you see the phenomenon as mimetic, as "like us," the greater you make the alterity, and vice versa.

War Paint

This alternating current is depicted in innumerable ways, none more strange than the two events when Marsh was personally involved in armed combat in the Cuna uprising. In each instance, according to Marsh, the Indian men opened fire on his orders, executing a plan he claimed to have had a large part in planning. The first occasion was just after he had drafted, together with Cuna chiefs, the Cuna Declaration Of Independence (based on his knowledge of the U.S. Declaration of Independence).[7] The second was an attack on a garrison in which twenty-two Panamanian soldiers were killed, and which had a great effect on the outcome of the uprising.

On these two occasions Marsh let slip that he was costumed in Indian dress. Before the battle, "All of us, including myself in Indian dress, had our cheeks painted red, a red stripe put on our noses, and each was given some concoction to drink, prepared by the Indian medicine men." (255) In no other circumstance does he mention being dressed like this except for the dance of the "Chocoi" Indians of the interior in 1924, a year before, when the women painted his body.

In the thick of struggle where men blend in common cause, mimesis and alterity are brought to a fine intertwinement. The alternating current flows smooth and fast, along with the paddles of the fast-moving war canoes. We can just about see him in there, dark as it is

for this night-time attack, concealed among the Indians he is leading. There seems, in our imaginations at least, to be a flurry of feathers and the glistening of war paint—then suddenly we haul back before a photograph of Cuna Indians from that time, for instance aboard the USS *Cleveland*. What is this "Indian dress" he is dressed in? While the Indian women, placed nicely in the center with their elaborate *molas* and nose-rings, carry the burden of tradition, like the U.S. sailors, the Indian men are dressed altogether differently. They are wearing Western-style long pants, white shirts, ties, and felt hats—the standard attire then and now for a well-dressed Cuna man. When Marsh first reached the San Blas coast and met Chief Ina Pagina, the latter was wearing a white shirt and trousers. Others state that Cuna men were wearing pants and shirts from "Victorian times."[8] The French naval official Armando Réclus, who visited some Cunas along the Paya River in the late 1870s, said that almost all the men wore trousers and a cotton shirt of U.S. make, and elaborated at some length that the visitor who expected in the midst of these wilds to encounter Indians in feathers, as they were at the time of the European Conquest of the Americas, would here suffer terrible disenchantment.[9]

Was this get-up in European trousers and shirt (perhaps with tie) Mr. Marsh's disguise, crouching in his war canoe mimicking an Indian mimicking a white man? Or was he perhaps dressed in drag, not mimicking the men but the women—the overwhelmingly dominant referent of "Indian dress"—instead? We shall never know. All we know is that finally, for two glorious moments, mimesis and alterity melted into each other in the attack "led" by Mr. Marsh on the "negroes" of the Panamanian government. *For now he was a white Indian himself!*

13

AMERICA AS WOMAN:
THE MAGIC OF WESTERN GEAR

To exercise the mimetic faculty is to practice an everyday art of appearance, an art that delights and maddens as it cultivates the insoluble paradox of the distinction between essence and appearance. Cuna ethnography has much to teach concerning the spirit powers that, in the form of images, emerge from this paradox. Suffice to say it would be an excruciating error to think of spirits as some sort of bounded population, like caterpillars, for instance. To the contrary, as the "clarified" translation of the Cuna Charles Slater's statement brings out, "image" and "spirit" become interchangable terms, testimony to the elusive and compelling power of appearance and its mysterious relation to essence, a fact nicely illustrated by the various meanings of the word for soul blurring imperceptibly with spirit, image, and appearance(s)— as listed in Chapter Eight, "Mimetic Worlds, Invisible Counterparts".

What is essential to grasp here is the strangely naive and ultimately perplexing point that appearance is power and that this is a function of the fact that appearance itself can acquire density and substance. It is this property that brings spirit, soul, and image, into the one constellation. That this arouses fear, longing, and wonderment, is surely no surprise. The fetish power of imagery in shrines and magic is merely a heightened and prolonged instance of this tangibility of appearance. The current coursing back and forth between Contact and Imitation, tactility and visual image, is also testimony to this power of

appearance. Epistemologies of science bound to the notion that truth always lies behind (mere) appearance sadly miss this otherwise obvious point. Daily life, however, proceeds otherwise.

Colonial history too must be understood as spiritual politics in which image-power is an exceedingly valuable resource. Cuna ethnography provides valuable lessons in this regard, the most notable being the gendered division of mimetic labor among the Cuna.

Imbricated in the age-old game of playing off one colonial power against the other, this division meshes with the sex dynamics of colonial power. While Cuna men, particularly in their high status and sacred roles, adorn themselves in Western attire with felt hat, shirt, tie, and pants, Cuna women bedeck themselves as magnificently Other. It is they who provide the shimmering appearance of Indianness. In so doing they fulfil a role common to many Third and Fourth World women as bearers of the appearance of tradition and as the embodiment of the Nation. What is so fascinating is the way this male/female division of mimetic labor fuses with the sexual dynamism of the colonizing imagination. We have already had opportunity to witness this fusion in the steady tension in Marsh's text to present Cuna Being as quintessentially of Woman—desirable but untouchable and in a profoundly uncanny sense "uterine" and imperiled by black pollution.

America As Woman

What then are we to make of the colonial practice of imagizing America as Woman from the sixteenth to the mid-nineteenth century? I have in mind here Europe's naked America with feather headress and bow, languidly entertaining Discoverers from her hammock or striding brazenly across the New World as castrator with her victim's bloody head in her grasp.

This colonial image of America as woman extends into anticolonial reckoning as well. Consider the anti-imperialist revolutionary iconography of independence in the following portrait of Bolívar by the Bogotá painter Pedro José Figueroa, painted in 1819: far from transforming the female image of colonized America, this work maintains

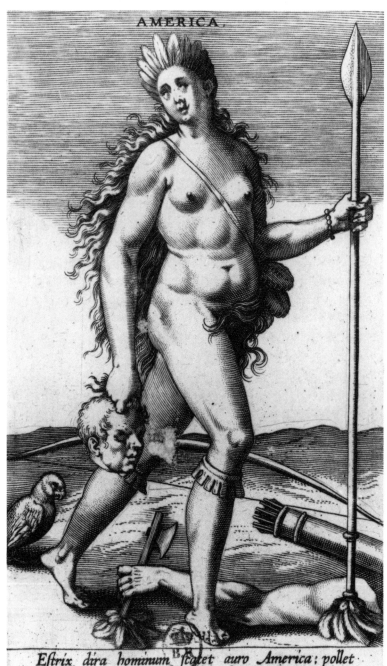

Eftrix dira hominum ftatet auro America; pollet
Arcu; psittacum alit; plumea ferta gerit.

43.

America, 1581–1600. Philippe Galle

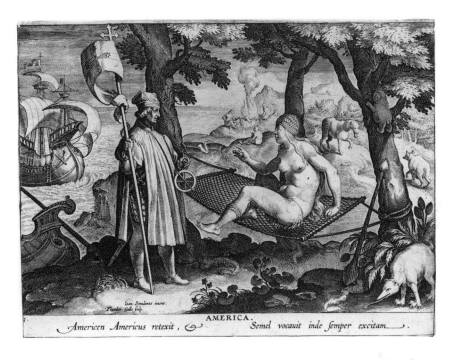

Vespucci "Discovering" America, late sixteenth century, Theodore Galle, after
Stradanus
(Jan van der Street)

it all the more securely in the name of the Revolution of Independence, firmly esconced in Bolívar's embrace. Adorned in (colonialized) alterity, tribute of pearls and gold, together with a bow and headdress of feathers, America is decisively mimetic of Europe. Her face is that of a European woman, perhaps from the Iberian penninsula. Her diminutive size in relation to Bolívar, who embraces her protectively, if not possessively, leaves no doubt as to the relation of power between this morose-looking Creole leader in scarlet uniform and this doll-like, Spanish-featured woman adorned with European symbols of Indianness.

This is Marsh's protective clasp a century later.

The basic form of this image was also rendered in bronze and installed in the mid-nineteenth century not far from the Cunas in the Panamanian port of Colón. It was a present from the aristocracy of Europe to the aristocracy of Spanish America, from ex-Empress Eugénie to Tomás Cipriano Mosquera, three times President of Colombia. It has been described by the French naval officer Armando Réclus, General Agent of the French Canal Company (Compagnie Universelle du Canal) in his memoir of his explorations of the Isthmus of Panama between 1876 and 1879. Highlighting the fact that this little port built on a marsh consisted of two different areas, one for whites and one for blacks who lived under appalling conditions, Réclus went on to describe the solitary public artwork in that port, a magnificent bronze statue of Columbus and America. Erect and fiery, the admiral is protecting America, a naked, beautiful, and tiny woman. To Réclus she seemed frightened but at the same time seductive, reminding him of an enchanting Parisienne—a "white Indian" we might say, or at least a French one.[1]

In her painstaking 1953 study of the legendary conquistador Vasco Nuñez de Balboa, Kathleen Romoli extends the women-centered narrative of Darién colonization. Quoting from the early chroniclers she describes how the Cuevan Indian women struck the Spanish men as astonishingly beautiful. What's more they "showed a flattering preference for Spanish lovers"[2] (a conquest of love, we might say, setting the stage for four centuries of "playing one side off against the other").

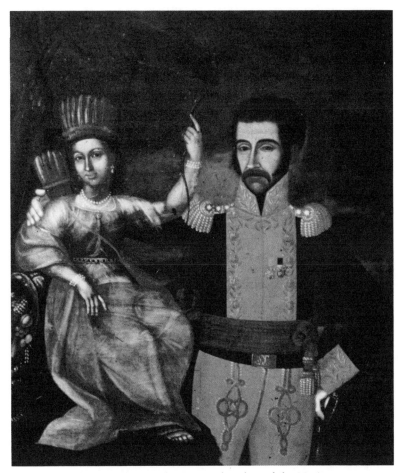

Simon Bolívar: Liberator and Father of the Nation
Pedro José Figuero, Bogotá, 1819

Then we have Romoli the historian displaying her own indebtedness, and not just that of the conquistadors, to women-centered tropes of the lay of the land and of the metaphysic of origins that inflamed Marsh with his "unknown valley" and which serves also to center Cuna cosmology. Almost the very first words of her carefully drawn text inadvertently establish Darién and her place in it as much as a legend as a place, and this legend is emphatically motherly, reproductive,

181

originary, and mimetological. The Darién, she writes, "was the mother of exploration and settlement from Mexico to Tierra del Fuego, and its story—at once a gaudy melodrama and an outline of early colonial methods—constitutes a small-scale working model, handy and complete, of the whole Spanish conquest of the New World."[3]

Yet if we were to study history guided by the allegory of Figueroa's portrait of Bolivar protectively, possessively, embracing America as woman, sexualized and/or motherized, what would we find? Unlike most of the world colonized by Europe from the sixteenth century onward, sexual intercourse as well as cohabitation between colonizing men and native women in Latin America was not uncommon and was the obvious source of the (in many places numerically dominant) mestizo fraction of the population. Balboa had his beautiful Indian mistress on the Isthmus, and it was poor Spanish men who, living with Indian women, established the European presence across the length and breadth of the Spanish New World. But for the Cuna the story seems different—very different. Here the outstanding feature is the male-controlled access to the women, sealing them off from the foreigner—totally in the case of blacks, partially in the case of whites, following an on again/off again rhythm—and the consequent investment of these women with an extraordinary colonial aura. Their very appearance, therefore, serves as fetish.

Woman's Image As Fetish: The Art of Appliqué

This Fetish-Allure is illustrated by the British trader Orlando Roberts who sailed the coasts of Central America in the early nineteenth century. First he makes clear that the (San Blas) Cuna are different from all other Indians with whom he has dealings; he singles out their short statue, their industriousness, their long hair, the high proportion of albinoes, and the fact that the men are:

> ... extremely jealous of their independence, which they have hitherto strenuously maintained; and what is not very common among the other Indians of South America, they are fond and careful of their women.[4]

The men's appearance barely rates a mention. On the other hand:

Some of these ladies accompanied their chiefs on board the vessel. They were clothed in wrappers of blue baftas, or stripped cotton of their own manufacture, reaching from the breast to a little lower than the calf of the leg. They wore a profusion of small glass beads round their ankles, forming a band of from two to three and a half inches deep, and similar bands or bracelets were worked around the wrists. Their ears were pierced, as well as the cartilage of the nose, in which they wore rings of gold or silver; the ear-rings principally supplied by the Jamaica traders— the nose-rings seem to be of their own manufacture, being a thick ring of gold in the form of an obtuse triangle, about three quarters of an inch in circumference. On their necks, they wore an immense quantity of fine seed beads of lively colours, and necklaces of red coral. Some of those worn by chiefmens wives, would alone weigh several pounds. Their hair, which is very long and black, was made up not inelegantly, and fastened on the top of the head with a sort of bodkin made of tortoise-shell, or hard wood. Their complexion is much clearer and brighter than that of the men. Over the head was thrown a piece of blue bafta or sahempore, completely covering the back, breasts, and one side of the face. Altogether the deportment of these women was extremely modest, diffident, and amiable.[5]

Perhaps this lavish visualization by the trader is to compensate for the inability to extend to the women any of the other senses. As with cinema, the eye grasps at what the hand cannot touch:

Their husbands are exceedingly jealous of strangers, and that is said to be one of their reasons for refusing to allow Europeans to settle on the mainland. Their trading intercourse is always carried on at one of the numerous kays or islands on the coast, selected at the time for that purpose.[6]

These women are only to look at. But that look is worth a good deal in the Nation-State politics of engendered difference that today gives such high value to woman as image bedecked in her gorgeous blouse. "The single most important connection between the San Blas Indians and the outside world," write some thoughtful students of the *mola*, "is the woman's *mola* blouse."[7]

As that which defines Cuna for the outside world, this appearance of women is also, in the words of two anthropologists who have worked amongst the San Blas Cuna since the late 1960s, "a magnificent element of social control for the Cuna." They explain that Cuna women are often considered (by Cuna men) to be "weak creatures, fragile, easily tempted, and in need of advice and direction." This theme, they say, is repeated endlessly in the Cuna gatherings or congresses that occur village-wide several times a week, usually in the evenings, these congresses being the main vehicle for advising women on correct behavior.[8] "Go and sew your *molas!*" is the most common cry by which these meetings are announced the day before.[9]

> The constant task of making *molas* keeps women out of trouble: more particularly it prevents them from wandering about the streets and keeps them in place where they make *molas*—in homes or in the congress. Since they make rather than buy their own clothing, and since this clothing is a source of prestige, there is incentive to make *molas*. Since the Cuna place great emphasis on maintaining their traditions and having them publicly performed, in such contexts as the congress, the congress then performs the dual function of bringing the members of the village together to communally listen to their leaders display their knowledge of tradition and at the same time keeping women from misbehaving and keeping them making *molas*[10]

In so industriously beautifying and setting apart the Cuna world by means of the clothing they are constantly making and wearing, it would seem from this account that Cuna women sew themselves into an iron cage.

The performance of these evening meetings, when the village comes together and orders itself by sex and rank, is revealing. Seated or reclining in their hammocks in the middle of the large room, the senior men discuss among themselves pressing business of the day. Then two of them stage a dialogue in ritual speech which will later, after two hours perhaps, be translated and interpreted for the rest of the village. To carry out this dialogue the two men stare fixedly into space, arms rigid by their sides, displaying no emotion. Around them are the women and children, and on the periphery surrounding the gathering are the

remainder of the men together with the Cuna police keeping order, waking up sleepers, and so forth. The women are in their finest clothes, wearing molas they have made themselves as well as gold jewelry, and they carry baskets with their evening's work— molas they are finishing. As the men at the center chant, the women (at least those who have not laid aside their tools to attend to their children) "are industriously cutting and sewing molas. Quite a few have brought tiny, one-legged tables for their work, each with a smoky, cough-producing, kerosene lamp made from a cocoa tin with a hole for a wick in the top."[11] The scene impresses itself on the anthropologist, beginning with the smell of different smokes—the pipes, the cigarettes, and those kerosene lamps— lending themselves to an aura consummated by

> . . . the symbolic seating arrangement in which the women are grouped together in a colorful array, dominated by the rich red of *molas* and headkerchiefs in the misty darkness, and the overall impression is that of a dramatic chiaroscuro, all under the towering roof of the "gathering house," which forms an intricate pattern of bamboo and palm.[12]

But what makes this chiaroscuro effect dramatic, surely, are not only the red molas rich in the misty darkness against the towering thatch, *but the garb of the men*, dressed in their best clothes—"western-style slacks, shirt, and hat," while the senior men often wear ties as well.[13] The imaging by and of woman becomes all the more notable when we stop to consider how different is the intercultural significance and image of Cuna men. Not only are they the great mediators with easy, adventurous access to the outside world since well over a century, working as sailors, migrant laborers, and Canal Zone employees,[14] and not only do they hold a monopoly over the acquisition and transmission of sacred lore and sacred languages, but their visual appearance is one that mimics Western design. While the women assume the task of wearing and hence signaling radical Alterity, from their nose-rings to their molas, the men for at least a century have been decked out in Western attire, not least when they dress up for important occasions with ties and felt hats, as when curing or carrying out chiefly duties— or when being photographed by influential outsiders. Indeed, photog-

raphy concentrates to an exquisite degree the very act of colonial mirroring, the lens coordinating the mimetic impulses radiating from each side of the colonial divide.

This is demonstrated by a three-quarter page photograph (in Ann Parker and Avon Neal's handsomely illustrated book, *Molas: Folk Art of the Cuna Indians*) which shows a Cuna "headman" standing alongside his wife in front of a thatched-roofed house.[15]

They stand stiff, hands by their sides and legs, not quite at attention. It does not take much imagination to think of them as very much "on view," prefiguring the eyes that will fasten them to their caption, "Headman and wife, Rio Sidra."

Does Western Photographic Representation of the Cuna Complement Cuna Use of Wooden Figurines to Represent and Gain Access to the Spirit World?

I cannot resist the temptation to compare this image with the *nuchus*—the carved wooden curing figurines with which I began my exploration of the mimetic. There I quoted Baron Nordenskiold to the effect that the figurines were of European types (below, p.3); Chapin, fifty years later, confirms this, saying they are of "non-Indians." But the baron also went on to say that nevertheless it is not the outer form but the inner substance—namely the personified spirit of the wood itself—that is accredited with the power to act out the healer's song. This personified spirit is very much a Cuna figure, not a European. The question is thus raised as to *why there should be a European exterior* if the spirit of the interior substance and not the outer form constitutes, according to Cuna informants, the essential, the "magical" element of the curing?

Might one suggest that the curing figurines match the male-female division of mimetic labor as registered by this Western photograph, that the outer form of the figurine mimics the outer image of the Cuna man, as that image so manifestly presents its brave front to the Western world, while the inner spirit of the figurine, which is where the womb-sprung origins of Cuna power lies, is replicated by Cuna womanhood?[16] This suggestion is important because, as with Orlando Rob-

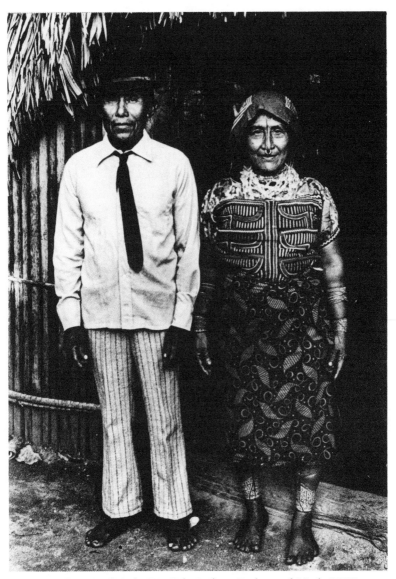

"Headman and Wife, Rio Sidra" (from Parker and Neal, 1977).

erts' lavish description of the Cuna women in the early nineteenth century, it pinpoints the role of the "select appearance" vis à vis the outside eye. In drawing a parallel between the composition caught by this outside eye and the magical composition of the nuchus, we draw attention to this intercultural optical source of magical power—not to mention the role of the First World photographer conspiring in the making of a *nuchu* by means of the photographic image. This male/female composite image is no less curative for the Western viewer than the nuchus are for the Cuna. "Photographers need plenty of small change," advises *The 1982 South American Handbook*, "as set price for a Cuna to pose is US 0.25."

Male Magic of Western Gear: The Journey of the Dead Man

Given the fastidious attention to woman's garb, hence display and image, it is interesting to come across fragments in which the male exterior is spiritually valorized. We read of this with the chant of the journey of the soul of a dead man published by Nordenskiold and Pérez. Here there is a twofold movement of dressing, the first when the man dies, the second when the healer, having begun his song, moves to the phase of carving out figurines which shall become spirits protecting the soul of the dead man as it undertakes its journey to the land of the dead. The song tells us these things:

When the man dies, his souls evacuate the body. The hair souls. The souls of the fingers. The souls of the heart, the tongue. The soul stands at the end of the hammock and weeps because it cannot return to its body. The tears drop. The tears trickle.

All this is being sung.

The family lift the dead man, places him on the shroud, and bathe him:

They put on him a white shirt, they put on him trousers. They put a tie on him. They paint his face, they draw on his face. They comb his hair and put a hat on him. His perspiration (blood) has run down onto the ground.[17]

The dead man's wife goes to the singer, the man who can conduct the spirits with his song. She asks him, "Will you get the pegs [figurines] ready for me?" All this is being sung.

Then comes the second movement. It is a repetition of dressing the male corpse in Western gear, but this time the dressing is of the singer himself and is directly associated with the singer eliciting spirit power in his curing figurines:

> The singer calls on his wife and asks her to get the water ready. She pours the water. The singer takes off his old trousers. He bathes in the water. The singer dresses himself in a white shirt and black trousers. He puts on a necktie and hat. "I will walk up God's road," he says.[18]

Then he carves the wooden pegs and places feathers and beads on them. All this is sung. He paints shirts on them and places them under the dead man's hammock. He asks for cocoa beans. Thus the singer changes these wooden pegs into spirits. There are eight men spirits and three women spirits. Their job is to protect the dead man's souls on the journey the song, hence the souls, is about to begin.

What the alterizing Western eye tends not to see, of course, in its infatuation with the Indian women's "colorful" gear, is that its own, Western men's, clothes can have magical significance: that trousers and ties and derby hats create magic too, preparing the corpse in relation to the journeying of its soul, readying the chanter, charging wooden figures with spiritual life.

Male Magic of Western Gear: Beat the Devil

In this regard it is pertinent to invoke a strange section of perhaps questionable veracity from the Cuna healer's song, the Nia-Ikala—The Way of the Nia (Devil). It was published in 1958 in Spanish and Cuna by two of Nordenskiold's former students, Nils Holmer and Henry Wassén, from the text they received by mail from the Cuna schoolteacher, Guillermo Hayans, with whom they corresponded concerning the accuracy and meaning of their translation into Spanish.[19] I wish to

invoke a section of this song that, in its description of the function of the male Western clothing, has a profound resemblance to the song for the journey of the souls of the dead man recorded by Nordenskiold and Pérez.

Following detailed descriptions of the domestic world of the male healer (some 170 song-lines), the song tells that a woman approaches saying her husband has been seduced by a female devil and is now crazy. The healer agrees to help, and the song he then sings describes the many wooden figurines that will help him capture the kidnapped souls of the sick man, how the figurines are being placed in a row, how each is being addressed as the spirit of the wood of which it is carved. One by one they are being named. Now they are all conversing, like living beings. The fact that the figurines are all standing in a row is repeated three times. Then comes the surprise:

> All like the virile member, come floating into the healer
> All like the virile member, come wavelike into the healer
> Like the virile member, they stand up in the stomach of the healer
> All like the virile member, they occupy the uterus of the healer
> The healer now is soul[20]
> It is the soul that makes the healer speak (lines 197–202)

At this culminating point the healer makes the following request of his wife;

> "Bring me the white shirt.
> It will strengthen me against the dangerous spirits."
> The healer is saying: "Bring me the black pants.
> They will strengthen me against the spirits: I will gain the courage necessary to face them."
> The healer is saying: "Bring me the black tie.
> It will strengthen me against the spirits: I will gain the courage necessary to face them." (lines 203–208)

He also asks his wife for color to paint his face, and for a mirror. The song he is singing then describes him putting on his clothes, garment by garment, an action that has also been described item by item much earlier on in the song, where the serene stillness of the

domestic scene is described. Surely it is significant here that the itemized listing of the clothes and putting them on and taking them off is repeated—like an actor donning another persona, like a fable in which, naked before the world of possibilities, one can play with identities, yet naked before the White man's felt derby, white shirt, and tie, one's play is straitened by endless repetition, taking them off, putting them on. If we pause and recall that the figurines themselves are also "clothed" as what Nordenskiold called "European types," then what extraordinary mimetological theater this major curing ritual turns out to be, with all the players on the side of justice, large and small, human and wooden, decked out in Western gear covering their inner, Cuna, "secret!"[21]

Not only is the healer copying the look of the West (imitation); he is also putting it on (contact). *In putting it on* he is establishing physical contact with the West, the touch, the feel, like putting on a skin. As with the mimetological technique of three-dimensional self-sculpting photography conceived by Roger Caillois in his essay on mimesis and legendary psychaesthenia, here the healer's very body becomes the vehicle onto which mimetic appearance becomes three-dimensioned, becomes optics in depth.

And where does this putting-on the skin of the West occur? Precisely where the healer is *bringing out* the Indian spirit-personae and spirit-powers of the different types of wood from which the figurines are carved as "European types." It is just at the point of assumption of Western male dress by the healer (in these two chant-texts) that this ineffable moment transpires where spirit flows from the wooden matter, from "nature," to be objectified, personified, and readied for the task in hand, namely the pursuit of the lost human soul. Born of woman, exercised continuously by men through intercourse with the spirit (read image) world, and honed to a fine edge of perfection by colonial alterities, the mimetic faculty bears exactly on this crucial matter of *bringing out* the spiritual power of image that material things stand in for.

As with Marsh donning Indian gear in the war canoe, and as with the very concept of white Indians, mimesis fuses brilliantly with alterity to achieve the connection necessary for magical effect, the connection

I have earlier alluded to as a kind of electricity, an ac/dc pattern of rapid oscillations of difference. It is the artful combination, the playing with the combinatorial perplexity, that is necessary; a magnificent excessiveness over and beyond the fact that mimesis implies alterity as its flip-side. The full effect occurs when the necessary impossibility is attained, when mimesis becomes alterity. Then and only then can spirit and matter, history and nature, flow into each others' otherness.

THE TALKING MACHINE

Along with his scientists and negro laborers, Marsh took quite a bit of equipment on his 1924 expedition in search of white Indians—an Elto outboard motor, wireless equipment weighing approximately one ton, including a 60-foot telescoping mast, a military field stove, a folding canvas deck chair for every white man, the trunk of gifts weighing some 370 pounds, firearms, ammunition sufficient for what he called a field military force, dynamite, fireworks, and two portable victrolas with a large and varied assortment of records.

Except for the dynamite, used for blasting apart logs jamming the river, the more obviously military equipment was useless: the heavy uniforms, the wireless, and the firearms. Even the outboard motor proved of limited value. What turned out to be effective and came to be considered as essential were the more obviously playful "cultural" items: the gifts, the fireworks, and the victrolas. Time and again the fireworks and the victrolas provided spectaculars of civilized primitivism, exchanges of magic and of metamagic satisfying to both primitive and civilized.

Dynamiting their way upriver through log-jams into what they considered to be dangerous Indian territory in the interior of the Isthmus in 1924, the explorers came across tracks of Indians and turkey feathers in an odd design, which Barbino, the old negro, said were magic signs. (Later on they came across twenty-one such feathers stuck in a row; one for each member of the expedition.) There was not an Indian to be seen:

Whatever the Indians might be planning to do, they were certainly watching us. So that evening on the Chiati we gave them an exhibition. Benton fired a volley from his Luger automatic, and I touched off an army signal rocket—the kind which goes up several hundred feet and explodes, leaving floating green lights which last for some time. That was to offset the Indians' magic.[1]

Other times the exhibitions were less obviously militant, defined by Marsh as intended for entertainment. One of the more touching features was their very timing. These were not the feasts of the Indians that went on day after day, but after-dinner events, when a northern man, sucking reflectively on a pipe, looked for a little peace of mind—and a little entertainment, only in this case, deep in the Darién, entertainment rested on entertaining the Indians, finding amusement in their amusement. As Marsh enthused after his first night in a "Chocoi" chief's house (the negroes being compelled to spend the night in the canoes, not being allowed to approach the house or mingle with the Indians):

With the evening meal over, and our mosquito bars suspended from the rafters over our sleeping quarters, the curiosity of our hosts demanded entertainment. Darkness had come suddenly. So we started our program with a military sky-rocket. Then the portable victrola was produced. After my experiences in the Darién I would never think of going into a "wild" Indian territory without a phonograph. Time and again we were to encounter surly, unfriendly, and even menacing Indians. We would appear to ignore them entirely. We would bring out and start a record while proceeding with our regular task of camp-pitching or what-not. The attention of the Indians would soon be diverted from us to the "music-box." Their hostility would cease and be replaced by curiosity. Gradually they would draw closer to the instrument, discussing it among themselves and finally would end up by crowding around it as closely as possible, touching and feeling it. From then on they would often keep us playing it until midnight, and were no longer our enemies though perhaps not yet our friends. That victrola, our fireworks, outboard motors and dynamite were four essentials without which we could never have traversed interior Darién.[2]

The victrola must have brought the explorers a good deal of pleasure, not least on account of the pleasure it brought the Indians. It proved

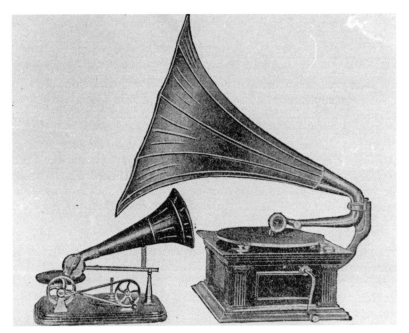

Earliest and latest phonographs, ca. 1908.

to be an easy way for making an intercultural nexus, a new cultural zone of white and Indian social interaction for discovering strangeness and confirming sameness—as when Marsh was teaching Cuna chief Mata's daughter Carmelita to dance to the victrola's music, her father contentedly smoking his pipe topped up with a gift of American Navy tobacco. "It was as happy a family group as I have ever seen," wrote Marsh—a remark that brings to mind the soothing blend of family and miming machinery sponsored in the ubiquitous advertisements of the Columbia Phonograph Company as early as 1895 in U.S. magazines. They pictured, according to a scholarly study aptly entitled *The Fabulous Phonograph*:

> . . . a family in a moment of rapt delight: grandfather sitting relaxed in an easy chair, his son and daughter-in-law standing attentively to his either side, and his grandson—clad in knee breeches and a Little Lord Fauntleroy jacket—hopping up and down between his legs. The attention

of all four was directed to the horn protruding from a small phonograph on a near-by table. They were clearly being entertained in imposing fashion by "the machine that talks—and laughs, sings, plays, and reproduces all sound."[3]

"You marry Carmelita," said the chief, "and you will be chief of all the Tacaruna tribes, and we will be rich and powerful as we used to be."

Marsh hesitated.

The chief offered him the "girl on the hillside" too, the woman who woke him up with hot chocolate and bare skin—all this in a society and in a text woven taut by men drawing boundaries between women and foreigners.

Marsh felt he had to decline the offer. Carmelita rushed away crying. Marsh put "Madam Butterfly" on the victrola and smoked his pipe.

Elsewhere in the land of the Cunas this intimate scene depicted by Marsh was played out on a grander and more tempestuous stage. There, victrolas threatened to break the barriers separating Cuna women from Panamanian ("negro") men, symbolizing the immediate causes of the 1925 Cuna revolt. The Panamanian police enforced attendance at social clubs (originally begun by young Cuna men back from the cities) at which there was Western-style dancing to phonograms playing Panamanian "folk" music as well as U.S.-derived fox trot and jazz—much to the distaste of Cuna parents and elders.[4] The Cuna High Chief (*nele*) is recorded in Baron Nordenskiold's compilation as declaring:

> And they began to force us to do hard labor and to carry heavy stones to the schoolhouses. If we had a headache they took no notice of it but we had to work hard just the same and they began to beat us with chains and ropes and they began to build club houses where they could dance with our women and our daughters and if we would not let our wives dance they put us in prison. And they began to speak to our people and say that we did not have anybody who could help us. They began to take off our women's nose-rings and ear-rings and the police dragged our women to the police houses and took the rings from their nose and broke them into pieces [and] thus they led our women to darkness and sin.[5]

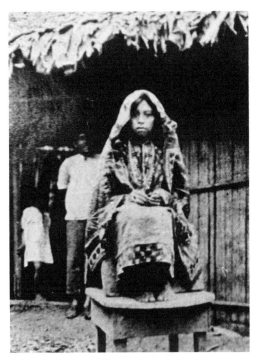

"Princess Carmelita of Pucho" [top], and R.O. Marsh having his back painted by Chocói women [bottom] (from Marsh, *White Indians of Darien*).

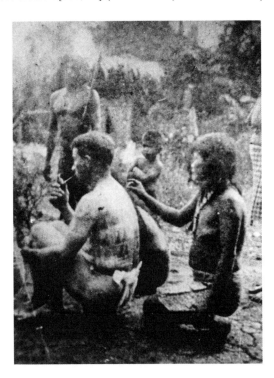

Thus with its transports of Western delight that magnificent miming machine, the victrola, was important in making the scene, providing the occasion for non-Cuna men to gain access to Cuna women, mainstay of the image-politics of Cuna Being. No wonder the chiefs and elders were mad. (And surely not only among the Cuna? The spread of U.S. popular culture throughout the world, from the beginning of the twentieth century, owes an enormous amount to the music reproduced by the phonograph. Indeed, the great contribution of the U.S. to world history has been precisely the shaping of the world's ears and eyes—not to mention "morals"—by popular music and Hollywood.)

Colonial Photography

I am not so much concerned with a "sociology" of the phonograph or camera or their effect on "the natives." The more important question lies with the white man's fascination with their fascination with these mimetically capacious machines. Here the camera compared with the phonograph provides relevant material.

While there appears to have been a lot of photography on Marsh's first expedition in search of white Indians, it barely rates a mention in comparison with the reproduction of sound by the victrola. Marsh had obtained the support of military photography, undertaken prior to the expedition. He needed to reconnoitre the unknown valley, verify its existence and extent, and locate as many Indian villages as he could. The commander of the Canal Zone Air Force provided him with two planes, one of which carried an expert military photographer equipped with a large military camera. Whenever Marsh's plane signaled, the second was to take a picture. But in all of this there is not hint of magic. On the contrary, it is very much an enthusiastic ride with "technology" as something antithetical to "magic." The planes and the big camera provide a nonchalant feeling of material and scientific power over the landscape and people below, who will soon be subjects for hand-held cameras.

Photographing the Indians was seen as an essential part of scientific

investigation. Indeed photography seems to be emblematic, to verify the existence of the scientific attitude as much as the existence of that which was photographed. A fragment from Baer's diary, published posthumously in the *American Journal of Physical Anthropology* by his boss at the Smithsonian, Ales Hrdlicka, reveals how obsessive and necessary to "doing science" this was:

> *Indians: Camp Townsend: Saturday, Feb. 9*: Put up charts for taking span and height measurements.
>
> *Sunday Feb 10*: Jose Mata and family gave us a call. Took pictures of him and squaw. Jose made her put on new dress for the occasion and naked son would not appear.
>
> *Tuesday Feb 12*: Group of Chocos arrived. Snapped man and ten year old daughter.
>
> *Wednesday, Feb 13*: Awakened by chatter of Chocos in Marsh's tent. Morning spent photographing and studying group of dozen children.
>
> *Thursday, Feb 14*: Measured a number of Cunas and a few Chocos. Photographed Jose and family, also courting Chocos.[6]

Other times Marsh speaks of Cuna men in the mountains running to him for protection from being photographed, but when the alliance between him and the Cuna chiefs is cemented on the San Blas coast, and all the white Indians he wants are promised to him, then everything can be photographed in mini-rituals of scienticity. And even here, with the doors to the Cuna kingdom flung wide open, there is little wonder recorded at either the camera or the resulting photos. When we see the latter, as in Marsh's own book with the frontispiece photograph of "Mimi" the white Indian girl, they seem to evacuate aura and normalize—even "over-normalize." You ask yourself, "So what?" But when it comes to filming the phonograph in action on the colonial frontier, then everything changes. Here every effort is made to represent mimeticizing technology as magical, and the question must be repeated—because the phonographic *mis en scène* is surprisingly common in twentieth-century descriptions of "primitive" peoples—as to why Westerners are so fascinated by Others' fascination with this apparatus.

Colonial Phonography

Who can forget, in what has become one of the classics of ethnographic film, Nanook of the North's look of wild disbelief on hearing sound emerge from the white man's phonograph, and then trying to eat the record? Mimetic sensuosity incarnate! Except for one factor; shouldn't we assume that this look and this eating is a contrivance not of the "primitive" but of the primitivist film-maker Robert Flaherty?—a set-up job. Mimesis of mimesis; a link in the chain of what Horkheimer and Adorno called "the organization of mimesis."

That Flaherty's intention was above all mimetological, that the eye was to become more an organ of tactility than vision, is made clear in the commentary of his wife and long-time cinematic collaborator Frances Hubbard Flaherty. Yet despite an apparent convergence here between her views of the new eye created by cinema and that of some early Soviet cinema theory (and Benjamin's extension of that theory), there is also a wide divergence. As against the logic of *shock, montage,* and *profane illumination,* Flaherty wallows in a discourse of *spiritual unity* to be achieved through the mimetic and sensuous possibilities now offered the human sensorium by cinema, and she does so by recruiting the sensory apparatus of the primitive, Nanook of the North, to do so—a wondrous if not somewhat sinister feat.

She begins with her husband's film image of a potter's hand (an image lovingly used by Benjamin, too, in his essay on the storyteller, his point being that the storyteller's presence and life are impressed into the tale just as the imprints of the potter's hand are impressed in the clay). In the same way that the potter's hand caresses the yielding clay, for Flaherty the cinematic image shall caress the yielding eye, the body it contains: "Take, for instance, the hands of the potter as he molds the clay," she writes:

> The motion-picture camera can follow these movements closely, intimately, so intimately that as with our eyes we follow, we come to feel those movements as a sensation in ourselves. Momentarily we touch and know the very heart and mind of the potter; we partake, as it were, of his life, we are one with him. Here through those nuances of movement

we found in [Flaherty's 1924 film] *Moana* we come again to that "partici-
pation mystique" we found in *Nanook* [1922]. Here is the "way" of the
camera, of this machine: through its sensitivity to movement it can take
us into a new dimension of seeing, through the mysterious rhythmic
impulses of life and love take us inward into the spirit, into the unity of
the spirit.[7]

I doubt whether a more emphatically clear statement has even been
made concerning the intimate relationship between primitivism and
the new theories of the senses circulating with the new means of
reproduction. And this I take to be the relevance of Robert Flaherty's
cinematic display of Nanook's wonderment at the phonograph and
subjecting the record to the viscerality of his tongue and teeth. Here
the alleged primitivism of the great hunter of the north, his very teeth,
no less, dramatobiotically engage with the claims being made by the
Modernist (Frances Flaherty) for the spiritual unities of life now re-
vealed by film.

Here the logic of mystical participation between subject and object,
between Primitive person and the world (as advanced by Lucien Lévy-
Bruhl, for instance), is reborn thanks to reproductive technology. It is
therefore curious, that this rebirth discussed in Modernist theory with
overwhelming predominance in terms of the optical medium of cinema,
is highlighted by the *mise en scène* of the phonograph.

This eating of sound by the great hunter, or rather of the reproducing
artifact of sound, this mimesis of mimesis, is nicely matched by Robert
Flaherty's story retold by his wife, printed opposite a photograph of a
dark-visaged Nanook in furry pants peering skeptically into a phono-
graph delicately perched on a pile of furs. A European man, perhaps
Flaherty, is seated on the other side of the phonograph, carefully
looking not at the machine but at the great hunter looking at it. The
caption reads: "Nanook: How the white man 'cans' his voice." The
story is that when Flaherty decided to explain to the Eskimos what he
was doing as a film-maker, he developed some footage of Nanook
spearing a walrus, hung a Hudson Bay blanket on the wall, and invited
"them" all in, men, women, and children. What happened then is not
simply one of a very long and endlessly fascinating series of dramas,
as told, of "first contact" of primitive man with the machine, but one

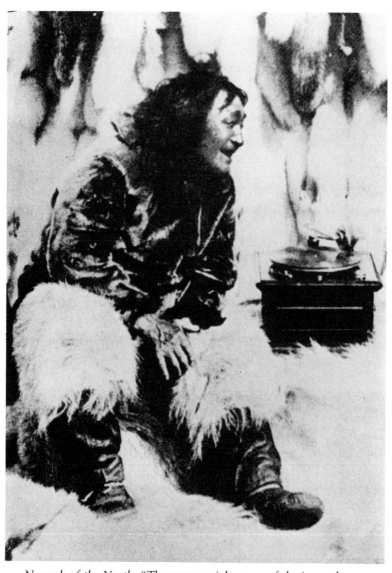

Nanook of the North: "The extra-social nature of the ice pack as a social experience," (from Frances H. Flaherty, 1984).

of the great stagings wherein the mighty mimetic power of the new instrument of mechanical reproduction, namely film, meets up with the mighty mimetic prowess—the epistemology of "mystical participation"—of the Primitive:

> The projector light shone out. There was complete silence in the hut. They saw Nanook. But Nanook was there in the hut with them, and they couldn't understand. Then they saw the walrus, and then, said Bob [Flaherty], pandemonium broke loose. "Hold him!" they screamed. "Hold him!" and they scrambled over the chairs and each other to get to the screen and help Nanook hold that walrus![8]

It needed the image of the mighty animal, the walrus thrashing in the surf at the end of a line, not Nanook, to convert the confusion in the spectator's minds into mimetic veracity. Moreover—and now its "our" turn to be a little disoriented by representational gymnastics— once the Eskimos had seen, or rather, participated in this screening, "There was no talk of anything," writes Frances Hubbard Flaherty, "but more hunting scenes for the 'aggie,' as they called the picture."

Then what of Werner Herzog's delirious effort in his film *Fitzcarraldo*, set in the early twentieth-century Upper Amazonian rubber boom and constructed around the fetish of the phonograph, so tenaciously, so awkwardly, clutched by Fitzcarraldo, the visionary, its great ear-horn emerging from under the armpit of his dirty white suit, Caruso flooding the forests and rivers, the Indians amazed as Old Europe rains its ecstatic art form upon them. Bellowing opera from the ship's prow, it is the great ear-trumpet of the phonograph, an orchid of technology in the thick forests of the primitive, that cleaves the waters and holds the tawny Indians at bay as the patched-up river-steamer wends its way into this South American heart of darkness.

This same unfolding orchid of technology, now in delicate, worn shades of purple and pink, appears at crucial moments in *The Camp at Thiaroye*, a film made in 1988 by the Senegalese director Ousamane Sembene (whose films are censored in Senegal). This phonograph is the proud possession of a Senegalese sergeant serving in the Free French Army during World War II. He and his fellow Sengalese soldiers now

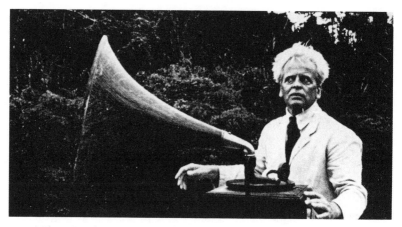

Klaus Kinski as Fitzcarraldo, playing Caruso for the "savages."

await discharge from the French army on Sengalese soil. Having suffered the Nazis, they now find they have to confront the racism of their own white officers. One Senegalese soldier has lost his mind in Buchenwald and through frenzied gesticulations insists on wearing a Germany Army "coal-scuttle" helmet bedecked with swastikas. Miming the Nazi soldiers, he becomes the elusive enemy of his enemies, the enemy of his French colonial masters. His shockingly disjointing presence, his dark-black face surrounded by this German helmet, his body at attention on a French parade ground in Africa, presages the shocking end of the film, when the entire company of black soldiers is wiped out by tank and machinegun fire at the orders of the French high command for staging a rebellion over the humiliating terms of demobilization.

But there is this other disjointedness as well, another elusive and complex form of miming Europe, and this is the sergeant's prize possession, the phonograph, spectral in the fetishicity of the looming folds of the massive ear-trumpet so ponderously balanced over the tiny needle moving up and down on the discs of what in the film are referred to as the great music of the Western classical tradition. It is this that he listens to in the spartan simplicity of his barrack-room as he writes to his white wife and their daughter in Paris. It is this machine and its

O, CARUSO!

reproduced music that tugs at the attention of the stream of filmic imagery as much as that of the white officers from France, in ways gratifying, in ways unsettling, as with graceful ease this black man evokes and assimilates the taste of Old Europe in the privacy of his room by means of its replayed music. On the one hand, it is pleasing to the officers to see this man becoming like them through a machine whose job it is to reproduce likeness. On the other, it is profoundly disturbing to them because this man is using this machine to manufacture likeness. Thanks in part to this machine, he is not only too comfortable with European culture, but he shows the way for a "new man" who can be both black and white, Senegalese and French. This is why the image of the phonograph in this film approaches that of an icon with the terrible ambivalence of the sacred coursing the circuitry of mimesis and alterity binding civilization to its savagery.

In this iconic power lies what Fitz Roy, Captain of Darwin's good ship, HMS *Beagle*, termed in 1832 the absorbing interest "in observing people displaying childish ignorance of matters familiar to civilized man." One hundred and fifty years later Bob Connolly and Robin Anderson's film *First Contact* provides just such a display—a display of the display, we might say. Using footage of *First Contact* filmed by an Australian gold prospector in the early 1930s in highland New Guinea, Connolly and Anderson are able to breathlessly capture this mythic moment, the white man drawing open the curtain of world history to reveal and revel in Otherness incarnate—and to do so spectacularly, thanks to the prospector having filmed his phonograph performing its mimetic wonders against the backdrop of the savage visage. As the sprightly tune "Looking On The Bright Side of Life" takes our acoustic memories Westward, the camera takes us through the optical unconscious into the needle rising and falling on the disc and then abruptly to the elongated, bearded faces of the highlanders staring stock-still in apparent amazement at the sound emerging from the machine. ("We thought it was our ancestors singing," they tell Connolly and Anderson decades later.) Not content with this, the prospector picks up the phonograph and thrusts it across the waist-high fishline that the whites always erect as a barrier to mark out their camp. He wants the highland women to dance. His movements are somewhat

awkward, even grotesque, as he lunges at people across the clearly marked frontier with this precariously balanced music box. It's as if he's more obsessed with white man's magic than the natives are, and this obsession demands showing showing. First he has to show the phonograph in action to Them. Then he has to capture the phono-graph-display on film. Then years later, correctly anticipating the late twentieth-century Euro-American hunger for such revelation, Connolly and Anderson display the display for us—and repeat it more than once, notably and lengthily at the very end of the film *First Contact*, as the credits roll to the dazzling incongruity-effect of "Looking On The Bright Side of Life." ("We thought it was our ancestors singing," I thought I heard someone say.)

Light is perhaps shed on the white man's fascination with Other's fascination with white man's magic when we read in the prospector's own book about a highland boy, Narmu, whom he sent as a sort of cultural experiment to the town of Lae by aeroplane ion 1932. Extricated from the Stone Age to the store age by one swift flight, the boy "listened to a phonograph, and saw an electric light, and wore out the switch turning the light on and off again. Gurney [the pilot] said that next to the electric light the thing that seemed to interest Narmu most was the heap of tin cans and bottles."[9] *First Contact* has a dizzying scene of a highlander recounting how as a kid he fearfully stole the lid of a tin can thrown away as garbage by the prospector, and worked it into a flashy ornament for his head. But unfortunately *First Contact* is too preoccupied to film those heaps of tin cans and bottles, for even though garbage is the outstanding sign of Western civilization—as Narmu perceived—it is not the side-effect of mechanical production that is congenial to the staging of First Contact, but rather the after-imaging of its mimetic machination.

Mimetic Surplus

What seems crucial about the fascination with the Other's fascination with the talking machine is the magic of mechanical reproduction itself. In the West this magic is inarticulable and is understood as the

technological substance of civilized identity-formation. Neither the prospector filming in the early 1930s in the New Guinea highlands nor Fitzcarraldo in the jungles of the Upper Amazon in the early twentieth century could make a phonograph, or an electric lightbulb switch for that matter. Vis à vis the savage they are the masters of these wonders that, after the first shock waves of surprise upon their invention and commercialization in the West, pass into the everyday. Yet these shocks rightly live on in the mysterious underbelly of the technology—to be eviscerated as "magic" in frontier rituals of technological supremacy. To take the talking machine to the jungle is to emphasize and embellish the genuine mystery and accomplishment of mechanical reproduction in an age when technology itself, after the flurry of excitement at a new breakthrough, is seen not as mystique or poetry but as routine. Taking the talking machine to the jungle is to do more than impress the natives and therefore oneself with Western technology's power, the Elto outboard motor compared to the wooden paddle; it is to reinstall the mimetic faculty as mystery in the art of mechanical reproduction, reinvigorating the primitivism implicit in technology's wildest dreams, therewith creating a surfeit of mimetic power.

Mary Had A Little Lamb

Moreover Westerners would do well to be reminded of the magic of sound-reproduction in their recent histories—their fascination with the introduction of transistor cassette recorders in their lifetimes, and beyond that the effect of the first sound recorders and reproducers in 1877 in the United States. The article that introduced Edison's "talking machine" to the informed public in the *Scientific American* (December, 1877) deliberately magicalized the apparatus as it if were animated by a little human inside it. This make-believe is a curious form of self-mockery. For on the one hand it expresses clumsy but genuine admiration for the mystery of sound reproduction, an admiration that extolls the technology and, given the enchantment of its achievement, strives to find a language of spirit and magic to express that enchantment. On

the other hand such magicalization is an attempt to gain mastery over technology's mastery of the mimetic faculty itself:

> Mr. Thomas A. Edison recently came into this office, placed a little machine on our desk, turned a crank, and the machine inquired as to our health, and asked how we liked the phonograph, informed us that *it* was very well, and bid us a cordial good night.[10]

This is not unsimilar to the performance of magic Marsh attempted in the jungle with the talking machine decades later. Roland Gelatt describes crowds listening with "astonished incredulity to the phonograph's raucous croak" (the reproductive fidelity was abysmally bad) and emphasizes that it provided the occasion—as with Marsh in the Darién forest—for great spectacles:

> As a show property the phonograph won immediate success. To audiences throughout the country it provided an evening's entertainment always fascinating and usually diverting. It would talk in English, Dutch, German, French, Spanish, and Hebrew. It would imitate the barking of dogs and the crowing of cocks. It could be made to catch colds and cough and sneeze "so believably that physicians in the audience would instinctively begin to write prescriptions."[11]

A single exhibition phonograph, so it is said, could in 1878 thus earn $1800 a week, and again we witness the self-conscious effort at make-believe, notably with the physicians' reaction to the reproduced sneeze. In Europe the fascination with the "talking machine" was no less intense. In 1894 just outside of Paris, the Pathé brothers (later famous in the moving picture industry) founded their factory to make cheap talking machines modeled closely on "The Eagle Graphaphone," and in the same year began making cylinders with sound punched into them. By 1899 there were 1500 sound-cylinder titles to choose from. They called their graphaphone "Le Coq," and so popular did this "Cock" machine become that the "swaggering bird"—as Roland Gelatt defines it—became the Pathé brothers' trademark. It can be still seen and heard, he wrote (in 1954), at the beginning of Pathé newsreels.[12]

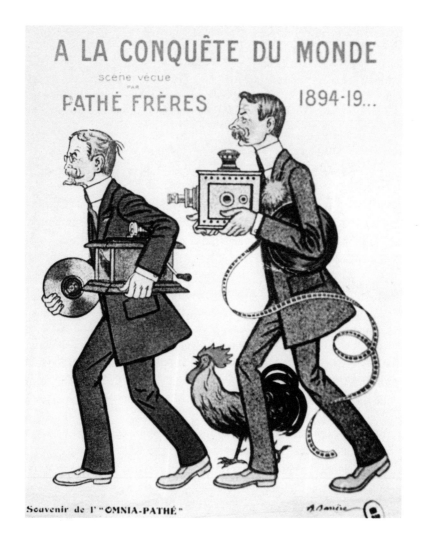

As with the dog of His Master's Voice, this trademark registers not only (Gallic) nationalism, as does the (American) eagle, but the link between mimesis, primitivism, and technological development. It is the task of the animal to register the rediscovery of the naturalness of the mimetic faculty in a technical age—confirming Walter Benjamin's insight regarding the rebirth of the mimetic with mechanical reproduction. When the great Thomas Edison, credited with the invention of

Edison's original phonograph (*Scientific American*, 1877).

"the talking machine"—and here we cannot easily bypass the obvious primitivism, the animism, built into the concept in the popular name of the apparatus from the start—first heard in 1877 his voice played back to him singing "Mary Had A Little Lamb," he is reported as saying, "I was never so taken aback in my life."[13] "Taken aback" is a significant choice of words for this historic moment, a spontaneously fitting way of expressing (what Adorno called) the "shudder of mimesis" being taken back to childhood, back to primitivism. And let's not forget the invocation here of animals as well as of girl children, of the little lamb as well as little Mary, reminiscent of the "talking dog" adorning Marsh's victrolas and records, and said to be the most successful logo in the history of advertising. For a deep chord has been struck here by early twentieth-century advertising and popular culture, substantiating the primitivism that Darwin connected to miming prowess on the beach of the Land of Fire:

They could repeat with perfect correctness each word in any sentence we addressed them, and they remembered such words for some time.

211

15

HIS MASTER'S VOICE

Given the Ur-history of the phonograph in the discovery and recovery of Primitive peoples the world over, the way it has itself to be recorded as having "been there," recording and playing, and given the militant role of the victrola in Marsh's expedition, let alone in the causation of the 1925 Cuna uprising, it is devastatingly appropriate that one of the most popular designs made by Cuna women for the appliquéd mola blouses they have made and worn since the late nineteenth century, and which they have sold internationally since the mid-twentieth century, is the logo of RCA Victor, "His Master's Voice."[1] From the viewpoint of modern Western culture—a culture that turns out to be richly endowed with the products of commercial imaginings—this is no ordinary logo.

It is stated in histories of the phonograph that His Master's Voice logo is "generally considered the most valuable trademark in existence."[2] It is surely of interest that a little picture considered in its day to be rather lacking in artistic merit should be the hottest of commercial properties. This can make us appreciate images central to our time in new ways, akin to an older love and beauty magic now destined to spirit money from our pockets, artful spells of mimetic sentience.[3] "What, in the end, makes advertisements so superior to criticism? Not what the moving red neon sign says—but the fiery pool reflecting it in the asphalt."[4]

Many people are fond of this Victor Talking Machine Company's "talking dog" logo, not least William Barry Owen, who bought the

painting from the artist for The Gramaphone Company in London in 1898 but, unlike his American associates, he could not use it for several years, as he already had the angel logo. The talking dog brings pleasure, a good deal of pleasure. It can make you smile inwardly. It attracts you: why?

RCA Victor is said to have thought the power of the logo is due to the dog being a figure of fidelity.[5] But what manner of figure? Surely an age-old history of Western allegory can be summoned here concerning the ways in which a dog and fidelity "go together." But this observation merely records longevity of the sign, not its powers to summon.

Fidelity and The Power to Summon

I think that the power of this world-class logo lies in the way it exploits the alleged primitivism of the mimetic faculty. Everything, of course, turns on the double meaning of fidelity (being *accurate* and being *loyal*), and on what is considered to be a mimetically astute being—in this case not Darwin's Fuegians but a dog. Blessed with that famous "sixth sense" this creature, like the Primitive, possesses a formidiable mimetic faculty, the basis for judging similitude.

This logo, then, can be thought of as displaying a mimetic super-power in action, the mimetically capacious dog straining itself pleasurably to distinguish copy from original as it comes through the ear-trumpet of the phonograph. But this logo is also internally referential, an image of the miming of miming, and in this regard it is pertinent to invoke a history of pictures used to embellish music-boxes—as presented in A. Buchner's work on eighteenth-century automata or androids, miracles of technical ingenuity imitating the movements of living creatures. Except for a drummer-boy and a clown, the living creatures thus mimicked, faithfully playing their faithfully reproduced sound, turn out on inspection of Buchner's display to be everything but the white male. There are negroes in top hats and tight breeches, the "upside-down world clock" with a monkey playing the drum, "the dance of the hottentots," a duck drinking water, quacking, eating grain, and defecating, birds in cages, birds on snuff boxes, and women—

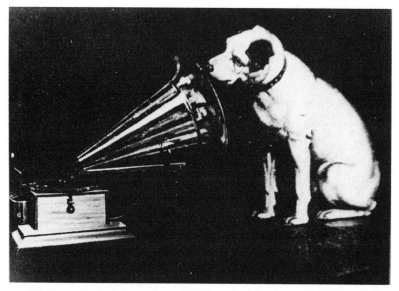

"The Most Valuable Trademark in Existence." RCA Victor's Talking Dog, bought in London by William Barry Owen in 1899 for The Gramaphone Company, painted by Francis Barraud several years earlier. The painting was not initially used as a trademark because The Gramaphone Company already had one, "The Recording Angel," a picture of an angel writing with a quill on a grammaphone disc. It was revived in 1953 as the trademark for Angel Records.

especially women. The oldest puppet that Buchner describes is from a so-called Renaissance grotto in St.-Germain en Lay, a figure known as Cecilia, who played the organ as a mechanism hidden inside her body made her fingers press the keys while her feet pumped the pedals. The skilled automaton-making team of Jacquet-Droz, father and son, were famous for their Young Writer and Clavecin Player. The Writer is a young girl seated writing a letter of some fifty words at a desk. The Clavecin Player as described by Dr. Buchner is a charming young woman playing an organlike instrument. Her torso, head, eyes, chest, shoulders, hands, and fingers are worked by a complex of levers, one of which produces the effect of breathing, the bosom rising and falling, the eyes moving so that she appears to be looking now at her hands, then at the audience. In short intervals between the pieces she continues

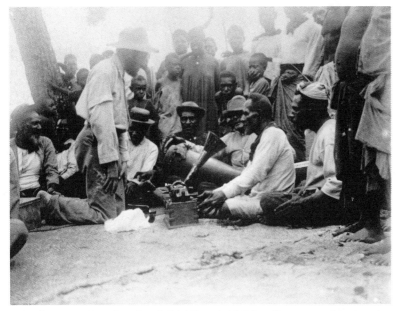

At the same time that that RCA Victor's Talking Dog was painted and purchased, the Cambridge anthropologist A.C. Haddon was field-working the Torres Straits Islands between Australia and New Guinea. According to my source, this photograph shows a Torres Straits islander being recorded as he sings a traditional song.[6] Is not the sacred pose of the recorder remarkable?

breathing and moves her head, dropping her eyes as if shy. "The illusion of a living creature," observes Buchner, "is thus complete."

Jacquet Droz, *père* (1721–1790), was invited to Madrid by the King of Spain where his automatons nearly cost him his life. The Inquisition accused him of sorcery, reminding us of Horkheimer and Adorno's major thesis that civilization (meaning Western civilization—the civilization of Capital) has replaced "mimetic behavior proper by organized control of mimesis":

> Uncontrolled mimesis is outlawed. The angel with the fiery sword who drove man out of paradise and onto the path of technical progress is the very symbol of that progress. For centuries, the severity with which the rulers prevented their own followers and the subjugated masses from

Mark of the mimetic: The Clavecin player (automaton).

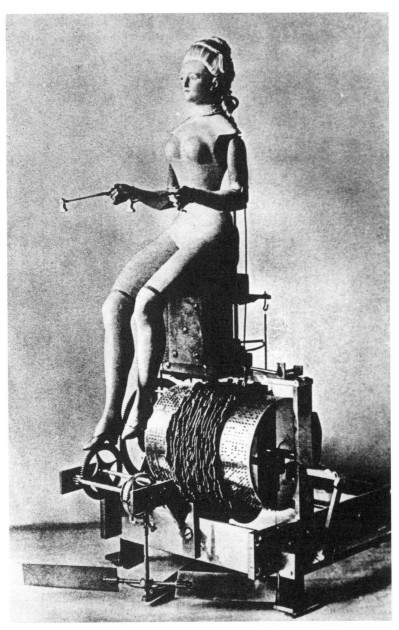

Mark of the mimetic: Marie Antoinette's girl playing a dulcimer (automaton).

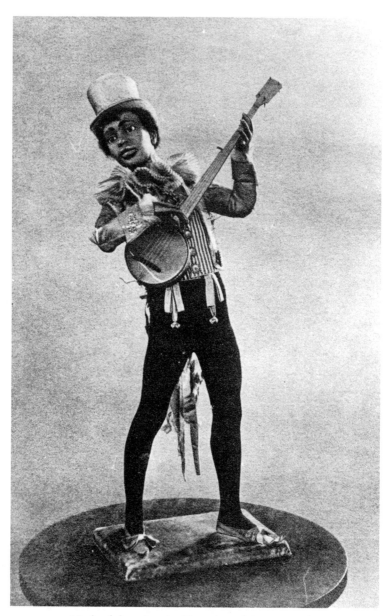

Mark of the mimetic: The minstrel (automaton).

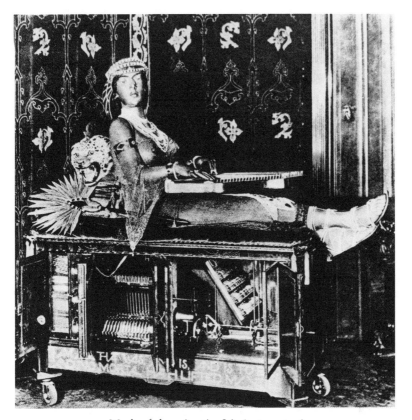

Mark of the mimetic: Isis (automaton).

reverting to mimetic modes of existence, starting with the religious prohi-
bition on images, going on to the social banishment of actors and gypsies,
and leading finally to the kind of teaching which does not allow children
to behave as children, has been the condition for civilization.[7]

On the other hand, controlled mimesis is an essential component of
socialization and discipline, and in our era of world history, in which
colonialism has played a dominant role, mimesis is of a piece with
primitivism. The last automaton was made in the twentieth century by
an American, Cecil Nixon. It is called Isis—a bare-breasted, dark-
skinned woman playing a zither while reclining on a couch decorated

with leopard skins, hiereoglyphs, and "other Egyptian motifs." It took twelve years to construct and has a mechanism of 1187 wheels and 2233 other parts. It is said to have caused a sensation in film studios and was shown in many American towns. When the temperature rose above 80° F Isis moved her veil until the temperature fell.[8]

The Talking Dog, Fingerprinting, and Sorcery

Together with her near-nakedness this unveiling of Isis reminds us of the heat in those torrid zones where the mimetic flourishes. It also reminds us of the heat of the senses and thus brings to the fore two interwoven meanings of the mimetic—imitation and sensuousness— that, partly through Horkheimer and Adorno, I have been at pains to elucidate throughout this book. These two dimensions of imitation and sensuousness match Frazer's classic distinction of "sympathetic magic" into "imitative" and "contagious" principles. Like police fingerprinting as well as the use of footprints in sorcery, His Master's Voice's Talking Dog not only draws upon sympathy and contagion but fuses them. Through contact (contagion) the finger makes the print (a copy). But the print is not only a copy. It is also testimony to the fact that contact was made—and it is the combination of both facts that is essential to the use of fingerprinting by the police in detection and by the State in certifying identities. The Talking Dog also interfuses contagion with sympathy, the sensuous with imitation, because it is on account of its sensorium, allegedly sensitive to an uncanny degree, that it can accurately register—i.e. receive the print—and distinguish faithful from unfaithful copies. Here Horkheimer and Adorno's Marxist inflection of Nietzsche's view of civilization, turning the animal in man against itself, receives its due, the dog now being the civilized man's servant in the detection, and hence selling, of good copy. With the transformation from the sorcerer's practice combining imitation and contact in the use of the footprint to that of fingerprinting (and use of the camera) by the State in the late nineteenth century, this "organized control of mimesis" has reached an unmatched level of perfection, truly the modernist rebirth of the mimetic faculty.

Characteristic peculiarities in Ridges
(about 8 times the natural size).

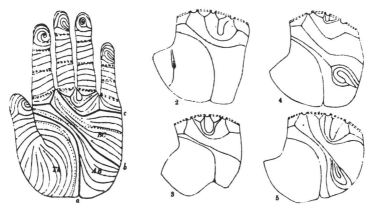

Systems of Ridges, and the Creases in the Palm.

Ridges and creases (from Galton).

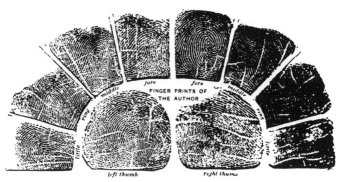

Title page of Galton's book, *Finger Prints*

It should be noted that fingerprinting as modern State practice owes everything to modern colonialism, beginning with the use of the sign-manuals of "finger-marks" by mid-nineteenth century British colonial administration in India so as to prevent people from impersonating pensioners after their deaths. In this history we encounter striking contradictions and collusions of mimesis and alterity across the colonial divide: a colonial administration dependent on writing and signatures in a largely illiterate colonial society; administrators' fear of massive fraud by means of false signatures; British administrators unable to discern unique facial and other identifying qualities among the masses of their Indian subjects ("they all look the same"); and last but far from least, the decisive ingredient in the discovery of fingerprinting, the use of the hand and thumb as a type of modernizing sorcery by the colonial bureaucracy.

It was this last feature which led to the discovery of the "scientific" value of fingerprinting. According to Charles Darwin's cousin the esteemed Sir Francis Galton, F.R.S., etc., and author in 1892 of *Finger Prints*, the text that established a system for the use of fingerprinting in State surveillance, Sir William Herschel informed him that because "it was so hard to obtain credence to the signatures of the natives, that he thought he would use the signature of the hand itself, *chiefly with the intention of frightening the man who made it from afterwards denying his formal act*" (emphasis added).[9] And no doubt the heady mixture of science, racism, State bureaucratic theatrics, and attribu-

Sections of the needle point.

tions of native supersitition involved was intimately connected to sub-
terranean notions, British as well as Asian, concerning the "magic" of
both copy and contact.[10]

There are still further mimetic features to consider with the logo of
the Talking Dog/His Master's Voice, features wherein analogy and
modeling fuse with the quite different principles of mechanical cause
and effect (indexical signs). The blossoming ear-trumpet of the phono-
graph, almost as large as the dog, is a mimetic modeling of ear-function
as well as of voice-throwing, as with a bull-horn (note the appellation).
Hidden in the technology of the talking machine are the hills and dales
of the grooves of the disc. These physical indentations correspond
point for mimeticizing point with the sound recorded and then played
back. Finally there is the curious mimetic gestus of the dog, its body
as well as its face miming the human notion of quizzicality. This dog
is testing for fidelity and is also a little mystified. What could be more
"human" (or at least anthropomorphic) than this "talking dog"? This
is one of the great faces, like Garbo's, of the twentieth century.

The Animal in the Machine

Where politics most directly enters is in the image's attempt to combine
fidelity of mimetic reproduction with fidelity to His Master's Voice,

Cuna mola: RCA Victor's "Talking Dog" (from Parker and Neal, 1977).

the hound like a dutiful servant being credited with precisely this artful combination. But in this logo it is also possible to discern a continuous and indecisive struggle between technology and magic, indicating co-dependence. For on the one hand the animal is what assures the fidelity of technical reproduction. But on the other, the dog not only looks quizzical but is in fact being fooled, for there is no real master, just the copy of the master's voice. The technology of reproduction triumphs over the dog but needs the dog's validation.

An oddly undisconcerting moment arises with the fact that the logo is generally referred to not as the listening dog but as "the *talking* dog." Quite apart from the fact that this goes against the original intention of the artist, Francis Barraud, who was moved in the 1890s (so he is said to have said) to paint his dead brother's dog Nipper on account of the quizzical expression on the dog's face when listening to a voice on an Edison phonograph (the dog's dead master's voice?), this of course cannot be a talking dog, as talk is something reserved for humans and the machines of the Victor Talking Machine Company.

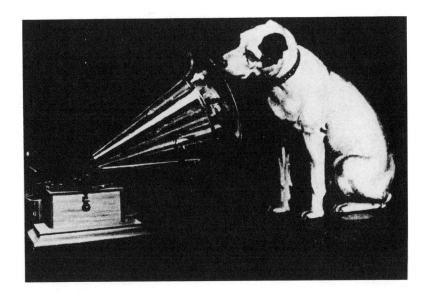

To refer to this as "the talking dog" is not only to reverse the talking machine from a player into a recorder, or to see the dog as entering into a conversation with the player, but also to magically endow— with effortless ease—the hound with the human faculties of the talking machine. It would seem that this transformation of the animal into the human, however, can only come from the machine itself, the machinery of sound-mimesis. The setting up of the contrast between (the then new) technology and the animal, between the machine and the primitive, has the curious result of moving the primitive into the machine to wrest the mimetic faculty from a bunch of wires and grooves. And this is precisely what the Cuna mola shows us, "minions in attendance." write two commentators, "busily employed keeping the phonograph functioning for the big dog's pleasure."[11]

This Cuna dog is certainly cute, even cuter than the original reproduced in a near-infinity of copies. I do not know if the dog is pleased, but what to me is beyond doubt is the intense pleasure—the catching of the breath, the delighted laugh, the stirring of curiosity—that this particular mola brings to Western viewers today, including myself, all the more so when held side by side with its Western original.

This Sudden Laugh From Nowhere

Why this laugh? Surely this is what I call Aristotle's pleasure, the (not so) simple fact that observing mimesis is pleasurable. And just as surely there is an element of colonialist mastery in this laughter; the very word 'cute' is as suggestive as my having belabored to show throughout this book how difficult it is to pry mimesis loose from pervasive intimations of primitiveness. But there is also the possibility that this sudden laugh from nowhere registers a tremor in cultural identity, and not only in identity but in the security of Being itself. This is like Bataille's laugh; a sensuous explosion of smooth muscle composing Being in the same instant as it extinguishes it. This is Benjamin's flash, as when he writes that there is something peculiar about similarity: "Its perception is in every case bound to an instantaneous flash. It slips past, can possibly be regained, but really cannot be held fast, unlike other perceptions. It offers itself to the eye as fleetingly and as transitorily as a constellation of stars."[12]

The West On The Chest

The ethnography tells us that while Cuna men carve curing figurines with Western exteriors and monopolize communication with spirits, Cuna women are meant to be seen but not heard in public space, serving as the ocular signifier supreme of Cuna Being, shrouded in the mysterious magnificence of their molas where the Western gaze and the Cuna presentation interlock.

While it is pointed out that the art of mola-making probably derives from the long-established but now defunct art of body-painting, by women of men as much as of women, we now need to emphasise that this body-painting is displaced in significant ways; first onto women's bodies, the men now garbed in Western gear; second, the women, the visual signifiers of Cuna Being, often wear on their chests no longer only abstract designs or flowers and animals, but the West—as indicated by their version of the Talking Dog and other consumer commodities, advertisements, trademarks, and icons of popular culture (long before this became a fashion on First World T-shirts). Since U.S.-mediated goods have passed into Cuna purview by means of Cuna men working in the Canal Zone since the 1930s, thanks to their convivial relationship

(From Parker and Neal, 1977)

Edison's first sketch of the phonograph.

with the United States, the chests (and backs) of the women have formed a species of trade catalog—and here we might do well to remember Baron Nordenskiold's and Rubén Pérez' references in the 1930s to a Cuna heaven stuffed with Western commodities, in which case we would also want to attend to healers burning illustrations torn from trade catalogs to release their spirits as part of the cure for snakebite and other community-threatening perils.

Yet if Western goods excite the Indians' imagination, how much more does such excitation excite the Western observer! It seems clear that one of the things that most turns on Western observers about

molas is the operation molas perform on the image of the West, in particular on the West in its commodity-expression. Concerning their first exposure to molas some time in the mid-1950s, at an exhibition in the Brooklyn Museum's Folk Art Shop, Ann Parker and Avon Neal first single out the abstract features of design and color, the skill of the stitching, and then the

> . . . amusing content—the fresh wit and humor that belied the naive presentation. Mixed in with dazzling abstract patterns were images right off Madison Avenue . . . only better.
>
> Two designs from that first show were especially memorable, a beautiful "His Master's Voice" trademark and a whiskey bottle, its colorful label meticulously duplicated right down to the smallest lettering in fine needlework. There was also a Kools cigarette ad, a primitive airplane, a rooster playing a guitar, several familiar cartoon characters, plus wonderfully conceived flora and fauna. It was a feast for eyes too long battered by the crass visual assaults of modern advertising.[13]

This importance of advertising is again signaled when Parker and Neal go on to state that "molas have been collected and admired for many different reasons, but examples based on the advertising world's pictographic symbols are the ones that have amazed and delighted many of the most sophisticated collectors."[14]

In vain these authors try to account for such delighted amazement. "Acculturation *molas* could be considered the great contemporary copy art," they write. "When the designs are looked at side by side with their sources, the magic of Cuna interpretation can be appreciated." But when it comes to thinking through in what this "magic"—this Cuna magic—of interpretation consists, the authors fall back on (a moralistic) formalism: "Unpleasing details are eliminated and something new is always added to support or enhance the design, and shapes are shortened, widened, repeated, patterned, and embellished in dozens of different ways."[15]

Formal considerations alone dictate other observations, such as the hallucinating, eye-scattering effect of the colored vertical rays (and sometimes tiny triangles) that fill up all available space on the *molas*. The entire surface of the Talking Dog mola from which I am working is thus covered. This vastly complicates the central image and, as with

seventeenth-century Baroque poetics, let alone certain forms of advertising, one has to work to "get it." This is clear when you compare RCA Victor's Talking Dog with the mola example. The painter of the RCA dog—an acknowledged late-nineteenth century British Realist—has striven to render what in his eyes would be considered a starkly straightforward, albeit sentimental photographic image. The sheer blackness of the large background not only serves to highlight the centrality of the image, but contrasts most emphatically with the mola background, which does the exact opposite, running into the central image, displacing its centrality in such a riot of marginalia that the eye finds it hard to stay still, to still the image itself.[16] RCA Victor's Talking Dog is frozen in a petrified gestus whereas this Cuna woman's dog is ready to talk. The blackness centralizing the petrified image has been irradiated by countless rays of bewildering color amounting to a "profane illumination."

This takes us beyond form to consider the spectral quality of the advertisements portrayed—their quality as source-objects "belonging" as commodity-representations to the cultural orbit of the United States (even if they are in fact manufactured in Taiwan or Japan or Brazil), and their quality as copies sewn by Indian women on a humid Caribbean Island. In a penetrating aside, Parker and Neal say the whole idea of such molas "is like a great spoof of our own mass-production advertising-oriented society."[17] Yet surely what becomes if not "magical," at least strangely powerful here, is not so much the Cuan "magic of interpretation" as invested in the mola copy, but the magic of the commodity-image itself—of the original of which the Cuna mola is copy. Indeed, what underpins the entire descriptive and assimilative effort of Western observers like Parker and Neal is their feeling that these molas *bring out* something indefinable, something powerful and refreshing. But what is this indefinable yet refreshing power brought out of the commodity-image, and how is this achieved?

Recently Outdated

Primitives make mighty mimics; thus the young Darwin in 1832, observing gaits and tongues and faces back and forth across the beach.

But in the second half of the twentieth century, objects as commodities have displaced one side of the mirror. No longer is it sailors of the Royal Navy dancing a jig and pulling horrid faces, but a still-life of a British dog selling faithful sound recordings. Truly the commodity economy has displaced persons, if not into things then into copies of things flaring with life of their own, briefly animated (as Disney has taught us) by animal life stirring in the thickets of an ever-receding lost nature. Modernity stimulated primitivism along with wiping out the primitive. Commodity production was the motor of this destruction, and it was in the representation of commodities in popular culture that the primitivism of modernity surfaced with unquenchable energy. Is this the undefinable power that Cuna women with their copies of copies *bring out* for Western eyes? It is a visceral effect, to be sure, a ripple of pleasure felt as sheer substance, in which the mimetic machinery of the West is now mimed by the handiwork of tropical women restoring aura to the opening up of the optical unconscious achieved by those machines. For what could better highlight, magnify, and bring out the viscerality hidden in the optical unconscious than the auratic sheen of mimesis and alterity provided by these demure women stitching the West on their chests with the same gesture as they preserve tradition? If the optical unconscious provided by mimetic machines is the preserve of waking dreams, as Benjamin would have it, then the Cuna Talking Dog awakens the dream. The Cuna Talking Dog, indeed, looks back—looks back at the viewer and looks back to what Benjamin theorized as the "recently outmoded," the Surrealist power of yesteryear's fashion, as well.

The *factual* reference here is to the well-known attraction of Parisian flea-markets for the Surrealists and the accompanying interest first formulated as a strategy by the Zurich Dadaists in objects found by chance, especially those objects whose time of glory had recently passed—objects not antiquities but "modern," yet no longer in vogue. The *theoretical* reference here is to Benjamin's speculations and enthusiasm for what he discerned to be the Surrealist discovery of the "revolutionary energies of the 'outmoded,' in the first iron constructions, the first factory buildings, the earliest photos, the objects that have begun to be extinct, grand pianos, the dresses of five years ago, fashionable restaurants when the vogue has begun to ebb from them."[18]

The Surrealists perceived an "atmosphere" concealed in these recently outmoded things. They based their (would-be revolutionary) art on bringing this "atmosphere" to the point of explosion, creating a "profane illumination," to which Benjamin referred as a "materialistic, anthropological inspiration." [19]

Is not the commodity-display in the Cuna molas precisely a Third/ Fourth World flea-market for the First World, displaying the "recently outmoded"? Is not the effect of amazement, delight, and feast for the eyes, noted by Parker and Neal, testimony to the profane illumination that flashes out with the release of "atmosphere" concealed therein?

But what is this "atmosphere" and how is it released? To a certain extent it is created by the way the Third World and its objects are in a global perspective generally seen as permanently "recently outdated," a reservoir of First World hand-me-downs and sleepy-eyed memories of its earlier consumer items. Defined in advance as backward and always lagging behind, Third Worlds are exemplary of the recently outdated, and Cuna molas constitute no exception. This character of being permanently out of date, moreover, applies not only to things actually made in the Third World, but with greater force to the objects imported and preserved over time—the 1930s and 1940s cars, the 1950s telephone systems, the prewar Singer sewing machines, the mechanical typewriters, and a thousand and one more such relics of modernity preserved in the time-warp of permanent underdevelopment and poverty, not to mention the dumping of First World waste, toxins, cigarette ads, and technologies found to be harmful, like DDT crop-spraying.

The RCA Victor Phonograph occupies a privileged position in this time-warp, for it is a knock-out instance of the recently outmoded and the power thereof, a gorgeous billowing forth of superseded promise. It is one of the great signs of the recently outmoded, shrouded in a mysterious atmosphere. This atmosphere is testimony to the Surrealist insight regarding the power of the ghosts embedded in the commodities created by yesteryear's technology—the whole point of modernity and capitalist competition being that technology and manufactured products are made obsolescent by progress' forward march.

Obsolescence is where the future meets the past in the dying body

of the commodity. Because history requires a medium for its reckoning, a temporal landscape of substance and things in which the meaning of events no less than the passage of time is recorded, in modern times it is the commodity that embodies just such a ready-reckoning of the objectification of the pathos of novelty.

The commodity does more than yield the measure of history as time. It is also the petrified historical event where nature passed into culture, where raw material combined with human labor and technology to satisfy cultured design. Standing thus at the crossroad of past and future, nature and culture, and submerging birth in death, the commodity is hardly a sign or symbol. Only in religion and magic can we find equivalent economies of meaning and practises of expenditure in which an object, be it a commodity or a fetish, spills over its referent and suffuses its component parts with ineffable radiance.

The commodity is a theater of operations in which honest labors achieve stunning metaphysical effects. The commodity is both the performer and the performance of the naturalization of history, no less than the historicization of nature.

In other words, the commodity is the staging of "second nature"— its unmaking no less than its making.

This has profound implications for the mimetic faculty, which I have defined as the nature that culture uses to create second nature. For if the "magic" brought out by the "recently outdated" is a magic achieved by framing, by highlighting the staging of second nature, its unmaking no less than its making, then this is also likely to be a privileged site for the revelation of mimesis and the flooding of mimetic excess—nowhere more so than in that reflection of the West forged by the handiwork of Third and Fourth World women on the global stage of primitivism.

Fortifying the Fetish: Magic and Necromancy in the Creation of Profane Illumination

Fashion is the realm in which the obsolescent character of the commodity is nourished and ritualized. In its tensed articulation of future and

past, fashion heralds birth and death. This is one reason why the commodity is endowed with a spectral quality. In his famous text on the fetishism of commodities, Karl Marx stated that all the "magic and necromancy" of the commodity is dissipated if we turn our gaze to noncapitalist societies, where production was not dictated by the free market and hence the commodity form. But in societies on the margin of capitalist industry or capitalist culture and profoundly influenced by that culture, and where strong local traditions of magic exist as well, then the magic and necromancy of the commodity is not so much dissipated as fortified.

Baron Nordenskiold's and Rubén Pérez' 1938 Cuna ethnography well displays this where they speak of the Cuna land of the dead as a world stuffed full of the souls of white man's commodities, which the Indians shall inherit—when dead (as I have described in Chapter 10). Forbidden access to the sacred, the province of men, Cuna women can be understood as inscribing this heavenly image-land of the dead onto their chests in the form of living molas such as the "talking dog." Hence in their busy hands the sacred illumination, reserved for men, becomes a profane illumination.

In trying to convey the Surrealist trick (and Benjamin insists it is a trick, not a method) by which the "atmosphere" of recently outmoded things is to be released, a trick that "substitutes a political for a historical view," Benjamin quotes a passage attributed to Guillaume Apollinaire (1880–1918) that is worth reading slowly so as to absorb its atmophere:

> Open, graves, you, the dead of the picture galleries, corpses behind screens, in palaces, castles, and monasteries, here stands the fabulous keeper of keys holding a bunch of keys to all times, who knows where to press the most artful locks and invites you to step into the midst of the world of today, to mingle with the bearers of burdens, the mechanics whom money ennobles, to make yourself at home in their automobiles, which are beautiful as armor from the age of chivalry, to take your places in the international sleeping cars, and to weld yourself to all the people who today are still proud of their privileges. But civilization will give them short shrift.[20]

Are not these keys the Surrealists' equivalent to the Cuna healer's practice of burning illustrations taken from trade catalogs so as to release their souls, a practice paralleled not so much by Cuna women in making their molas, but by the burning Western gaze upon them?

16

REFLECTION

There is something absorbing in observing people displaying childish ignorance of matters familiar to civilized man.

—Captain Fitz Roy of HMS *Beagle*

These reflections on Cuna women's copies of the "most valuable trademark in existence" point the way to a reappraisal of the study of custom and and a new relationship to the accustomed. This would be a novel anthropology not of the Third and Other worlds, but of the West itself as mirrored in the eyes and handiwork of its Others.[1] It is a field for which inquiry is overdue, given that the West has not only long been everywhere, in the form of tangible goods and even more so in their images, but that just as the West itself is no longer a stable identity against which mimetic alters can be confidently construed, so those alters too have a powerful capacity, like Cuna spirits, to elude fixing.

To call these reflections on Western reflections an "inquiry" suggests that the anthropological project can continue unabated with the same old desire for intellectual mastery of the object of study and the same old desire for the enigma of the "powerful explanation." But world history has decreed otherwise. Mastery is mocked as First World and Other Worlds now mirror, interlock, and rupture each other's alterity to such a degree that all that is left is the excess—the self-consciousness

as to the need for an Identity, sexual, racial, ethnic, and national, and the roller-coastering violence and enjoyment of this state of affairs.

Mastery is no longer possible. The West as mirrored in the eyes and handiwork of its Others undermines the stability which mastery needs. What remains is unsettled and unsettling interpretation in constant movement with itself—what I have elsewhere called a Nervous System—because the interpreting self is itself grafted into the object of study.[2] The self enters into the alter against which the self is defined and sustained.

Let me try to explain this mimetic vertigo through examples, and let me emphasize my intention to bring out the ways that the mimetic and alteric effect of such reflections must problematize the very act of making sense of reflection—which is why it fascinates and emits social power, and why it strips the anthropologist naked, so to speak, shorn of the meta-languages of analytic defence, clawing for the firm turf of cultural familiarity. The problem, then, is how to stop yet another defensive appropriation of the unfamiliar by means of an "explanation", instead of creating another quite different mode of reaction to disconcertion adequate to late twentieth-century patterning of identities and alterities. For just as nature abhors a vacuum, so the vertiginous cultural interspace effected by the reflection makes many of us desperate to fill it with meaning, thereby defusing disconcertion. To resist this desperation is no easy task. After all, this is how cultural convention is maintained. But let us try. Let us try to uncover the wish within such desperation and be a little more malleable, ready to entertain unexpected moves of mimesis and alterity across quivering terrain, even if they lead at the outermost horizon to an all-consuming nothingness.

The White Man

Julia Blackburn's book *The White Man: The First Responses of Aboriginal Peoples to the White Man* (published in 1979) provides striking illustrations of contemporary sacred representations of whites by (post)colonial subjects, such as those in an Ibo Mbari shrine-house in

northern Iboland photographed by Herbert Cole in Nigeria. On one page we see a photo of a mud sculpture of a white man operating a telephone in an "office." On another page we see a photo of a mud sculpture a white man with spectacles and pith helmet bursting out of the ground, his right arm confidently raised, his left lying relaxed on the earthen shell from which he is emerging.[3] It is, I think, a terrible face, so true to life, yet dead, its glasses highlighting a blind visual fix, mouth slightly parted with a protuberant lower lip, arrogant and a little anxious but knowing it's going to get its way. Like an image of the sun rising, he could also be read as sinking, frozen in im-mobility between this world and the underworld.

He frightens me, this African white man. He unsettles. He makes me wonder without end. Was the world historical power of whiteness achieved, then, through its being a sacred as well as profane power?[4] It makes me wonder about the constitution of whiteness as global colonial work and also as a minutely psychic one involving powers invisible to my senses but all too obvious, as reflected to me, now, by this strange artifact.

I know next to nothing of the "context" of ritual, belief, or of social practice in which an older anthropology, eager for the "native's point of view," would enmesh this African white man, "explain" him (away), "Africanize" him (as opposed to "whitenize" him). All I have is the image and its brief caption, and I am my own gaping subject of analysis, for it is precisely this fractured plane of visibility and invisibility that constitutes the impact of the image on an uncomprehending West now face to face with its-self, bursting the earth. For the white man, to read this face means facing himself as Others read him, and the "natives' point of view" can never substitute for the fact that now the native is the white man himself, and that suddenly, woefully, it dawns that the natives' point of view is endless and myriad. The white man as viewer is here virtually forced to interrogate himself, to interrogate the Other in and partially constitutive of his many and conflicting selves, and as yet we have few ground rules for how such an interrogation should or might proceed. Such is the effect of the reflection, an after-image of an after-image receding to a limitless horizon where the contemplative stance of "their" aura-filled cult-object becomes "our" *objet d'art—*

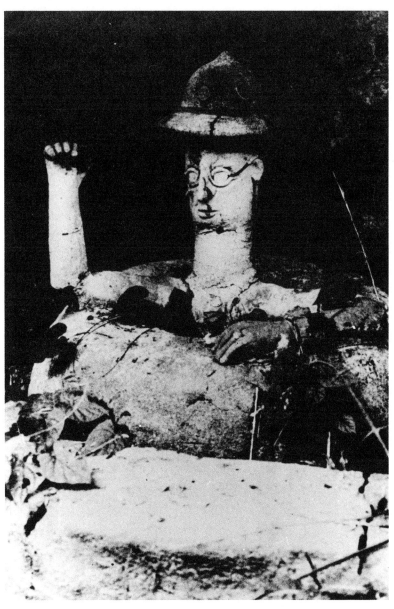

"White man from the ground" (*Bekee ime ala*). Image from an Igbo mbari shrine house. Photograph by Herbert M. Cole, 1967.

but not before the ground has been cleared by the erasure of critical distance effected by shock. Such face-to-faceness no doubt brings its quotient of self-congratulation. "They think we are gods." But being a god is okay only so long as it isn't excessive. After all, who knows—in imaging us as gods, might they not take our power?

Hauka

He is similar, not similar to something, but just similar. *And he invents spaces of which he is the convulsive possession.*
—Roger Caillois, "Mimicry and Legendary Psychaesthenia"

Consider the jailing (and all that goes along with jailing) of the members of the Hauka movement in Niger by the French in the late 1920s, and by the British in Accra in 1935. Those involved in this rapidly growing movement, begun among the Songhay people in 1925, would dance and become possessed by the spirits of colonial administrators. They became possessed by the spirit of the French major who had first taken the offensive against them, who imprisoned those who began the movement, who slapped them around until they said there was no such thing as Hauka. Thus deified as "the wicked major," his spirit got into the first floor of the Hauka pantheon as one of its most violent spirits. Thus possessed, Songhay would mimic the white men (and sometimes their wives, too) and acquire strange powers. Thus the movement spread—"an intolerable affront to French authority," one scholar has called it.[5] Thus they took the power of the man who slapped them around, and the French (and native chiefs) discovered:

> . . . the presence of an open dissidence, a society the members of which openly defied the social, political, and religious order. It is here that we discover the most original aspect of the Hauka movement: their total refusal of the system put into place by the French.[6]

They even formed their own, overtly anti-French, villages.[7]

Jean Rouch claims that in Ghana the Hauka movement died out with the formal disappearance of colonial government in 1957. "There

was no more colonial power and there never was a Hauka called Kwame N'krumah," he is credited with saying.[8] One of the last Hauka spirits in Ghana was a French general, a commander during the Indo-China war that preceded the U.S. war in Vietnam. Paul Stoller found the Hauka movement to be strong in Niger, however, even after independence, and he saw this as a continuing reaction to what he called European "force," less formal than the days of colonial administration, but still highly visible—still highly possessable.[9] Stoller, whose experience with the Hauka movement dates from 1969, found that the Hauka were supposed by African people in Niger to be funny as well as horrific, for even though they were considered a terrifying sight, they are also mocking the white man. "They were aping the ways of the European," he says. "Dressed in pith helmets and carrying their swagger sticks, I often observed the Hauka take the roles of European army generals who speak to their troops in pidgin French or pidgin English."[10]

But in addition to the conscious play-acting mimicking of the European, conducted with wit and verve, there is bodily possession—which is what makes the mimicry possible yet generally works at a less than conscious level with special, even disturbing, bodily effects: frothing at the mouth, bulging of the eyes, contorted limb movements, inability to feel pain. Strange "Europeans" indeed. And surely that's the point— they so clearly are and are not Europeans. It's the ability to become *possessed*, the ability that signifies to Europeans awesome Otherness if not downright savagery, which allows them to assume the identity of the European and, at the same time, stand clearly and irrevocably eye-bulgingly apart from it. What's being mimicked is mimickry itself— within its colonial shell. You see actors acting, as Brecht would have it, but you wonder about this mimetic capacity as much as any specific action.

In 1953, before independence, Jean Rouch filmed the ritual of possession by Hauka spirits in Ghana. This became the celebrated ethnographic film *Les maîtres fous*. In a raspy voice-over that is hard to follow in the English-language version of this film, he tells us through a blur of movements, irregularly stopping and starting, who is imitating what colonial officer as they parade and stomp around the "Governor's

Palace"—a six-foot high conical termite's nest painted black and white. Then, two-thirds of the way through the film comes this enormously clarifying moment—a moment that absorbs the miming of the powerful Hauka spirits and uses that miming not only to make the film as a whole "take fire," but does so by displaying, so I want to argue, the colonial endowment boosting the mimetic faculty in modern Europe.

A man possessed by a Hauka spirit stoops and breaks an egg over the sculpted figure of the governor (a little statue not unlike the Mbari shrine of the white man) that presides over the day's event of Hauka possession. Cracked on the governor's head, the egg cascades in white and yellow rivulets. Then the film is abruptly cut. We are transported to a big military parade in the colonial city two hours away. The film hurls us at the cascading yellow and white plumes of the white governor's gorgeous hat as he reviews the black troops passing. Those of us watching the film in a university lecture hall in New York City gasp. There is something immensely powerful released at this moment, begging for interpretation. The film with its ability to explore the optical unconscious, to come close and enlarge, to frame and to montage, creates in this sudden juxtaposition a suffusion of mimetic magic. Here film borrows from the magical practice of mimesis in its very filming of it. The primitivism within modernism is allowed to flower. In this colonial world where the camera meets those possessed by gods, we can truly point to the Western rebirth of the mimetic faculty by means of modernity's mimetic machinery.

Small wonder that years later Rouch, on the basis of thirty years work in Africa, would talk of his film-making as comparable to the sorcerer's hunt for spirit-doubles.[11]

The British authorities in Ghana banned the film. The reason? According to Rouch they "equated the picture of the Governor with an insult to the Queen and to her authority."[12] But what was the insult? It turns out to be exactly that moment of montaged dynamite I have singled out, where the mimetic power of the film piggy-backs on the mimetic power of African possession ritual. The insult, explains Rouch, "was because the film shows an egg being broken over the head of an image representing the Governor-General, in imitation of the real Governor-General's plumes cascading over his ceremonial helmet."[13]

The Hauka were jailed in 1935 for mimicking the white man who possessed their very bodies, and Rouch's film was banned in the 1950s for mimicking that mimicking.

Moreover Rouch himself banned showing it—at least to people in it who had been filmed in trance, for upon its being projected onto a screen they went into trance in an uncontrollable and almost dangerous way. "It is a kind of electroshock," he said, "to show a man a film of himself in trance."[14] Is not this same electroshocked man mimicking mimicking? (And we, who are watching who have never been possessed; what of us? How is that we escape this shock of the possessed?)

Is this bizarre colonial conjunction of the man with the movie camera at the midpoint of the twentieth century a beguiling confirmation of Benjamin's "history" of the mimetic faculty—that strangely "dialectical-image" point in time that colonialism brings into being, wherein the mimetically capacious person, as possessed by the Hauka, meets the mimetic cripple blessed with the mimetically capacious machine (the movie camera), the one receiving an electroshock, the other, a ban?

Trobriand Cricket

Some fifteen years after Rouch's film, the very same moment of filmic magic mimicking mimicking was repeated by the film *Trobriand Cricket*, depicting the mimesis and transformation of the British game of cricket by men of the Trobriand islands off the east coast of New Guinea, who were encouraged by missionaries, beginning in 1903, to replace precolonial warfare with this game of bat and ball.

Among the many ways by which the game is copied, and transformed (like the Cuna mola), there is one in particular that drives the film to its spectacularly successful revelation of the mimetic faculty. This is in the dancing by the players intermittently throughout the game, when the team is in trouble, when a team member makes a great catch, and when the team enters the playing field. The teams are four to five times larger than the British standard eleven, and the whole team of half-naked, dark-skinned, muscular men dances in unison, dressed in feathers with pandanus leaves and magical herbs around their limbs. The

sound-track emphasizes the sound-beat of the dancers. Dark bodies glisten with coconut oil. Face and body paint shine. The chanting and excitement is "infectious." The collective movement is hypnotizing. As the men dance, the British anthropologist-narrator tells us something of what the different dances mean, and we see how the dancers perform with their (collective) bodies the great Trobriand art of magic and metaphor made famous in the West via the pen of Malinowski and his commentators. What the film seizes upon is that in performing metaphor, many of these dances incur the return of the colonially repressed. Ironically, they mime war—World War II, to be precise— war being what Trobriand cricket was designed, by missionaries, to displace. Hence the subtitle to the film, *Trobriand Cricket: An Ingenious Response to Colonialism*. We see the dancers moving smartly along. Then the film switches abruptly to black and white, the absence of color that signifies the entry of black-and-white Pacific history. Against a tropical background and thatched roofs, we see rows of Australian soldiers in World War II marching at a good clip, three abreast, wheeling, rifles on their shoulder. The film cuts again, back to the color of the glistening dancers. There is a slight but audible gasp from the film's audience wherever I have seen this film, from the U.S. middle west as well as California, Texas, New York City. And the gasp is followed by a rippling chuckle, an outward opening of the soul, a satisfying enclosing of possession. We "got it." We got the idea. And something more than an idea. You feel you are on the verge of something amazing. As with the Cuna mola and the Hauka "governor," something ineffable is being "brought out" by this interaction of miming bodies and mimetic machinery.

Again and again the film makes this sort of move, interspersing dancing, half-naked cricketers imitating planes, with black-and-white shots of World War II U.S. Air Force bombers on the tarmac of an island airfield, then lifting off, just as the dancers in unison, shaking their great bunches of leaves, lift off too. "Squawking Hawk" is the name of one of the U.S. bombers. Of course the success of this move for a Western viewer depends enormously on the recruitment of wildness as something antithetical yet defining of civilized adulthood. As an "ingenious response" to colonialism, as a parody of British cricket

and missionary intention, it is the apparent wiliness, easy-going disre-
gard, and "natural" force of these wonderfully fit island men that is
displayed as turning the tables on old England's male character-build-
ing pastime. "Play Up. Play Up. And Play the Game." *Boys Own
Annual*. And all that. What makes the parody succeed, then, is extraor-
dinary mimicry, but mimicry exceeding certain bounds, and the fact
that that mimicry as figured by the film is solidly anchored in savage
wildness vis à vis the playing fields of Eton, Lord's cricket ground and
so forth. Perhaps nowhere is this point made more succinctly than
where (promoted by the film maker, so it would seem), some Trobriand
VIPs explain that not only did they massively expand the team size,
and that dance and magic, very much including war magic, is an
ubiquitous feature of the game, but that they gave up the prescribed
over-arm bowling of the ball, a defining element of the game in England,
and replaced it with a spear-throwing action instead. Moreover, they
had to place the stumps of the wicket closer together than is done in
England because—prompts an edited voice—their spear-throwing style
of bowling is so accurate. Thus the stiff-armed "unnatural" movement
of the players seriously playing the "civilized" game in the metropolitan
center is stiffed by the "natural" movement of the "naturally" agile
spear-throwing men of the island seriously playing the dancing game—
and the northern audience in the postmodern First World city loves it, as
do I. Civilization and its body-stiffening regimen succumbs to the filmic
release of wildness repressed—and nowhere is this more strategic than
with regard to the filmic miming of the mimetic faculty itself.

Just as the film makes its move into the archives to find the footage
of source-images from World War II history, so we as an audience
are moved into colonial history—not necessarily as the filmmakers
intended, however. For by this black and white sign of "colonial his-
tory," we are moved into a sort of miming machine, not just the mime
in the dancing itself, but the mime specific to the abrupt, cutting power
of filmic image to splice white soldiers wheeling in unison, next to,
before, and after black men mimicking them, pandanus leaves shaking,
the very earth vibrating. Through the film's piggy-backing on the Tro-
brianders' great tradition of magic-poetics enacted here in dance in
cricket, and through the film's imitating that tradition in its own filmic

technique, what suddenly bursts through, like the African white man bursting through the earth, is the mimesis of mimesis, self-reflexive mimesis, mimesis made aware of itself as through fusion of the mimetically capacious machine with the mimetically capacious dancing body, image partakes of mobile flesh, imitation becomes contactual—taking us ever nearer to what Caillois, in his essay on mimicry and legendary pychaesthenia described as being similar, "not similar to something, but just *similar*."[15] Benjamin expressed the same strange phenomenon, I think, in his essay "Doctrine of the Similar." "The perception of similarity is in every case bound to an instantaneous flash," he wrote. "It slips past, can possible be regained, but really cannot be held fast, unlike other perceptions. It offers itself to the eye as fleetingly and transitorily as a constellation of stars."[16] Thus "captured" by film, only to slip past, these dancing cricketers become mimetic substance incarnate—what spills out from the screen, rendering the post-colonial viewer speechless, gasping for air—mimetic excess, demanding yet disrupting any possibility of mastering the circulation of mimesis in alterity.

Made in the USA

Such demanding yet disrupting creates a frenzied stasis of interpretation, a profoundly reflexive late twentieth-century anthropology as the mimetic faculty is exposed, as never before, to the drunken see-sawing of the civilizing dialectic that once fused nature with culture in a settled pattern of alterities nicely secured by the aura of "first contact." To become aware of the West in the eyes and handiwork of its Others, to wonder at the fascination with their fascination, is to abandon border logistics and enter into the "second contact" era of the borderland where "us" and "them" lose their polarity and swim in and out of focus. This dissolution reconstellates the play of nature in mythic pasts of contactual truths. Stable identity formations auto-destruct into silence, gasps of unaccountable pleasure, or cartwheeling confusion gathered in a crescendo of what I call "mimetic excess" spending itself in a riot of dialectical imagery. To the instances already alluded to— the Cuna talking dog, the African white man, Rouch's Hauka, and

Trobriand Cricket—I feel compelled to add a powerful image, a performance-tableau depicting the West and which, by virtue of such depiction, would seem to siphon off its magic as Other by what I call "reverse" or "second contact."

It happened in an agribusiness town that I know well in western Colombia, in a little "alternative" hospital which I visited in 1981, because the mother of a friend of mine had gone crazy and wanted to go there for treatment. She'd had enough of the big state hospital in the city. In this African-American town that from the abolition of slavery in the nineteenth century until the 1950s was a region of relatively well-off cocoa farmers, but now bears the burden of "development" in which land monopoly, state and paramilitary terror, and modern technology—agricultural and pharamaceutical—have played prominent roles, this little hospital had a reputation for mystical curing, but nobody was sure in what it consisted, as it was new to the town. When I visited it with my friend from the town, I found a three-room house, and because the curer was unavailable, one of his assistants, a black woman from the remote Pacific coast, showed us around. A few patients were lying on the floor, and she directed us to the special room used, she said, for treatment. It was like no spiritual, shamanic, or folk-healing space I had ever seen before in all my wandering through the southwest. For there were no saints nor bottles of herbs nor candles burning in this bare, laboratory-like space. Instead the outstanding, the amazing, thing was the pictures on its cracked mud walls. They were advertisements, cut from medical journals. It was the context which brought out their strangeness. After all, I'd seen pictures like these in medical journals when I used to work in "real" hospitals years before. There was a flesh-toned, very precisely drawn, cross-sectional view through the body of a woman in an advanced stage of pregnancy, showing the fetus cozily curled up in the womb, pressed back against the gridwork of ligaments and articulations of the vertebrae. It was an advertisement for iron medicine to be taken during pregnancy. Next to it was another cut-out illustration of two pink kidneys being squeezed by lime-green surgical gloves, golden drops of urine emerging like tears from the snipped ureters—an advertisement for a diuretic. *Made in the USA.* Clear plastic I-V tubes and bottles were looped and whorled like

modernist sculpture along one of the walls, and a blue lightbulb centered on a board surrounded by clear bulbs completed the room's equipment. "Don't look too hard," advised the assistant drily as I gazed at the blue light as at some sort of altar, "It could cause cancer."

Nevertheless I am still looking at the blue halo of its afterglow years later, wondering how the magical laws of sympathy have moved from Darwin's wonder through Frazer and back into the peasant appropriation of modern advertising's appropriation of magic by means of awakening the optically unconscious. If I find myself virtually speechless, it is because I have looked too long at that light and simply don't know how to channel this strange power running through me that is being used to sell and to cure. To rely on native exegesis would be to break the rules of that exegesis. "Don't look too hard," is what she said. To see this remarkable tableau as mimesis taken to the point of parody of Western technology (as many of my friends in New York want to when I tell them about it) is to enter into a chamber of endlessly reflecting mirrors without resolution because while it is truly parodic of the West, it is patently unintended parody from the viewpoint of those who made it. Indeed to call it parodic would be to run the serious risk of creating a cruel parody of the understandings of the wage-workers' life-world as set into the tableau itself. Yet there is no denying its parodic power, even though unintended. To further complicate the interweaving of actions and reactions, I think one could even say that it's the very unintendedness that creates the parody, even though it cannot be parodic if not intended. This is impossible, but true, and this impossible truth represents the significant weirdness that intercultural connectedness of image-practice can take in our time. Other times, observing me staring at the afterglow of the blue light, my friends in northern climes tell me that it serves to bring out the magic repressed and therefore all the more powerfully deployed by modern industry, by Horkheimer and Adorno's "dialectic of enlightenment," and that is why I keep staring at it as some sort of Third World revelation of First World occultism hidden in the depths of technology's great promise. But this revelation depends for its power on the Third World authors' "misunderstanding," I protest, of how technology and industry and commerce "really" work. But nevertheless the revelation is there. The

very power of the insight depends on the powerful error (in my opinion) that they make. How can this revelatory chamber of mirrors exist whose reflections depend upon each other, while each one is remarkably "wrong" yet no less remarkably "right"? The very wrongness makes for rightness. Cultural relativism is clearly not an option here ("Let them believe what they want to, and we'll believe we want to"), because the different reactions are profoundly implicated in each other; they are "relative" to each other more than they are "relative" to what we used to call their "own cultural context." Nor can anthropological "contextualization" and more empirical investigation of that sort come to our aid, if only because there is no "context" anymore, other than cascading glimpses of splintered Othernesses on the world screen of mechanically reproduced imagery. In this world the glimpse, like the sound-bite and the after-image, is where the action is, Dada-like impulsions of Othernesses hurled at disconcerted beings splayed open to the future. The whole point of the power of this tableau of pink kidneys, green gloves, and luminscent I-V tubes against mud walls is that it's (promise of) meaning, and hence power, keeps ricocheting from West to Other, from mimesis to alterity, and back again in what can only be thought of as endless mobility one step ahead of interpretive discharge. Indeed, this tableau is preeminently "out of context" and thus preeminently exemplary of the fact that mimesis and alterity are now spinning faster than the eye can take in or the mind absorb. This seems to me more than turning the tables, inverting the Third into the First world, for instance. This spinning is giddying. As opposed to "first contact," this type of "second contact" disassembles the very possibility of defining the border as anything more than a shadowy possibility of the once-was. The border has dissolved and expanded to cover the lands it once separated such that all the land is borderland, wherein the image-sphere of alterities, no less than the physiognomic aspects of visual worlds, disrupt the speaking body of the northern scribe into words hanging in grotesque automutilation over a postmodern landscape where Self and Other paw at the ghostly imaginings of each other's powers. It is here, where words fail and flux commands, that the power of mimetic excess resides as the decisive turning point in the colonial endowment of the mimetic faculty itself.

17

SYMPATHETIC MAGIC IN A POST-COLONIAL AGE

In a manner of speaking, it is the image of the thing to be displaced that runs along the sympathetic chain.

—Hubert and Mauss, *A General Theory of Magic*

Since "first contact" the chain of sympathetic magic courses through all worlds and the displacement of the image running along it has observed a strange history indeed. How today we react to the after-imagery of that contact in all its displacements and effusions, and how that reaction is determined by histories of preceding reactions, is very much on my mind as I write these final pages. The strange history I have amassed for you to peruse is as much fable as history, yet always factual. Its fabulous nature comes as much from its logic of development as from its chosen materials, and that logic is one that has been determined by the dictum set forth with considerable anxiety at the beginning of this work as to the two-way street operating between nature and history, in this case between the mimetic faculty and colonial histories, it being my assumption that in modern times the two are inseparable. Given the impossibility of any representational act being achieved without the intervention of the mimetic faculty—the nature that culture uses to create second nature—this is no small claim.

But my interest began, and still rests, on the power of the copy to influence what it is a copy of. This was a primitivist view of magic.

Frazer's charming charms seduced me too. Mine is an old-fashioned interest in magic, but applied to fashion itself.

Not the depths but the surface has attracted me—the sheen of the image, its inconquerably opaque status between concept and thing. I have found the passions may be deep, but the action has been continuously on the surface, on the fetish-power of appearance as demonstrated by the power released by releasing the spirit, which is to say, the image of things, in magical spurts of reproduction. And I thank the Cuna ethnography for the power of this demonstration so useful for understanding what has been termed the postmodern condition, the virtually undisputed reign of the image-chain in late capitalism where the commodification of nature no less than mechanical and uterine reproduction link in a variety of power-assuming, power-consuming, ways.

The nature of the history of the mimetic faculty I have presented is in the form of what Benjamin called a "dialectical image." Nothing less could satisfy the demands of the two-way street, historicizing nature and naturalizing history, and nothing less could satisfy the claims of the mimetic faculty to be the nature that culture uses to create second nature. The history I have presented thus forms a triptych that somersaults backwards then forwards through time, awakening mythical pasts for modern projects. "In order for the past to be touched by the present," wrote Benjamin, "there must be no continuity between them." From the mid-nineteenth century onwards, mimetically capacious machines reinvigorated the mimetic faculty such that the mythic foundational moment of colonial "first contact" (as with Darwin on the beach in Tierra del Fuego) passed into the mechanically reproduced image as a new sort of sympathetic magic of imitation and contact. Later on, from the mid-point of the twentieth century with the final dissolution of formal colonial controls there emerged a sort of reversal of contact, a "second contact," with the birth of a radically different border between the West and the rest, between civilization and its Others.

Not only has this border been punctured porous by the global market and multinational corporations, together with desperate emigration from the south, but the border as cultural artifact has been diffused to cosmic proportion. Its phantasmic reality looms daily larger than ever

was the case with "first contact." Now Fitz Roy's sailor is really dancing his little jig. The Berlin wall crumbles. The fence along the Rio Grande is erected higher and higher. Yet the border becomes increasingly unreal, micromental, and elusive.

Intriguing testimony to the powers unleashed by "second contact" and the destabilization of the border is the fact that the self is no longer as clearly separable from its Alter. For now the self is inscribed in the Alter that the self needs to define itself against. This accounts for the combination of fear and pleasure that mimetically capacious machines can create when interacted with mimetic reflections of the West as portrayed in the bodies, eyes, and handiwork of its Alters.

Such interaction creates mimetic excess—mimetic self-awareness, mimesis turned on itself, on its colonial endowment, such that now, in our time, mimesis as a natural faculty and mimesis as a historical product turn in on each other as never before.

If, as I have suggested, it is useful to think of mimesis as the nature culture uses to create second nature, the situation now is that this famous second nature is foundering and highly unstable. Veering between nature and culture, essentialism and constructionism—as evidenced today everywhere, from the ethnic surge in politics to the delight in artifactualization, as one after the other new identities are spun into being—the mimetic faculty finds itself on the verge of dramatically new possibilities.

Yet the particular history of the senses I have presented to you is fabulous in still another way than its leap-frogging through time and its reassemblage of spirited materials. This is because of a curious inner tension, the northern scribe sailing bravely forth to southern climes and puzzled as to how to react—how to be, might be a better way of putting it—vis a vis images of "himself" that were intimately organized into spiritual healing of and by people patently different to "himself." These were Cuna figurines. One could, I suppose, do the usual thing and "analyze them" as anthropologists do, as things to be layered with

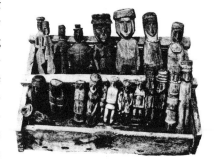

context, then stripped, but that would seem to be an evasion and miss the whole point—that something crucial about what made oneself was implicated and imperilled in the object of study, in its power to change reality, no less. (I fear this point is so important, yet so obvious, that it will continue to be completely overlooked. There must be massive cultural repression at work here.)

Yet what would it mean and what would it take for the "European type" carved into the figurines to be so nosy about its-self thus carved, sung to, and somehow, mysteriously, involved in realizing the spirit power of the inner substance, the "secret" of reproductive origin of spirit-appearance within that outer appearance? And behind these brave figurines gathering dust in island houses or standing tall under the hammock of the sick by the curer, behind them emerged others— West Africans possessed by Hauka on Jean Rouch's flickering screen, no less than Rouch himself possessed by their possession, Trobriand cricketers dancing war magic where soaring gulls and Australian soldiers in black-and-white create, through the film-maker's magic of montage, the flash of the dialectical image and the delightful squandering of mimetic excess, dripping off the screen of possibilities, displaced/replaced "talking dogs" diffusing, sympathizing, inverting His Master's Voice . . .

Thus in my roundabout way I have in the preceding pages tried to work out my reaction to being thus presenced in their mimetics, feeling through the ethnographies and through the films and photographs that indeed a question has been asked of me that is constitutive of my cultured Being. Perhaps "working out" is misleading here. It suggests a degree of control dependent on a magical capacity to step outside the field of referents. Reaction is probably a better choice of words, the authorial self being the "outer form" by means of which the mimetic shudder (as Adorno used that term) tears at identity and proliferates associations of a self bound magically to an Other, too close to that Other to be but dimly recognizable, too much the self to allow for satisfying alterity. Selves dissolve into senses and the senses show signs of becoming their own theoreticians as world histories regroup. This is not a question of being out of balance, or of not being able to find the golden mean—would that it were that simple. Instead it's a matter

of what used to look like impossibility, of being in different places at one and the same time—"place" here assuming the bountiful burden of presence, its plurality assuring the permanent evacuation of such. The search for identity through the many circuits of mimesis and alterity ends at this point in our history with the conclusion that, finally, although there is no such thing as identity in any grand sense— just chimeras of possible longings lounging in the interstices of quaint necessities—nevertheless the masks of appearance do more than suffice. They are an absolute necessity.

Mimetic Excess

With the trapped ape aping civilized humanity's aping, Kafka drew attention to the closed circle of mimesis and alterity in the modern age. But the colonial wildness imputed to the primitive and to mimesis could function in ways other than domestication. The circle could be broken by that very same wildness. Hence he also wrote of,

The Wish to Be a Red Indian

If one were only an Indian, instantly alert, and on a racing horse leaning against the wind, kept on quivering jerkily over the quivering ground, until one shed one's spurs, for there needed no spurs, threw away the reins, for there needed no reins, and hardly saw that the land before one was smoothly shorn heath when horse's neck and head would be already gone.

Where not repressed, the mimetic faculty may serve as a tool of repression in the "civilizing" project of Enlightenment. Horkheimer and Adorno emphasized this with their notion of the "organization of mimesis." But throughout his considerable body of work Adorno gave greater emphasis to the notion that the mimetic faculty, with its capacity to combine sensuousness with copy, provided the immersion in the concrete necessary to break definitively from the fetishes and myths of commodified practices of freedom.

What I have termed "mimetic excess" is just such a possibility— an excess creating reflexive awareness as to the mimetic faculty, an

awareness that can reconstellate Kafka's despair oscillating between the ape's melancholy awareness of its aping, and the wild abandon of sympathetic absorption into wildness itself, as with the identification with the Indian. History would seem to now allow for an appreciation of mimesis as an end in itself that takes one into the magical power of the signifier to act as if it were indeed the real, to live in a different way with the understanding that artifice is natural, no less than that nature is historicized. Mimetic excess as a form of human capacity potentiated by post-coloniality provides a welcome opportunity to live subjunctively as neither subject nor object of history but as both, at one and the same time. Mimetic excess provides access to understanding the unbearable truths of make-believe as foundation of an all-too-seriously serious reality, manipulated but also manipulatable. Mimetic excess is a somersaulting back to sacred actions implicated in the puzzle that empowered mimesis any time, any place—namely the power to both double yet double endlessly, to become any Other and engage the image with the reality thus imagized. This excessiveness was once in the hands of seers and magicians who worked images to effect other images, who worked spirits to affect other spirits which in turn acted on the real they were the appearance of. How we all in our different ways and different walks of life are used today by this mimetic excess is perhaps, now, to some significant degree going to be a matter of choice and not the monopoly of mediums and the media. Ethnic, gender, and sexual struggle would seem to indicate this. I would certainly hope so and this book is, if anything, directed towards that end by making the nature of that excess more clear than it might be otherwise, drawing attention to the exuberance with which it permits the freedom to live reality as really made-up.

NOTES

Chapter 1

1. Nils Homer and Henry Wassén, "The Complete Mu-Igala in Picture Writing: A Native Record of a Cuna Indian Medicine Song," *Etnologiska Studier* 21 (Göteborg, 1953). The text was first published, without pictures, in this same journal in 1948.

2. T. W. Adorno, " A Portrait of Walter Benjamin," *Prisms*, trans. Samuel and Sherry Weber (Cambridge: MIT Press, 1981), p. 233. Susan Buck-Morss, *The Origin of Negative Dialectics: Theodor W. Adorno, Walter Benjamin, and the Frankfurt Institute* (New York: Free Press, 1961), p. 86.

3. Erland Nordenskiold, with Rubén Pérez, edited by Henry Wassén, *An Historical and Ethnological Survey of the Cuna Indians*, Comparative Ethnographical Studies 10 (Göteborg: Ethnografiska Musuem, 1938). Subsequent references to this work appear in the text in parentheses.

4. David Stout, *San Blas Acculturation: An Introduction* (New York: Viking Fund Publications in Anthropology 9, 1947), pp. 103–104.

5. Henry Wassén, "An Analogy Between a South American and Oceanic Myth Motif and Negro Influence in the Darién," *Etnologisker Studier* 10 (Göteborg, 1940), pp. 76, 79.

6. Could we tentatively suggest that what was once a lively mimicry of sound with frequent changes of voice and a dialogical interaction between healer and spirits became, sometime late in the nineteenth or early twentieth century, a mimicry of figurines in ritual healing in which, to all accounts, the voice of the chanter never shifts from its steady droning monotone? But note that carved figures are prominent in Christopher Columbus' and Oviedo's descriptions concerning indigenous divination and magic in other parts of the Caribbean at the opening stage of European conquest. Also note that in Lucien de Puydt's account of the scientific

expedition that he led in 1865 in the Isthmus of Darién, financed by a French consortium interested in building a canal, he was impressed by the presence of what he called fetishes. (He wrote that the Cunas, "although idolators, believing in the supernatural potency of the grotesque festishes suspended in their houses, bowing reverentially to grossly formed figures and holding certain trees as sacred. . . .")

7. Norman Mcpherson Chapin, "Curing Among the San Blas Kuna of Panama," unpublished Ph.D. dissertation (Tucson: University of Arizona, 1983), pp. 93–95. "Non-Indian" is inaccurate for the reason that, as far as I can ascertain, there are no *nuchukana* figurines representing African-American or black people. On the other hand, as Chapin himself points out (p. 93), when *ponikana*, or evil spirits, assume the form of human beings, they often do so as blacks, whom the Cuna, apparently, loathe. It should be pointed out here that blacks form a large part of the population of Panama and of the Caribbean and Darién peninsula surrounding the Cuna.

8. Leon S. De Smidt, *Among the San Blas Indians of Panama: Giving a Description of Their Manners, Customs, and Beliefs* (Troy, New York: 1948), cited in Chapin, 1983, pp. 356–57.

9. Gerardo Reichel-Dolmatoff, "Anthropomorphic Figurines from Colombia, Their Magic and Art," *Essays in Pre-Colombian Art and Archaeology.* Samuel K. Lothrop, ed. (Cambridge, Mass: Harvard University Press, 1961), pp. 240, 495.

10. Ibid., 240.

11. Stephanie Kane, "Emberá (Chocó) Village Formation: The Politics and Magic of Everyday Life in the Darién Forest." Unpublished Ph.D. dissertation (Austin: Department of Anthropology, University of Texas at Austin, 1986), p. 448.

12. Ibid., 449.

13. Stephanie Kane, "Surreal: Taboo and the Emberá-Gringa," paper delivered at the 87th Meeting of the American Anthropological Association (Phoenix, 1990), p. 11.

14. Marcel Mauss and Henri Hubert, *A General Theory of Magic*, trans. R. Brain (New York: W. W. Norton, 1972). This work is published in book form under the authorship of Mauss, yet the original *Année sociologique* essay is credited to the joint authorship of Henri Hubert and Marcel Mauss. I persist, therefore, in acknowledging this to be a jointly authored work.

15. Kane, 1990, p. 17.

Chapter 2

1. Susan Buck-Morss, *The Dialectics of Seeing: Walter Benjamin and the Arcades Project* (Cambridge, Mass: MIT Press, 1989), p. 267.

2. Yrjo Hirn, *Origins of Art* (London, 1900; reissued New York: Benjamin Bloom, 1971), p. 293.

3. Karl Marx, *Capital: A Critique of Political Economy*, 1 (New York: International Publishers, 1967), p. 72.

4. Walter Benjamin, "Surrealism: The Last Snapshot of the European Intelligentsia," *Reflections*, ed. Peter Demetz, trans. E. Jephcott (New York: Harcourt Brace Jovanovich, 1978), pp. 177–92.

5. Walter Benjamin, "A Small History of Photography," *One-Way Street and Other Writings*, trans. E. Jephcott and K. Shorter (London: New Left Books, 1979), pp. 243–44.

6. Walter Benjamin, "The Work of Art in the Age of Mechanical Reproduction," *Illuminations*, ed. Hannah Arendt, trans. Harry Zohn (New York: Schocken, 1969), p. 238.

7. Georges Duhamel, *Scenes de la vie future* (Paris: Mercure de France, 1930), cited in Benjamin, "The Work of Art in the Age of Mechanical Reproduction," p. 238.

8. Benjamin, "The Work of Art in the Age of Mechanical Reproduction," p. 236.

9. Elaine Scarry, *The Body in Pain: The Making and Unmaking of the World* (New York: Oxford University Press, 1985).

10. Benjamin, "The Work of Art in the Age of Mechanical Reproduction," p. 240.

11. Paul Virilio, *War and Cinema: The Logistics of Perception*, trans. P. Camiller (London: Verso, 1989), p. 11.

12. Ibid., p. 20.

13. Sergei Eisenstein, "The Filmic Fourth Dimension," *Film Form: Essays in Film Theory*, trans. J. Leyda (New York: Harcourt Brace Jovanovich, 1949), p. 7.

14. Eisenstein, "The Cinematographic Principle and the Ideogram," in ibid., p. 42.

15. Theodor W. Adorno, "Transparencies on Film," *New German Critique* 24–25 (Fall–Winter 1981–82), p. 202.

16. Georges Bataille, *Erotism, Death, and Sensuality*, trans. M. Dalwood (San Francisco: City Lights, 1986), pp. 37–38.

17. Benjamin, "The Work of Art in the Age of Mechanical Reproduction," p. 223.

18. Ibid., p. 236.

Chapter 3

1. Walter Benjamin, "On the Mimetic Faculty," *Reflections* ed. Peter Demetz, trans. E. Jephcott (New York: Harcourt Brace Jovanovich, 1979), p. 333.

2. Roger Caillois, "Mimicry and Legendary Pychaesthenia," *October* 31 (Winter 1984), pp. 17–32. (Subsequent page references appear in the text in parentheses). Originally published as "Mimetisme et psychasthenie legendaire" in *Minotaure* 7 (1935), pp. 4–10, and reprinted in *Le Mythe et l'homme* (Paris: Gallimard, 1938). Note that Caillois later forcefully criticized this essay. In a footnote in *Man, Play, and Games* (New York: Free Press, 1959), p. 178, he wrote that "unfortunately this study treats the problem with a perspective that today seems fantastic to me. Indeed I would no longer view mimetism as a disturbance of space perception and a return to the inanimate, but rather, as herein proposed, as the insect equivalent of human games of simulation." Caillois, however, goes on to observe that the examples used in that essay "nevertheless retain their value."

3. Gertrude Koch, "Mimesis and the Ban on Graven Images," unpublished MS distributed in the Department of Cinema Studies, New York University, 1990, p. 5.

4. Ibid.

5. Julia Kristeva, *Revolution in Poetic Language* (New York: Columbia University Press, 1984), especially Chapter 1, "The Semiotic and the Symbolic."

6. G.W.F. Hegel, *The Phenomenology of Mind*, trans. J.B. Baillie (New York and Evanston: Harper and Row, 1967), pp. 111, 112, 114.

7. Miriam Hansen, "Benjamin, Cinema and Experience: The Blue Flower in the Land of Technology," *New German Critque* 40 (Winter 1987), pp. 179–224.

8. Letter of July 7, 1924, *Briefe* (Frankfurt: 1966), p. 351. Quoted in "Publisher's Note," *Walter Benjamin: One Way Street and Other Writings*, (New Left Books, London, 1979), p. 34.

9. Walter Benjamin, "One Way Street," *Reflections*, p. 68; under the subhead "To The Public: Please Protect and Preserve These New Plantings."

10. Benjamin, *Briefe*, Letter to Hofmannsthal, Feb. 8, 1928, cited in "Publisher's Note," *Walter Benjamin: One Way Street and Other Writings*. On conceptual issues in this relation between woman and the detail see Naomi Schorr's *Reading in Detail: Aesthetics of the Feminine* (New York: Methuen, 1987).

11. Benjamin, "Surrealism," *Reflections*, p. 181.

12. Benjamin, "Theses on the Philosophy of History," *Illuminations*, ed. H. Arendt, trans. Harry Zohn (New York: Schocken, 1969), p. 255.

13. Benjamin, "Doctrine of the Similar," trans. K. Tarnowski, *New German Critique* 17 (Spring, 1979), pp. 65–69.

14. Benjamin, "The Storyteller," *Illuminations*, p. 103.

15. Ibid.

16. Caillois, "Mimicry and Legendary Pychaesthenia," p. 31.

17. Gustave Flaubert, *The Temptation of St. Antony*, trans. Kitty Mrosovsky (Harmondsworth: Penguin, 1983), p. 232.

Chapter 4

1. G.W.F. Hegel, "Preface," *The Phenomenology of Mind*, trans. J.B. Baillie (New York and Evanston: Harper and Row, 1967), p. 94.

2. Max Horkheimer and T. W. Adorno, *Dialectic of Enlightenment* (New York: Continuum, 1987), p. 17.

3. It is therefore strange that the nature and function of mimesis in Adorno's work and that of the Frankfurt School has not, as far as I know, been subject to close analysis.

4. Horkheimer and Adorno, *Dialectic of Enlightenment*, p. 227.

5. Sigmund Freud, *Jokes and Their Relation To The Unconscious*, SE vol. 8, p. 192.

6. Frazer, *The Golden Bough, Part 1, The Magic Art and the Evolution of Kings*, 3rd edition (London: Macmillan, 1911), p. 52. Subsequent page references to this work appear in parentheses in the text.

7. It should be noted, however, that early in his discussion of sympathetic magic, Frazer restricts his analysis to that of "charms," which would probably mean a topic narrower than magic per se. He also distinguishes the analysis of the underlying *principles* of thought from the *practice* of magic, and he regards such practice as art, meaning something like habit, in which the logic is implicit, not explicit. This makes the status of ideas and individual reason in his analysis—features which have been held to over-narrowly define the approach of the "British Intellectualist School" of magic (Tylor and Frazer)—much more ambiguous than is usually allowed for, and certainly opens the door invitingly to performatively sensitive approaches.

8. In reference to Frazer's style of work building on the insights of Tylor, Robertson Smith, and so on, compare with Mary Douglas' unflattering characterization in her *Purity and Danger* (Harmondsworth: Penguin, 1966), p. 20: "Frazer had many good qualities, but originality was never one of them."

9. The reference to Tylor is to his *Primitive Culture* (rpt. New York: Harper and Row, 1958), and to E.E. Evans-Pritchard's "The Intellectualist (English) Interpretation of Magic," *The Bulletin of the Faculty of Arts* (Cairo: The University of Egypt), 1933.

10. Roman Jakobson's fertile distinction between metaphor and metonomy is indebted to these Frazerian principles of Similarity and Contact. In his essay "Two Aspects of Language and Two Types of Aphasic Disturbances" (p. 113 in *Language in Literature*, eds. K. Pomorska and S. Rudy, Cambridge, Mass: Belknap, Harvard University Press, 1987), Jakobson refers to Frazer's distinction as "indeed illuminating," and cites it side by side with Freud's dream work mechanisms of identification and symbolism, with regard to similarity/metaphor, and condensation and displacement with regard to contact/metonomy.

11. E.B. Tylor, vol. 1 *Primitive Culture* (New York and Evanston: Harper and Row, 1958), pp. 116, 119.

12. S.J. Tambiah, "Form and Meaning of Magical Acts: A Point of View," *Modes of Thought*, ed. Robin Horton and Ruth Finnegan (London: Faber and Faber, 1973), p. 207

13. E.E. Evans-Pritchard, *Witchcraft, Oracles, and Magic Among the Azande* (Oxford: Clarendon Press, 1937). G.E.R. Lloyd, *Polarity and Analogy: Two Types of Argumentation in Early Greek Thought.* (Cambridge, England: University of Cambridge Press, 1966).

14. Gerardo Reichel-Dolmatoff, "Anthropomorphic Figurines from Colombia: Their Magic and Art," *Essays in Pre-Colombian Art and Archaeology.* ed. S. Lothrop (Cambridge, Mass: Harvard University Press, 1961), p. 232.

15. See Freud's principle of "the omnipotence of thoughts' in Chapter III, "Animism, Magic, and the Omnipotence of Thoughts," *Totem and Taboo: Some Points of Agreement between the Mental Lives of Savages and Neurotics*, published in parts between 1912 and 1913, SE, vol. 8. Writing on imitative magic Freud says, for instance: "All we need to suppose is that primitive man had an immense belief in the power of his wishes" (83), so much so that by means of representations "things become less important than the ideas of things; whatever is done to the latter will inevitably also occur to the former" (85). One of the main arguments about representation and totemism in Emile Durkheim's *The Elementary Forms of Religious Life* (trans. J. Swain, London: Allen and Unwin, 1915) is identical; see Michael Taussig, "Maleficum; State Fetishism" in *The Nervous System* (New York: Routledge, 1991), pp. 111–140.

16. Yrjo Hirn, *The Origins of Art* (first published in London, 1900; rpt. New York: Benjamin Bloom, 1971), p. 289.

17. Ibid., p. 290.

18. Marcel Mauss and Henri Hubert, *A General Theory of Magic*, trans. R. Brain, Norton (New York: Norton, 1972), p. 68.

19. Freud, *Totem and Taboo*, p. 79.

20. Mauss and Hubert, *A General Theory of Magic*, pp. 72–73.

21. Michael Taussig, *Shamanism, Colonialsm, and the Wild Man: A Study in Terror and Healing* (Chicago: University of Chicago Press, 1987), pp. 393–467.

22. This would seem to provide a basis for the misleading formalist distinction that in "shamanism" the soul departs from the body, while in "possession" the apparent opposite occurs; the body is taken over by an external spirit (see, for instance, Mircea Eliade, *Shamanism: Archaic Techniques of Ecstasy*, Princeton, Princeton University Press, 1964, pp. 5–6).

23. Benjamin, "A Small History of Photography," *One-Way Street and Other Writings*, trans. E. Jephcott and E. Shorter (London: New Left Books, 1979), p. 243. Benjamin, p. 256, also refers to photographers as the descendants of magicians (augurers).

24. Benjamin, "Surrealism: The Last Snapshot of the European Intelligentsia," *Reflections*, ed. Peter Demetz, trans. E.E. Jephcott (New York: Harcourt Brace Jovanovitch, 1978), p. 192.

Chapter 5

1. See Michael Taussig, "The Old Soldier Remembers," in *Shamanism, Colonialism, and the Wild Man: A Study in Terror and Healing* (Chicago: University of Chicago Press, 1987), pp. 337–41.

2. Ibid., pp. 3–135.

3. Max Horkheimer and T.W. Adorno, *The Dialectic of Enlightenment* (New York: Continuum, 1987), p. 184.

4. Bronislaw Malinowski, *The Sexual Life of Savages (in North-Western Melanesia)*, (New York: Harcourt, Brace & World, 1929), p. 449.

5. Horkheimer and Adorno, *Dialectic of Enlightenment*, p. 180.

6. Ibid., p. 186.

7. Harry Kessler, *The Diaries of a Cosmopolitan: Count Harry Kessler, 1918–1937*, trans. and ed. C. Kessler (London: Weidenfeld and Nicolson), p. 284.

Chapter 6

1. Marcel Mauss and Henri Hubert, *A General Theory of Magic*, trans. R. Brain (New York: Norton, 1972), pp. 65–66.

2. "First Contact," of course, was made in Tierra del Fuego centuries before Darwin. The Selk'nam Indians, for instance, are recorded as having

first encountered Europeans, namely the Spaniard Pedro Sarmiento de Gamboa, in 1579. A Dutch commander, Olivier van Noort, landed on islands in the Magellan Straits in 1598. Haush Indians were first contacted later, in 1619, by the Nodal brothers. Captain James Cook, with scientists and sailors, met Haush Indians in 1769. See Anne Chapman, *Drama and Power in a Hunting Society: The Selk'nam of Tierra del Fuego* (Cambridge, England: Cambridge University Press, 1982).

3. Charles Darwin, *Charles Darwin's Diary of the Voyage of H.M.S. "Beagle"* ed. Nora Barow (Cambridge, England: Cambridge University Press, 1934), p. 118. Subsequent references to this work appear in the text in parentheses.

4. Darwin, *Journal of Researches* . . . (New York: D. Appleton, 1896), p. 206. Subsequent references to this work appear in the text in parentheses.

5. Darwin, *The Beagle Record*, ed. R.D. Keynes (Cambridge, England: Cambridge University Press, 1979).

6. Ibid., p. 96.

7. Michael Leahy and Maurice Crain, *The Land That Time Forgot* (New York and London: Funk and Wagnalls, 1937), p. 48.

8. Ibid., p. 50.

9. Gananath Obeyesekere pointed out this possibility to me.

10. Emile Durkheim, *The Elementary Forms of Religious Life*, trans. J.W. Swain (London: Allen and Unwin, 1915), p. 395.

11. Ibid., p. 395.

12. E. Lucas Bridges, *Uttermost Part of the Earth* (London: Hodder and Stoughton, 1951), p. 418.

13. Martin Gusinde, *Los Indios de Tierra del Fuego*, 3 vols. (Buenos Aires: Centro de Etnología Americana, 1982). Also see *The Yamana: The Life and Thought of the Water Nomads of Cape Horn*, trans. F. Shutze, 5 vols. (New Haven: Human Relations Area Files, 1961); and Anne Chapman, *Drama and Power in a Hunting Society*. For a comparison of these Tierra del Fuegan accounts with the central Amazon and the use of gang-rape against women to maintain the taboo against their seeing the sacred flutes kept in the men's house, see Joan Bamberger, "The Myth of Matriarchy: Why Men Rule in Primitive Society," in *Women, Culture, and Society*, ed. M.D. Rosaldo and L. Lamphere (Stanford: Stanford University Press, 1974); also see Thomas Gregor, *Anxious Pleasures: The Sexual Lives of Amazonian People* (Chicago: University of Chicago Press, 1985). For Australia, see among many sources the classic account of Baldwin Spencer and F.J. Gillen, *The Native Tribes of Central Australia*, (first published in 1899; rpt. New York: Dover, 1968). Chapter Five on the sacred objects known as Churinga begins thus: "Churinga is the name given by the Arunta natives to certain sacred objects which, on penalty

of death or very severe punishment, such as blinding by means of a firestick, are never allowed to be seen by women or uninitiated men."

14. Georges Bataille, *Erotism: Death and Sensuality*, trans. M. Dalwood (San Francisco: City Lights, 1986), p. 74. Also see his *Lascaux, Or the Birth of Art* (Switzerland: Skira, n.d. [1955?]).

15 Quoted from Martin Gusinde, *The Yamana*, vol. 1, p. 143. Subsequent references to this work appear in the text in parentheses.

Chapter 7

1. Charles Darwin, *Journal of Researches* . . . (New York: D. Appleton, 1896), p. 204. Subsequent references to this work appear in the text in parentheses.

2. Charles Darwin, *The Beagle Record* . . ., ed. R.D. Keynes (Cambridge, England: Cambridge University Press, 1979), p. 106. Subsequent references to this work appear in the text in parentheses.

3. Where the philosopher Michael Polanyi uses Evans-Pritchard's study of Zande witchcraft to show similarities between science and magic as systems impervious to empirical refutation, he cites William James as follows: "We feel neither curiosity nor wonder concerning things so far beyond us that we have no concepts to refer them to or standards by which to measure them." The Fuegians encountered by Darwin, notes James, wondered at the small boats but paid no attention to the big ship lying at anchor in front of them. Michael Polanyi, *Personal Knowledge* (Chicago: University of Chicago Press, 1958), pp. 286–94.

4. Martin Gusinde, *The Yamana: The Life and Thought of the Water Nomads of Cape Horn*, trans. F. Shutze, 5 vols. (New Haven: Human Relations Area Files, 1961), vol. 3, pp. 877–78. See also Georges Bataille, *The Accursed Share*, vol. 1 (New York: Zone, 1990).

5. Gusinde, *The Yamana*, vol. 3, p. 857.

6. L.E. Elliot Joyce, "Introduction," Lionel Wafer, *A New Voyage and Description of the Isthmus of America* (rpt. Oxford: Haklut Society, 1933), p. lix.

7. Gusinde, *The Yamana*, vol. 1, pp. 92, 95.

8. Anne Chapman, *Drama and Power in a Hunting Society: The Selk'nam of Tierra del Fuego* (Cambridge, England: Cambridge University Press, 1982), p. 99.

9. Note the pungent 1938 diary-response of the ever-practical Brecht to Benjamin's notion of "aura" as a type of animism: "benjamin is here . . . he says: when you feel a gaze directed to you, even behind your back, you return it (!). the expectation that what you look at looks back at you, provides the aura. the latter is supposed to be in decay in recent times, together with the cultic. b[enjamin] discovered this through the

analysis of film, where aura disintegrates because of the reproducibility of artworks. it is all mysticism mysticism in a posture opposed to mysticism. it is in such a form that the materialist concept of history is adopted! it is rather ghastly." Quoted in Susan Buck-Morss, *The Origin of Negative Dialectics* (New York: Free Press, 1977), p. 149.

10. Karl Marx, *The Economic and Philosophic Manuscripts of 1844*, ed. D. Struik, trans. M. Milligan (New York: International Publishers, 1964), p. 139.

11. Ibid.; the emphasis is Marx's.

12. Certainly this is how A. Kluge sees his own filmmaking in "On New German Cinema Art, Enlightenment and the Public Sphere," *October* 46 (1988), an issue dedicated to his work.

Chapter 8

1. Erland Nordenskiold and Rubén Pérez, ed. Henry Wassén, *An Historical and Ethnological Survey of the Cuna Indians*, Comparative Ethnographical Studies 10 (Göteborg: 1938), p. 355. Compare this with the respresentational tranquility of Franz Boas and the Koskimo Indians of the famous Northwest Coast of the New World, among whom, at the time of Boas' writing, serious illness was generally considered to involve soul-loss. In his lengthy description of the Winter Ceremonials in 1886, Boas includes a paragraph on the Koskimo dancing the soul-catcher. "The soul was represented in the dance by a small ball of eagle down, which was attached to a string. As many balls were attached to the string at equal distances as there were men who offered their souls to be captured" (Franz Boas, *Kwakiutl Ethnography*, ed. Helen Codere (Chicago: University of Chicago Press, 1966), p. 195. Also consider these synonyms: the soul has no bone nor blood, for it is like smoke or shadow; it is the human long body; something human, human mask; means of life; bird (ibid., p. 169).

2. Norman Macpherson Chapin, "Curing Among the San Blas Kuna," unpublished Ph.D. dissertation (Tucson: University of Arizona, 1983), p. 75. Subsequent references to this work appear in the text in parentheses.

3. Nordenskiold and Pérez, *An Historical and Ethnological Survey of the Cuna Indians*, pp. 494–506.

4. Ibid., p. 506; emphasis added.

5. Ibid., p. 506; emphasis added.

6. Jean Langdon, "The Siona Medical System: Beliefs and Behavior," unpublished Ph.D. dissertation (New Orleans: Tulane University, 1974), pp. 127–28.

7. Nordenskiold and Pérez, *An Historical and Ethnological Survey*, p. 87. I am reminded of seventeenth-century pirate-surgeon Wafer's account of

Darién Indians' "conjuring" when I read this, a description remarkable for its attempt to mime the conjuror's miming of animals sounds in his partitioned space as prelude to telling the pirates' immediate future. I am also reminded of the description provided by Nordenskiold's junior colleague Henry Wassén of the journey of a Cuna seer or nele to one of the many *kalus*—spiritual fortresses vital for Cuna well-being and inhabited by spirits, including animal spirits, which the seers, accompanied by their carved figurines, must visit to both learn and instruct. In Wassén's account, the nele organizes the preparation of special tobacco for ritual use, along with the hunting of a deer and the making of a special clay plate by an old woman. Accompanied by the *apsoekt* ("converser" and singer of the medicinal and curing chants), the nele entered a specially constructed *surba*, where the singer sang a long song during which the rattle, in the middle of the surba, began to move by itself and make a noise—*chi, chi, chi*, all on its own. The rattle thus reached the roof from where a wind spoke through it, *pu, pu, pu*, and in this wind you could hear the voice of a young woman singing. Thus the nele and the apsoket went to visit the fortress named Achu. When they arrived at the front door, the rattle in the surba began to sound slow, *arar, arar*. The people outside the surba went in to see what was going on and found the nele dead with his tongue stretched out to his waist.

8. Joel Sherzer, *Kuna Ways of Speaking: An Ethnographic Perspective* (Austin: University of Texas Press, 1983), p. 215. Compare with Bronislaw Malinowski in his chapter "Words in Magic," in his *Argonauts of the Western Pacific* (New York: Dutton, 1961), pp. 451–52: "Again, certain parts of the spell contain systematic meticulous enumerations, the reciter going over the parts of a canoe one by one; the successive stage of a journey; the various Kula goods and valuables; the parts of the human head; the numerous places from which the flying witches are believed to have come. *Such enumerations as a rule strive at an almost pedantic completeness*" (emphasis added).

9. Claude Lévi-Strauss, "The Effectiveness of Symbols," pp. 181–201 in *Structural Anthropology* (New York: Doubleday, 1967), p. 188.

Chapter 9

1. Erland Nordenskiold, Nele, Charles Slater, Charlie Nelson, and Other Cuna Indians, "Picture Writing And Other Documents," *Comparative Ethnological Studies*, vol. 7, part 2, p. 2.

2. Ibid., pp. 30–35.

3. Norman Macpherson Chapin, "Curing Among the San Blas Kuna of Panama," unpublished Ph.D. dissertation (Tucson: University of Arizona 1983), pp. 64–65. This origin history was copied down by Chapin from a

healer's notebook into which it had been written in the 1940s. Subsequent references to Chapin's dissertation appear in the text in parentheses.

4. Joel Sherzer, *Kuna Ways of Speaking: An Ethnographic Perspective* (Austin: University of Texas Press, 1983). Sherzer is refering to the *ikar* form of chant, what the Swedish anthropologists spelled as *Igala*.

5. Ibid., p. 121.

6. In *A General Theory of Magic*, trans. R. Brain (New York: Norton, 1972), Mauss and Hubert conclude that magic is indeed a "force," of which the Polynesian *mana* is exemplary. They see this as the answer to what is needed for a theory of magic, to wit, "a non-intellectualist psychology of man as a community" (108), and they define mana as a spiritual action that works at a distance and between sympathetic beings, and also "a kind of ether, imponderable, communicable, which spreads of its own accord" (112). They thus explain magic in terms of what they call people's belief in the existence of automatic efficacy. It is mobile and fluid without having to stir itself. Ten years later in his book *The Elementary Forms of Religion* (London: Allen and Unwin, 1915, first published in Paris in 1912), Emile Durkheim extended this to the very idea of "the sacred." Fifty years later Claude Lévi-Strauss in his introduction to the collected works of Mauss (trans. F. Barker, London: Routledge and Kegan Paul, 1987) squashed Mauss' and Hubert's thesis equating magic with mana with the semiotic argument that mana was not a force but the great empty signifying function which brought signifier and signified together, hence magic.

7. Michael Lambek, *Human Spirits: A Cultural Account of Trance in Mayotte* (Cambridge, England: Cambridge University Press, 1981), pp. 28–29.

8. The great seer nele of the San Blas island of Ustúpu, who was so important in shaping the destiny of the Cuna during and after the 1925 revolt against Panama as well as the destiny of the anthropology of the Cuna, had for a time as his tutor the evil spirit Nugaruetchur, an elephant. This spirit, like all spirits, could also appear in human form (Nordenskiold and Pérez, p. 358). Ann Parker and Avon Neal present a remarkable black-and-white image of an appliquéd mola-style elelphant across from the table of contents of their book *Molas: Folk Art of the Cuna Indians* (Barre, Mass: Barre Publishing, 1977). Their caption states that this nele of Ustúpu visited the Panama Canal Zone in the early 1930s and upon seeing an elephant in a traveling circus said, "There are things easier to understand than the reason for such an animal."

9. Taken from "Mitología Cuna: Los Kalu; según Alfonso Díaz Granados," by Leonor Herrera and Marianne Cardale de Schrimpff, *Revista Colombiana de Antropología* 17 (1974), pp. 201–47.

10. See Freud's comment on self-picturing in dreams and memories in his paper on "Screen Memories." He takes this as evidence that the original

impression, which gives rise at a later date to a memory, has been, in his phrase, "worked over"; *SE*, vol. 3, p. 321.

11. Freud, "The Uncanny," *SE*, vol. 17, p. 246.

12. By "never developed" I mean not only never theorized but never elaborated upon—in other words, a repression of the repression. This strikes me as a revealing sign of the ethnography of the Cuna, and not just of Cuna culture.

13. In theory all things have such Origin Histories, equivalent to their soul, because all things were born from the Great Mother. But in practice only a handful of Origin Histories exist, as for several medicinal spirits such as balsa and genipa, as well as for several powerful personages of the spirit world, such as Muu, and for things such as snakes, scorpions, wasps, and (!) bars of incandescent steel (Chapin, p. 191).

14. Sherzer, *Kuna Ways of Speaking*, p. 29.

15. Nordenskiold and Pérez, pp. 370–71. Compare with my notion of the "public secret" as advanced in the preceding discussion of mimesis amongst the Yamana and Selk'nam of Tierra del Fuego.

16. For Freud an essential part of the meaning of the uncanny in modern European culture was that something eerie was afoot, hence his speculations concerning the part played by allegations of spiritual forces and animism in its production. In this sense the uncanny is a sign of the hidden presence or the threat of the return into our modern time of an alleged archaic and primitive time when ghosts and monsters, spirits and magic, held sway. There is little validity, therefore, in arguing that "magic" among the Cuna would also correspond to this Western European sense of the uncanny, but the connection is intriguing nevertheless.

17. Jacques Derrida's "The Double Session" makes this point in a number of ways. Refering specifically to the existence of fantasy (in the sense of invention of something new) within a mimetic doubling, Derrida lists three distinct meanings of the mimetic in Plato's *Sophist*. Of the meaning that Derrida calls "the double inscription of mimesis," we read: "But just at the point of capture, the sophist still eludes his pursuers through a supplementary division, extended toward a vanishing point, between two forms of the mimetic: the making of likenesses (the *eikastic*) or faithful reproduction, and the making of semblances (the *fantastic*), which simulates the eikastic, pretending to simulate faithfully and deceiving the eye with a simulacrum (a phantasm), which constitutes 'a very extensive class, in painting and in imitation of all sorts.' This is an aporia for the philosophical hunter, who comes to a stop before this bifurcation, incapable of continuing to track down his quarry (who is also a hunter)." See Derrida, "The Double Session," *Disseminations* (Chicago: University of Chicago Press, 1981), p. 186.

18. Jean Langdon, "The Siona Medical System: Beliefs and Behavior," Ph.D. dissertation (New Orleans: Tulane University, 1974), p. 113.

19. Ibid., pp. 131–32.

20. Ibid., p. 132.

Chapter 10

1. A recent comparison of the position of Cuna and Guyami Indians in the United Fruit Company's plantation in Boca del Toro province, Panama, since the 1950s, endorses the point about the political advantages of Indianness (although it overlooks the starkly gendered nature of this Indianness). While the Guyami are treated on and around the planations like offal and react with extremely self-destructive behavior, "the Cuna have achieved remarkable upward mobility in the ethnic hierachy by self-consciously organizing around their 'Indianness'," a U.S. anthropologist noted recently. This has allowed them to overcome the discrimination directed against Amerindians by accentuating their 'Indianness' rather than by minimizing it." P. Bourgeois, "Conjugated Oppression: Class and Ethnicity Among Guyami and Kuna Banana Workers," *American Ethnologist* 15 (1988), pp. 330, 334.

2. Erland Nordenskiold and Rubén Pérez, ed. Henry Wassén, *An Historical and Ethnological Survey of the Cuna Indians*, Comparative Ethnographical Studies 10 (Göteborg: Etnografiska Museum, 1938), p. 429. Subsequent references appear in the text in parentheses.

3. Norman Macpherson Chapin, "Curing Among the San Blas Cuna of Panama," unpublished Ph.D. dissertation (Tucson: University of Arizona, 1983), pp. 113–14.

4. Erland Nordenskiold, Nele, Charles Slater, Charlie Nelson, and Other Cuna Indians, "Picture-Writing And Other Documents," *Comparative Ethnographical Studies*, vol. 7, part 2 (1930), p. 10.

5. Joel Sherzer, *Kuna Ways of Speaking: An Ethnographic Perspective* (Austin: University of Texas Press, 1983), pp. 231–32.

6. Chapin, "Curing Among the San Blas Kuna," pp. 284, 290–91.

7. Sherzer, *Kuna Ways of Speaking*, pp. 135, 187.

8. Chapin, "Curing Among the San Blas Kuna," p. 293.

9. This and related points on photography and memory I owe to Rachel Moore and her reading of Hollis Frampton's studies on the photographic image.

10. Orlando W. Roberts, *Narrative of Voyages and Excursions on the East Coast and in the Interior of Central America; Describing a Journey Up the River San Juan, and Passage Across the Lake of Nicaragua to the City of Leon* (first published in 1827; rpt. Gainesville: University of Florida Press, 1965), pp. 35–36.

11. James Howe, *The Kuna Gathering: Contemporary Village Politics in Panama* (Austin: University of Texas Press, 1986), p. 14.

12. L.E. Elliot Joyce, "Introduction: Lionel Wafer and His Times," in *A New Voyage and Description of the Isthmus of America* by Lionel Wafer (Oxford: The Hakluyt Society, 1933), p. xi–lxvii.

13. David Stout, *San Blas Cuna Acculturation: An Introduction* (New York: Viking Fund Publications in Anthropology, 1947), p. 52.

14. Ibid., p. 92.

15. The phrase cited is from Haskin, *The Panama Canal* (Garden City, N.Y.: Doubleday, 1913).

16. Concerning the history of the Cuna uprising in 1925, I am indebted to the published research of James Howe.

Chapter 11

1. David Stout, *San Blas Cuna Acculturation: An Introduction* (New York: Viking Fund Publications in Anthropology, 1947), p. 58.

2. Ibid., p. 51.

3. Based on ethnographic and historical study of the Cuna, James Howe's work can be cited in support of my position, for he quite specifically denies economic competition over "scarce resources" as a possible factor in the marked anti-Negro feelings of the Cuna. My point, however, is that the very terms of this argument are strapped to and determined by a "market orientation" which begs the question of the cultural constitution of the categories at play. Instead of being explained, race and racism become givens that further sustain the capitalist paradigm of "scarce resources" as a "natural fact." See Howe's "Native Rebellion and U.S. Intervention in Central America," *Cultural Survival Quarterly* 10:1 (1986), pp. 58–65, and his "An Ideological Triangle: The Struggle Over San Blas Culture, 1915–1925," G. Urban and J. Sherzer, eds., *Nation-States and Indians in Latin America* (Austin: University of Texas Press, 1991), pp. 19–52.

4. David McCullough, *The Path Between the Seas: The Creation of the Panama Canal, 1870–1914* (New York: Simon and Schuster, 1977), p. 557.

5. See Michael Coniff's *Black Labor on A White Canal: Panama, 1904–1981* Pittsburgh: University of Pittsburgh Press, 1985). This sober study describes the white fraction of the Canal Zone by 1914 as: "a close-knit, defensive, inbred, status-conscious, white supremacist society" that scrambled to ensure even more stringent apartheid-type controls once the canal had been completed (p. 51). In his introduction the author states; "Gold-silver segregation, rationalized as local custom, accomplished the isolation of whites from blacks the Americans apparently

desired. The southerners among the canal mangers helped mold the system into a replica of Jim Crow. Northerners, as one observer noted, readily learned to hate blacks. A high level of racial antagonism prevailed, exacerbated by the hardships of the construction camp setting. Whites treated blacks harshly, and white children learned to bully black children. Disparities in living conditions convinced the next generation of whites that they were superior to blacks. Only then—in the 1930s—did whites display the benevolent paternalism toward blacks with which white southerners justified their superior status. The fact that the silver workers were not U.S. citizens, however, kept Zonian paternalism on a formal level. As the descendants of West Indians [who had formed the bulk of the manual labor on the canal] became integrated into Panamanian society, formality between the races stiffened and benevolence waned. The simple racial model of the early gold-silver system became obsolete" (p.8)—which is not to say, however, that racism itself became obsolete. Far from it. "Even in the 1970s," Coniff continues, "racism remained the most glaring sin of canal life. Management had done much to break down segregation, yet to outsiders the Zone looked like the Old South resurrected" (p. 157).

6. Frederic J. Haskin, *The Panama Canal* (New York: Doubleday, 1913), p. 155, with all chapters pertaining to the construction of the canal read and approved by Colonel George Goethals. The Canal was completed in 1914.

7. In the last years of canal construction the full work force was about 45,000 to 50,000. There were some 6000 white North Americans, of whom roughly 2500 were women and children. In 1913 there were 5362 gold-roll employees, with an average pay of 150 dollars a month (McCullough, *Path Between the Seas*, p. 559).

8. Ibid., p. 576.

9. Haskin, *The Panama Canal*, pp. 159–60.

10. Ibid., p. 160.

11. Quoted in McCullough , *Path Between the Seas*, p. 575.

12. Ibid., p. 575.

13. Not the digging of ditches but employment in Zone cafeterias from an early date in the life of the Canal appears to have been an important source of income for Cuna men. U.S. Consular officials played a pivotal role in securing and overseeing their collective labor contracts with corporations such as United Fruit. (See P. Bourgeois, "Conjugated Oppression: Class and Ethnicity Among Guyami and Kuna Banana Workers," *American Ethnologist* 15 (1988), 328–48) and it would seem that the Cuna provided a sort of utopic dreamscape and amateur ethnographic laboratory for certain Zone officials and their wives—as it has done for countless North Americans since the Canal was dug.

14. Erland Nordenskiold and Rubén Pérez, ed. Henry Wassén, *An Historical and Ethnological Survey of the Cuna Indians*, Comparative Ethnographical Studies 10 (Göteborg: 1938), p. 5.

15. Chapin, p. 122.

16. Nordenskiold and Pérez, p. 4.

17. The contemporary Cuna rendering of these marriages between Frenchmen and Cuna women is less happy. "The History of the Cuna Indians from the Great Flood Up to Our Time," by the great seer, the nele of Kantule, transcribed from the Cuna by his secretaries and brought to Göteborg by Rubén Pérez, makes it clear that the Cuna chiefs exchanged women for political advantage. Then the French tried to change the women's mode of dress, build prisons and a dance hall, and hence had to be killed. This account folds eighteenth-century Frenchmen into early twentieth-century Panamanians. Here is the passage relating to marriage: "The Spaniards sought out and worked the gold mines. Then a civil war broke out among the Indians. At Icocri lived Dada Fransoa with his little son Miguana and on the other side lived Dada Tugueuarpoguat and his sons Machi-Cala and Uanu. A Frenchman came and built his house near the Indians. Dada Fransoa gave his daughter to the Frenchman in order that he should marry her. Dada Fransoa and Tugueuarpoguat now became powerful men because they were chieftans to these Frenchmen" (ibid., p. 197).

18. Ibid., p. 34.

19. James Howe, "Native Rebellion and U.S. Intervention in Central America," *Cultural Survival Quarterly* 10:1 (1986), p. 61.

20. James Howe, *The Kuna Gathering: Contemporary Village Politics in Panama* (Austin: University of Texas Press, 1986), p. 54.

21. Emile Durkheim, *The Elementary Forms of Religious Life*, trans. J.W. Swain (London: Allen and Unwin, 1915), pp. 455–56.

22. Coniff, *Black Labor on a White Canal*, p. 43 (as in n. 5).

23. R.O. Marsh, *White Indians of Darien* (New York: Putnam's, 1934), p. 66. Subsequent references to this work appear in the text in parentheses.

24. Lionel Wafer, *A New Voyage and Description of the Isthmus of America* ed. G.P. Winship (New York: Burt Franklin, 1970; rpt. from the original edition of 1699), p. 338.

25. Ibid., p. 337.

26. Ibid., pp. 137–38.

27. Not 370 but "nearly a hundred men and officers" according to David McCullough, *The Path Between the Seas*, p. 20, including a photographer, Timothy H. O'Sullivan, who had been Mathew Brady's assistant during the U.S. Civil War.

Chapter 12

1. R.O. Marsh, *White Indians of Darien* (New York: Putnam's, 1934), p. 136. Subsequent references to this work appear in the text in parentheses.

2. As it worked out, the white Indians were taken to Washington, declared to be albino, then not albino, then "imperfect" or "partially" albino. At pains in his *White Indians of Darien* to distinguish his white Indians from albinoes, Marsh stumbled into a mystery as much biological as mythological, where science itself was prey to all manner of racist fantasy and colorful metaphor. This becomes clear upon consideration of the key terms "partial" or "imperfect" albino which, in the hands of at least one expert geneticist, came to designate the white Indian. Writing in the *American Journal of Physical Anthropology* in 1926, the noted (eugenicist) geneticist R.G. Harris, from the nation's foremost genetics laboratory in Cold Springs Harbor, Long Island, who accompanied Marsh on his second expedition in the rebellion of 1925, stated: "The White Indians obviously express a form of albinism which has been termed imperfect or partial albinism by Geoffroy Saint Hilaire, Pearson and others. These terms signify that either the skin, hair, or eyes, any two or all three may fail to express the full albinotic condition, but that one or more are, partially at least, relatively free from pigment" (34).

3. Norman Macpherson Chapin, "Curing Among the San Blas Kuna of Panama," unpublished Ph.D. dissertation (Tucson: University of Arizona, 1983), p. 28, n. 8.

4. Erland Nordenskiold and Rubén Pérez, ed. Henry Wassén, *An Historical and Ethnological Survey of the Cuna Indians*, Comparative Ethnographical Studies 10 (Göteborg: 1938), p. 291.

5. Joel Sherzer, *Kuna Ways of Speaking: An Ethnographic Perspective* (Austin: University of Texas Press, 1983), first page of preface.

6. In New Guinea great valleys, sometimes gold-bearing, were "discovered" in just this way about the same time and with the same judicious and self-congratulatory blend of frontiersman's savvy and white man's science. See Michael Leahy and M. Crain, *The Land That Time Forgot* (New York: Funk and Wagnalls, 1937), and Edward Schieffelin and Robert Crittenden, *Like People You See In A Dream: First Contact in Six Papuan Societies* (Stanford: University of Stanford Press, 1991).

7. Howe (1986) states that this document of 25 pages was handwritten in English, "supposedly transcribed and translated by Marsh, but very obviously composed by him."

8. Ann Parker and Avon Neal, *Molas: Folk Art of the Cuna Indians* (Barre, Mass: Barre Publishing, 1977), p. 57.

9. Armando Réclus, *Exploraciones a los istmos de Panamá y Darién en 1876, 1877, y 1878* (Ciudad de Panamá: Publicaciones de la revista "Lotería" 1, 1958), p. 149. Réclus was an engineer and a leader of two

survey-expeditions to determine and map a French route for a canal across the Isthmus, and later became a key figure, the general agent, in the French attempt to build a canal beginning in 1881. The surveys appear to have been casual and unskillful (see David McCullough, *The Path Between the Seas: The Creation of the Panama Canal, 1870–1914* (New York: Simon and Schuster, 1977), pp. 62—63, 65, 131).

Chapter 13

1. Armando Réclus, *Exploraciones a los Istmos de Panamá y Darién en 1876, 1877, y 1878* (Ciudad de Panamá: Publicaciones de la revista "Lotería," 1, 1958), p. 20. Lieutenant Réclus' job was to investigate in 1876 the prospects for a canal across the Darién, a task that took him a mere eighteen days. In 1881 when the Compagnie Universelle du Canal began work in earnest, Réclus was the company's general agent; see McCullough, *The Path Between the Seas: The Creation of the Panama Canal* (New York: Simon and Schuster, 1977), pp. 62–63, 131. The death rate from yellow fever and malaria was apalling, affecting managers and laborers alike. Workers were largely recruited from the West Indian islands. In the eight years from 1881, 19,000 laborers died, according to official statistics, 100,000 according to unofficial ones; see Lancelot S. Lewis *The West Indian in Panama: Black Labor in Panama, 1850–1914 (Washington: University Press of America, 1980), pp. 23–24.*

2. Kathleen Romoli, *Balboa of Darién: Discoverer of the Pacific* (Garden City, N.Y.: Doubleday, 1953), p. 107. But because she is writing of people called "Cuevans," whom she insists are to be clearly distinguished, through the mists of time and innumerable migrations, from people called Cuna, we have to be cautious in adding these portraits of lusty Isthmian women to a colonial genealogy of Cuna women.

3. Ibid., p. 1.

4. Orlando W. Roberts, *Narrative of Voyages and Excursions on the East Coast and in the Interior of Central America* . . . (Gainesville: University of Florida, 1953), p. 43.

5. Ibid., pp. 43–44.

6. Ibid., pp. 44.

7. Dina Sherzer and Joel Sherzer, "Mormaknamaloe: The Cuna Mola," in P. Young and J. Howe, eds., *Ritual and Symbol in Native Central America* (Eugene: University of Oregon Anthropological Papers 9, 1976), p. 31. See also on this point Stout, *San Blas Acculturation: An Introduction* (New York: Viking Fund Publications in Anthropology 9, 1947).

8. Sherzer and Sherzer, "Mormaknamaloe . . . ," p. 31.

9. Joel Sherzer, *Kuna Ways of Speaking: An Ethnographic Perspective.* (Austin: University of Texas Press, 1983), p. 73.

10. Sherzer and Sherzer, "Mormaknamaloe . . . ," p. 31.
11. James Howe, *The Kuna Gathering: Contemporary Village Politics in Panama* (Austin: University of Texas Press, 1986), p. 37.
12. Sherzer, *Kuna Ways of Speaking*, pp. 75–76.
13. Ibid., p. 73.
14. Since the 1930s the U.S. Consulate in Panama has had extensive experience in facilitating Cuna migrant labor in the Canal Zone and with the U.S. military. See Bourgeois, "Conjugated Oppression: Class and Ethnicity among Guyami and Kuna Banana Workers," *American Ethnologist*, 15 (1988), 328–48.
15. Ann Parker and Avon Neal, *Molas: Folk Art of the Cuna Indians* Barre, Mass: Barre Publishing, 1977), p. 171.
16. The denial of power to the European outer form or apperance of the figurine, in place of the spirit-power of the inner substance, the wood, fits perfectly with Cuna "ethnocentrism" and all that is implied by this euphemism. For while that ethnocentrism is itself based on the power of the white world as mirror, such dependence has to be effaced. Hence the (un)importance—the need—of the outer form so as to uphold the inner substance.
17. Erland Nordenskiold and Rubén Pérez, ed. Henry Wassén, *An Historical and Ethnological Survey of the Cuna Indians*, Comparative Ethnographical Studies, 10 (Göteburg, 1938), p. 448.
18. Ibid., p. 449.
19. Nils M. Holmer and S. Henry Wassén, "Nia Ikala: canto mágico para curar la locura. *Etnologisker Studier* 23 (Göteburg, 1958). Understandably this unusual technique, which the authors practiced with regard to several key Cuna texts, has been criticized because, as with the baron, there seems to have been too little actual fieldwork and what there was done has been judged as falling short of contemporary, scientific, standards. Yet science can be practiced in more than one way, and there is much to be said in favor of these earlier techniques. What is more, I know of only one other published rendition of the *Nia-Ikala*, that published by Carlo Severi, "Los Pueblos del camino de la locura," *Amerindia* 8 (1983), pp. 129–80. It seems to me that it hardly bears comparison, let alone provides replicable criteria for faithful transcription and translation because it is so obviously a different song in many ways, albeit one with the same general aim of dealing with a Nia-induced illness.

 Among the many differences between Severi's and the Swedes' chant, Severi's version contains no section or passage in which the chanter readies his wooden figurines, which is what concerns me in my analysis. On the issue of methodology, which certainly must include the writing as well as the carrying-out of ethno/graphy, it should be noted that of all the ethnographic publications on the Cuna that I have seen, that of

Nordenskiold and Pérez (1938) comes closest to overcoming the objections to ethnography made by George Marcus and D. Cushman (1982, "Ethnographies As Texts," *Annual Review of Anthropology*, 11 (1982), pp. 25–69. This is particularly notable when that early work is compared with the most recent and sophisticated book-length works on the Cuna which, unlike the 1938 Nordenskiold/Pérez/Wassén text, do (1) strive to create totalizing and coherent accounts, immune to auto-critique; (2) use the third-person narrative voice as a cultural prop to provide the appearance of science; (3) keep individuals as nameless, characterless types serving as illustrations of "the general"; (4) refer the context of investigation to a preface or an afterword; (5) erase the eccentric or idiosyncratic; and (6) use jargon. I believe that Nordenskiold's and Pérez' text, by contrast, does well on these criteria, and I suspect it would be the notion of ethnographic realism closest to the Cuna ideal.

It is also pertinent to note that as early as 1930, Nordenskiold was publishing Cuna texts prepared by Cunas under their own names in the Göteborg Ethnographic Museum's regular publications. This "giving voice" has not, so far as I know, been replicted by any U.S. or European anthropologist. What "voice" has been given is the standard museum-piece and easily objectified "chant."

20. Guillermo Hayans comments, "Now comes the soul of the figurines." See Henry Wassén, "New Cuna Indian Myths According to Guillermo Hayans," *Etnologisker Studier* 20 (Göteborg: Ethnografiska Museum, 1992), 85–106.

21. Whatever errors and misunderstandings may exist in the text of Holmer and Wassén, it seems justifiable to cite it as further evidence of the considerable importance attached to Western male dress, especially since this is not only reinforced by the earlier text from Nordenskiold and Pérez concerning the chant for the soul of the dead man, but resonates with indications from many quarters. Of course what this particular song-text achieves, with or without the blatant phallicism preceding it, is a sort of capstone effect that would seem to sum up and condense the meaning of male garb as the magical power of mimesis involved in imitating the (outer form of the) white man.

Chapter 14

1. R.O. Marsh, *White Indians of Darien*. New York: Putnam's, 1934, p. 147.

2. Ibid., p. 81.

3. Roland Gelatt, *The Fabulous Phonograph: From Edison to Stereo* New York: Appleton-Century, 1954), p. 69. Marsh, *White Indians*, p. 122.

4. James Howe, "An Ideological Triangle: The Struggle Over San Blas Culture, 1915–25," in G. Urban and J. Sherzer, eds., *Nation-States and Indians in Latin America* (Austin: University of Texas, 1991).

5. Erland Nordenskiold and Rubén Pérez, ed. Henry Wassén, *An Historical and Ethnological Survey of the Cuna Indians*, Comparative Ethnographical Studies 10 (Göteburg, 1938), p. 221.

6. Ales Hrdlicka, "The Indians of Panama: Their Physical Relation to the Mayas," *American Journal of Physical Anthropology* 9:1 (1926), p. 1.

7. Frances Hubbard Flaherty, *The Odyssey of a Film-Maker: Robert Flaherty's Story* (Putney, Vermont: Threshold Books, 1984), p. 58. "Participation mystique" in this passage refers to the often-contentious theories of Lucien Lévy-Bruhl concerning "primitive" epistemologies vis à vis Enlightenment models.

8. Flaherty, *The Odyssey of a Film-Maker*, p. 18.

9. Bob Connolly and Robin Anderson, *First Contact* New York: Viking, 1987), p. 164. They are quoting Michael Leahy and Maurice Crain, *The Land that Time Forgot* (New York and London: Funk and Wagnalls, 1937).

10. Gellat, *The Fabulous Phonograph*, p. 25.

11. Ibid., p. 27

12. Ibid., p. 102. There was a newsreel photographer from Pathé on Marsh's first expedition; see James Howe, "Native Rebellion and U.S. Intervention in Central America: The Implications of the Cuna Case for the Miskito," *Cultural Survival Quarterly* 10:1 (1986), pp. 59–65.

13. Gellat, *The Fabulous Phonograph*, p. 22.

Chapter 15

1. Ann Parker and Avon Neal, *Molas: Folk Art of the Cuna Indians* Barre, Mass: Barre Publishing, 1977) state that as a mola design this began in the 1930s and was most widely copied in the 1950s (p. 241). For popularity, they say, it has enjoyed one of the longest runs of any mola.

2. Oliver Read and M.L. Welch, *From Tin Foil to Stereo: Evolution of the Phonograph* (Indianapolis: Bobbs Merrill, 1976), p. 134.

3. Compare with B. Malinowski of Trobriand ethnography fame, who considered advertising, in his *Coral Gardens and Their Magic* (vol. 2, pp. 236–37, first published 1934, rpt. Bloomington: Indiana Univ. Press, 1965), to be the richest field of modern verbal magic. He argued that advertising is similar, if not in many ways identical, to much of the love, beauty, and gardening magic of the Trobriand Islands. He also urged consideration of modern political oratory as a magical art. In stressing the parallel between Trobriand magic and modern European advertising and political oratory, he overlooked, however, the singular importance in the West of the mythology of science and of Enlightenment, a mythology which casts a very different light on the culture of magic and hence its functions, capacities, and power in advertising, politics, and so forth.

Benjamin's notion of "the fiery pool" reflecting the language of the advertisement in the asphalt makes just this point. It's not a question of the universals of rhetoric, as Malinowski would have it, but of the rebirth of mythic force in and by modernity creating fire, with neon and pools on urban asphalt.

4. Walter Benjamin, "One-Way Street," in *Reflections* (New York: Harcourt Brace Jovanovich, 1978), p. 86.

5. Robert Rosenblum, *The Dog in Art: From Rococo to Post-Modernism* (London: John Murray, 1987).

6. Julia Blackburn, *The White Man: The First Responses of Aboriginal Peoples to the White Man.* (London: Orbis, 1979) p. 52.

7. Max Horkheimer, and T. W. Adorno, *Dialectic of Enlightenment.* (New York: Continuum, 1987), pp. 180–81.

8. Alexander Buchner, *Mechanical Musical Instruments.* trans. I. Urwin, (Westport, Conn.: Greenwood Press, 1978).

9. Francis Galton, *Finger Prints,* (1892, rpt. New York: DaCapo Press, 1965), pp. 27–28. Also see letter by W.J. Herschel in "Letters to the Editor," in *Nature*, 23 (Nov. 25, 1880), p. 76, and Berthold Laufer, "History of the Finger Print System," in the *Annual Report of the Smithsonian Institution* (1912), pp. 631–52. From Laufer's report we see that fingerprinting was first established in the U.S. on prisoners and American Indians.

10. I have come across discussion about the antiquity, use, and significance of thumb, finger, and hand prints in Japan and China in connection with this mid-nineteenth century British Imperial discovery. Yusuke Miyamoto, a modern Japanese author and an engineer by training, has devised a scientific system with which fingerprints tell character and fortune. "We are modern people," he writes, "and we should study our fates in every detail." Fingerprints, he goes on to say, "are the pure and instained truth of one's self." They tell the part you should play in life and foretell your destination."

11. Parker and Neal, *Molas*, p. 241.

12. W. Benjamin, "Doctrine of the Similar," trans. K. Tarnowski, in *New German Critique* 17 (Spring, 1979), pp. 65–69; p. 66. Composed in Berlin, early 1933).

13. Parker and Neal, *Molas*, p. 14. "We soon concluded," write these authors, "that *molas* were among the most exciting and important art forms being created in our time" (p. 15).

14. Ibid., p. 219.

15. Ibid., p. 43.

16. Also to be borne in mind, the black-and-white reproduction cannot demonstrate that in the mola these vertical rays covering the entire surface are of different colors.

17. Ibid., p. 219.

18. Walter Benjamin, "Surrealism: The Last Snapshot of the European Intelligentsia," *Reflections*, New York: Harcourt Brace Jovanovich, 1978), p. 181.

19. Ibid., p. 179.

20. Ibid., p. 182.

Chapter 16

1. In his book *The Savage Hits Back* (New Hyde Park, N.Y.: University Books, 1966), Julius Lips, a German refugee, compiled a large assortment of examples of such reflections, and B. Malinowski wrote an interesting preface to it. Also see Julia Blackburn, *The White Man: The First Responses of Aboriginal Peoples to the White Man* (London: Orbis, 1979)

2. Michael Taussig, "Why the Nervous System?" *The Nervous System* (New York: Routledge, 1992), pp. 1–10.

3. These photographs were taken by and first published by H. Cole in three articles concerned with Ibo Mbari ritual as art in *African Arts*, 1969.

4. Cf. Henri Junod on war in vol. 1, p. 473, *Life of a South African Tribe* (New Hyde Park, NY: University Books, 1962).

5. Paul Stoller, *Fusion of the Worlds: An Ethnography of Possession Among the Songhay of Niger* (Chicago: University of Chicago Press,1989), p. 152.

6. Finn Fugelstad, "Les Hauka," *Cahiers D'Etudes Africaines*, 58 (1975), pp. 203–16. Quoted in "Horrific Comedy: Cultural Resistance and the Hauka Movement in Niger," Paul Stoller, *Ethos* 12:2 (1984), pp. 165–88.

7. Stoller, *Fusion of the Worlds*, p. 152.

8. Toby Alice Volkman, *Films from D.E.R.* (1982), p. 13.

9. Stoller bases his article "Horrific Comedy" on anthropological field work in Niger in intervals between 1969 and 1981. See also Chapter Seven, n. 1 of his *Fusion of the Worlds*.

10. Stoller, "Horrific Comedy," p. 167.

11. Jean Rouch, "On the Vicissitudes of the Self: The Possessed Dancer, The Magician, The Sorcerer, The Filmmaker, and The Ethnographer," *Studies in the Anthropology of Visual Communication*, 15:1 (1978), 2–8, p. 8.

12. Jean Rouch, "Jean Rouch Talks About His Films to John Marshall and John W. Adams (Sept. 14th and 15th, 1977)," *American Anthropologist*, 80 (1976), p. 1009.

13. Jean Rouch, "Our Totemic Ancestors and Crazed Masters," *Senri Ethnological Studies*, 24 (1988), pp. 225–38. Quote is on page 232.

14. Ibid. Compare with Alfred Metraux in his book *Voodoo in Haiti* (New York: Oxford University Press, 1959), p. 138: "Song, or more often drumming, has an undeniable effect on certain subjects. The *hungan* [Voodoo priest] Tullius, during an audition in Paris, was listening to the tape recording of a ceremony which he had himself conducted when he was suddenly seized with dizziness at the exact moment when he had been possessed during the 'live' recording. There and then, dancing on a Parisian stage, he was properly 'ridden' by the god Damballah, much to the annoyance of his colleagues."

15. Roger Caillois, "Mimicry and Legendary Psychaesthenia," *October* 31 (Winter, 1984), p. 30.

16. Walter Benjamin, "Doctrine of the Similar," trans. K. Tarnowski, *New German Critique* 17 (Spring, 1979), p. 66.

BIBLIOGRAPHY

Adorno, Theodor W. "A Portrait of Walter Benjamin." *Prisms*. Transl. Samuel and Sherry Weber, Cambridge: MIT Press, 1981, pp. 227–42.

Adorno, Theodor W. "Transparencies on Film." *New German Critique*, 24–25: (Fall–Winter, 1981–82), 199–205.

Arendt, Hannah. "Introduction." *Illuminations*, New York: Schocken, 1969, pp. 1–55.

Bamberger, Joan. "The Myth of Matriarchy: Why Men Rule in Primitive Society." *Women, Culture and Society*, ed. M.Z. Rosaldo and L. Lamphere. Stanford: Stanford University Press, 1974.

Bataille, Georges. *Erotism: Death and Sensuality*. Transl. Mary Dalwood. San Francisco: City Lights, 1986.

Bataille, Georges, *The Accursed Share: An Essay on General Economy*, Vol. 1. Transl. Robert Hurley. New York: Zone Books, 1988.

Benjamin, Walter. "Doctrine of the Similar." (Composed in Berlin early 1933). Transl. Knut Tarnowski, *New German Critique* 17 (Spring, 1979), 65–69.

Benjamin, Walter. "One-Way Street," and "A Small History of Photography." *One-Way Street and Other Writings*. Transl. Edward Jephcott and K. Shorter, London: New Left Books, 1979, pp. 45–106 and pp. 240–57.

Benjamin, Walter. "Surrealism: The Last Snapshot of the European Intelligentsia." *Reflections*, New York: Harcourt Brace Jovanovich, 1978, pp. 177–92.

Benjamin, Walter. "The Storyteller," "The Work of Art in the Age of Mechanical Reproduction," and "Theses on the Philosophy of History." *Illuminations*. Ed. Hannah Arendt. Transl. Harry Zohn, New York: Schocken, 1969, pp. 83–109, pp. 217–51, and pp. 253–64.

Benjamin, Walter. "Theoretics of Knowledge: Theory of Progress." *The Philosophical Forum*, 15:1–2, (Fall/Winter, 1983–84) pp. 1–39. Translated from

"Konvolut N" of *Das Passagen-Werk*. vol. 2, Frankfurt-am-Main: Suhr-kamp Verlag, 1982, pp. 570–611.

Blackburn, Julia. *The White Man: The First Responses of Aboriginal Peoples to the White Man*. London: Orbis, 1979.

Boas, Franz. *Kwakiutl Ethnography*. Ed. Helen Codere. Chicago: University of Chicago Press, 1966.

Bourgeois, P. "Conjugated Oppression: Class and Ethnicity among Guyami and Kuna Banana Workers." *American Ethnologist*, 15(1988), pp. 328–48.

Bridges, E. Lucas. *Uttermost Part of the Earth*. London: Hodder and Stoughton, 1951.

Buchner, Alexander *Mechanical Musical Instruments*. Transl. Iris Urwin. Westport, Conn.: Greenwood Press, 1978.

Buck-Morss, Susan. *The Dialectics of Seeing: Walter Benjamin and the Arcades Project*. Cambridge, Massachusetts: MIT Press, 1989.

Buck-Morss, Susan. *The Origin of Negative Dialectics: Theodor W. Adorno, Walter Benjamin, and the Frankfurt Institute*. New York: Free Press, 1977.

Caillois, Roger. *Man, Play and Games*. Transl. Meyer Barash. New York: Free Press, 1961.

Caillois, Roger. "Mimicry and Legendary Psychasthenia," Transl. John Shepley. *October*, 31(Winter, 1984), 17–32.

Chapin, Norman Macpherson, "Curing Among the San Blas Kuna of Panama." Unpublished Ph.D. dissertation, Tucson: University of Arizona, 1983.

Chapman, Anne. *Drama and Power in a Hunting Society: The Selk'nam of Tierra del Fuego*. Cambridge: Cambridge University Press, 1982.

Clastres, Pierre. *Society Against the State*. Transl. Robert Hurley. New York: Urizen Books, 1977.

Cole, Herbert M. "Art as a Verb in Iboland," *African Arts* 3:1 (Autumn, 1969), 34–41, 88.

Conniff, Michael L. *Black Labor on a White Canal: Panama, 1904–1981*. Pittsburgh: University of Pittsburgh Press, 1985.

Connolly, Bob and Robin Anderson. *First Contact*. New York: Viking, 1987.

Cook, James. *Captain Cook's Journal During His First Voyage Round the World Made in H.M. 'Endeavour' 1768–71*. Ed. Captain W.J.L. Wharton. London: Elliot Stock, 1893.

Darwin, Charles. *The Autobiography of Charles Darwin, and Selected Letters*. Ed. Francis Darwin (first published New York: D. Appleton, 1892). Rpt. New York: Dover, 1958.

Darwin, Charles. *The Beagle Record: Selections from the Original Pictorial Records and Written Accounts of the Voyage of the H.M.S. Beagle*. Ed. Richard Darwin Keynes. Cambridge: Cambridge University Press, 1979.

Darwin, Charles. *Charles Darwin's Diary of the Voyage of the H.M.S. Beagle.* Ed. Nora Barow. Cambridge: Cambridge University Press, 1934.

Darwin, Charles. *Journal of researches into the natural history and geology of the countries visited during the voyage of the H.M.S. Beagle round the world, under the command of Capt. Fitz Roy, R.N.* New York: D. Appleton, 1896.

Derrida, Jacques. "The Double Session." *Dissemination.* Transl. Barbara Johnson, Chicago: University of Chicago Press, 1981, pp. 173–286.

De Smidt, Leon S. *Among the San Blas Indians of Panama: Giving a Description of Their Manners, Customs and Beliefs* Troy, New York.

Duhamel, Georges. *Scènes de la Vie Future.* Paris: Mercure de France, 1930.

Durkheim, Emile. *The Elementary Forms of the Religious Life.* Transl. J.W. Swain, London: Allen and Unwin, 1915.

Durkheim, Emile. *Suicide: A Study in Sociology.* London: Routledge, 1952.

Eisenstein, Sergei. *Film Form: Essays in Film Theory.* Ed. and transl. Jay Leyda. New York: Harcourt Brace Jovanovitch, 1949.

Eliade, Mircea. *Shamanism: Archaic Techniques of Ecstasy.* Princeton: Princeton University Press, 1964.

Evans-Pritchard, E.E. "The Intellectualist (English) Interpretation of Magic." *The Bulletin of the Faculty of Arts,* 1:2, (1933). Cairo: University of Egypt.

Fitz Roy, Robert. *Narration of the Surveying Voyages of His Majesty's Ships 'Adventurer' and 'Beagle' Between the Years 1826 and 1836.* Vol. 2. London: Henry Colburn, 1839.

Flaherty, Frances Hubbard. *Robert Flaherty, The Odyssey of a Film-Maker: Robert Flaherty's Story.* Putney, Vermont: Threshold Books, 1984.

Flaubert, Gustave. *The Temptation of Saint Anthony.* Trans. with Introduction and Notes by Kitty Mrosovsky. Harmondsworth: Penguin, 1980.

Frazer, Sir James George. *The Golden Bough: A Study in Magic and Religion.* 3rd edition, Part I, Volume 1, 1911.

Freud, Sigmund. See under *SE* for edition of Freud's works.

Freud, Sigmund. *Jokes and Their Relation to the Unconscious* (first published 1905). *SE,* Vol. 8.

Freud, Sigmund. "Screen Memories" (first published 1899), *SE,* Vol. 3, pp. 303–22.

Freud, Sigmund. *Totem and Taboo: Some Points of Agreement Between the Mental Lives of Savages and Neurotics* (first published 1913–14). *SE,* Vol. 13, pp. ix–162.

Freud, Sigmund. "The Uncanny" (first published 1919). *SE,* vol. 17, pp. 217–52.

Fugelstad, Finn. "Les Hauka." *Cahiers D'Etudes Africaines*, 58 (1975): 203–16.

Galton, Francis. *Finger Prints* (first published 1892). New York: DaCapo Press, 1965.

Gelatt, Roland. *The Fabulous Phonograph: From Edison to Stereo.* New York: Appleton-Century, 1954.

Gregor, Thomas. "Men's House," *Anxious Pleasures: The Sexual Lives of an Amazonian People*, Chicago and London: University of Chicago Press, 1985, pp. 92–115.

Gusinde, Martín. *Los indios de Tierra del Fuego.* 3 vols. Buenos Aires: Centro Argentino de Etnología Americana, 1982.

Gusinde, Martín. *The Yamana: The Life and Thought of the Water Nomads of Cape Horn.* Transl. Frieda Shutze. 5 vols. New Haven: Human Relations Area Files, 1961.

Hansen, Miriam. "Benjamin, Cinema and Experience: The Blue Flower in the Land of Technology," *New German Critique*, 40 (Winter, 1987), 179–224.

Harris, R.G. "The San Blas Indians," *American Journal of Physical Anthropology*, 9:1 (1926), 17–58.

Haskin, Frederic J. *The Panama Canal.* Garden City, NY: Doubleday, 1913.

Hegel, G.W.F. *The Phenomenology of Mind.* Transl. J.B. Baillie. New York and Evanston: Harper and Row, 1967.

Herrera, Leonor and de Schrimpff, Marianne Cardale. "Mitología Cuna: los Kalu (según Alfonso Díaz Granados)," *Revista Colombiana de antropología*, 17 (1974), 201–47.

Herschel, W.J. "Letter to the Editor." *Nature*, 23 (Nov. 23, 1880), 76.

Hirn, Yrjo. *The Origins of Art* (first published in London, 1900). Rprt. New York: Benjamin Bloom, 1971.

Holmer, Nils and Henry Wassén. *The Complete Mu-Igala in Picture Writing: A Native Record of a Cuna Medicine Song.* Etnologiska Studier 21. Göteborg: Etnografiska Museum, 1953.

Holmer, Nils and Henry Wassén. *Nia-Ikala: Canto mágico para curar la locura.* Etnologiska Studier 23. Göteburg: Etnografiska Museum, 1958.

Horkheimer, Max and Adorno, Theodor W. *The Dialectic of Enlightenment.* Transl. John Cumming. New York: Continuum, 1987.

Howe, James. "An Ideological Triangle: The Struggle over San Blas Culture, 1915–1925." Greg Urban and Joel Sherzer, eds., *Nation-States and Indians in Latin America.* Austin: University of Texas Press, 1991, pp. 19–52.

Howe, James. *The Kuna Gathering: Contemporary Village Politics in Panama.* Austin: University of Texas Press, 1986.

Howe, James. "Native Rebellion and U.S. Intervention in Central America:

The Implications of the Kuna Case for the Miskito." *Cultural Survival Quarterly*, 10:1 (1986), 59–65.

Hrdlicka, Ales. "The Indians of Panama: Their Physical Relation to the Mayas." *American Journal of Physical Anthropology*, 9:1 (1926), 1–15.

Hubert, Henri. See Mauss, M.

Hurston, Zora Neale. *The Sanctified Church*. Berkeley: Turtle Island, 1983.

Jakobson, Roman. "Two Aspects of Language and Two Types of Aphasic Disturbances," *Language in Literature*, Ed. K. Pomorska and S. Rudy. Cambridge, Massachusetts: Belknap, Harvard University Press, 1987, pp. 95–119.

Joyce, L.E. Elliot. "Introduction: Lionel Wafer and His Times." Lionel Wafer, *A New Voyage and Description of the Isthmus of America*. Oxford: The Hakluyt Society, 1933.

Junod, Henri. *The Life of a South African Tribe*. 2 Vols. New Hyde Park, New York: University Books, 1962.

Kane, Stephanie. "Emberá (Choco) Village Formation: The Politics and Magic of Everyday Life in the Darien Forest," Unpublished PhD dissertation, Department of Anthropology, University of Texas (Austin), 1986.

Kane, Stephanie. "Surreal: Taboo and the Embera-Gringa." Paper delivered at the 87th meeting of the American Anthropological Association, Phoenix, Arizona, 1990.

Kessler, Harry. *The Diaries of a Cosmopolitan: Count Harry Kessler, 1913–1937*. Transl. and ed. Charles Kessler. London: Weidenfeld and Nicolson, 1971.

Kluge, Alexander. "On New German Cinema, Art, Enlightenment and the Public Sphere: An Interview With Alexander Kluge," *October*, 46 (1988), 23–59.

Koch, Gertrude. "Mimesis and the Ban on Graven Images," Unpublished MS distributed in the Department Of Cinema Studies, New York University, 1990.

Kristeva, Julia. *Revolution in Poetic Language*. New York: Columbia University Press, 1984.

Lambek, Michael. *Human Spirits: A Cultural Account of Trance in Mayotte*. Cambridge, London, New York: Cambridge University Press, 1981.

Langdon, Jean. "The Siona Medical System: Beliefs and Behavior." Ph.D. dissertation, New Orleans, Tulane University, 1974.

Laufer, Berthold. "History of the Finger Print System." *Annual Report of the Smithsonian Institution*, 1912, pp. 631–52.

Leahy, Michael and M. Crain. *The Land that Time Forgot*. New York and London: Funk and Wagnalls, 1937.

Lévi-Strauss, Claude. *Introduction to the Work of Marcel Mauss*. Transl. Felicity Baker. London: Routledge and Kegan Paul, 1987.

Lévi-Strauss, Claude. *Structural Anthropology*. Transl. Claire Jacobson. Garden City, NY: Doubleday, 1967.

Lewis, Lancelot S. *The West Indian in Panama: Black Labour in Panama, 1850–1914*. Washington, D.C.: University Press of America, 1980.

Lips, Julius E. *The Savage Hits Back*. Introduction by Bronislaw Malinowski. New Hyde Park, NY: University Books, 1966.

Malinowski, Bronislaw. *Argonauts of the Western Pacific*. New York: Dutton, 1961.

Malinowski, Bronislaw. *Coral Gardens and Their Magic*. Vol. 2 (first published 1934). Bloomington: Indiana University Press, 1965).

Malinowski, Bronislaw. *The Sexual Life of Savages (in North-Western Melanesia)*. New York: Harcourt, Brace & World, 1929.

Marcus, George and D. Cushman. "Ethnographies As Texts." *Annual Review of Anthropology*, 11 (1982), 25–69.

Marsh, R.O. *White Indians of Darien*. New York: Putnam's, 1934.

Marx, Karl. *Capital: A Critique of Political Economy*, vol. 1. New York: International Publishers, 1967.

Marx, Karl. *The Economic and Philosophic Manuscripts of 1844*. Ed. and with an introduction by Dirk Struik. Transl. Martin Milligan. New York: International Publishers, 1964.

McCullough, David. *The Path Between the Seas: The Creation of the Panama Canal, 1870–1914*. New York: Simon and Schuster, 1977.

Mauss, Marcel and Henri Hubert, *A General Theory of Magic*. Transl. Robert Brain. New York: W.W. Norton, 1972.

Metraux, Alfred. *Voodoo in Haiti*. Transl. H. Charteris. New York: Oxford University Press, 1959.

Nele, Charles Slater, Charlie Nelson and other Cuna Indians. *Picture Writing and Other Documents*, Comparative Ethnological Studies, no. 7, part 2. Göteburg: 1930.

Nietzsche, Friedrich. *On the Genealogy of Morals*. Ed. Walter Kaufmann, transl. Walter Kaufmann and R.J. Hollingdale. New York: Vintage, 1989.

Nordenskiold, Erland, with Rubén Pérez Kantule. *An Historical and Ethnographic Study of the Cuna Indians*. Ed. Henry Wassén. Comparative Ethnological Studies, no. 10. Göteburg: Ethnografiska Museum, 1938.

Nordenskiold, Erland. See Nele.

Parker, Ann and Avon Neal. *Molas: Folk Art of the Cuna Indians*, Barre, Massachusets: Barre Publishing, 1977.

Polanyi, Michael. *Personal Knowledge*. Chicago: University of Chicago Press, 1958.

Puydt, Lucien de. "Account of Scientific Explorations in the Isthmus of Darien in 1861 and 1865," *The Journal of the Royal Geographical Society*, 38 (London, 1868), 69–110.

Read, Oliver and M.L. Welch. *From Tin Foil to Stereo: Evolution of the Phonograph*. Indianapolis: Bobbs-Merrill, 1976.

Réclus, Armando. *Exploraciones a los Istmos de Panamá y Darién en 1876, 1877 y 1878*. [From the Madrid publication, 1881.] Ciudad de Panamá: Publicaciones de la revista "Lotería" 1 (1958).

Reichel-Dolmatoff, Gerardo. "Anthropomorphic Figurines from Colombia, Their Magic and Art." In *Essays in Pre-Columbian Art and Archaeology*, Ed. Samuel K. Lothrop. Cambridge, Massachusets: Harvard University Press, 1961.

Roberts, Orlando W. *Narratives of Voyages and Excursions on the East Coast and in the Interior of Central America: Describing a Journey Up the River San Juan, and Passage Across the Lake of Nicaragua to the City of Leon* (first published in 1827). Gainesville: University of Florida Press, 1965).

Romoli, Kathleen, *Balboa of Darien: Discoverer of the Pacific*. Garden City, NY: Doubleday, 1953.

Rosenblum, Robert. *The Dog in Art: From Rococo to Post-Modernism*. London: John Murray, 1989.

Rouch, Jean. "Jean Rouch Talks About His Films to John Marshall and John W. Adams (Sept. 14th and 15th, 1977)." *American Anthropologist*, 80 (1978).

Rouch, Jean. "On the Vicissitudes of the Self: the Possessed Dancer, the Magician, the Sorcerer, the Filmmaker, and the Ethnographer." *Studies in the Anthropology of Visual Communication*, 5 (Fall, 1978), 2–8.

Rouch, Jean. "Our Totemic Ancestors and Crazed Masters." *Senri Ethnological Studies*, 24 (1988), 225–38.

Scarry, Elaine. *The Body in Pain: The Making and Unmaking of the World*. New York: Oxford University Press, 1985.

Schieffelin, Edward and Robert Crittenden. *Like People You See in a Dream: First Contact in Six Papuan Societies*. Stanford: Stanford University Press, 1991.

Schorr, Naomi. *Reading in Detail: Aesthetics and the Feminine*. New York: Methuen, 1987.

SE: Standard Edition of the Complete Psychological Works of Sigmund Freud. 24 vols. Ed. James Strachey. London: The Hogarth Press and the Institute of Psycho-Analysis, 1960–74.

Severi, Carlos. "Le chemin des métamorphoses: une modèle de connaissance de la folie dans un chant chamanique cuna." *RES* 3 (Spring, 1983), 33–67.

Severi, Carlos. "Image d'étranger." *RES* 1 (Spring, 1981), 88–94.

Severi, Carlos. "The invisible path: ritual representation of suffering in cuna traditional thought." *RES* 14 (Autumn, 1987), 66–85.

Severi, Carlos. "Los pueblos del camino de la locura: canto chamanístico de la tradición cuna. *Amerindia*, 8 (1983), 129–80.

Sherzer, Dina, and Joel Sherzer, "Mormaknamaloe: The Cuna Mola." In Philip Young and James How (eds.), *Ritual and Symbol in Native Central America*. Eugene: University of Oregon Anthropological Papers, 9 (1976), 21–42.

Sherzer, Joel. *Kuna Ways of Speaking: An Ethnographic Perspective*. Austin: University of Texas Press, 1983.

Spencer, Baldwin and Gillen, F.J. *The Native Tribes of Central Australia* (first published in 1899). Rpt. New York: Dover, 1968.

Stoller, Paul "Horrific Comedy: Cultural Resistance and the Hauka Movement in Niger." *Ethos*, 12:2 (1984), 165–188.

Stoller, Paul. *Fusion of the Worlds: An Ethnography of Possession Among the Songhay of Niger*. Chicago: University of Chicago Press, 1989.

Stout, David. *San Blas Acculturation: An Introduction*. New York: Viking Fund Publications in Anthropology, 9. New York: 1947.

Tambiah, S.J. "Form and Meaning of Magical Acts: A Point of View," *Modes of Thought*, Ed. Robin Horton and Ruth Finnegan. London: Faber and Faber, 1973.

Taussig, Michael. "Maleficium; State Fetishism," *The Nervous System*. New York: Routledge, 1991.

Taussig, Michael. *Shamanism, Colonialism and the Wild Man: A Study in Terror and Healing*. Chicago: University of Chicago Press, 1987.

Turner, Victor. "A Ndembu Doctor in Practice." *The Forest of Symbols*, Ithaca and London: Cornell University Press, 1967.

Tylor, E.B. *Primitive Culture* (first published 1871). New York: Harper & Row, 1958.

Virilio, Paul. *War and Cinema: The Logistics of Perception*, Transl. Patrick Camiller. London: Verso, 1989.

Wafer, Lionel. *A New Voyage and Description of the Isthmus of America* (first published 1699). New York: Burt Franklin, 1970.

Wassén, Henry. "An Analogy Between a South American and Oceanic Myth Motif and Negro Influence in Darién," *Etnologisker Studier*, 10. Göteburg: Etnografiska Museum, 1940.

Wassén, Henry. "New Cuna Indian Myths According to Guillermo Hayans." *Etnologisker Studier*, 20. Göteburg: Etnografiska Museum, 1952.

INDEX